"*Living in Truth Mind, Body, Spirit* God's Word and real-life stories from other women who have been where you are. I'm sure, like me, you will be able to relate to so many experiences shared in this devotional, laughing and maybe even crying along with the authors. Combined with the power of God's Word, it will draw you into a deeper, more intimate relationship with Christ. Open your mind and heart and allow God to use the words on these pages to speak to you. You are not alone, and *Living in Truth Mind, Body, Spirit* will help you understand he's been with you every step of the way. Like the stories on these pages, the Lord can take your struggles and pain and transform them into something beautiful."

~Linda Hutchinson,
Executive Director, Rock Solid Families
www.rocksolidfamilies.org

"*Living in Truth Mind, Body, Spirit* is a devotional for the 21st century woman who wants a scriptural bedrock for every aspect of their lives. Every generation of the Church has seen women rise to the challenge of full surrender to the truth of the gospel. This devotional is a daily, transformational pathway for this generation's challenges."

~ Maureen Laniak,
Founder of TruthGirl Inc.
Vice President of Strategic Partnerships, Bible Journey
www.BibleJourney.com

"You will be greatly inspired as you read the stories of these godly women sharing how they have experienced a personal, intimate relationship with Jesus. You will be drawn closer to His heart because of their openness to share their hearts through their unique journeys. May many come to know Him more because of this powerful devotional."

~ Nancy Lindgren,
Founder of MORE Mentoring
Author of *TOGETHER*
www.morementoring.org

"Rae Lynn has an incredible gift. She is able to connect real life moments to God's Word. That is why I love her devotional, *Living in Truth Mind, Body, Spirit*. Rae Lynn has the unique ability to find God in the everyday moments of life. When we take the time to slow down and listen, we can hear His voice amidst the noise. The guest authors in the book offer their

perspectives on this incredible walk of faith with its mountains, valleys, and everything in between. The devotions in this book are relatable, and they do the most important thing of all which is helping us to connect to our Heavenly Father and draw closer to Him. No matter where we are in the journey, our hearts yearn for His unconditional love and presence."

~Michele Eich,
Founder of Voices of Recovery
www.20voicesofrecovery.com

"Beautifully written and incredibly relevant, *Living in Truth Mind, Body, Spirit* is a must-read for every woman of faith. This story-driven devotional is packed full of rich content that will help you get closer to the heart of God, his truth and his purpose for you. Readers will be empowered with practical gems of wisdom to implement in their everyday lives. I would highly recommend this devotional!"

~Barbara R. Lownsbury,
Author, Speaker, and Executive Director
*D*ented Fender Ministry
www.thedentedfender.com

"*Living in Truth Mind, Body, Spirit* is packed with biblical wisdom and truth, it brings the reader into real life examples that make you yearn for a greater presence of the Holy Spirit. It provides the type of comfort that makes you feel like you're curled up in God's lap when reading these daily devotionals. So thankful for a devotional like this, written in a timely manner for women to receive the daily dose of grace and love they need."

~Nicole Mesita,
Registered Dietitian,
Founder of Body Bloved
www.bodybloved.com

"I found this daily devotional to be extremely helpful in my walk with Jesus. I love daily reminders of how in my weakness He is strong. I could relate to every story told in some small way. The scriptures quoted were very relevant and reminders of God's love, forgiveness, and grace."

~Beverly McArthur,
Women's Ministry, Bright Christian Church
www.brightchristian.org

"Intentionality is necessary to stay healthy: emotionally, physically, and spiritually. Part of that intentionality is daily soaking in God's Word. This is why I recommend *Living in Truth Mind, Body, Spirit*. This devotional is biblically-based and filled with truth. The daily devotions are caressed in relatable stories to help women better understand God's love, grace, and power. If you are looking for a boost to your mental and spiritual health, I recommend *Living in Truth Mind, Body, Spirit*."

~Kenda Moss,
Executive Director of Eve Center
www.evecenter.org

"*Living in Truth Mind, Body, Spirit* helps us keep Christ at the center. It shows women how to tie God into day-to-day life, instead of putting God into a 'church on Sunday' box. This devotional is for any woman who wants a little more of Jesus and wants to walk closer to Him each and every day."

~Taylor Kiser,
Author of *Eat the Cookie*
www.foodfaithfitness.com

"*Living in Truth Mind, Body, Spirit* will ignite your desire to look at your life through a biblical worldview, inspire you, and invite you to move closer in a relationship with your Creator. What incredible insight into Scripture and practical applications to daily living in this crazy world. I love the transparency of the writers as they share a glimpse of their personal trials and triumphs. If you are looking for a gentle guide to remind you that God is greater than anything you face today, this is your devotional book!"

~Karla Raab,
CS Director, Pregnancy Care Center Southeast
www.pregnancylawrenceburg.com

Living in
TRUTH

Mind, Body, Spirit

a women's devotional

Living in TRUTH

in

Mind, Body, Spirit

a women's devotional

RaeLynn DeAngelis

Featuring Additional
LITM Authors

LIVING IN TRUTH MIND, BODY, SPIRIT

ISBN: 978-0-578-95895-8

Printed in the United States of America

Find out more at livingintruthministries.com

Living in Truth Mind, Body, Spirit

L iving in Truth Mind, Body, Spirit.
 Perhaps you're thinking… great title, but what does it mean?

Before I answer, let's start with a more basic question: *What is truth?*

Some say truth is subjective, that it's whatever we determine in our heart, and that it can change, depending on the person or circumstance.

Oh my, that's a treacherous road to travel!

Sweet Sisters, truth is not whatever we conjure up in our fickle hearts and minds. There has to be a standard for truth, and it needs to be determined by a Power higher than ourselves.

Real truth, the kind that guides our lives, must be a hardline drawn in the sand, a benchmark, something that's immovable and unchanging. And that's just what we have in God's Word—the Bible.

Jesus said, "Sanctify them by the truth; your word is truth" (John 17:17).

"Show me your ways, Lord, teach me your paths. Guide me in your truth and teach me, for you are God my Savior, and my hope is in you all day long" (Psalm 25:4-5).

"Send me your light and your faithful care, let them lead me; let them bring me to your holy mountain, to the place where you dwell" (Psalm 43:3).

Written thousands of years ago, the Bible continues to be the best-selling book of all time. Unlike any other piece of literature,

the Word of God is living and active; it is our handbook for everyday living. God preserved His Word all these years so that you and I wouldn't have to wonder what is true and what is not.

> We also have the prophetic message as something completely reliable, and you will do well to pay attention to it, as to a light shining in a dark place, until the day dawns and the morning star rises in your hearts. Above all, you must understand that no prophecy of Scripture came about by the prophet's own interpretation of things. For prophecy never had its origin in the human will, but prophets, though human, spoke from God as they were carried along by the Holy Spirit (1 Peter 1:19-21).

"All Scripture is God-breathed and is useful for teaching, rebuking, correcting and training in righteousness, so that the servant of God may be thoroughly equipped for every good work" (2 Timothy 3:16-17).

"For the word of God is alive and active. Sharper than any double-edged sword, it penetrates even to dividing soul and spirit, joints and marrow; it judges the thoughts and attitudes of the heart" (Hebrews 4:12).

"For everything that was written in the past was written to teach us, so that through the endurance and the encouragement of scripture, we might have hope" (Romans 15:4).

God doesn't want us to just hear the truth, read the truth, or ponder the truth. He wants His truth to permeate every fiber of our being.

> Do not merely listen to the word, and so deceive yourselves. Do what it says. Anyone who listens to the word but does not do what it says is like someone who looks at his face in a mirror and, after looking at himself, goes away and immediately forgets what he looks like. But whoever looks intently into the perfect law that gives freedom, and continues in it—not forgetting what they have heard, but doing it—they will be blessed in what they do (James 1:22-25).

Incorporating God's life-giving truths into our entire being requires intentionality. Don't worry... it's about progress—not perfection. God knows the challenges we face. "For we do not have a high priest who is unable to empathize with our weaknesses, but we have one who has been tempted in every way, just as we are—yet he did not sin" (Hebrews 4:15).

God is able to help us navigate this fallen world with all its traps and pitfalls, but we need to do our part too. Let me explain.

Have you ever tried to solve a Rubik's cube? The goal of the puzzle is to line-up all the coordinating colors on each side of the block. The cube is packaged with all the colors properly aligned, proving it is indeed solvable, but as soon as you begin twisting the blocks this way and that, the colors become jumbled. The challenge of this brain-teaser is to realign the cube back to its original form.

As a child, I remember spending hours trying to figure out how to achieve its proper alignment. Unfortunately, no matter how hard I tried, I was only able to solve one side of the puzzle. Whenever I began working on another side, the previously aligned colors got mixed-up again.

Living in truth, mind, body, and spirit can be just as challenging. Whenever we get one aspect of our lives in order, other parts suffer from lack of attention.

Can you relate?

One day I watched a YouTube video with step-by-step instructions for how to solve a Rubik's cube. It was quite interesting. Solving a Rubik's Cube and living in truth, mind, body, spirit have more in common than you might think. The first step for solving a Rubik's cube is to line-up one of the sides into the formation of a cross. With the cross in place, solving the rest of the puzzle is just a matter of following an algorithm (a sequence of steps) so that you can realign the colors into their proper place.

Like it is with a Rubik's cube, when we keep Christ at the center of all we do and follow God's step by step instructions for our lives, everything else falls into place. Life becomes more balanced and manageable. "But seek first his kingdom and his righteousness, and all these things will be given to you as well." (Matthew 6:33)

Life is a great teacher, especially when we look at it through the lens of biblical truth. Several years ago, I wrote a devotion book called *Living in Truth Day by Day*. In it, I share true stories from my personal life and the many life-lessons God has taught me along the way.

In this book, I share a new set of stories taken from my personal life. But this devotion book has an added bonus. It includes stories from women I admire and respect, my dear sisters-in-Christ.

I hope these short stories resonate and cause you to reflect on what God might want to speak into your heart. Stories have a way of unlocking the mind and providing deeper understanding.

Meditate on the Scriptures woven throughout, and ask God to help you apply these biblical truths to your own life story. After each day's devotion, try asking yourself these two questions:

- What is God saying to me?
- What am I going to do about it?

Remember, we want to be doers—not just hearers. Like it is with a Rubik's cube, once we have Jesus at the center, *Living in Truth Mind, Body, Spirit* is just a few twists and turns away.

The Purpose Driven Life

A comment that I frequently hear when ministering to others is, "It must be nice to know your calling in life. I'm still trying to figure mine out."

Rick Warren's book, *The Purpose Driven Life: What on Earth Am I Here For,* topped the New York Times Bestseller list for over ninety weeks. Tens of millions of copies were sold, shared, and devoured by readers around the globe.

Why did the book become so popular?

Deep within the core of every human being there is an innate desire to matter, to know that our lives have meaning, to leave our mark on the world. This longing is not a sin. It is not prideful or self-serving. Rather, our yearning for significance is both aspiration and inspiration threaded into our souls at conception. God literally wove "purpose" into our DNA. "For you created my inmost being; you knit me together in my mother's womb…Your eyes saw my unformed body; all the days ordained for me were written in your book before one of them came to be" (Psalm 139:14; 16.)

While we were still in the warm, safe cocoon of our mother's womb, God already knew the hopes, dreams, and plans of our lives. The Psalmist David's revelation goes on to declare God's foreknowledge of even the words we would speak. "Before a word is on my tongue you, Lord, know it completely" (Psalm 139:4). It is mind boggling, but true.

"How precious to me are your thoughts, God! How vast is the sum of them" (Psalm 139:17)!

I will be the first to admit there is a great sense of fulfillment in knowing you are doing what God has called you to do. I will also admit that I once struggled to know my purpose. From the

time that I was a little girl, all I wanted to be was a wife and mom. I didn't even go to college because I had absolutely no desire to have a career. I felt completely fulfilled by motherhood. I loved being a wife, caring for our home, and raising our children. But then something horrible happened. Our kids grew up. Despair set-in and I felt a deep sense of loss over what I thought was the "end" of my God-given purpose. For a while I wandered aimlessly, looking for what I was supposed to do next. I was too young for my life to be over.

So how did I go from being lost and in despair to knowing in the core of my being what God was calling me to do?

First, I acknowledged to both myself and God that I wanted my life to matter. Then I began seeking God with intentionality. I had some prophetic sense that God held the key to my purpose-filled future. And for good reason. "For I know the plans I have for you," declares the Lord, "plans to prosper you and not to harm you, plans to give you hope and a future" (Jeremiah 29:11). As I grew closer to God through an experiential relationship with Him, Jesus started opening my eyes and heart to see what He wanted to do next in my life.

There is something really amazing that happens when we grow closer to God. His desires, thoughts, and ways become our desires, thoughts, and ways. The more I learned about God, the more I wanted to learn about God. To this day, my intense desire to implement the ways of God has not diminished. My passion to know Him more with each day is all consuming. Eventually, God set my feet on the path towards healing, and after Jesus set me free from the enemy's lies, He taught me how to speak His truths into the lives of others.

Friends, I can't tell you what calling God has for your life. But I can tell you where you should go to find out. "But seek first his kingdom and his righteousness, and all these things will be given to you as well" (Matthew 6:33).

Jesus holds the key to our purpose-filled life. "Trust in the Lord with all your heart, and lean not on your own understanding. In all your ways acknowledge him and he will make your path straight" (Proverbs 3:5-6).

As long as we have blood coursing through our veins and oxygen pouring into our lungs, God has a purpose for our lives.

~Rae Lynn DeAngelis

Reprogrammed

A computer is a complex piece of machinery, yet if you know the proper language and keystrokes, one can manipulate technology with relative ease. My husband is what you might call a "computer geek." He knows more about computers than the average Joe. So, when my laptop becomes a little sluggish and no longer performs at the level I need, I call on him for help.

Oftentimes, the culprit for slowing down my computer is all the needless junk or corrupted data I've downloaded into my system over time. In order to fix my PC, my husband must first spend some time diagnosing the problem. With a proper diagnosis in place, he is able to find the corrupted files, remove them, and get my computer up and running smoothly again.

Changing unwanted patterns of behavior is a little more complicated than tapping out commands on a keyboard. However, I do believe there are some parallels we can take from the analogy.

When we first begin to notice unwelcome behavior patterns developing in our lives, we need to carefully determine what might be causing our unfavorable reaction. Behavior patterns (positive or negative) are first born in the mind. How we process incoming data in our mind and what we believe about that information will greatly impact our actions. The mind is a powerful command center. If we want to impact change in our behavior, we must first transform our minds.

How do we do that in practical terms?

"We demolish arguments and every pretension that sets itself up against the knowledge of God, and we take captive every thought to make it obedient to Christ" (2 Corinthians 10:5).

We need to reject anything that does not line up with God's truth, and we need to reprogram our thoughts so they agree with Christ. One of the ways we can reprogram our thoughts is through daily meditation of God's Word. As God's Word permeates our hearts and minds, unwanted thought patterns and behaviors gradually filter out.

Another way we can reprogram our thoughts is by clothing ourselves with Christ, learning all we can about Jesus and doing our best to emulate his example. "Clothe yourselves with the Lord Jesus Christ, and do not think about how to gratify the desires of the flesh" (Romans 13:14).

As we clothe ourselves with Christ, we begin to see the world through God's eyes. Worldly thoughts and behaviors morph into Christ-centered thoughts and behaviors. The Holy Spirit brings about this restoration; it is not something we can accomplish on our own.

"Do not conform to the pattern of this world, but be transformed by the renewing of your mind. Then you will be able to test and approve what God's will is—his good, pleasing and perfect will" (Romans 12:2).

Don't allow the world's corrupted data to contaminate thoughts and actions any longer. Take every thought captive, clothe yourself with Christ, and view everything against the backdrop of biblical truth.

~Rae Lynn DeAngelis

Knowledge Changes Everything!

When school was let out for the day, either Mom or our babysitter, Annie, would meet my brother (age 7) and me (age 10) by the school playground. We'd go on to do something fun for a couple hours, like go to the park or a museum. On one particular day, Annie announced, "We're going straight home. Sorry, no fun stops today." Shocked, I asked why. She wouldn't give me an answer.

The next day she proclaimed the same thing, "We're going home."

"What! Two days in a row? Not fair. Why?" I cried, but I still got no explanation. All she said was we weren't being punished, which surprised me.

"You can play in the yard." (Well, that's a real treat. Our yard was the size of a postage stamp!)

The same thing happened the next day…and the next. I got really mad. "None of my other friends have to go home after school!" You are cruel and mean. I'm being punished!

This went on for almost two weeks. I was on the verge of a tantrum and Annie sensed it. She broke her code of silence. "I didn't want to tell you this because I didn't want to scare you. But you're being such a brat, I have no choice." (Scare me? What's going to come out next?)

"They found a young girl's naked body in a dumpster behind the library (which was two blocks away). They think it's connected to the other two neighborhood murders. Now do you

understand why we're coming straight home? It's for our protection."

Then I understood. My crab-apple attitude disappeared immediately. I was frightened but now I wanted details. "How old was she? When and how was she abducted? Did she know the murderer? Tell me! Tell me!" The more I could learn about this awful incident, the more I might avoid the same kind of horrible death.

Knowledge changes everything!

If you understand something, you can begin to control it instead of letting it control you. A wise woman once said, "I am never afraid of what I know."

Proverbs 2:10 says, "Wisdom will enter your heart and knowledge will be pleasant to your soul." The reason we have conflict is lack of information and indifference. "My people are destroyed from lack of knowledge" (Hosea 4:6). The apostle Paul said, "Put on the new self, which is being renewed in knowledge in the image of its Creator" (Colossians 3:10). God wants to re-make us into the image of his Son! How does that renewal come about? Through knowledge.

If your mind was a movie screen for everyone to view, what would they see? Would your screenplay be rated G, R, or PG-13?

We are created in the image of God (Genesis 1:26-27). This involves our personality, intellect, emotion, will, and our spirituality. When man first sinned, this image was ruined, but through the work of Jesus Christ we can be transformed into God's image again! This doesn't mean we *become* God, but as his creation we can mirror his image. First, we must renew our minds (Ephesians 4:22-24) because our minds affect our whole being.

We cannot live the life God intended, a life of freedom and joy, without a change of mind. Knowledge is the investigation of the truth. As we grow in the knowledge of the Word of God, we begin to make better choices and bear his glorious image (2 Corinthians 3:18). He starts the transformation process of renewing our minds (Romans 12:2).

My challenge to you is to commit to get into the habit of reading daily Scripture. Begin by reading God's Word every day for 30 days. I'm confident your mind and thinking will begin to

change, which will have a positive impact on your life. You can do it!

~Kimberly Davidson

Blurred Vision

While waiting for my mom to come out of the grocery store, my dad and I sat in the old white station wagon trying to pass away time. Amused by what he saw, my dad pointed out a cleverly worded sign that was hanging near the entrance of a parking lot across the street. Not only could I not see the words, but I couldn't see the sign itself. This was the day my parents discovered I needed glasses.

Who knows how long my eyesight had been impaired! Since I didn't have anything with which to compare my vision, I had no idea my eyesight was compromised.

When I put on my new glasses for the first time, I was completely amazed. I could see everything. Each blade of grass, each branch, each leaf—everything was crystal clear.

It's amazing what we miss in life when we are not looking through the proper lens. God's Word provides biblical perspective for everything we face in life. I will say it again... the Bible continues to be the best-selling piece of literature in print. Why? Because the sacred words of Scripture are living, active, and God-breathed.

"For the word of God is alive and active. Sharper than any double-edged sword, it penetrates even to dividing soul and spirit, joints and marrow; it judges the thoughts and attitudes of the heart" (Hebrews 4:12).

"All Scripture is God-breathed and is useful for teaching, rebuking, correcting and training in righteousness, so that the

servant of God may be thoroughly equipped for every good work" (2 Timothy 3:16-17).

We can easily become so blinded by the world's pleasures and treasures that we miss the awesome beauty and life transforming truths tucked into the pages of Scripture. With vision distorted by the world's viewpoint, like my childhood experience, we may not even realize what we are missing.

"Your word is a lamp for my feet, a light on my path" (Psalm 119:105).

Are you looking at the world through a distorted lens? Reach for the biblical lens of God's Word and start seeing life from a whole new perspective.

~Rae Lynn DeAngelis

His Warm Embrace

Although spending time in the hospital is difficult to endure, sometimes it's unavoidable. I've had a few overnight stays of my own, and while I'm not exactly a fan of the hospital, I've experienced something delightful during each of my visits—*the infamous heated blanket.*

Apparently, hospital blankets are heated through some sort of warming device. Not only are they used to warm patients; they are also used to calm patients, helping them relax when they're feeling pain or discomfort. I don't know who came up with the idea, but it's ingenious. The warmth of the heated hospital blanket has always offered me immediate comfort and relief.

God's Word has a similar effect. A girl in one of my healing groups shared how the Words of God enveloped her like a warm blanket each time she read through her Scriptures for Renewing

the Mind. Peace and serenity washed over her in a way she had never before experienced.

I love it when someone is able to put into words the exact sentiments that I've been feeling but couldn't accurately express. The comfort that God provides through His Word is immediate, much like that warm hospital blanket. It's as if God is saying… *It's going to be okay. I've got this.*

Are you going through a difficult time? Allow these life-affirming truths to warm your heart, calm your spirit, and give you much needed hope and encouragement.

- So do not fear, for I am with you; do not be dismayed, for I am your God. I will strengthen you and help you; I will uphold you with my righteous right hand (Isaiah 41:10).

- And my God will meet all your needs according to his glorious riches in Christ Jesus (Philippians 4:19).

- Be strong and courageous. Do not be afraid or terrified because of them, for the lord your God goes with you; he will never leave or forsake you (Deuteronomy 31:6).

- The righteous cry out and the Lord hears them; he delivers them from all their troubles. The Lord is close to the brokenhearted and saves those who are crushed in spirit (Psalm 34:17-18).

- And we know that in all things God works for the good of those who love him, who have been called according to his purpose (Romans 8:28).

- In the same way the Spirit helps us in our weakness. We do not know what we ought to pray for, but the Spirit himself intercedes for us with groans that words cannot express (Romans 8:26).

God has this world and everything in it in the palm of His hand. He knows exactly what we are going through, and He offers to

wrap us in His comforting truths and carry us safely through to the other side.

~Rae Lynn DeAngelis

Letting Him In

T his weather has me so thrown off! One day it's hot. The next day it's freezing cold. One day we have snow showers, and the next we're wearing shorts and a t-shirt. I mean, come on!

Lately, that's how I've been with God. One day I feel super close and I'm present with Him. Another day I fly out of bed and don't think twice about inviting Him into my day.

If I'm honest, often I treat Him like a house-guest, like one I keep at the front door while I tidy up the house, clean the toilets, and light a candle so they don't smell my nasty garbage disposal or trash that needs to go out. It's like I only want Him to see the "best" part of me.

Jesus wants me every day. On my best day. On my worst day. Rain or shine. Snow or tornado. He wants me when I have no makeup, when things are messy, when I'm lying on the bed trying to get my pants buttoned (sucking in my belly a little bit more). He wants me when I'm disappointed that I've turned to food for comfort once again, or frustrated that I'm still looking in the mirror and picking myself apart. That's how close He wants to be with me. But will I let Him into the shame and struggles?

I know that the only way to do this is for me to get comfortable being myself with Him. When I'm quiet and still, I can get raw and real with Him. That's when He speaks. He restores. He resurrects.

When I feel like I can handle things on my own, my struggles, I think that's when He's knocking the loudest. He wants me to let Him in. He's gentle and won't barge in. I have to invite Him in. Like Martin Luther King said, "It's in the darkness we see the stars." That's when I notice Him most. On my darkest days and my loneliest nights, that's when I notice that He's missing.

I ask these questions of myself: *What am I trying to do on my own? What am I trying to control and fix by myself? What does it look like to let Him in?*

I say to each of you, as you are going through your day, fighting your battles, wondering if you can still carry this burden, let Him in. He will do it for you if you let Him.

Action steps I encourage you to take this week: set a timer, turn everything off, no talking, and let Him speak to you. Practice being still. I often imagine myself cuddled on His lap like a little girl with Him running His hands through my hair like I'm His most precious daughter. This is where He wants to be. This is when He moves into your heart. Start with five minutes. Trust me; it's worth it. This could be where "letting Him in" starts!

"Be still before the Lord, all mankind, because he has roused himself from his holy dwelling" (Zechariah 2:13).

"The Lord will fight for you; you need only be still" (Exodus 14:14).

"The Lord is my shepherd I shall not want. He makes me lie down in green pastures. He leads me beside still waters. He restores my soul" (Psalm 23:1-2 ESV).

~Alison Feinauer

Against the Current

With the sun beating down and temperatures rising above the ninety-degree mark, we decided to drop anchor and go for a swim. We were enjoying a lazy summer afternoon on the river. Without a care in the world, we appreciated the opportunity to have fun with treasured friends.

The smooth surface of the water broke when we jumped into the river cannonball style, trying to see who could make the biggest splash. Enjoying the cool refreshment of the water, we didn't realize how far we had drifted from the boat. (The river's current was unusually strong that day.) Once realization set in, we struggled to swim against the current, back to the safety of the boat.

Finally, one of the guys made it back to the boat and threw us a line. With his feet planted firmly on the anchored craft, he was able to pull us back in.

The Christian life can make us weary, especially when we are swimming against the tide of secularism, worldliness and materialism. These can create a great chasm between us and God. Children are especially vulnerable to being swept downstream by the cultural flow. Parents helplessly watch as their loved ones drift further and further from God.

Drugs, alcohol, violence, and promiscuity run rampant at a time when our kids should be shrouded by innocence. And since God is no longer welcome in many of the environments our children frequent, it's difficult to pull them back to safety.

"Do what is right and good in the Lord's sight, so that it may go well with you and you may go in and take over the good land the Lord promised on oath to your ancestors…" (Deuteronomy 6:18).

As parents we must have unmovable faith, tethered to the secure hold of Jesus Christ. With both feet planted firmly on solid ground, we can pull loved ones out of harm's way, back to safety.

Every day we must speak truth into their lives and show them (through our own example) what it looks like to swim against the current. We must teach our children from the time they are very young, pray for our loved ones daily, and place them at the feet of Jesus.

> Love the Lord your God with all your heart and with all your soul and with all your strength. These commandments that I give you today are to be on your hearts. Impress them on your children. Talk about them when you sit at home and when you walk along the road, when you lie down and when you get up. Tie them as symbols on your hands and bind them on your foreheads. Write them on the doorframes of your houses and on your gates (Deuteronomy 6:5-9).

Each time we or our loved ones begin to stray, we need to pray boldly and trust God's higher ways. Our God is faithful. He is always there to draw his children back into His secure and loving embrace. "We have this hope as an anchor for the soul, firm and secure" (Matthew 6:19).

~Rae Lynn DeAngelis

Direct Line

The first public phone conversation made its debut on March 10, 1876 when Alexander Graham Bell communicated a brief message to his assistant Mr. Watson.

Since its invention, the phone has changed in both appearance and functionality. I wonder what Mr. Bell would think of his invention today, how our 21st century phones double as mini computers.

Just the other day I used my smart phone to research movies playing in our small-town cinema. In a matter of seconds, all the information I could possibly need was right there.

A trip to the movie theater thirty years ago, however, required a bit more effort. Option one: Search the entertainment section of the newspaper to find movie information. Option two: Call the cinema directly and listen to the pre-recorded message highlighting each movie title, rating, and show time. If you missed part of the message or got a busy signal, you had to hang up and try again. (I'm so thankful for modern technology!) No more "busy signal." No more hassle.

Here's something else I'm grateful for—instant access to my Father in heaven. We can commune with Him anytime, anywhere. "Call to me and I will answer you and tell you great and unsearchable things you do not know" (Jeremiah 33:3).

Friends, when Jesus went to the cross and gave His life as a final sacrifice for our sins, we were instantly set free from the burdensome rituals of the Old Testament. The very moment Jesus breathed His last breath, the temple curtain (four inches thick and 70 ft. high) tore in two, signifying open access to our Father in

heaven. No more barriers. No more animal sacrifices. No more hassle. Just you and me having an intimate conversation with God.

I'm so grateful to have a direct line to the Father. Thank you, Lord Jesus, for paving the way towards a fulfilling relationship with you!

"At that moment the curtain of the temple was torn in two from top to bottom. The earth shook, the rocks split and the tombs broke open. The bodies of many holy people who had died were raised to life" (Matthew 27:51-52).

> Therefore, brothers and sisters, since we have confidence to enter the Most Holy Place by the blood of Jesus, by a new and living way opened for us through the curtain, that is, his body, and since we have a great priest over the house of God, let us draw near to God with a sincere heart and with the full assurance that faith brings, having our hearts sprinkled to cleanse us from a guilty conscience and having our bodies washed with pure water. Let us hold unswervingly to the hope we profess, for he who promised is faithful (Hebrews 10:19-23).

~Rae Lynn DeAngelis

Question of the Day

At a recent job interview, an open-ended question left me stumped. "Can you tell us a little about yourself?"

I thought to myself: *I could tell you a lot about myself. Could you be more specific please?*

I am a wife, mother, and Registered Nurse. (No, that describes titles held.)

I clean, run errands, cook, and try to instill positive thoughts into my children. (No, that describes tasks completed.)

I am entering my 6th year in recovery from an eating disorder. I pushed through nursing school, surviving countless triggers trying to pull me down along the way. I lived in various cities and dealt with plenty of hardships along the way, and I married the love of my life nine years ago. (No, that describes my past situations and circumstances).

Alright, I guess I just don't understand the question. Next question please!

Have your ever experienced difficulty in answering the question, "Can you tell me a little about yourself?" Define you. If I never met you before and wanted a brief summary before meeting in person, what words would be used?

Of course, we all want to jump to the titles held or the many hats worn. We like to list tasks completed to describe our worth and value and place emphasis on the challenges and situations overcome in the past. These bring purpose to our life, right? When we pump up our pride, we help others see a hero, right?

I would tell you that not too many years ago I would have believed all the descriptions above. My worth depended on my title. My value came through doing 'things' for everyone and keeping everything in perfect order. My credibility relied on all the past hurdles I had overcome.

Guess what, my friends, I was so wrong!

My worth—child of God. "Yet to all who did receive him, to those who believed in his name, he gave the right to become children of God— children born not of natural descent, nor of human decision or a husband's will, but born of God" (John 1:12).

My value—making disciples. "Therefore go and make disciples of all nations, baptizing them in the name of the Father and of the Son and of the Holy Spirit, and teaching them to obey everything I have commanded you. And surely I am with you always, to the very end of the age" (Matthew 28:19-20).

My credibility—faith in Christ, a new creation. "So from now on we regard no one from a worldly point of view. Though we once regarded Christ in this way, we do so no longer. Therefore, if anyone is in Christ, the new creation has come: The old has gone, the new is here" (2 Corinthians 5:16-17)!

Seeking worth, value and credibility in the world will forever be disappointing.

"Can you tell us a little about yourself?"

My answer – saved, given the grace to begin anew each day and finish the work laid before me. I am beautifully and wonderfully made for a purpose. I am a child of the one true King. And so are you, my dear friend.

You will find your worth in Him, not this world. Go to Him.

~Sheree Craig

Fragile Exterior

I reached into my refrigerator and pulled out one of my favorite early autumn treats—a pear.

Just a few days prior, I had purchased the bag of the perfectly ripened delights. The pears were without blemish when I placed them into my refrigerator; but just days later, each piece of fruit bore what appeared to be war wounds. Small cuts and bruises dotted the fruit's casing.

I was perplexed. The pears had not been through any great conflict; yet here they were, appearing as though they'd been through some dreadful battle. Why?

I'm not a produce expert; but apparently, pears have extremely tender exteriors and bruise easily. The bruise doesn't always show up immediately. It's only after a bit of time that the damage is visible.

"A gentle answer turns away wrath, but a harsh word stirs up anger" (Proverbs 15:1).

We are all unique, and like a piece of fruit, our unique differences add variety, color, and flavor to the world. Some people put on a tough exterior, while others' facade is more fragile

and delicate. Some are able to shake off hurtful words or comments easily, while others carry around a cloud of gloom like Eeyore and experience a great amount of distress. One person's manner is not better than the other—just different.

"Whoever derides their neighbor has no sense, but the one who has understanding holds their tongue" (Proverbs 11:12).

Many times, we struggle to understand another person's actions because we forget to factor into the equation the manner of our unique differences. What bothers or frustrates me, may seem trivial to you. What exasperates you, may be insignificant to me. Depending on our unique makeup, we might react to situations differently.

If we could remember to take into consideration one other's distinct variances when dealing with those around us, we might see less battle scars surfacing on our relationships later on.

"Be completely humble and gentle; be patient, bearing with one another in love" (Ephesians 4:2).

"Therefore, as God's chosen people, holy and dearly loved, clothe yourselves with compassion, kindness, humility, gentleness and patience" (Colossians 3:12).

~Rae Lynn DeAngelis

Last Day on Earth

Maybe it's my age or season of life or perhaps it's the ever-increasing awareness of my true identity and knowing that I am so much more than a body, but I've been thinking a lot about death lately.

Death doesn't really scare me. Actually, the opposite is true. Not that I have a death wish or that I'm sensing the end is near,

but I can't wait to meet Jesus face-to-face, to see His glory and the splendor of heaven!

"No eye has seen, no ear has heard, no mind has conceived what God has prepared for those who love him" (1 Corinthians 2:9). The thought of spending eternity with Jesus fills me with so much hope, excitement, and wonder.

Believers have the assurance of heaven, but landing safely in paradise should not be our only objective. You and I have been given this one life, this one opportunity, this one span of mortal existence to make an eternal impact for the Kingdom of God. Against the backdrop of eternity, our time of influence is pretty short. Perhaps today is a good opportunity to take inventory of our Kingdom impact thus far and contemplate our future legacy after we are gone.

What has God called you to in this life? Are you carrying that out? If not, what steps do you need to take to start heading in that direction?

When I die and get to heaven, I hope to hear Jesus say, "Well done, good and faithful servant! You have been faithful with a few things; I will put you in charge of many things. Come and share your master's happiness" (Matthew 25:21)!

I don't want to get to heaven and see all the things God could have done with my life. I want to get to heaven and see all the things God did do with my life because my days were surrendered to Him.

Our span of time (whether it is days, years, or decades) is not the important thing. What truly matters is what we do with the time we've been given.

Life is so very fragile and can be taken away in an instant. The influx of news alerts, terrorist attacks, shootings, pandemics, and natural disasters gives us ample evidence of this fact.

Dear friends, we can become overwhelmed and depressed about the influx of unsettling news, or we can get busy living the lives God long ago called us to live, lives that reflect His Son Jesus, putting others before ourselves.

Let us live each day as if it is our last day on earth.

"For to me, to live is Christ and to die is gain" (Philippians 1:21).

"For whoever wants to save their life will lose it, but whoever loses their life for me will save it" (Luke 9:24).

~Rae Lynn DeAngelis

Worth the Effort

Clink. As I reached into my coat pocket for the car keys, a penny fell to the ground. Instead of picking it up, I continued walking to my destination. It was just a puny little penny. Not even worth the effort it takes to bend over and pick it up. After a few steps, the Holy Spirit began His work in my heart and mind. God purposed this penny as a lesson in disguise.

If a quarter dropped out of my pocket, I would pick it up without hesitation. It's worth the effort to pick it up. A dropped penny is a trivial amount. Then I began thinking about the parable of the poor widow's mite and about the parable of the talents that were given to each of the three servants.

Think about pocket change as being tasks God has given you. Has He given you a puny penny task that, in your view, doesn't amount to a hill of beans? Give a friend a ride, visit a neighbor, open a door for someone, spend time helping your child with homework? Did you obey without grumbling to fulfill your God-appointed duty, or did you let the opportunity pass? In other words, did you let the penny fall and continue walking?

You see, when we fail to respond to a call-to-action in the menial things, God will not bestow on us greater things. No quarters, ones, fives, hundreds. Nope. Nada. God does not see things as we do. His ways and thoughts are higher, oh so much higher, than our human minds can fathom. When He calls you to an area of servitude, He doesn't measure things in pennies and quarters. He simply wants you to joyfully carry out what He has

purposed for you. Nothing is menial to Him. He doesn't measure things according to task size. God will bless your obedience like He did for me.

He dropped a seemingly menial opportunity in front of me at an assisted living facility. I stumbled upon a 67-year-old woman named Patty. She was almost blind. As I talked with her, I found out she liked listening to several different preachers on TV. We talked about some Bible stuff and I asked her if she'd like me to come read to her. Reading one book led to another, and our relationship grew in the process. She told me she asked God to send someone to read to her, and I was the angel He sent (Ha!). If I were blind, I too would long to be able to read my Bible, devotions, and other books.

The only thing that made me take on this responsibility was the teaching of Jesus. He said, treat others how you would like to be treated.

This small act of obedience has been rewarding for me and for Patty. She is very inquisitive which makes me more studious. I want to answer her questions accurately according to what the Bible says. After a while, an opportunity opened up to teach the Word to several others. Now I sit on the edge of my seat, waiting to see the next door God opens up. It's exciting!

What small step of obedience is God asking you to take? Taking this step will lead to joy and fulfillment. It will help you become more discerning to God's voice when He asks you to take another step.

One small step of obedience could have a ripple effect that touches multitudes.

"So he who had received five talents came and brought five other talents, saying, 'Lord, you delivered to me five talents; look, I have gained five more talents besides them.' "His lord said to him, 'Well done, good and faithful servant; you were faithful over a few things, I will make you ruler over many things. Enter into the joy of your lord.'" (Matthew 25:20-21).

~Rhonda Stinson

In Full Bloom

I love springtime. There's something delightful about the beauty of the season, perhaps even more so because here in the Midwest spring follows the very cold and dreary days of winter.

Although the season is barely beginning by the end of March, often the flowering trees are already in full bloom—lush and vibrant.

Part of the branding for Living in Truth Ministries is represented by flowers—all shapes, colors, and varieties. That's because flowers are a lot like women—beautiful and diverse.

I'm not much of a gardener, but I know at least a few basics when it comes to growing flowers. I know there are a few factors that are essential for cultivating healthy plants.

The first thing plants need is healthy soil. Flowers thrive in nutrient rich soil that is void of rocks and weeds, soil that is properly tilled, allowing the best possible opportunity for growth. Plants also need water and sunlight.

We can apply similar fundamentals towards spiritual growth and healing. Women looking to grow or heal, need a safe, healthy environment where they can be open and real. That's just what Living in Truth Ministries has to offer. Our programs for women provide love, support, acceptance, and understanding. We meet people right where they are, without judgement, expectations, or pressure. Our desire is to come alongside women and point them to the one true light—Jesus. Through our programs, women receive a daily dose of life-giving truths—water through the Word, truths that help to renew the mind (Romans 12:2) and free the captives (John 8:32).

Many women come from a place of bondage, heartache, rejection, and pain. Never before have they been surrounded by such love and acceptance. And because they are growing and healing in a healthy, safe environment, they are able to develop deep roots which enable them to produce spiritual fruit long after the program ends.

Just as flowers bloom and grow at different rates, each woman's journey is unique. Every person heals and grows at a different pace. "There is a time for everything, and a season for every activity under the heavens: …a time to plant… and a time to heal" (Ecclesiastes 3:1-3).

Amazingly, God knows exactly what each woman needs on her journey. The Lord is patient, kind, loving and encouraging. He never leaves or forsakes us. He is always by our side, encouraging us to take that next step. Day by day, He continues to nurture our growth, spurring us on to victory and freedom, giving us just what we need, when we need it.

"I am the vine; you are the branches. If you remain in me and I in you, you will bear much fruit; apart from me you can do nothing" (John 15:5).

Whether you are looking to heal or just need to be rooted in biblical truth, may God plant you in just the right environment where you, too, can bloom and grow.

~Rae Lynn DeAngelis

Expect the Unexpected

Already by age two, our daughter, Heather, was eager to please and rarely veered from the path of good behavior. However, in true artistic fashion, our little girl was a free spirit. Barely old enough to hold a crayon, she had a passion to

create, and like most parents of free-spirited children, we learned to expect the unexpected.

During a time period when our young family was in-between moves, we spent a few months living with my parents. Staying with them made us a bit anxious because their home was neat as a pin, and we had a toddler. I worried we might ruin our welcome if there was any kind of mishap.

Although we were a bit leery about the living situation, we needed a place to stay. So, out of desperation, we made the move and tried our best to respect their home.

One afternoon while Heather was content coloring in her picture book, I used the opportunity to fold a load of laundry. Although Heather was out of my line of sight, she was still within ear range. I decided she would be okay for a few minutes. (An assumption I would later regret.)

Our parent's home had a small staircase leading from the dining room to the family room below. When I came back upstairs with the basket of laundry, only moments later, I was stunned to find our budding artist engrossed in her newest masterpiece. As she looked up at me with a big smile, obviously proud of her pretty picture, my heart sank into the pit of my stomach. Bright, red, crayon swirls decorated my parent's staircase wall.

Frantically, I called my husband at work and told him what happened, hoping against all hope that he would know what to do. He told me not to panic; he would see what could be done as soon as he got off work.

When Gerry got home, he assessed our toddler's graffiti, and after a few moments, offered up an idea to remedy the situation. He suggested we check to see if my parents had any leftover wallpaper from their recent renovation. Since the area was fairly small, he thought that perhaps we could repaper the area.

Thankfully, my parents did have some extra wallpaper, and it was just enough. In no time the staircase wall looked as if nothing had ever happened.

"And my God will meet all your needs according to the riches of his glory in Christ Jesus" (Philippians 4:19).

When we explained everything that had happened to my parents, they didn't freak out like I thought they would. Instead, they reminded me that they were once parents of a toddler too.

"Whoever conceals their sins does not prosper, but the one who confesses and renounces them finds mercy" (Proverbs 28:13).

Things we don't expect are going to happen—that's a given. But when life throws us a curveball, we need to face our fears, learn from our mistakes, and do what we can to make amends. Never fear. God's got it.

"Call upon me in the day of trouble and I will deliver you" (Psalm 50:15).

~Rae Lynn DeAngelis

Beauty and Peace

Today, while my students were in art, I went for a walk around town. It was an amazing spring morning. The temperature was perfect, coupled with a spring breeze. Children were gathered in front of the courthouse to have their field trip picture taken. The flowers all around the courthouse were in bloom. (I particularly love the irises in the north east corner of the courthouse lawn.) The children were playing outside on the playground at the daycare. Their squeals of delight and laughter could be reveled in from a block away. A lady was enjoying her day gardening. We spoke briefly, as friendly folks do.

Very few drivers were out and about. It felt like I was walking around inside a Norman Rockwell painting. And for the briefest moment, I had a yearning for that yesteryear, Norman 'Rockwellish' town.

Then God nudged me. (I love it when He does that.) Paintings are moments. And this one was mine.

We often waste time wishing we had something other than what has been given to us: a different time, a different place, a different body, different choices . . .

Those Norman Rockwellish towns were dealing with WW2. Over 400,000 would not come home.

Later, those Norman Rockwellish town children were playing duck and cover under their desks at school.

This world has been broken since the Garden of Eden. It is what it is. It has big scary moments and moments of beauty and peace. But we have to look for the beauty and peace. They don't scream out for our attention like troubles do.

Look for something beautiful today. Then thank your Maker for it. Focus on the beautiful. Hold onto it as long as you can. When you lose it, God will give you more. Let Him.

"Finally, brothers, whatever is true, whatever is honorable, whatever is just, whatever is pure, whatever is lovely, whatever is commendable, if there is any excellence, if there is anything worthy of praise, think about these things" (Philippians 4:8).

The more you focus on these things, the less room for negative thinking will be left in your heart and mind.

"A heart at peace gives life to the body, but envy rots the bones" (Proverbs 14:30).

~Melody Moore

Do-Over

During a team building exercise at a local retreat center, our ministry team was instructed to navigate a course designed to help us work together as a team.

After a rocky start, we began to make progress towards our predetermined destination. But just when we thought we had the

challenging course conquered, one of the team members lost her balance and fell off the wooden beam.

Rules are rules. If someone fell, the whole group had to go back to the beginning and start again.

Frustrated because we had almost made it to the finish line, we begrudgingly got into our positions and started over. But before we started moving forward again, one of the team members suggested that we try things a little differently this time. We gave her idea a try, and to our surprise, the new method got us to our goal in record time.

"Blessed is the one who perseveres under trial because, having stood the test, that person will receive the crown of life that the Lord has promised to those who love him" (James 1:12).

Often in life, we grow frustrated by our mistakes, especially when it means we must start all-over again. But like it was with our team building exercise, sometimes life's little slip-ups are the perfect opportunity to gain a fresh perspective and do things differently.

Don't get discouraged by your mistakes. Mistakes provide you great opportunities to learn and grow. Who knows, like our team building experience, your do-over just might lead to a remedy for future success.

"You need to persevere so that when you have done the will of God, you will receive what he has promised" (Hebrews 10:36).

If at first you don't succeed, try, try again.

~Rae Lynn DeAngelis

Weed and Feed

Every year my husband spreads a chemical across our lawn to help it stay healthy, lush, and green. Each application of Weed and Feed enriches the soil and nourishes the desirable part of our lawn—grass. At the same time, the product distributes poison that quickly destroys any unwanted weeds. We wisely care for our yard now, but this wasn't always the case. In the early years of our marriage, especially when finances were tight, lawn fertilizer wasn't a particularly high priority in our family budget.

After a while, the effects of our neglect became obvious with the progressive onslaught of weeds. The little yellow flowers looked enchanting at first. But after a few short days, the blooms morphed into mysterious white orbs, releasing a frenzy of seed spores throughout our cul-de-sac. The weeds were out of control and our neighbors became increasingly annoyed.

We eventually realized spending a bit of time and money treating our lawn was worth the effort. The results were not immediate, but persistent determination caring for our lawn eventually offered a good return on our investment.

"The kingdom of heaven is like a man who sowed good seed in his field. But while everyone was sleeping, his enemy came and sowed weeds among the wheat, and went away" (Matthew 13:24-25).

Neglecting one's spiritual health is like neglecting one's lawn. It's an open invitation for Satan to sow his intrusive garden of lies. Deception laced with a small dose of truth appears harmless at first. *Everybody's doing it... You can stop anytime you want... You deserve better... Life is short...You only live once.... You're not hurting anyone...*

But given enough time, lies turn into more lies and eventually choke out the positive growth in our lives. The constant neglect doesn't impact us alone. Toxic thoughts and destructive behaviors, left to their own devices, eventually poison the world around us too.

"Be alert and of sober mind. Your enemy the devil prowls around like a roaring lion looking for someone to devour" (1 Peter 5:8).

The mind becomes entangled with deception when we do not protect ourselves with a daily measure of God's unchanging truths.

"Do not conform to the pattern of this world, but be transformed by the renewing of your mind. Then you will be able to test and approve what God's will is—his good, pleasing and perfect will" (Romans 12:2).

Meditate on scriptural truths aimed at your specific areas of weakness so that your mind, body, and soul are healthy and strong. Rest assured... your family, friends, and neighbors will thank you!

"They are like a well-watered plant in the sunshine, spreading its shoots over the garden" (Job 8:16).

"But let all who take refuge in you be glad; let them ever sing for joy. Spread your protection over them, that those who love your name may rejoice in you" (Psalm 5:11).

~Rae Lynn DeAngelis

Kind and Loving

It seems to be so much easier for me to be kind to others and to show more compassion towards complete strangers than to myself. Okay, except maybe when my toddler has been pushing me all day, then it's difficult for me to consistently find

my compassionate voice. I can be so critical of myself: the way I look, my achievements, my knowledge, my parenting, my relationship with Jesus. Can anyone else relate to this?

Maybe I can offer more grace and compassion toward others because it is written over and over in the Bible.

"Be kind to one another, tenderhearted, forgiving one another, as God in Christ forgave you" (Ephesians 4:32).

"Bear one another's burdens, and so fulfill the law of Christ" (Galatians 6:2).

"Love the Lord your God with all your heart and with all your soul and with all your mind and with all your strength.' The second is 'Love your neighbor as yourself.' There is no commandment greater than these" (Mark 12:30-31).

Why do we find it so difficult to be compassionate toward ourselves? If we are meant to be kind and loving to others, then surely, we are meant to be kind and loving to ourselves as well.

Here is some good news about self-compassion; we can change the way we talk to ourselves. We have the choice. I've done it. I know you can too. My inner critic voice has slowly gotten quieter over the past couple of years, and my compassionate voice has become more dominant. It definitely didn't happen overnight. It's been a process of relearning how I can speak to myself with a voice of gentleness and kindness. Does that mean I'm no longer critical of myself at times? No. I still find that it's easier to be kinder to others than to myself. But I'm choosing self-compassion much more often than I used to, and that's a step in the right direction.

A few things that may help you start using a more compassionate inner voice:

- Speak kind words when you're looking in the mirror. You don't have to love what you see, but you can start accepting your body for what it does. Maybe it's, "my belly grew my children," "my legs allow me to move," "my nose allows me to smell dinner every night when I walk in the house." It's starting to believe your body is good and does good things.

- Speak kindly when you're feeling overwhelmed. Instead of saying, "I have too much to do. I can't get this done. I'm a failure," look at your list, prioritize it, be realistic about what is manageable that day, and just do that. You're not Superwoman, and you don't need to be. Also, taking time to write down all of the things you actually did accomplish in the past few days may help put things in perspective and help you speak to yourself from a place of gentleness.

- Carve out some time just for yourself each day or week. You deserve it, and tell yourself that. Do something that fills your cup and makes you feel good, rested, or energized. Read a book, go get a latte, go on a walk, take a nap, snuggle your dog, turn up the song and dance . . .

More kindness to all, but please let's not forget that we also need to be speaking kindly to ourselves every single day.

~Kelsey Klepper

Ebb and Flow

Our family vacations often take us to the beach. We love to soak up the sun and enjoy the refreshing water and sand.

On a recent vacation, we forgot to check the tide schedule before heading over to the beach. When we arrived, there was barely enough room to stake our claim with a few beach chairs and an umbrella. The high-tide ocean was literally at our feet.

The landscape of any seashore drastically changes its appearance with the ebb and flow of the ocean's tide. By later that

afternoon, the water receded with the tide, and we had much more terrain on which we could relax and enjoy.

Sometimes, my day-to-day life takes a similar turn. During high stress seasons, it seems I have barely enough room to breathe. I feel confined to the busyness and pressures of deadlines, schedules, and appointments. There's not a lot of room to simply let loose and enjoy life.

At other times, my life seems to have more space and time than I know what to do with.

During a recent holiday break, life was extremely chaotic. My busy schedule went from one thing to the next. Don't get me wrong. All of the festivities were a blessing, and I loved having time with my family and friends. It's just that the crammed schedule didn't lend itself to much time for rest, especially since I was the one hosting the out-of-town guests and holiday dinners.

"The Lord replied, 'My Presence will go with you, and I will give you rest'" (Exodus 33:14).

Only a week later, the landscape of my life looked totally different. My 'high tide' schedule began to recede. The holidays were over, and the out-of-town guests went home. Days later, our son left for Japan to study abroad and my husband resumed his travel, work schedule. Suddenly, I had more time than I knew what to do with. "There is a time for everything, and a season for every activity under the heavens..." (Ecclesiastes 3:1a).

Seasons come and seasons go, but I'm encouraged to know that, much like the ocean, the highs and lows of life will continue to come and go. Rather than focusing on the stress surrounding us, we need to focus on the One who controls the ebb and flow of each moment. Just when the pressures of life get to be too much, God will pull back the tide and provide us with much needed space and rest.

"The Lord is near. Do not be anxious about anything, but in every situation, by prayer and petition, with thanksgiving, present your requests to God. And the peace of God, which transcends all understanding, will guard your hearts and your minds in Christ Jesus" (Philippians 4:5-7).

~Rae Lynn DeAngelis

Proper Immunization

This is the season for the creepy crud. Colds, viruses, and stomach bugs have been making their rounds in our home. I suppose the only upside to being sick now is that we build-up tolerance so we can stay healthy later on. God created our bodies with an amazing ability to ward off intruders that make us sick. When functioning properly, our immune system is able to identify and attack a variety of threats, including viruses, bacteria, and parasites.

Thankfully, God offers us protection against another ill-fated condition—pride. Jealousy, envy, vanity, and covetousness are some of the more prominent forms of pride, but possessiveness, greed, bitterness, and resentment can be just as destructive. A sister's recent weight loss, a friend's new house, a coworker's unexpected promotion, our Facebook friend who seems to have the perfect life should be celebrated; but if our heart is in the wrong place, the good fortune of others can produce noxious fumes of negativity in our spirit.

How we react to the success or failure of others says a lot about our spiritual maturity.

"I will put an end to the arrogance of the haughty and will humble the pride of the ruthless" (Isaiah 13:11).

Friends, let us not forget; Satan was cast out of heaven because of self-serving pride (Ezekiel 28:12-19). It's kind of a big deal. We would be wise to eradicate the ugly contaminate of pride before it becomes harmful to others. Like a booster shot in the arm, the Holy Spirit's gut-check acts as our first round of defense.

When we get that nauseating feeling that we've become a little too "me" focused, we need to bow before the Lord, seek

forgiveness, and consider this important truth: there's a whole lot more in this world than little old us.

"Do nothing out of selfish ambition or vain conceit. Rather, in humility value others above yourselves, not looking to your own interests but each of you to the interests of the others" (Philippians 2:3-4).

WARNING: Pride is lethal. Disregard the Holy Spirit's conviction, and like a toxic bacterium that grows undetected, our most precious relationships are at risk of dying a slow and painful death.

"Pride goes before destruction, a haughty spirit before a fall" (Proverbs 16:18).

~Rae Lynn DeAngelis

Being Enough Takes Connection

Recently a friend shared sentiments of feeling like she was not enough. As she talked, she realized it is something she has subtly dealt with for many years. However, with some new roles she had taken on, the feelings of not being enough were taking deeper root.

This is a feeling I could certainly relate to. I have been there—done that—and have the medal to show for it. Like many other women, I have battled for many years with feelings of not being enough, doing enough, and knowing enough. Satan has used those feelings to tell me lies that I need to do more, do it better, and do it differently in order to achieve. It has been one of the most

effective avenues that the evil one has used to alter my thoughts and decisions.

In Matthew 11:29-30, Jesus beckons us to learn from him to ease our burdens of inadequacy. "Take my yoke upon you and learn from me, for I am gentle and humble in heart, and you will find rest for your souls. For my yoke is easy and my burden is light."

Did you see it? Gentle and humble in heart. Paul re-enforces this call to be gentle and humble in Ephesians 4:2, "Be completely humble and gentle; be patient, bearing with one another in love."

This call includes being humble, gentle, and loving of ourselves, especially in times of uncertainty: a humbleness in the expectation that we should be able to know it all, do it all, and be everything for everyone, and a gentleness and quietness that understands these are states of the Spirit and not behaviors. Peter reminds us in 1 Peter 3:4, "Rather, it should be that of your inner self, the unfading beauty of a gentle and quiet spirit, which is of great worth in God's sight."

Being humble and gentle in spirit requires us to yield to the thoughts and feelings that pervade. Feelings of inadequacy and thoughts of comparison can take root and cause us to forget the truth of WHO we are and WHOSE we are. So how can we find this humble and gentle heart? By yoking ourselves to Christ!

A yoke is a harness type mechanism to keep oxen or other animals tethered together. It is worn on the neck and shoulders to ease the burden and pain of the work they are doing together. When we yoke ourselves to Christ, we connect to him, follow his guidance, and take his lead. The tasks and decisions we have to make become less taxing when we allow Christ to take some of the burden through reliance on his word. The closer we work with him, the more we take on his character. This ultimately allows the Holy Spirit to cultivate these important fruits in us, fruits that will help us turn away from the acts of the flesh and the mindset the evil one loves to use against us.

I have found in my walk that the closer I am connected to Jesus, am yoked to him, the less I hear or believe what the evil one is whispering in my ear. I can learn from His word and rest in the realization that to Him, I am enough. As long as I am connected

to him and following his lead, I will do just what he calls me to do, when he calls me to do it, and that is ALWAYS enough.

~Tanya Jolliffe

Investment Worth Protecting

My husband and I have decided to protect the investment of our home through ongoing maintenance and repairs. This includes the occasional face-lift by replacing or refurbishing outdated fixtures, flooring, and cabinets.

After our ninety-pound golden retriever went to his eternal home, we realized our scratched and weathered hardwood floors needed a bit of love and attention. We were ill-equipped to tackle the project on our own, so we hired a flooring expert. The plan was to sand-away the old surface and re-stain the stripped hardwood with a more "up-to-date" color and finish.

Let me just say, refurbishing hardwood floors is a messy and taxing project. We began to wonder if the chaos was really worth it.

As we neared the end of the project, the flooring expert asked us if we would like the shoe molding to be painted white (like our other wall trim) or would we like it to be stained the same as the new floor. Since this was our first experience refurbishing hardwood floors, we hadn't a clue as to which application would be best. The flooring guy said, "If it was me, I would stain them. Paint eventually chips, peals, and flakes. Stain lasts forever, and in my opinion, it's a more beautiful finish." We took his advice

and now our floors look amazing! It was definitely worth the time and money we had invested.

"For God so loved the world that he gave his one and only Son, that whoever believes in him shall not perish but have eternal life" (John 3:16). Our LORD paid a steep price to redeem you and me from our former way of life. It's an investment that's worth protecting, don't you think?

"I will give you a new heart and put a new spirit in you; I will remove from you your heart of stone and give you a heart of flesh" (Ezekiel 36:26).

Accepting Christ takes only a moment. *Becoming like Christ* takes a lifetime.

Like any makeover project, Jesus begins by stripping away old layers of worldly influence: deceptive lies, toxic thoughts, and destructive behaviors. Yes, it might get messy for a while, but we need to keep trusting God. Like it was with our hardwood floors, beneath the marred façade, something beautiful is waiting to shine through.

Are you protecting the investment Christ made to redeem you from your old way of life? Are you giving Him full access to renew your mind, body, and spirit?

"Do not conform to the pattern of this world, but be transformed by the renewing of your mind. Then you will be able to test and approve what God's will is—his good, pleasing and perfect will" (Romans 12:2).

Get rid of the old, and embrace the new! I promise, the transformation will be worth it in the end.

"Do you not know that your bodies are temples of the Holy Spirit, who is in you, whom you have received from God? You are not your own; you were bought at a price. Therefore honor God with your bodies" (1 Corinthians 6:19-20).

~Rae Lynn DeAngelis

Changing Things Up

I've had my share of challenges when it comes to sense of direction, especially when I'm in unfamiliar surroundings. I've even been known to get lost at the Hampton Inn. Just ask my husband who snickers every time we exit our room and I begin walking down the wrong hall, thinking I'm heading to the elevator. (Please tell me I'm not the only one who has done this.)

As you can imagine, I was pretty stoked to learn about the invention of GPS. No longer would I have to panic at the helm of my vehicle. I simply plug an address into my mobile device and Siri guides me through the complex streets and thoroughfares. (Now, if I could just get Siri to guide me through the corridors of a hotel, I'd be doing great!)

In all seriousness, I tend to rely on my GPS... *a lot*, especially when I'm in the city. Although my navigation app has been a life-saver, it has also become a crutch I've grown increasingly dependent upon, so much so that I no longer trust my natural instincts when it comes to trying a better travel route.

Case in point, after arriving at a particular destination I'd been traveling to weekly, someone pointed out that I was not taking the most direct route to get there.

Usually, I'm a creature of habit and like the familiarity that accompanies routine. But this time, I stepped out of my comfort zone and gave my colleague's recommended new route a try.

I decided to keep Siri plugged into the address, just in case I got lost, so that if I took a wrong turn, she would be able to promptly reroute my journey back on track.

To my surprise, my friend's alternate route cut ten minutes off my trip. I was pumped! Not only did her suggestion take time off my travels, but I found the scenery more enjoyable too.

This started me thinking; I wonder how many other areas of my life could benefit from a few intentional moves in a different direction. Perhaps there were other ways I could become more efficient and resourceful with work, or maybe I could make a few changes to help improve my health, relationships, or walk with God.

Here's what I've been finding. Sometimes change can be a really good thing.

What about you? Instead of settling for the same old way of doing things, perhaps you too could benefit from a few intentional moves in a different direction. "The Lord will guide you always" (Isaiah 58:11).

Never fear. Much like my GPS, if you take a wrong turn, the Holy Spirit will promptly nudge you back on track.

"This is what the Lord says— your Redeemer, the Holy One of Israel: "I am the Lord your God, who teaches you what is best for you, who directs you in the way you should go" (Isaiah 48:17).

~Rae Lynn DeAngelis

Break Every Chain

I was a drag racer's girlfriend for many years until three years ago when I went to a two-day women's conference. At the end of the first night, they opened the altar for prayer. I was still new in my walk with the Lord but knew that I needed change in my life. So, I went up and asked for prayer.

I asked for the Lord to hit me upside the head with a neon sign to help me see what he wanted me to do with my life. In my heart, I wanted to do ministry work. The next day of the conference during the last song, I got this overwhelming peace that came over my entire body. I raised my hands. Right then and there, I felt the

Lord speak to me very clearly, for the first time. But it was not something I wanted to hear at all. The Lord spoke to my spirit and said I needed to leave my situation. Then I saw an image of my ex standing next to me. I was beside myself. I told the Lord, "I'm sorry Lord, no can do. I love him; he loves me; we are going to get married; everything is okay. I am not going to leave."

One thing I have learned is, when the Lord tells you something, He will win one way or another. Needless to say, he won that battle.

Leaving my ex was one of the hardest things I have ever done in my entire life. I loved him very much, and I just wanted to be happy. I wanted badly to have a family and live happily ever after.

Deuteronomy 5:9 says, "You shall not bow down to them or worship them; for I the LORD your God am a jealous God."

So many times, we find ourselves in relationships that are unequally yoked, but because we are blinded by love, we brush it off and tell ourselves, "Its ok, I can change him." But most of the time, it is us that change because we want love so badly. We forget how much we are loved by the one who created us.

Even though leaving was one of the hardest things ever, I can't imagine my life if I would have stayed. Nothing has happened the way that I thought it would. I ended up in ministry work, which was the main reason I went up for prayer that night, but it was not as I had planned. I lost weight, but the start of that was because after I left, I went weeks without eating a full meal. I went on dates, but nothing was filling this hole that I had inside of me.

We serve a jealous God, yes. He is jealous because He loves us very much and wants every part of us, not just a piece here and there. He wants to be the one to hold our hands when we are scared, to wipe out tears when we are sad, to capture our smiles when we are laughing uncontrollably. He wants to be there for it all and know that He has all of us.

During these past three years, I have learned that "my plan" stank. I don't know the end of my story, but He does. I am so grateful that I have Him along on journey with me to make my path straight and point me back to Him when I feel alone.

After three years, I finally made it back to the track with a very dear friend of mine when she asked me to come. I always enjoyed going, hearing the roar of the cars, and smelling the fuel.

You could just feel the adrenaline of the drivers as they went down the track. But on the way there, my heart started racing. What if I see him? What if he hates me? I had only seen him twice since that day. I began to pray harder than I had prayed in a while, and then that same peace came over me again. While praying, that very same song that was being played when the Lord spoke to me at the women's conference popped into my head. The Lord told me I was there to "Break Every Chain," that it was time to truly be set free. I am incredibly grateful for that experience. Even though I am still single, I am not alone. My prince will come, but until then, I am grateful to be in the arms of my King.

I am going to lean into His promises and trust that no matter what, He's got me. "For I know the plans I have for you declares the Lord, plans to prosper you and not to harm you, plans to give you hope and a future" (Jeremiah 29:11).

~Lindsey Jones

Atta-Girl

One word from God is worth more than a hundred atta-girls from others ~Glynnis Whitwer.
How very true! Nothing compares to receiving affirmation from God. And this comes from a girl who's lived most of her life in bondage to people-pleasing. I won't lie; I still fall prey to this mindset at times, but the closer I grow in my relationship with Jesus, the more I seek to please God—not man.

"Am I now trying to win the approval of human beings, or of God? Or am I trying to please people? If I were still trying to please people, I would not be a servant of Christ" (Galatians 1:10).

People are fickle. One day you can be a hero and the next day a zero. Trying to win over people is a fleeting and futile cause. But when we seek to please God, the effects are lasting and eternal.

"When a man's ways are pleasing to the Lord, he makes even his enemies live at peace with him" (Proverbs 16:7).

What I appreciate most about God's "Atta-girls" is the fact that His love is not hinged on His approval of us. God's love is a gift. It's not something we earn through our actions. God does not love us any more or less by our adherence to (or negligence of) His ways. This is great news! But it is also a foreign concept to grasp, because that's not how the earthly realm works.

Pleasing God will not ever result in gaining more love from Him. God loves us no matter what! We can do nothing to earn it. And we can do nothing to lose it. Love is both who God is and what He does.

Unfortunately, because we have been brainwashed by the ways of this broken world, we have a hard time conceptualizing unconditional, unmerited, undeserved love. The closest we can come to grasping God's agape love is the relationship we witness between a parent and child. And even this example falls miserably short as a comparable illustration.

God loves us. Period. The desire that we have in our hearts to please our Heavenly Father should only come from our soul's yearning to love Him in return.

"We love because he first loved us" (1 John 4:19).

"Love the Lord your God with all your heart and with all your soul and with all your mind and with all your strength" (Mark 12:30).

~Rae Lynn DeAngelis

God Speaks!

When I was a little girl, my dad and I had a special way of communicating with one another. It drove my brother and sister crazy! Many times, my siblings would put our 'secret language' to the test. Dad would babble a few words and they would ask me to interpret. Of course, Dad always confirmed my translation was correct. To my brother and sister (or anyone else who was listening), our coded conversations sounded like gibberish. Although it was nothing more than a clever ruse to trick my brother and sister, our nonsensical babble had made me feel a special connection to my dad. Through our secret language I felt cherished and loved.

Today it is my Heavenly Father who communicates with me in special ways. God and I have a special connection and a secret language of sorts, known only to us. However, our furtive dialect is not a childhood game—it's the real thing.

"Then Eli realized that the Lord was calling the boy. So Eli told Samuel, "Go and lie down, and if he calls you, say, 'Speak, Lord, for your servant is listening'" (1 Samuel 3:8-9).

We often think of communication with God as only prayers, meditations, and hearing Him speak to us through His Word. While those are wonderful ways to communicate with our Heavenly Father, they are not the only ways God speaks to His children.

God knows each one of us intimately; He knows exactly how to get our attention. One of the special ways God speaks to me is through a succession of three numbers that are all the same.

Every day, at different times, God directs my attention to numbers in sequence of three. For example: I just happen to pick up my phone and the time reads 4:44. I just happen to glance at

the highway billboard sign as I'm passing by and the advertisement's phone number begins with 222. After driving the highway for miles, my eyes are suddenly drawn to mile marker 111. It's not a coincidence! God knows that this is a way that He is able to get my attention. It has now become a special reminder that Jesus is right there with me.

It happens so many times throughout the day, I have even started pointing it out to my husband. "Look," I say, "777—God is speaking to me!" When I first started pointing these out to him, he thought I was crazy. But now, even he admits that as often as it happens there's no way it could be a coincidence.

So why does God continue to speak to me in this unique way? I think it's because He delights in knowing He's able to get my attention. Three numbers in a row remind me that God is Three in One—Father, Son, and Holy Spirit. Each time my attention is drawn to these numbers, I immediately stop what I'm doing and pray, thanking God for revealing Himself and praising Him for who He is. I tell him how much I love Him and appreciate knowing that He takes time to speak to me.

Like any cherished relationship, it takes time to build intimacy with God. God will speak to you in special ways too. It may be a different method than how He speaks to me, but I can promise you this, if you ask God to reveal Himself to you in special ways, He will. "Ask and it will be given to you; seek and you will find; knock and the door will be opened to you. For everyone who asks receives; the one who seeks finds; and to the one who knocks, the door will be opened" (Matthew 7:7-8).

The Lord is eager to reveal Himself to us.

"Call to me and I will answer you and tell you great and unsearchable things you do not know" (Jeremiah 33:3).

Well would you look at that! Jeremiah <u>33:3</u>.... *God speaks!*

~Rae Lynn DeAngelis

Bookends of Life

After graduating from college, I secured a coveted job as a pharmaceutical sales rep. Immediately management swooshed me off to Palo Alto, California for an intense 2-week training program. For a young girl from Iowa this meant V-A-C-A-T-I-O-N, particularly because it was January. I was one of the youngest in the group and definitely acted the least mature.

Four years later at a regional training conference, I ran into one of the women I trained with. Her comment was something like, "I'm surprised to see you here! I never thought *you* would make it." She had me pegged. Soon after this encounter I was fired.

Admittedly, I wasted the first three decades of my young adult life. Fortunately, those years represent only one bookend. My story has another bookend. My life as a follower of Jesus Christ.

What forms the bookends of our life stories?

If somehow, we were measured at the beginning of our adult life, and again at the end, how would we be different? Would you say, "Cool! I can still fit into my wedding dress!" Or, would you be waiting for Jesus to say, "Well done, good and faithful servant?"

God is always with us and challenging us to grow. I think of Judah in the Old Testament. First, Judah was not born into a position of honor, but it was bestowed upon his descendants. Second, Judah did not always live a righteous life; he was the one who persuaded his brothers to sell their youngest brother Joseph to the Ishmaelites—bookend #1. Yet, years later we see the tribe of Judah as the leading tribe, a position they would retain throughout rest of Scripture—bookend #2.

The same encouragement is offered to each of us. God has a special plan and place for each one of us. Even if we had a bad start, we can change and leave a legacy of "good." God's promise to us:

"For I know the plans I have for you," says the Lord. "They are plans for good and not for evil, to give you a future and a hope" (Jeremiah 29:11, TLB).

"Therefore, if anyone is in Christ, he is a new creation; the old has gone, the new has come" (2 Corinthians 5:17, NIV)!

~Kimberly Davidson

Letting Go

Our twenty-one-year-old son looked back and waved goodbye one last time before boarding his international flight to Tokyo, Japan. It was a day of many firsts for Ben. His first time to board a plane alone. His first time to leave home for more than a week. His first time to leave the country. He was stepping onto a path he had never before traveled, a three-month study-abroad program overseas. Speaking with the heart of a mom, it was excruciatingly hard to let him go.

Even though our son was six feet tall with whiskers on his chin, he was, and always would be, my little boy. When I looked into the confident eyes of our young-adult son, my mind immediately traveled back in time to Ben's first day of school. My scared little boy grabbed hold of me, kicking and screaming while the preschool teacher attempted to pry him off my pants leg. (Those were the good old days—the days when he needed me.)

Watching Ben disappear into the crowded security check line, I knew in my head he was more than capable of succeeding on his

own; he was mature beyond his years. I knew this to be true in my head, but my heart was a different story.

I worried… What if he gets lonely? What if he gets lost? What if he gets robbed?

I voiced some of those concerns to our son before he left, but he was adamant, "Mom, Tokyo is one of the most populated cities in the world, and if I get lost, I can ask for directions or use a map." Our son's final reassurance put my mind more at ease, "Mom, Tokyo has one of the lowest crime rates of any big city. I'll be just fine."

My mind may have been more at ease, but my heart was still breaking. He would be gone for such a long time!

"Do not be anxious about anything, but in every situation, by prayer and petition, with thanksgiving, present your requests to God. And the peace of God, which transcends all understanding, will guard your hearts and your minds in Christ Jesus" (Philippians 4:6-7).

Our son's journey to a foreign land was a quest that our family took together even though we were separated by a great divide of land and water. As the saying goes, absence really does make the heart grow fonder, and experience is still a great teacher.

"Listen, my sons, to a father's instruction; pay attention and gain understanding. I give you sound learning, so do not forsake my teaching" (Proverbs 4:1-2).

Millions of moms and dads had passed the "letting go" test with flying colors.

We would too… eventually.

To be continued…

~Rae Lynn DeAngelis

Change of Plans

When our son traveled across the U.S. and Pacific Ocean to begin his new adventure in a foreign land, the journey took more than eighteen hours. And since Tokyo is fourteen hours ahead of our time in Cincinnati, the expedition included real life time travel. Ben departed the CVG airport at 8:30 AM, January 8th and landed in Japan, 4:30 PM, January 9th. How crazy is that!

Our final hug goodbye was the hardest thing I've ever had to do. That experience was even harder than when our daughter got married. At least, when she moved out, we were still able to visit and talk on the phone. Not so with Ben. He was thousands of miles away without a working cell phone. We were only able to connect through the Internet (and those opportunities were few and far between).

As Ben packed his last-minute belongings the night before he left, he received an email saying his original flight was cancelled. This unwelcome news added even more anxiety into an already stressful situation. We learned his new flight would arrive in Tokyo an hour and a half later than the original flight. The result of this delay meant Ben would be on his own when he arrived in Tokyo. There would be no one from the school to meet him and take him to his dorm building. After printing a lengthy list of instructions that would, hopefully, get him to his end destination, Ben resolved to go with the flow and make the best of it.

"Trust in the Lord with all your heart and lean not on your own understanding; in all your ways submit to him, and he will make your paths straight" (Proverbs 3:5-6).

Sometimes life throws us a lemon, and we have a choice. We can either let the lemon sour our attitude, or we can squeeze out every last drop of opportunity and positivity and make lemonade.

I saw much growth and maturity in our son through this experience. I knew God would continue to watch over Ben and direct his steps day by day.

"For he will command his angels concerning you to guard you in all your ways" (Psalm 91:11);

"Whether you turn to the right or the left, your ears will hear a voice behind you, saying, 'This is the way; walk in it'" (Isaiah 30:21).

To be continued…

~Rae Lynn DeAngelis

Cause for Celebration

Ben boarded the plane for Tokyo as a slightly cocky college student. But after living in a foreign country for three months, he returned home a mature and confident young man. My husband and I were extremely proud of his accomplishment, especially after hearing some of the challenges he had to overcome while he was there.

Allowing our children to spread their wings and fly on their own is extremely difficult. It feels so unnatural. Hard as it may be to let go, it's a whole lot easier once we know they are truly ready to spread their wings and fly on their own. Ben had certainly proved to us that not only was he ready to leave the nest, he was ready to soar with the eagles.

I don't know what season of life you are in right now. But I can tell you from personal experience, if you're a parent, cherish each and every moment, and recognize that the time you have with

your children is a gift from God. Take it from someone who knows. This season will be gone before you know it.

Treasure these years, but don't allow your identity to become wrapped up in your kids because, eventually, this season ends.

Sometimes we can become so wrapped up in our kids' lives that someone from the outside might wonder… *whose life is it?*

It's okay to celebrate our children's accomplishments, but there's a fine line between celebrating our children's accomplishments and vicariously living through them. (Been there, done that.)

Let's face it. At some point, our kids are going to do things we don't agree with, and when they go in a different direction than we hoped or envisioned, what then? Here is where it gets really hard. We need to let our kids fail. One of the gravest mistakes we, as parents, can make is to try and keep our kids from failing or experiencing natural consequences from their actions.

Nobody wants their kids to suffer; but as Dr. Henry Cloud says, "To rescue people from the natural consequences of their behavior is to render them powerless."

Do we really want to render our kids powerless?

Our children might reject us for taking the tough stand, but we shouldn't let that keep us from holding them accountable when they make mistakes. Our Heavenly Father is a perfect Father, yet even He experiences rejection from His children. That means, if we could be perfect parents (which we cannot) we would still face challenges and rejection with our kids.

God celebrates our accomplishments, but He also celebrates our failures. *Do you know why?*

Failure can teach us just as much, if not more, than success. God is able to use both failure and success to shape us into the vessels He desires us to be. "And we know that in all things God works for the good of those who love him, who have been called according to his purpose" (Romans 8:28). "For I know the plans I have for you," declares the Lord, "plans to prosper you and not to harm you, plans to give you hope and a future" (Jeremiah 29:11).

Lord, help us to remember that you are there to catch our children when they fall, and that you can ultimately bring good from each and every choice they make.

Not only so, but we also glory in our sufferings, because we know that suffering produces perseverance; perseverance, character; and character, hope. And hope does not put us to shame, because God's love has been poured out into our hearts through the Holy Spirit, who has been given to us (Romans 5:3-5).

~Rae Lynn DeAngelis

The Work of His Hands

Today, our young adult son is a 3-D Digital Design Artist. If you aren't sure what that is, you're not alone. When Ben first entered his chosen career path, my husband and I were equally baffled. Ironically, it is something that he became interested in while he was studying abroad in Tokyo, Japan.

3-D digital artists use computer programming tools and technology to sculpt three-dimensional characters and images, similar to traditional sculptures using clay. The main difference being that one uses a computer and the other uses physical material. Although digital designs are made with a computer, they can be 3-D printed into actual physical forms.

When something is 3-D, it has length, depth, and width. All three dimensions help to bring the form to life. According to the Merriam-Webster Dictionary "three–dimensional" is defined as: relating to, or having three dimensions describing or being described in well-rounded, completeness, true to life: lifelike.

These definitions remind me of something else three-dimensional—you and me. And not just you and me—God too! "Then God said, "Let us make mankind in our image, in our likeness… So God created mankind in his own image, in the

image of God he created them; male and female he created them" (Genesis 1:26-27).

While the full concept of being made in God's image is somewhat of a mystery, it is not entirely perplexing. The Bible tells us that God is three in one: Father, Son, and Holy Spirit. In the same way that God has three parts, we have three parts: a mind, body, and spirit.

For decades I struggled with self-acceptance. It was one of the biggest factors that drove my obsession with food and body-image. I placed entirely too much focus on only the one dimension of who God created me to be, my body—diets, exercise, beauty products, clothes, anything that would help me achieve the ideal image that the world was projecting.

Eventually, I began seeking God with more intentionality, and as I did so, He began opening my eyes to the truth. *Who I am (and who you are) is so much more than a body!*

A healthy body-image, renewed mind, and steadfast spirit complete our multidimensional identity (Romans 12:2; Psalm 51:10).

"The works of his hands are faithful and just..." (Psalm 111:7).

May we be ever pliable in the Artist's hands, allowing Him to fashion us this way and that, bringing length to life, depth to character, and wide-reaching impact for the Kingdom of God.

"Yet you, Lord, are our Father. We are the clay; you are the potter; we are all the work of your hand" (Isaiah 64:8).

Be true to your God-given design—well-rounded, complete, and true to life.

~Rae Lynn DeAngelis

Back to Basics

My friends asked me to do a triathlon with them. I'm like, "Nah, I'm not really a swimmer or biker. I'll come cheer." Then I thought, why not. Something new may be just the challenge I need. So, I decided to try to train for it. I went swimming for the first time in ages. Another friend of mine gave me some tips on swimming: the right way to breathe and hold my hands to get the most distance out of each stroke. The first time I tried, I went longer and faster than I ever thought I could. And I actually enjoyed it!

Part of my swimming story is: When I was little, I was in the beginner's class for about 5 years in a row because I just couldn't learn how to swim. There was always a fear paralyzing me. I was afraid of the water, and my mother kept putting me through the same class thinking, "this year she will get it." Around age 9, I finally moved on. My mom had to make a choice each year to keep me in the basic class because she knew it would be worth the hard work.

When I was 6, I almost drowned in a pool at Disney. A little boy convinced me to go to the middle with him, and then he left me. I was underwater for a long time. Satan tried to take my life when I was only learning the basics. Is he trying to take yours too?

As I was reflecting on this, I was reminded of the first 5 years of my eating disorder healing journey. I felt like I was stuck in the same basic class, learning the same things over and over. Little did I know, 30 years later it would pay off. Do you feel stuck in the basics, like you just can't move past that one thing? Is Satan trying to discourage you? I encourage you to keep at it. Allow God to keep teaching you the basics.

The basics are this: He loves you, and he wants you to love who He's created you to be.

Seems simple, right? Ha! It takes years and the Holy Spirit to really believe that. We have to come with open hands and hearts each morning and ask God to teach us that.

The fear that used to grip me, is now propelling me forward into freedom to try new things like a triathlon.

Is there something new He wants you to step into? Or do you need to revisit the basics? One is not better than the other, but we've got to move.

> *Father, teach me to love you and love myself. Remind me of the basics of your love for me. I give you an open heart so that I can receive your love. Crack whatever hardness covers it so that I can fully feel it and believe it. I'm asking you to help me make space and time to swim in your love for me. Drown out my fears with your perfect love. I know the healing that will come when I lay down the weights I'm carrying in exchange for your presence.*

~Alison Feinauer

Eyes on the Prize

"Let your gentleness be evident to all. The Lord is near" (Philippians 4:5).

I met her about five years back. I held small conversations with her here and there, nothing of real substance or life changing topics. I helped on very few occasions to serve alongside her. I did not have the privilege to learn from her words or hear of her experiences. I missed out on opportunities to serve

as she did due to schedule conflict. My contribution to her ministry fell short weekly. Looking back, I wish I would have shared more conversations, served alongside, and contributed more. . .

Although none of this took place, an indelible mark lay on my heart. I am not one to go and join a conversation or bring attention to myself in any way, shape or form. I observe and take in my surroundings. The example set by this woman was not spoken or taught directly. The learning occurred from afar. I watched her smile with each encounter. No matter the situation in her life, a smile lit every room entered. "A glad heart makes a cheerful face" (Proverbs 15:13).

I watched her serve day in and day out, saying 'Yes' each time God asked. . . "For we are God's handiwork, created in Christ Jesus to do good works..." (Ephesians 2:10).

I watched her joyfully care for her grandson. She also worked in a school. She taught the next generation. . . "Preach the word..." (2 Timothy 4:2). The next generation needs us to show the way to Christ.

Down to her last breath, she set an example of strong faith, hope, and love. "Well done, good and faithful servant" (Matthew 25:23).

"Sing to the Lord a new song..." (Psalm 98:1). Worship Him in song. It prepares us for Heaven. Don't be scared – crank up the radio, roll down the windows and sing of His glory. Your voice is nothing short of beautiful when singing praise to our God.

We do not realize who could be watching us from afar. Be aware and with each move set an example worth following. Ask, in every situation, "What would Jesus do?" Then, do it! Smile through it all, for this is only temporary. "Why, you do not even know what will happen tomorrow. What is your life? You are a mist that appears for a little while and then vanishes" (James 4:14).

There is so much more than this. Keep your eyes on the prize! Serve wholeheartedly and give back to Him who gave us everything that we did not deserve.

~Sheree Craig

Simon Says

In one of my favorite childhood games, the leader (affectionately known as Simon) directed his followers through a list of rapid-fire instructions, such as... clap your hands, stand on one foot, jump up and down, or lie on the floor. The winner of the game was the one who carefully discerned which commands to follow or ignore.

We live in a technological age where there is a plethora of information at our fingertips. It seems that anyone with a microphone, camera, or platform is an instant subject matter expert. *But are they?*

Let's say you and your family are watching a nature program and your daughter asks, "Mom, what's the difference between mammals and reptiles?" Now, back in the day, we had to go to the bookshelf of encyclopedias to get our answer. But today, all you need to do is tap the link provided on your cell phone and start reading. "Well honey, it says here, mammals have hair all over their bodies, give live births, and produce milk for their young, while reptiles have scales and lay eggs." Satisfied, your family continues watching the nature program. That is, until the narrator starts talking about the platypus, a mammal that lays eggs. Your daughter looks at you with questioning eyes. Once again, you pick up your phone and follow the next rabbit trail of information.

The Internet is filled with "Simons" who would like nothing better than to have us follow their every post, video, or hashtag. But what if these so-called leaders are only providing partial information on the subject? What if they are only expressing their opinion on the matter? What if what they're saying can't be backed up with truth. Is there any way we can protect ourselves from being deceived?

The answer is YES!

- **Pray**
 - o "And pray in the Spirit on all occasions with all kinds of prayers and requests. With this in mind, be alert and always keep on praying for all the Lord's people" (Ephesians 6:18).

- **Ask the Holy Spirit for wisdom and discernment**
 - o "Ask and it will be given to you; seek and you will find; knock and the door will be opened to you" (Matthew 7:7).

- **Test everything through the lens of biblical truth**
 - o "Jesus said, "If you hold to my teaching, you are really my disciples. Then you will know the truth, and the truth will set you free" (John 8:31-32).

- **Ask yourself if the leader's character is in alignment with the character of Jesus**
 - o In your relationships with one another, have the same mindset as Christ Jesus: Who, being in very nature God, did not consider equality with God something to be used to his own advantage; rather, he made himself nothing by taking the very nature of a servant, being made in human likeness" (Philippians 2:5-7).

- **Be self-controlled and alert**
 - o "Be alert and of sober mind. Your enemy the devil prowls around like a roaring lion looking for someone to devour. Resist him, standing firm in the faith, because you know that the family of believers throughout the world is undergoing the same kind of sufferings" (1 Peter 5:8-9).

- **Trust and obey the Holy Spirit's prompting**
 - o "Trust in the Lord with all your heart and lean not on your own understanding; in all your ways

submit to him, and he will make your paths straight" (Proverbs 3:5-6).

Be very careful who you follow, dear friends, and always listen to the Lord's voice above the others.

"I am sending you out like sheep among wolves. Therefore, be as shrewd as snakes and as innocent as doves." (Matthew 10:16). "Do not treat prophecies with contempt but test them all; hold on to what is good, reject every kind of evil" (1 Thessalonians 5:20).

~Rae Lynn DeAngelis

Permanent Ink

I remember the early years of elementary school when students were forbidden to do schoolwork with anything but pencil. Unfortunately, with two older siblings generating homework assignments in ink-pen, the pencil seemed inefficient, a juvenile tool. (Or so I thought.) Compared to the free-flowing script trailing from a ballpoint pen, the graphite pencil restricted my creative workflow. How was I supposed to get any work done with all those trips to the pencil sharpener?

Rule follower that I am, I complied with the school's standardized rule, although I didn't fully understand the reasons behind why such guidelines had been set in place. It wasn't until I was much older that I began to appreciate the usefulness of a device which allowed me to erase my mistakes. When I messed up, I didn't have to crumble up my paper and begin again. Eventually, the pencil became my preferred writing utensil. I could erase and start from where I left off.

Much like ink pens, careless words cannot be easily erased. God impressed this truth upon my heart when a gel pen brushed across my shirt while I was taking notes at a conference. Several washings later, the ink was still visible.

Our careless words towards others, more often than not, leave lasting impressions. These enduring marks can damage the fabric of our relationships. It may take years to repair the harm that's been done.

Verbal judgements expressed decades ago still feel tender in my heart, both those coming to me and those coming from me. Whoever said "sticks and stones may break my bones but words will never hurt me" was crazy. Words often cut deeper than a knife and take longer to heal.

Just today, I said something I wished I could take back. The moment the words left my mouth I wanted to retract them. Unfortunately, once the words spilled from my lips, the damage had already been done. The Holy Spirit quickened my spirit with remorse and I apologized immediately. Quick repentance may soften the blow, but it doesn't necessarily negate damage done.

"The words of the reckless pierce like swords, but the tongue of the wise brings healing" (Proverbs 12:18).

"Be very careful, then, how you live—not as unwise but as wise, making the most of every opportunity, because the days are evil" (Ephesians 5:15-16).

Yes, we will make mistakes, and yes, some of our offenses will leave lasting impressions like permanent ink. But thankfully, Jesus Christ, the perfect Lamb of God, after we have repented, erases our transgression and wipes our sin-slate clean.

~Rae Lynn DeAngelis

Trip-Tik

My husband and I always come away from our vacation time feeling refreshed and ready to tackle the world. Fully rested, we are ready to get back into the swing of work. Working in ministry through a non-profit organization provides me a variety of opportunities that keep me from getting bored.

Although I love most of the work I do, writing is my passion. It's one of the ways that I process the world around me, however, sometimes, my creative flow takes a vacation of its own, and I find myself lost for new ideas.

A good long rest has a way of taking care of writer's block. I usually come away from our trips with enough material to fill a short novel. The trip I'm about to describe was no exception.

During our fifteen-and-a-half-hour car drive to the beach, I had a lot of time to think. My thoughts took a trip down memory lane, remembering my childhood vacations of long ago. Whenever we took a long car trip, my mom brought along something she called a trip-tik, given to her by a travel agent. It was a spiral bound notebook, filled with maps to guide us along our journey. (That's how we did it back in the day.) I remember my mom getting out the trip-tik to show us how far we had traveled and how far we had yet to go. Looking at the pages still unturned, it appeared we would never reach our destination.

I have noticed that life can be kind of like a road trip. Some journeys take longer than others, but all life journeys have twists, turns, and places to pause and reflect how far we've come.

At fifty plus years of age, my life is most likely more than half over. It has been quite the ride at times, but it sure feels good to look back and see how far I've come. Fifteen years ago, my life

looked completely different. God has been working amazing miracles in my life and allowed me to join Him on some incredible adventures along the way. I wouldn't change a thing.

I'm not sure how many life-miles I have left on my journey, but I am committed to following Jesus wherever He leads, and I'm choosing to enjoy the ride along the way. "I will instruct you and teach you in the way you should go; I will counsel you and watch over you" (Psalm 32:8.)

What about you? Where are you on this journey called life? Are you struggling up a mountain pass, paused at the top, or coasting down easy street?

Wherever you are, take a moment to reflect back and see how far you've come. And don't forget to take a moment to pause and thank God for the adventure thus far.

Be encouraged, your destination will be worth the many potholes and detours you had to encounter along the way.

"You have made known to me the path of life; you will fill me with joy in your presence, with eternal pleasure at your right hand" (Psalm 16:11).

~Rae Lynn DeAngelis

Tears of Betrayal

Natas entered into my life when I least expected. He'd called me on the phone one day. I knew the voice and found it to be comforting. Natas was friends with many other people, especially women. I was never interested in forming a relationship with Natas until that day he befriended me.

I heard a knock at my door. It was the same voice I'd been hearing long distance on the phone. Natas had come to visit. I usually don't trust anyone enough to let them in, but Natas seemed

different. I really needed a friend because I was at such a desperate and lonely point in life. Love and acceptance were the things I was seeking. I figured, what's the harm in letting him in just this one time? After all, I knew no one else would be knocking at my door anytime soon to reach out and befriend me.

Soon, Natas came to visit many times each day. I enjoyed the relationship we were forming. We became so close, in fact, that Natas asked if he could move in with me to which I gladly said yes. He gave me such comfort, confidence, and love.

Natas became very possessive of me. Wow! He loved me so much he wanted me all to himself. I cut off all other relationships, even with God. I knew Natas and I shared a sinful relationship that God definitely would not approve of. Family and friends said this relationship was dangerous and scary, but I had to disagree. I was empty, and Natas was the only one who cared enough to fill my void.

In time, I began to realize that nothing Natas gave me came free. I had to earn it. Each void he filled was temporary. He made me exercise all day long and wouldn't let me eat. He made sure food and exercise were constantly on my mind. He always patted me on the back and encouraged me when I was exercising or not eating.

Natas was very faithful to remind me that I needed to lose weight, didn't measure up, wasn't intelligent enough, was too shy, too insecure, not popular enough, etc... Overall, I just wasn't perfect. Natas assured me that I could attain his standard of perfection if I continued doing things his way.

For many years he pushed me harder and harder until I finally reached the point of physical and emotional collapse. I had been physically and emotionally abused for so long that I couldn't handle any more. I wanted out of the abusive relationship badly, yet the fear of leaving was too overwhelming.

I began crying uncontrollably. At that moment, I heard a knock at my door. A still, small voice whispered, "Open up the door my child, I am here to listen." I flung the door open to behold God with His outstretched arms of love. I felt a sense of peace and hope.

God instructed me to call a woman who'd been friends with Natas for many years. She told me she'd cried tears of betrayal too

when she found out Natas was not a friend at all, but was a liar, thief, and deceiver. Her tears turned to joy when she broke off her relationship with him. She was finally free. She opened me up to God's Word and pointed the way to true freedom. I was so ready to begin a journey of hope and life.

I'd lost my hair, teeth, memory, vitality, bladder control, menstrual cycle, brain cells, and control of emotions, just to name a few. It had been a long and tortuous road, but I was ready to end this relationship with Natas, to begin a life anew with God, the One who loves me unconditionally, who fashioned me with His own hands and called me His masterpiece. The Healer.

Sure, Natas offers many "gifts" and the final one is death. Natas' gifts always come beautifully wrapped. They look wonderful on the outside, but are completely dark and empty within. Betrayal comes wrapped beautifully just as Natas does. You see, Natas looks good on the outside, but once opened, he turns into Satan *(Natas spelled backward)!*

God has an abundant life in store for those who trust and obey. Take the gift of life and never look back! "For we do not wrestle against flesh and blood, but against principalities, against powers, against the ruler of darkness of this age, against spiritual hosts of wickedness in the heavenly places" (Ephesians 6:12 NKJ).

~Rhonda Stinson

Believing is Seeing

We live in a world that tells us seeing is believing. *But is that accurate?* I suppose it depends on the lens through which we are viewing life—the worldview lens or the biblical view lens.

"Therefore I tell you, whatever you ask for in prayer, believe that you have received it, and it will be yours" (Mark 11:24). According to Jesus, believing before seeing is the crux of the Christian faith. "Now faith is confidence in what we hope for and assurance about what we do not see" (Hebrews 11:1).

The book of Hebrews, chapter eleven first highlights the definition of faith and then it goes on to give examples of the biblical heroes who demonstrated such faith.

True faith believes *before* it sees.

I remember when I first learned that I was pregnant with our daughter Heather. Although the pregnancy test told me I was going to have a baby, the reality of a little person growing inside me didn't fully resonate until I saw the tangible signs that I was pregnant, my belly swelling and feeling our daughter kick for the first time. And even with that evidence, I didn't fully grasp parenthood until I held our baby girl the first time. As I gazed upon our sweet little girl's face, I more fully understood what I had only partially understood before. The reality of motherhood may not have come until I saw our daughter face to face, but motherhood was no less a reality the nine months prior to her birth.

God wants to get us to the place in our faith journey where we begin to believe before we see, standing on the promises that He has given us in His Word.

Thomas was a man who needed proof to believe. When Jesus finally revealed Himself to the doubting disciple, He told him, "Because you have seen me, you have believed; blessed are those who have not seen and yet have believed" (John 20:29).

God's Word is filled with His promises. But are you really taking Him at His Word, or do you wait to see proof of His promises first?

Perhaps you have a long-standing prayer, one that you have not yet seen evidence of its answer. Is it possible that God is waiting for you to fully believe before He performs your miracle, whatever that may be? Whether it is physical healing or spiritual wholeness, unbelief is the biggest obstacle we Christians face, and it is often what keeps us from experiencing true healing and wholeness in our lives.

"Jesus replied, "Truly I tell you, if you have faith and do not doubt, not only can you do what was done to the fig tree, but also

you can say to this mountain, 'Go, throw yourself into the sea,' and it will be done" (Matthew 21:21).

"Then he touched their eyes and said, 'According to your faith let it be done to you" (Matthew 9:29);

Beloved, Jesus wants so much for you to take Him at His Word. He is jealous for you to know His promises are true. Like the bleeding woman who was finally freed from her suffering, Jesus longs to whisper those same words to our hearts, "Daughter, your faith has healed you. Go in peace and be freed from your suffering" (Mark 5:34).

When you believe without seeing, your joy will be complete, your peace will surpass all understanding, and your spirit will be made new. Keep praying and keep moving forward as if it has already been done. Trust the promises of God! "If you believe, you will receive whatever you ask for in prayer" (Matthew 21:22). *When it comes to faith, believing is seeing!*

~Rae Lynn DeAngelis

Help, I'm Stuck!

I sometimes find myself stuck, unable to string meaningful thoughts and ideas together when it's time to write something for Living in Truth Ministries. The blinking cursor on the computer screen mocks my futile efforts while the enemy whispers, *face it... you've got nothing.*

Some people work well under pressure. I'm not one of them. I need time to think through, process, and marinate on creative thoughts before I put them down on paper. If writing styles were cooking methods, I'd fall into the slow-cooker category.

Writer's block is especially challenging when I have a deadline to meet. It's easy to become frustrated by my lack of

inspiration, but I've finally learned, after many years, not to panic when my mind draws a blank.

Rather than forging ahead with no clear sense of direction, I step away from the computer and redirect my attention towards something else.

God has taught me over the years that sometimes the reason I'm stuck is because there's a particular piece of information that has not yet been revealed to me, be it through a person or experience. Once that critical piece of information is revealed, a fresh downpour of revelation causes the words to flow once again with ease. My willingness to wait on the Lord is what leads me back to the path of forward motion.

Is there a place in life where you feel stuck, unable to move forward? What's true in writing is true in life. Prayerfully step away for a time, and allow God time and space to work.

"Be still, and know that I am God" (Psalm 46:10).

Whether you're feeling trapped in a relationship, stuck on a project, or bound by a stronghold... *Sometimes moving forward in faith means standing completely still.* ~Nicki Koziarz

"Wait for the Lord; be strong and take heart and wait for the Lord" (Psalm 27:14).

You'll be glad you did!

~Rae Lynn DeAngelis

Strong Women

I thank God for encouraging friends.

In the past few years, some gals from high school reunited thanks to Facebook. I wasn't all that close to them in high school, but now I sure wish I would have been. They are godly

women and encouragers. Few things could be more important in this crazy world. We call ourselves the Guilford Gals.

As the years have not so slowly crept up on us, we are trying to be healthier, or at least be less unhealthy. Our group doesn't focus on weight or food, just health and love. What a concept in today's world!

Recently one of our gals invited us to join her in a plank challenge. Without thinking, I responded, "I'm in!"

Seriously? Can I plank?

Yes, I can! I was thrilled and amazed that I could plank. That first day, it was a fight to hold the position for a whole thirty seconds. But I did it!

I'm not small. Never have been. But I'm learning how strong I am and how strong I can become.

What adventure awaits me next? I am steadily losing the fixation on my weight. It's not completely gone. But it's dwindling. Praise God!

I don't remember what I said after I replied that I was in, but I remember my friend's response, "We are strong women! We've got this!"

Part of God's desire for us is that we have strong (in the Spirit), encouraging friends of like-faith. After all, a cord of three strands is not easily broken (Ecclesiastes 4:12).

Seek out friends of like faith. They are extensions of God's hands.

"The godly give good advice to their friends; the wicked lead them astray" (Proverbs 12:26 NLT).

"As iron sharpens iron, so a friend sharpens a friend" (Proverbs 27:17 NLT).

Let God give you those who will help you climb your barriers. They will be your encouragers. We all need a cheerleader every now and then. Your biggest cheerleader is Jesus Christ. He's already proven how much He loves you.

~Melody Moore

The Label Maker

I read something recently that sparked a memory from my childhood. I was reminded of a little gadget that would be considered archaic by today's standards, but it got the job done. It was a hand-held label maker, fairly simple to use. You merely twisted the dial until the black arrow lined up with a desired letter. When you squeezed the trigger, the desired letter was pressed into a thin strip of plastic. After your label was complete and the backing was removed, it was ready to be applied to whatever needed labeling.

I was fascinated by this little instrument and spent more time than I care to admit affixing labels to just about everything. But after a while, the labels fell off, only to be found later in some remote location of our home. No longer sticky, the tags forfeited their usefulness and were thrown into the trash.

I'm embarrassed to admit this, but sometimes I catch myself ascribing labels to people too. I'm tempted to throw individuals into metaphorical boxes, slapping a name tag on them: Chronic Complainer, Debbie Downer, Needy Nancy, Skinny Minnie, or Jolly Juniper.

Thankfully, later after I got to know these people beyond first or second impressions, I found that my haphazardly placed labels no longer stuck.

I realized that "Chronic Complainer" just had a really bad day.

"Debbie Downer" had simply fallen victim to her hormones.

"Needy Nancy" was struggling with abandonment issues and just needed a friend who would stick by her through thick and thin.

"Skinny Minnie" was actually struggling with an eating disorder.

And "Jolly Juniper" was just wearing a mask to cover up the pain buried deep within her heart.

"… in the same way you judge others, you will be judged, and with the measure you use, it will be measured to you" (Matthew 7:2).

Ouch!

Here's the truth. When we take time to get to really know a person beyond first impressions, we realize that they have far more dimensions than the one-sided label we slapped upon them.

Lesson learned. Labels belong on files, drawers, and containers—not people.

"… do not let wisdom and understanding out of your sight, preserve sound judgment and discretion; they will be life for you, an ornament to grace your neck" (Proverbs 3:21-22).

~Rae Lynn DeAngelis

Total Recall

My husband and I have a friend named Chris. Like so many others who have been diagnosed with Autism, Chris has been given a special gift. Some might say he is a savant. Here's why. Ask Chris the weather from any day since he was born and he can tell you if it was cloudy, sunny, rainy, snowing, and even the temperature. He has total recall about weather in the city where he has lived.

When Chris first told us about his special aptitude, we tested him using dates like our wedding or birthdays. Chris was 100% right every time. We even used the Internet to pull up random days, and guess what? Chris still hit the mark every single time.

Unfortunately, most of us have *not* been blessed with a supercharged memory like Chris; we have to work hard at remembering. Shortly after I fully surrendered my life over to Christ, I had a profound conversation with one of my Christian

mentors when I had asked her about Scripture memorization and why it was such an important practice to implement into my daily life. Honestly, it seemed like a waste of time, but Ann's explanation made a lot of sense to me. She said, "You won't always have your Bible with you to know whether you're hearing the truth or being deceived. Therefore, if you tuck God's Word into your heart through scripture memory, the Holy Spirit is able to bring God's truth to mind every time you need it."

"All your words are true; all your righteous laws are eternal" (Psalm 119:160).

Ever since that day, I have had a deep desire to sow God's truth into the recess of my heart and mind. I want to be equipped with every tool available as a Christian so I can identify truth, throw out lies, and preach the love of Jesus wherever I go.

"Always be prepared to give an answer to everyone who asks you to give the reason for the hope that you have" (1 Peter 3:15).

Memorizing Scripture helped me escape bondage. Being continually deceived in the areas of food, body-image, and self-esteem is what led to my 25-year battle with an eating disorder called bulimia. In those days, the enemy was easily able to plant lies in my mind because I didn't know the truth.

"Jesus said, 'If you hold to my teaching, you are really my disciples. Then you will know the truth, and the truth will set you free'" (John 8:31-32).

Every time God's truth is intentionally planted in our minds, it becomes a protective layer over the heart, a barrier that shields us from Satan's ongoing deception.

What about you; are you taking time to memorize God's truth?

"Your word, Lord, is eternal; it stands firm in the heavens" (Psalm 119:89).

God has given us an incredible gift to remember; let's not let it go to waste.

"But from everlasting to everlasting the Lord's love is with those who fear him, and his righteousness with their children's children—with those who keep his covenant and remember to obey his precepts" (Psalm 103:17-18).

~Rae Lynn DeAngelis

Size Doesn't Matter

We are living in a culture that is saturated in the idea that our worth is determined by our bodies. It repeatedly tells us that we cannot fully live until we have a smaller waist and thighs, toned arms, flawless skin, etc. I'm here to tell you, that's a lie. It's a lie that the enemy feeds us so we won't say yes to what the Lord wants for us.

How much of your time are you spending thinking about your body, what you're eating, or on social media wishing your body was different?

How often do you hold back on your dreams because you're not the size you find ideal, therefore you lack confidence in moving forward to make those dreams reality?

How much time do you spend trying on clothes before going out in public because you are worried about how others perceive you?

How often have you said no to going to the beach, going swimming, or enjoying a warm summer day with your friends or kids because you were ashamed of your body?

How often are you numb to what's really going on around you because your body is always on your mind?

I know I can tell you my answer to those questions was too much time and far too often. My worth was so caught up in my body that I was never good enough. My eyes and mind were focused on my body, and nothing else seemed to really matter to me. I had a life dreamed up in my head that if I looked a certain way or hit a certain number, then I would have a life in which everything would just fall into place. That never happened for me because we were never meant to focus on our body. We were

never meant to find our sense of worth in our body's size, shape, color, or abilities.

The enemy is stealing our lives when we believe the lie that our worth is determined by our bodies. He's stealing our time when we're focused and obsessed with our bodies. Do you feel numb to life when you're focused on your body because it makes you feel unhappy? I know, I do. I remember feeling so numb to life – feeling laser focused on what I should do to manipulate the size of my body, I was only present some of the time with everything else outside of my body.

Jesus wants so much more for you, friend, so much more. He's waiting for you to say yes to Him and believe His truth that your worth comes from Him alone. He doesn't care about your body and whether you're in a size 2 or 22. He wants your heart. He wants big things for you. He does not want you to feel trapped and feeling worthless. You are so much more than that. That's the truth. Believing that truth wholeheartedly is incredibly freeing.

"But the Lord said to Samuel, "Do not consider his appearance or his height, for I have rejected him. The Lord does not look at the things people look at. People look at the outward appearance, but the Lord looks at the heart" (1 Samuel 16:7).

There's WAY more to health and honoring your body than your size. You can honor your body and be healthy to do Kingdom work at any size.

~Kelsey Klepper

In the Minority

I'm learning that being a devoted follower of Jesus means that I will be in the minority more and more. I'm not going to lie; sometimes that's really hard. The closer I grow to Jesus, the further I drift away from the world.

One of the first times that I really felt like I was among the minority was when my husband and I decided to homeschool our kids.

When we left the public-school system, a lot of people thought we were crazy. People had all kinds of reasons why they thought we shouldn't homeschool. You're not a teacher. Your kids won't be socialized enough. They won't get a quality education...

Believe me I didn't need more reasons to be insecure about homeschooling. I was already questioning whether what we were doing was the right thing. After all, I didn't have a college degree.

I have since learned that God doesn't call the qualified. *He qualifies the called.*

After much prayer, research, and preparation, we finally took the plunge and began homeschooling.

Unfortunately, we didn't quite fit-in amongst the homeschool community. Most families were extremely conservative. I'm not saying that is a bad thing. It just wasn't where we were at the time.

We tried hard to get connected with other homeschool families, but with each experience, I came away feeling like we just didn't measure up. It felt like we were outcasts, floundering in limbo. We didn't fit-in with the homeschoolers and we no longer fit-in with the public schoolers either.

Being in the minority can be a barren place. I knew God had called our family to homeschool, but I was really struggling at times with feelings of loneliness and insecurity. Many times, I

prayed to God asking Him if we were really doing the right thing, and each time He reassured me we were.

Hindsight is 20/20. Looking back, I can see how God used those years of homeschooling to grow each and every one of us. We became a close-knit family who learned more and more about the faithfulness and character of God.

I learned that through my weakness, God is strong. I learned that it doesn't matter what people think, only what God thinks (Galatians 1:10). I learned that God's ways are not our ways, and His thoughts are not our thoughts (Isaiah 55:8-9). I learned that when you obediently follow God's call on your life, deny yourself, and take up your cross and follow Him, the Lord is able to do immeasurably more than all you can ask or even imagine (Mark 8:34-35).

If you feel like you're standing alone or living among the minority because God called you to step out for Him, I can tell you from personal experience—you are in a place to receive God's abundant blessings and glorious riches in Christ Jesus. *Don't give up!* One day you will look back and see how God used this uncomfortable time of separation to bring about tremendous growth. Standing in the minority with God—there is no better place to be.

"Consecrate yourselves, for tomorrow the Lord will do amazing things among you" (Joshua 3:5).

"May God himself, the God of peace, sanctify you through and through. May your whole spirit, soul and body be kept blameless at the coming of our Lord Jesus Christ" (1 Thessalonians 5:23).

~Rae Lynn DeAngelis

Broken Fences

Winters in the Ohio-Miami valley are long, arduous, damp, and dreary. As a result, many people are SAD (suffering from Seasonal Affective Disorder). No wonder geese and retirees fly south for the winter.

Spring is always a welcome relief from winter, but this season ushers in its own set of problems: thunderstorms, tornadoes, hail storms, and flooding. It's not all tulips and daffodils as we might be tempted to believe during the doldrums of winter.

During a recent conversation with my daughter, I learned that high winds from a powerful storm the night before took down their neighbor's fence. Since the fence connected their two yards, both families were impacted. Our daughter's golden retrievers were no longer securely enclosed in their own yard.

I started thinking about how we are often impacted by the life-trials of others. Instead of broken fences, they might be dealing with addiction, broken relationships, failing health, strained finances, or the loss of a job.

We are much more connected to the world around us than we might realize. Just this morning, I saw a social media post that wrecked me. A dear woman from my Church family posted a picture of her husband on the two-year anniversary of his passing, along with a touching journal entry recounting how much she missed him. I was overcome with emotion. Even though we hadn't spoken in quite some time, I couldn't hold back the tears.

The truth is every season of life comes with a different set of challenges. Some impact us. Some impact our neighbors. And some impact us because they impact our neighbors.

We are not on this life-journey alone. God places family, friends, and even neighbors in our life to help us mend broken

fences, pick up the pieces in the aftermath of a storm, and carry on.

"Therefore if you have any encouragement from being united with Christ, if any comfort from his love, if any common sharing in the Spirit, if any tenderness and compassion, then make my joy complete by being like-minded, having the same love, being one in spirit and of one mind. ...in humility value others above yourselves, not looking to your own interests but each of you to the interests of the others" (Philippians 2:3-4).

If we would really and truly put this into practice, fences would be mended, hearts would be encouraged, and lives would be less broken.

~Rae Lynn DeAngelis

Spread Wings and Fly

One of the first phrases I said as a baby was, "I do myself." So when it was time to head off to college, I was 18 and certain I was ready to spread-my-wings and fly. The car was packed, and my parents drove me to campus a few hours away to move into my dorm room for week two of volleyball pre-season and freshman orientation. I remember being excited to be moving into my room. But as the room got closer and closer to being finished, there was an ache that began in my heart. Suddenly this 18-year-old, ready to fly young woman wasn't so ready anymore.

As we walked down to the car and said our good-byes, there were no tears from my mother. She was tough, proud, and encouraging. After final hugs they drove off. It was real. I was on my own, and I wouldn't see them for weeks. I made sure the car made it around the corner and out of sight before I broke down in

tears. I never asked my parents, but I have often wondered how long it took them to let their own tears flow.

The pre-season training was physically and emotionally taxing. When this would happen to me in high school, my mother had always been there at the end of the day to provide encouragement, love, and support. By Wednesday evening I was an emotional mess and called home. Sobbing over the phone, I told my mother about how I was a horrible player. The coach was surely going to figure out she had made a mistake in offering me a scholarship, and I was never going to make it through college. Classes hadn't even started yet! My mother calmly and lovingly provided me with reassurance, encouragement, and strength, successfully talking me off the ledge, as I have come to refer to it. In that moment, my mother was the mentor I needed to help me see things more clearly.

Now that I am on the other side of the journey, I know how hard those experiences were for my mother. Over the years, I have been on the other side of the college drop off where the mixture of excitement, pride, and heartache intertwine. I have received those college phone calls and talked my own daughter off the ledge a time or two, and then cried my own tears for her when the call was over. I continue to offer prayers of safety and protection as my daughter heads back into the classroom to teach during a pandemic. Just as my mother did for me all those years ago.

The process of parenting an adult child makes me think about Jesus's mother Mary. She loved her son deeply yet had to stand back and allow him to live out his purpose. Can you imagine the strength it took to stand and watch her son be in agony without being able to help him? Some of you can relate because you have been there watching helplessly as your own child has fought cancer or addiction. Others have had to watch as their child suffered under the consequences of a mistake they made.

In John 19:25 we read that "near the cross of Jesus stood his mother, his mother's sister, Mary the wife of Clopas, and Mary Magdalene." That is the key I suppose, to have others to provide support, encouragement, and Biblical perspective. We need people to help us bear the burdens and stay strong for our children, especially when they are out of sight.

Hopefully you have people providing you with support, perspective, and encouragement through the ups and downs of life. Or perhaps you are the person holding up another going through a tough time.

Mentoring relationships provide an opportunity to grow in our faith. If mentoring is of interest, consider the <u>Reaching New Heights Mentoring Program</u> through Living in Truth Ministries where you can serve as a mentor or be the person who receives mentoring. Biblical truth guides us upward and keeps us from falling. The journey of life can be much more enriching when we are traveling and supported by others.

~Tanya Jolliffe

Reap What You Sow

When I was seven years old, our parents purchased an old farm in Milan, IN with another couple. Every weekend our two families would head out to the country and do life together. We were like one big happy family. I have *many* fond memories from this time in my childhood. The sixty-three acres of property provided ample room for all nine of us kids to roam and explore.

One year our parents planted a garden to help fill our bellies with good wholesome food. We all had high hopes for enjoying the fresh vegetables from our little plot of land, but we quickly realized that tending a garden on weekends alone was insufficient time to cultivate the abundant harvest we envisioned.

The result?

We received a small return on our investment. The plants yielded very little produce, definitely not enough food to sustain two families.

Thankfully, our neighboring farmer friends were gracious enough to share their bountiful harvest with us.

As the saying goes, we reap what we sow—a statement that rings true for both gardens and spiritual growth. When we invest adequate time and effort into our personal spiritual growth, just like a well-tended garden, we will yield a great return on our investment.

Bask in the Son's light and goodness, fill your heart and mind with water through the Word, weed out worldly lies on a daily basis, and watch your relationship with God bloom and grow.

Remember, just like nurturing a garden, a fruitful relationship with God requires intentional time and effort. You will get out of it what you put into it.

Sow on weekends only, and you will reap a weekend harvest.

Sow all-week-long, and you will reap a bountiful harvest that will not only nourish your family, but it will nourish others as well.

"The Lord will indeed give what is good, and our land will yield its harvest" (Psalm 85:12).

"They are the shoot I have planted, the work of my hands, for the display of my splendor" (Isaiah 60:21).

~Rae Lynn DeAngelis

Ounce of Prevention

My aversion to the medical profession began when I was just a toddler. Office visits often ended in one of three ways: rebuke, pain, or embarrassment—all of which I deemed unpleasant. While I have no clear memory of sticking dried peas up my nose when I was two-years old, I do remember the doctor's reprimand after my second trip to have them removed.

The pediatrician's scolding must have left a pretty big impression. My mom said I never did it again.

Trips to the doctor's office grew more traumatic with the progression of age. I couldn't understand why my mom would allow a total stranger to not only see, but to also poke around my practically naked body. As if that wasn't enough, healthy or sick, most visits ended with a shot—booster or otherwise.

It wasn't until I became an adult and had children of my own that I began to truly appreciate the value doctors bring.

Chronic allergies, infected tonsils, asthma, scarlet fever, and pneumonia were a few of the ailments for which our kids needed treatment. I was extremely grateful to have each physician's recommendation, treatment, and help. Pain, discomfort, and embarrassment (while not particularly enjoyable) are a part of life.

Our LORD answers to many names: Shepherd, Creator, and Bread of Life. But the attributes of God that I cling to most, especially when I'm feeling down and out, are those associated with this title— The Great Physician.

The LORD comforts, heals, and binds up our wounds. He lifts up our head when we are weary or despised. And yes, sometimes the Great Physician, motivated by love, allows us to experience pain, discipline, and even embarrassment. He allows these uncomfortable situations to come into our lives as a way to help ward off future heartache down the road.

"No discipline seems pleasant at the time, but painful. Later on, however, it produces a harvest of righteousness and peace for those who have been trained by it" (Hebrews 12:10-11).

"[God] said, "If you listen carefully to the Lord your God and do what is right in his eyes, if you pay attention to his commands and keep all his decrees, I will not bring on you any of the diseases I brought on the Egyptians, for I am the Lord, who heals you" (Exodus 15:26).

Have you spent adequate time with the Great Physician today and received your daily dose of God's Word which is medicine for the soul?

An ounce of prevention is worth a pound of cure!

~Rae Lynn DeAngelis

There's Only One You

I wanted to listen to worship music I hadn't heard in a little while, so I went back to my music library and stopped on a particular song. Then more and more music began to play from different seasons of my life, reminding me of what I was going through when they were downloaded. I was in awe. The Lord was showing me how far I had truly come in my walk with Him and how much I truly needed Him.

In the past, I would take things and hold them in my hands, saying I was leaving them to the Lord to take care of, but in reality, only gave Him a small piece of that something. Giving it all over to Him meant that I didn't have control of the situation. Controlling and trying to do things my way was hurting me more than anything, but I didn't realize it.

I've had weight and body image issues my entire life and cannot even remember a time when I did not see myself as the bigger girl. I was so mean, calling myself names and looking in the mirror in disgust thinking, "Who would ever want me? I'm too fat and too ugly." And that was as a child.

I remember being in the sixth grade and tying a dark gray warm-up jacket with a green stripe going down the sleeves around my waist because my pants were incredibly tight. I was ashamed to let anyone know how uncomfortable they were. I thought tying the jacket around my waist would hide how I felt on the inside. I remember actually telling myself that if I did not lose weight by high school graduation, I did not want to go on. Life was too hard; I didn't want to live in this body any longer.

It is crazy how we allow the enemy to creep into our minds to plant these seeds, and then we water them by starting to believe they are true. Well ladies, I am here to tell you something! We

serve a God who is so much greater than any thought, habit, or anything we can imagine. The Lord loves us! He does not want to see his children suffer in the depths of their own minds. He is calling out to you. He is calling you by name saying, Lindsey, Sarah, Mary Joe, whatever your name may be, "I am here. I love you, and I want to grow closer to you. I want to hold your hand and pull you out of the depths of your thoughts and give you freedom, a freedom only I can give. But you have to allow me to come in and help you. You do not have to walk this alone. I know you are hurting, and I am here for you."

God gave us an AMAZING book full of truths. He wants us to use it to renew our minds. He wants you to look in that mirror and see beauty. He wants you to see you through his eyes. He wants you to see the masterpiece he created. There is only one you. There will only ever be one you, and He loves you just the way you are, love handles, gray hair, crazy eyebrows, and all. He loves you so much, He sent His one and only son to die so that you can live in freedom.

I am happy to say that now, looking in that mirror, I am beginning to be able to see things through His eyes. I still have my days, but those days do not last as long, and I remember that He "knit me together in my mother's womb" (Psalms 139:13). He wouldn't knit something that was not made with love and beauty. I am so grateful that He is giving me beauty from what I felt was ashes.

"My frame was not hidden from you when I was made in the secret place, when I was woven together in the depths of the earth. Your eyes saw my unformed body; all the days ordained for me were written in your book before one of them came to be" (Psalms 139: 15-16).

See ladies, it is written that He already knew what our bodies would look like. He had each and every day ordained. Whether you are a size 30 or a size 3, He loves you just the same. Each and every one of us has a story. So how do you want to live yours? In the lies? Nah! Let's live in the truth of knowing that He wants to set you free! There is only one way to do it. Let go of the pen and hand it over to the one who started your story.

~Lindsey Jones

Pulling Out Weeds

About mid spring, in preparation for summer's imminent arrival, my husband and I prepare our outdoor area in the backyard for a new season of enjoyment. Since our home is nestled in the woods, we get to enjoy God's creation up close and personal. Our outdoor space has become our own little piece of paradise.

Getting the space ready for summer is quite a chore since we have a fairly large space, and it's surrounded by lots of landscaping. The landscaping area always needs tending after the long arduous winter. I'm always amazed at how quickly the area becomes overtaken by the weeds and debris.

Carpet-like moss creeps up between the tiles of our patio area too, threatening to take over our little piece of heaven on earth. The unwanted vegetation continues its invasive assault until my husband and I take the needed time to pull out the weeds and spray the area with weed killer. It's a tedious chore that's a bit time-consuming, but once we cover the area with weed killer, it keeps the unwanted vegetation to a minimum all summer long.

Like weeds in our backyard garden area, sin can gradually creep into our lives without us even realizing it. Once there, it threatens to choke out the good and positive growth in us. Especially when we have gone through a season of neglect concerning our time with God.

The sudden recognition of our negligence can sometimes catch us off guard. Yet, if we are completely honest with ourselves, we can usually follow a trail of breadcrumbs that led to our defeat. Instead of spending time with Jesus, we hit the snooze button and kept sleeping in. Instead of going to worship service, we crammed our Sundays with activities and events. As the dust

gathers on our Bible, apathy settles into the crevices of our heart and God becomes an afterthought.

Like weeding a garden, our spiritual health needs to be an ongoing priority. When sin threatens to choke out God and positive growth in your life, take action. Identify areas of encroaching sin, pull them out by the root, and replace them with God's truth.

Weed out sin, and let God in.

~Rae Lynn DeAngelis

Strained Faith

I love orange juice, but like any connoisseur, I'm very particular about my beverage of choice. It must be 100% pure (not from concentrate) and pulp-free. (I'm guessing it's a texture issue because I'm not a fan of chunky peanut butter or bits of fruit in my yogurt either.)

I must admit, God gives me some of the strangest inspiration for writing. I was reading a spiritual growth book that talked about how God sometimes allows difficulties and hardships into our lives so He can stretch and strain our faith. The word *strain* stood out to me and jolted my memory to childhood mornings of long ago (before the days of pulp-free orange juice) when I had to remove the annoying bits of orange with a kitchen strainer.

As the vision played out in my mind, I began to wonder about strained faith. What does that look like and might there be some parallels I could draw upon? Whenever God relates the physical world to something spiritual, I usually have a deeper understanding of the concept He's trying to teach.

Like many words in our English vocabulary the word strained has more than one meaning depending on its context. For example, strained is defined several different ways:

- Having been passed through a strainer
- Done with or marked by excessive effort; forced
- Extended beyond proper limits
- Antagonized to the verge of open conflict
- Twisted; wrenched

I don't know about you, but I'm getting a mental picture of *strained faith* by definition alone.

The past couple of weeks, I have felt extended beyond usual limits. It seems every area of my life has been a struggle these days. I'm not going to lie. I find myself growing weary. Although I rarely appreciate the benefits of trying circumstances in the moment, I can often look back and see how God has used hard times to weed out character deficiencies in my heart. Pride, anger, selfishness, and impatience usually make an appearance in unexpected ways when I'm under a lot of stress. That's when I realize I'm not as far along on this spiritual journey as I had hoped.

Stressful jobs, challenging relationships, troublesome finances, and failing health have a way of revealing the 'ugly' in us. Like a goldsmith who purifies precious metals over a controlled fire, God uses circumstances such as these to turn up the heat so that the impurities buried deep within can rise to the surface and be *strained* away. If we surrender our lives to the refining work of God, He uses these opportunities to filter-out things in our character that are not of Him.

The next time that you feel extended beyond your limit, antagonized to the verge of conflict or marked by excessive effort, remember this: Slowly but surely, you and I are becoming clearer reflections of the One whose image we bear—Jesus.

> In all this you greatly rejoice, though now for a little while you may have had to suffer grief in all kinds of trials. These have come so that the proven genuineness of your faith—of greater worth than gold, which perishes even though refined by fire—

may result in praise, glory and honor when Jesus Christ is revealed (1 Peter 1:6-7)

~Rae Lynn DeAngelis

Don't Miss Out

There have been many times in my life that I've regretted my choices. The other day I was thinking about what a bad friend I was to the few friends I had amidst my addictions. I met both Lisa and Jennifer through my job. Being single, we connected and immediately became good friends. As life would have it, they both found their soul mates and decided to get married. I wasn't in their wedding parties, but they'd share with me all the exciting details.

Lisa's wedding was first. I bought the gift, picked out my outfit, and anticipated her big day. The night before, I went out "partying." Hungover, the next day I chose instead to stay home and binge and purge several times. The shame and embarrassment were overwhelming. I couldn't face her and kept her present. Because I chose to miss the party, I lost a great friendship.

Jennifer invited me to her bachelorette party. After a stressful day at work, I chose instead to stay hidden in my apartment with ED, my binge and purge partner. Again, the shame and embarrassment were overwhelming. I had severed two relationships all because I chose to not go to the party.

This reminded me of Jesus's parable in Luke 14:

> "A man prepared a great feast and sent out many invitations. When all was ready, he sent his servant around to notify the guests that it was time for them to arrive. But they all began making excuses. One said

he had just bought a field and wanted to inspect it, and asked to be excused. Another said he had just bought five pairs of oxen and wanted to try them out. Another had just been married and for that reason couldn't come. "The servant returned and reported to his master what they had said. His master was angry and told him to go quickly into the streets and alleys of the city and to invite the beggars, crippled, lame, and blind. But even then, there was still room. "Well, then," said his master, "go out into the country lanes and out behind the hedges and urge anyone you find to come, so that the house will be full. For none of those I invited first will get even the smallest taste of what I had prepared for them" (Luke 14:16-24).

When we're living a destructive lifestyle, we miss the party. We get so caught up in our coping methods and addictions that we make excuses. Two excuses were made in the parable—two had to do with work and the other with family. These people settled for living at a level far below the joy God wanted for them. The final warning is that we can miss the place that has been prepared for us by resisting God's design and His Word, living in opposition to His ways of love. We can miss the love of God and His Kingdom by being so caught up in our "stuff" that we miss the party by default.

The good news is: God's party is ongoing. You can show up anytime and He will welcome you with open arms. He will say to us just as the Father said to his prodigal son:

"It is right to celebrate (to party) ... For he (she) was lost and is found" (Luke 15:32)!

~Kimberly Davidson

First Edition

I was watching one of my favorite television programs when God spoke to my heart about something I had been continually berating myself over—the grammatical errors found in the first run of each of my books. My stomach turned each time I found a new mistake. I felt so inadequate. How could anyone benefit from my books with those errors? Surely the mistakes would detract from the message I was trying to communicate.

But then when I was watching an episode of Pawn Stars (a reality show about a pawn shop in Las Vegas), I learned something new and it changed my perspective. A customer brought in a book which he believed to be the first edition of a classic book by a well-known author. Rick, the shop's owner, decided to call in an expert to verify if the book was indeed a first edition and also to get an accurate appraisal of the book.

When the expert came into the shop, she carefully looked over the book by paging through the manuscript, obviously she was looking for tell-tale signs as to whether the book was indeed a first edition.

First edition means the first published printing of a book. Apparently, after the initial run of a publication, mistakes were often found, causing the publishing company to go back with new typesetting to fix those mistakes for the next round of printing. (What a boost to my confidence to learn that even successful authors made mistakes in their books.)

The appraiser began looking for the known errors in that particular novel's first printing to prove it was a first edition. After the expert's evaluation, she came to the conclusion that the book was indeed a first edition. This was good news for the owner who

was looking to sell the book because the book appraised for several thousand dollars. Not bad!

Perhaps mistakes have value after all. And not just the kind found in the first addition of a classic novel. Even mistakes that we make each and every day of our lives have value.

Mistakes teach us valuable life lessons. They remind us that we are not perfect; only our Heavenly Father is perfect. Mistakes keep us relatable to others and show us the wrong way to do something, so we can learn the right way. "If at first you don't succeed, try, try again." Mistakes teach us humility in a world that strives for carnal perfection. And most importantly, mistakes can be turned into blessings if we surrender them over to Jesus Christ.

So the next time you're tempted to beat yourself up over past mistakes, remind yourself that one day your little blunder has the potential to yield a great big return.

> Not that I have already obtained all this, or have already arrived at my goal, but I press on to take hold of that for which Christ Jesus took hold of me. Brothers and sisters, I do not consider myself yet to have taken hold of it. But one thing I do: Forgetting what is behind and straining toward what is ahead, I press on toward the goal to win the prize for which God has called me heavenward in Christ Jesus (Philippians 3:12-14).

"For the Lord takes delight in his people; he crowns the humble with victory" (Psalm 149:4).

~Rae Lynn DeAngelis

Cease Striving

I was scanning my social media feed the other day and came across a video clip entitled "Dogs Who Fail." The dog lover in me couldn't resist taking a peek. The clip began with dogs in slow motion, some failed to catch a ball or frisbee, a few tripped and fell, one got stuck, others missed their landing. But then came a portion of the clip that struck a chord in my heart—a bull terrier trying to fetch his ball from the couch. The little guy kept reaching and pawing at the ball, but every time he made contact, the ball scooted further from his grasp. Sometimes the ball rolled closer to him for a brief second, but when he tried to grab it with his mouth, it was once again pushed just beyond his reach.

I thought to myself... *This little guy needs to wait for his master to reach down and hand it to him.*

In that moment God spoke to my heart. It was about a certain something that I've been striving to achieve, something which I've worked hard to accomplish, but much like the little pup in the video, the closer I get to my goal, the further it seemed to drift from my grasp.

Watching the little dog, I felt a check in my spirit, the kind that takes place whenever God is trying to speak to me. Our conversation went something like this:

Me: God, I don't understand why this is taking so long.

God: *Rae Lynn, I know what you desire; I know what you're trying to achieve, but you need to wait.*

Me: Seriously, God, wait even longer? I'm growing weary. I'm not sure how much longer I can keep this up.

God: *Child, I haven't abandoned you. I'm still right here by your side.*

Me: Then why do I feel so alone, God? If you're by my side, why does it feel like I'm wandering around in the dark? Why do things keep getting pushed further out of my reach the harder I strive? Don't you see me struggling here, Lord? "How long will you hide your face from me? How long must I wrestle with my thoughts and day after day have sorrow in my heart? How long will my enemy triumph over me" (Psalm 13:1-2)?

God: *Beloved, I know what you want. In fact, the aspirations you have in your heart are not your own; they came from Me. They are in perfect alignment with My will for your life. However, these dreams cannot be accomplished in your own strength. They are just beyond your reach so that you need Me to help you achieve them. Cease striving, and wait for My perfect timing. There are things taking place in the heavenlies, things that you know nothing about, things beyond your understanding. "For my thoughts are not your thoughts, neither are your ways my ways. As the heavens are higher than the earth, so are my ways higher than your ways and my thoughts than your thoughts." (Isaiah 55:8-9). Trust Me, Child. I know what I'm doing.*

Me: I'm sorry for doubting you, Lord. Help me to trust your higher ways and be more patient. When I grow weary, lose heart, and feel like giving up, please give me strength through the power of your Holy Spirit to wait for your perfectly-timed, fully-ripened blessing.

Is there something you've been waiting to achieve but seems just out of reach? Perhaps God wants you to cease striving and wait for Him to hand it to you.

"Trust in the Lord with all your heart and lean not on your own understanding; in all your ways submit to him, and he will make your paths straight" (Proverbs 3:5-6).

Dear Lord, thank you for your continued course corrections and your gentle nudging that leads me straight to you. Even when it comes through a video on my social media feed.

~Rae Lynn DeAngelis

Sifted and Steadfast

"Who then is the faithful and wise servant..." (Matthew 24:45a)?

The night of the Last Supper, Jesus told Peter that he would deny Him three times before the cock crows (at dawn). Peter swore that he would die for his Lord. But by dawn Peter had indeed denied knowing Jesus three times. I can only imagine the waves of guilt and sobbing that overtook Peter when he realized what he had done (see Luke 22:33-34, 60-61).

I know the feeling of guilt. I know what it feels like to break God's heart. But I also know what kind of repentance (change of direction) a time like that brings. When you finally quit sobbing, you become the most loyal person in the world, one who will suffer any type of wound in order to keep from causing that kind of hurt again.

The faithful and wise servant fails sometimes. We all do.

Make no mistake, the words Jesus spoke to Peter shortly before going to the cross apply to us all today: "Then the Lord said, "Simon, Simon, listen! Satan has demanded to have you to sift you as wheat. But I have prayed for you that your faith may not fail. And when you have repented, strengthen your brothers" (Luke 22:31-32 MEV).

Satan wanted the Apostles then, and he wants us just as badly now. We live in a fallen world. For the time being, he has access.

Sifting is quite unpleasant. The old-fashioned way to sift is to spread wheat onto a floor made from stone or tamped earth and beat it vigorously with a flail. Simply put, sifting is going to hurt. These hard times scare us; they hurt us so badly, they shake our faith.

But Jesus intercedes for us, just as he did for Peter. "Consequently, he is able to save to the uttermost those who draw near to God through him, since he always lives to make intercession for them" (Hebrews 7:25 ESV).

Jesus was blunt with Peter, "When you have repented" (after you've sinned)… other Bible versions say, "after you come back (to me)." We're going to fall. No way around it. We must get up. Go back. Repeat.

We are not only called, but commanded to strengthen our brothers and sisters in Christ. We are stronger together. "A cord of three strands is not easily broken" (Ecclesiastes 4:12).

Becoming the faithful and wise servant usually involves stumbling around and falling down.

The faithful and wise servant gets back up.

~Melody Moore

Follow-Through

Early one morning while I was getting ready for Bible study, I felt a strong conviction to do something that at the time seemed a bit crazy. I suddenly had a thought which came out of nowhere, but I sensed it was coming from the Holy Spirit.

If there is one thing I have learned at this point in my spiritual journey, it's that I need to obey the Holy Spirit's prompting, even when I don't understand it.

On this particular morning, I felt strongly that I was supposed to take a certain CD to one of the ladies in my Bible study group. I was clueless as to why, but I wanted to be obedient so I went up to my desk drawer (the place where I knew it would be) and put the CD in my purse for safe keeping.

When I entered Bible study that morning the conviction was strong, but I didn't feel the timing was right.

Throughout our study time, I kept thinking to myself... *She's going to think I'm crazy! What if I totally misunderstood the Spirit's prompting? What if my friend is offended by my gesture?*

After our Bible study meeting, a few of us went out to lunch together. The Holy Spirit's prompting wasn't letting up as I pulled my car into the parking lot. I thought to myself... *Stop procrastinating and just do it.*

I grabbed hold of the CD and walked over to my friend's car.

Just as she was closing the door of her SUV, I said, "Okay.... I have no idea why, but... I felt a strong conviction this morning that I was supposed to give you this."

As I handed her the CD, she gracefully accepted and replied, "Well, if the Holy Spirit prompted you to give it to me, then it must be something I need."

As if it were an afterthought, she looked down at the CD and read the title. I could see sudden realization set-in through her facial expression. My friend's telling response sent a chill up my spine. In that moment, I knew that this was *definitely* the work of the Holy Spirit.

She looked up at me with tears in her eyes and said, "Rae Lynn, I can't believe it; this is an answer to my prayers!"

Relieved by her confirming response, I asked her to explain further. She then went on to share how a recent teaching at her church had been causing her spirit a lot of uneasiness because it was not in line with what the Scriptures taught. The title of the CD, *Why the Church and Culture are Losing Biblical Authority*, confirmed what she was already feeling in her heart.

After listening to the teaching on the CD, my friend called me a few days later and asked if it would be okay to share the CD with her church pastor. It was even more confirmation that the Holy Spirit was at work.

This experience was a huge faith builder for us both. Not only did my friend gain reassurance that God answers prayers when we need it most; I learned that I need to obey the Spirit's promptings more and more.

We may not understand why, but we are wise to follow through with the Spirit's conviction.

"For those who are led by the Spirit of God are the children of God" (Romans 8:14).

"And he who searches our hearts knows the mind of the Spirit, because the Spirit intercedes for God's people in accordance with the will of God" (Romans 8:27).

"Since we live by the Spirit, let us keep in step with the Spirit" (Galatians 5:25).

~Rae Lynn DeAngelis

Angels Among Us

When my husband first received the call that my mother-in-law was nearing the end of her ten-year battle with lung cancer, we were cautiously skeptical. After all, Beverly had beaten the odds before, time and time again.

During one of one my mother-in-law's yearly checkups, an x-ray image revealed a small spot on her left lung. Further testing confirmed our worst fear—lung cancer. Thankfully, it was caught early so the only course of treatment was surgery.

Recovery from losing half of a lung is difficult, but God sent ministering angels in the form of compassionate doctors and nurses, making her journey back to health more tolerable. Eventually, my mother-in-law was back on the move, living life to the fullest.

A few years later, her cancer returned, only this time, it was much more serious. Because small cell cancer is aggressive, her treatment was equally aggressive—intense chemotherapy along with chest cavity radiation followed by cranial radiation (a preventive measure to keep the cancer from spreading to her brain). My husband and I remember my mother-in-law expressing fear over the cranial radiation. Her intuition would prove to be

correct. Six months after her cranial radiation treatments, my mother-in-law began falling, having gating issues, and suffering memory impairment. Eventually, she was bound to a wheelchair with 24/7 care in her home.

I accompanied my mother-in-law to one of her oncology appointments and asked why we had not been told about the devastating side-effects of cranial radiation. I'll never forget the doctor's response. He said there hadn't been a lot of research conducted on the long-term effects of cranial radiation because most patients died before experiencing side-effects. The doctor told us Beverly was only 1 of 8 people who had lived as long as she had after the cranial radiation treatment. Knowing Bev's tenacity, we were not surprised that she had beaten the odds. *But to what end?* She was not able to care for even her most basic needs without help.

In January of 2018, we were told that Bev's cancer advanced to stage four. We knew her time on earth was fleeting. Two days after celebrating Thanksgiving dinner together as a family, Beverly's body began shutting down. She stopped eating, drinking, and was barely conscious. We were told the end was near. Bev's last audible sentence was heard when Gerry and his sister were at her bedside. Clear as day after not speaking for days she said, *"I'm going home."*

In the days that followed, my husband kept saying, "Mom, it's okay to go home. We love you, and we will miss you, but we will see you again. Go into the arms of Jesus. The angels are here waiting to take you home."

Psalm 91:11 says, "For he will command his angels concerning you to guard you in all your ways."

God gave our family incredible peace as He allowed us a glimpse into the spiritual realm during Bev's final days on earth. Cameras set up in her home to ensure she was properly cared for picked up globes of light which periodically floated or darted about her room. We have no doubt that these globes of light were angels (celestial beings) sent on a mission to watch over Bev and to usher her into heaven when her spirit left her body. On December 8, 2018, at 7:27 pm, my mother-in-law took her last breath. My husband and I were blessed to be holding her hands as she made her final journey into heaven.

Throughout Bev's battle with cancer, God provided angels. Some came in the form of doctors, nurses, caregivers, and church pastors. Others appeared as globes of light. All were sent by God. "Praise the Lord, you his angels, you mighty ones who do his bidding, who obey his word" (Psalm 103:20).

Don't ever doubt. Heaven is for real. Angels are among us. And every once in a while, God peels back the veil and provides a tiny glimpse of His glory and majesty.

~Rae Lynn DeAngelis

Problem with Photoshop

On the cover of almost every magazine is the image of a "perfectly shaped" individual. Usually there's a topic on the cover about a fabulous diet which, if implemented, will result in the body on the magazine cover (NOT). These images have been chiseled to eye-appealing form with the help of photo editing. It's not even simple editing; it's a total recreation. Anyone can go from a size 20 to a size 2 with the help of this kind of application.

God doesn't want us to fashion ourselves after the world. He wants us to learn more of Him that we might be fashioned into the image of Christ. I wanted to be thin because I thought it would help me to be more likable. I also thought I would be more accepting of myself. I went from a size 12 in women's clothes to children's sizes. Yes, I was secretly shopping in the children's department. It was so embarrassing that I already had a lie made up as to what I'd say if a salesperson came to help me. "I'm just looking for clothing for my friend's little girl." The weight loss didn't make others more accepting of me, nor did it make me like

myself any better. I was thin, frail, isolated, depressed, and stuck. If anything, I was more depressed and unhappy than ever.

When I began thinking deeply about the fact that my body is God's temple and that the Holy Spirit dwells in me, it gave me a sick feeling to think about the way I was abusing His possession. God has endowed us with these bodies because they are the vehicles through which He accomplishes His work through us. Therefore, we must make sure we are getting proper nutrition and exercise physically and spiritually.

A drastic change began occurring in my thought patterns and actions as I began studying the Word and praying every day throughout the day. As I look back, I can see the fingerprints of God on my journey toward recovery. I love the person He has created me to be. I say this out of pure humility. I am special because God created me. I am loved because He will never stop loving me. I am accepted because I am His child.

TRUTH: YOU ARE SPECIAL BECAUSE YOU WERE CREATED BY AND FOR YOUR PERFECT CREATOR! WHEN YOU LOOK UP ON A STARRY MOONLIT CANVAS OF THE VAST NIGHT SKY, JUST THINK, THE SAME GOD WHO CREATED SUCH AMAZING BEAUTY CREATED YOU. HE MAKES NO MISTAKES!

"Do you not know that your body is the temple of the Holy Spirit who is in you, whom you have from God, and you are not your own? For you were bought at a price; therefore glorify God in your body and in your spirit, which are God's" (1 Corinthians 6:19-20 NKJ).

~Rhonda Stinson

Devotion in Motion

I've never really been a big fan of exercise, but one day a felt a strong conviction to somehow, someway, work exercise into my weekly schedule. It was prompted by a book I was reading which was geared towards overall health. I loved the way the book talked about becoming healthy from the perspective of our body being a temple of the Holy Spirit. It's important to care for all aspects of who God created us to be: mind, body, and spirit.

I dreaded the chapters on physical fitness because I'm not as motivated to exercise as I used to be. When I was in the throes of my battle with an eating disorder, exercise was associated with losing weight to achieve a certain body type. There was a lot of pride involved in my disorder—I wanted to look good so others would take notice and approve of me. Now that I have been free from bulimia for many years, I never want to go back to that mindset again. I believe it's the main reason I've continually veered away from exercise plans altogether. I still associated exercise with my negative past.

I must say that I was pleasantly surprised by the book's approach to the subject. The author explained how we need to approach physical fitness through the mindset of a child. Children are naturally active because exercise is built into the things they already love to do—play. The author then went on to explain how we need to get back to viewing exercise in the same way. Rather than being a dreaded chore, exercise should be something we enjoy.

I was a bit skeptical that anything could cause me to enjoy exercise, but I continued reading. Two of the author's motivation suggestions to exercise piqued my interest—*faith and worship*. Now this was something I could really (no pun intended) jump up

and down about. I simply needed to change my exercise motivation to something I already loved—Jesus!

Wow! It probably sounds crazy, but this new mentality totally changed the way I view exercise. Motion is now part of my devotion. Sometimes I walk. Sometimes I ride a bike. Sometimes I swim. But I don't exercise for me. I exercise for Him. It has now become an act of worship and faith.

What about you? Are feeling uninspired to exercise? Perhaps changing your motivation and mindset will get you moving once again too. *If you can't do it for you, do it for Him!*

"Do you not know that your bodies are temples of the Holy Spirit, who is in you, whom you have received from God? You are not your own; you were bought at a price. Therefore, honor God with your bodies" (1 Corinthians 6:19-20).

~Rae Lynn DeAngelis

The Twilight Zone

My husband is an avid fan of an old television program called *The Twilight Zone*. He never tires of watching rerun after rerun. The story-lines are usually strange, but they certainly cause you to think outside the box.

I've had a few twilight zone moments of my own over the years. These nirvana-like experiences have often taken place in the morning, when I'm not fully awake. Oddly, some of my more inspired ideas have occurred during these times. Perhaps it's because my mind hasn't been hijacked by all the clamoring thoughts of cognizance yet and so I'm more receptive to hearing God's still small voice. I can't explain it; I just know it happens.

During one such episode while lying in bed half awake, I was thinking about Living in Truth Ministries and sensed it was time

to put on another event that would help encourage women and help them see their true beauty through God's eyes. It had been nearly three years since our last event, a daylong conference called *Reflecting God's Image: Mind, Body, & Soul.*

Although our previous conference was a great success, it had drained our leadership team physically, emotionally, and spiritually; we needed time to recover. Two and a half years later, God began prompting my spirit to get back in the game and plan another event.

During my 'twilight' state of consciousness, an idea popped into my mind—we should put on a fashion show event to help celebrate the beauty of everyday women.

Almost immediately, I thought of Shari Braendel of *Fashion Meets Faith.* Shari's ministry complements our own mission. An expert in the fashion industry, Shari teaches women how to dress with confidence, no matter their body type.

At our next leadership meeting, I shared my vision with the team, and everyone agreed it was, indeed, time to plan another event. We began to cover the idea in prayer and started putting some plans in motion.

I decided to give Shari a call, even though I had doubts whether she would be available on such short notice since our event was less than six months away. I also had reservations as to whether we could afford Shari's speaking fee (if by some miracle she actually *was* available). As a Christian speaker, Shari is in high demand, speaking at more than fifty events a year. Even with all these doubts and concerns swirling about in my mind, God kept prompting me to take a leap of faith. I knew that I needed to be obedient.

God continues to show off in big, bold, radical ways, doing immeasurably more than all we can ask or even imagine! Not only was Shari available to come and speak, but through the course of our conversation (after explaining the mission of our event), Shari told me that God had laid it on her heart to waive her normal speaking fee. We would only have to cover her travel expenses.

Wow, I couldn't believe it! "And we know that in all things God works for the good of those who love him, who have been called according to his purpose" (Romans 8:28).

Perhaps you have sensed God's still small voice prompting you to take a leap of faith in some area of your own life. Don't let the world's criticism or unbelief drown out the voice of God and keep you from being obedient. If it is God's will, He will make a way.

"The people walking in darkness have seen a great light" (Isaiah 9:2). "They will be called oaks of righteousness, a planting of the Lord for the display of his splendor" (Isaiah 61:3b).

If like me you are in doubt, wondering whether you heard God correctly? Share your vision with others. Seek God's wisdom through prayer and petition. And if you still feel the Spirit's conviction on the matter, step into the unknown, and watch God part the waters. He will do immeasurably more than all you can ask or even imagine.

~Rae Lynn DeAngelis

Know Who You Are

I first watched the Disney movie, Moana, last January with my eighteen-month-old, who then became obsessed and refused to watch anything else for two months. The movie is fantastic by the way – five stars from me, but I'm not writing a review on the movie. This really has nothing to do with Moana and everything to do with a short song from the movie where I heard God whispering some beautiful truth to me. When you take the song out of context from the movie, you may just feel like God is whispering some super important words to you too.

So either read this below or google 'Know Who You Are Moana' and listen to it, if that's your jam, or do both.

I have crossed the horizon to find you.

I know your name.
They (the world) have stolen the heart from inside you.
But this does not define you.
This is not who you are.
You know who you are.

Friend, it's difficult stepping into a new role or a new season of life. It can feel confusing, like your identity has been shaken. I've found my new(ish) title as mom an extremely difficult one, as I've transitioned from the title of working wife to stay at home mama. With that identity, new emotions have surfaced or become more prominent with anxiety being a top contender. I knew who I was. But suddenly the title 'mom' got thrown onto the end of my name and now I'm unsure. Is this who I am? – tired, anxious, constantly picking up, praying for patience, head in hands breathing so I can survive another toddler tantrum, crying from the overwhelm, mama? Can anyone else relate to this feeling of taking on a new role and feeling like your identity was lost somewhere along the way?

When it comes down to it, do any of those titles I hold really matter if I know where my true identity lies? I do play the role of mama, and maybe it comes with a lot more emotional stress and growth than originally anticipated, but those are just extensions of who I am, not who I truly am. I think it's important to remember that. We have a lot of roles as humans, but only one true identity to find freedom.

God knows us and wants us. The world can make us feel lost and confused, but this doesn't have to define my identity. It's not who I am. I know who I am in Christ. I am loved. I am treasured. I am a daughter of the King. My identity lies with Jesus first.

This song lets my soul rest for a minute. It brings me back to think about who I truly am, not just the daily roles I juggle. Maybe it can do that for you too.

~Kelsey Klepper

I Declare War

As a child, I spent hours playing a card game called *War*. The goal was to eventually win all the cards in your opponent's deck by laying down the highest card in each round.

Every once in a while, the players laid down the same exact card, resulting in a declaration of card "war." Each player would lay three cards down and the last card face-up. The person with the highest card was the winner and got to take all the cards that had been laid during that round. If you lost, it was often disappointing to see all the good cards you had given up once the 'blind' was revealed.

Some of us approach life in a similar way, trying to copy or one-up the people around us. Consciously or subconsciously, we strive to have the best material possessions, physical appearance, and lifestyle.

Even when we don't *want* to engage in such rivalries, we often get drawn in because of our competitive nature. The lure to impress or copy those around us is tempting, especially if we are already struggling with our identity.

Definition of identity: *The condition of being oneself or itself, and not another; the distinguishing character or personality of another.*

According to this definition, identity is the thing that sets us apart from everyone else. It's what makes us uniquely us. Yet, many of us willingly relinquish our identity because we desire to be like or better than someone else.

The end result is that we lose something very precious in the process—our true and unique God-given identity—the part that makes us distinct and special.

Friends, the only one we should compare ourselves to or aspire to be more like is Jesus. When we seek to be more like Jesus, we get to also keep our unique identity because all the things that make us unique are already a part of Him too. We were made in His image. And each one of us is able to uniquely reflect our Creator.

When it comes to real life, don't let Satan tempt you to engage in a game of war called comparison. Be content with the person God created you to be and stick to playing the hand He has given you.

"A heart at peace gives life to the body, but envy rots the bones" (Proverbs 14:30).

"I have learned the secret of being content in any and every situation, whether well fed or hungry, whether living in plenty or in want. I can do all this through him who gives me strength" (Philippians 4:12-13).

~Rae Lynn DeAngelis

The Blame Game

The responsibility for our faults, failures, and mishaps seldom rests upon our shoulders alone. But sometimes it feels like we have been hardwired to shift blame and displace responsibility. *It's that time of the month... I didn't get enough sleep... I had a difficult childhood... You don't know how badly I've been hurt... I need more time... It's just who I am...* Heck, we even get all spiritual with our excuses. *That's not my gifting... God hasn't called me to that... Satan has been attacking me.* OUCH!

Shifting the blame is not a new development. It's been around since the beginning of time.

Then the man and his wife heard the sound of the Lord God as he was walking in the garden in the cool of the day, and they hid from the Lord God among the trees of the garden. But the Lord God called to the man, "Where are you?" He answered, "I heard you in the garden, and I was afraid because I was naked; so I hid." And he said, "Who told you that you were naked? Have you eaten from the tree that I commanded you not to eat from?" The man said, "The woman you put here with me—she gave me some fruit from the tree, and I ate it." Then the Lord God said to the woman, "What is this you have done?" The woman said, "The serpent deceived me, and I ate" (Genesis 3:8-13).

I have to admit that I'm a lot like Adam and Eve. When it comes to my sin, my gut reaction is to look for a scapegoat, to shuffle blame, even if it's only in my mind. *But why?* Why is it so hard for mankind to accept responsibility?

Three words: SIN. IS. HEAVY.

We cannot bear the burden alone, and God knew it. Although there were some pretty hefty consequences for Adam and Eve's disobedience, it was God Himself who made restitution for their sin. "The Lord God made garments of skin for Adam and his wife and clothed them" (Genesis 3:21).

There is only one way to get a skin from an animal. (Just stating the obvious.) God showed Adam and Eve the severity of their actions and exposed the ugly truth that sin—no matter how small—results in some kind of death.

Thousands of years later, God did it again. Only this time, He covered over mankind's sin with His own precious blood. "When he had received the drink, Jesus said, 'It is finished.' With that, he bowed his head and gave up his spirit" (John 19:30).

Jesus Christ, the pure and spotless Lamb of God, shifted blame to Himself and paid the ultimate price for our sins. Why? Because He knew full-well that we couldn't carry sin's burden alone.

"Greater love has no one than this: to lay down one's life for one's friends" (John 15:13).

Thank you, Jesus, for carrying my burden, knowing full-well that I could never bear it alone.

~Rae Lynn DeAngelis

Loving Yourself First

A couple of weeks ago, I turned to Romans chapter thirteen. When I got to the end of verse nine, I was stopped in my tracks as the words reverberated in my mind, "love your neighbor as yourself." Suddenly, the Spirit within me began to whisper, "How can people love their neighbors if they don't love themselves first?"

The next day during my morning devotional time, I was reading in the book of James. Guess what jumped out at me? James 2:8 which reads like this in the NIV, "If you keep the royal law found in Scripture, "love your neighbor as yourself," you are doing right."

Here the text is quoted from the Old Testament law in Leviticus 19:18 which reads, "Do not seek revenge or bear a grudge against anyone among your people but love your neighbor as yourself. I am the Lord." Ok, so love does not seek revenge or bear a grudge. That reminded me of 1 Corinthians 13 and its comprehensive explanation of biblical love.

As I continued to ponder the words of James 2:8 a little further, "royal law" rolled around in my head. Contemplating those words further, I was reminded of Jesus' teaching in Matthew 22:34-40 and its reference as the great commandment. There, Jesus taught about two interconnected laws, the first being to love God and the second to love your neighbor. Both commands

together summarize all the Ten Commandments. I referenced the same teaching shared in Mark and Luke as well. After a quick search, I found that this great command is repeated eight times in the Bible. If the Scripture is taught by Jesus, recorded in three different Gospels, recorded twice by Paul, and once by James, it must be important.

After referencing each of these eight listings, I was once again struck by the last portion of the phrase, "as yourself" and my thoughts quickly went back to the question, can people love their neighbors if they don't love themselves first?

Perhaps that is part of the problem in our world. If people don't see their worth, are riddled with guilt, or believe they are undeserving, it makes sense that they might view others through the same lens.

So how do we love ourselves unconditionally first?

We only need to start by being patient and kind with ourselves, being mindful not to dishonor or discredit ourselves for past or current mistakes. Jesus died on the cross to forgive us for those mistakes. The cross is proof that Jesus made the first move to forgive our mistakes. Even if we are living with consequences of our mistakes, love keeps no record of wrongs. We can trust in the Lord, hope in the plans He has for us, and persevere because love never fails.

Jesus didn't wait for us to find our way to him, he came running after us instead of leaving us at our worst. Love moved first. We need to follow that example, *turn toward gratitude*, and embrace the love we have been given. When we do, we will learn to love ourselves first so we can truly love our neighbors as well.

~Tanya Jolliffe

Learning How to Sail

When my best friend invited me to join her for a week of church camp, brilliantly disguised as sailing camp, I was all in. What teenager didn't want to embark on a perilous journey across the open seas? *Or as it was in this case— a man-made lake.* My family grew up boating, so I was no stranger to water, but I was still eager to learn how to glide across the water with only wind and waves as my propeller.

Although I had grown up in the church, God did not take center stage during my teenage years. I was more concerned about building relationships with friends than I was with Jesus. However, something was sparked in my spirit during that week of church camp, something I didn't expect. Jesus became real to me. A deep sense of longing rose to the surface of my heart, a longing for Jesus. Far from away from a church building, I learned that Jesus truly cared about me as an individual, and He wanted me to know Him on a personal level.

My camp counselor Ann had a very positive influence on me as she displayed what it looks like to have godly character and integrity. She didn't just share the gospel of Jesus, she lived it.

God used this beautiful role model to lure me into a deeper relationship with Him. Ann showed me (through her example) what it looked like to have a personal relationship with Jesus. There was something very attractive about her relationship with Jesus. I wanted what she had.

As I look back over my life, I can see how Jesus had been chasing after me my entire life, placing people and circumstances along my life's journey, drawing me in and drawing me closer to Him. These pivotal moments in my own life continually remind

me of God's tremendous love and persistence to win us over. He is always trying to get our attention.

I didn't surrender my entire life over to the Lord that week, but many seeds were planted. Over time, God brought others into my life to water those seeds. And eventually, those seeds took root, matured, and began to bloom. And because of the faithfulness of others, my life is now bearing fruit.

A guest speaker at our church shared a profound truth. He said, *"Anyone can count the number of seeds in an apple, but only God can count the number of apples in a seed."* When I was asked to share my story with a group of church campers, I spent a few minutes offering encouragement to the camp counselors, reminding them of their important role and how they may never fully realize the impact they are making in the Kingdom of God.

"The one who plants and the one who waters have one purpose, and they will each be rewarded according to their own labor. For we are co-workers in God's service; you are God's field, God's building" (1 Corinthians 3:8-9).

Take every opportunity to plant and water seeds of faith in the people God has placed around you. You never know, you might just be the only reflection of Jesus they have an opportunity to see.

I love the wise counsel given by Christian author Oswald Chambers, *"You can never give a person that which you have found. But you can make them homesick for what you have."*

~Rae Lynn DeAngelis

Slower Pace—God's Grace

O ur house is nestled in a wooded area of the subdivision, surrounded by lush green trees. In the spring of 2020, the leaves seemed greener than I remembered from seasons past. Perhaps it was the tremendous amount of rainfall we had experienced, or maybe it was due to the reduction of pollution released into the air with stay-at-home orders during quarantine. Or… maybe, just maybe, it's the fact that life slowed down enough for me to actually appreciate some of the simpler things in life. Things like the sights, sounds, and smells of God's creation?

Now before I go any further, allow me to clarify that I am not, in any way, belittling the very real hardships people have faced as a result of Covid-19. Real people went through real trials. Everyone faced challenges to some extent. Some people coped better than others. Perhaps it had something to do with perspective.

Where is your focus when life gets hard? Is it on your problems, or is it on your God? 2 Corinthians 4:18 reminds us that we need to fix your eyes not on what is seen, but what is unseen, because what is seen is temporary, but what is unseen is eternal. Problems are temporary. God is eternal. Instead of fixing focus on all the negative things we are experiencing, let's focus on the faith muscles being flexed during difficult times which will make us stronger down the road. Let's stop complaining about what we can't control and start praising God for what we can. The one thing we can control is our attitude. *Our response is our responsibility.*

The Lord promises to work ALL things together for the good of those who love him and have been called according to His purpose (Romans 8:28). God's promises are true. He brings beauty from our ashes if we let Him. Here's some ways our family experienced God's grace during the pandemic's slower pace:

- My husband was forced to take a pay cut, but he still had a job. And because his company stopped all work travel, he got to work from his home office, allowing us more time to spend together.

- I greatly missed going to church, but what a blessing that we live in an age of technology that allowed us to experience worship services online and from the comfort of our own home. (Sometimes we didn't even get out of our pjs!)

- I didn't get to see friends and family members as much as I would like, but I was able to stay connected in other ways like Zoom video conference calls.

- My husband, Gerry, and I enjoy going out to eat on the weekends, but eating more home-cooked-meals forced us to eat healthier and spend less money.

What do you remember from the pandemic? How awful things were, or how you got to see God's grace in the midst of living life at a slower pace. You get to choose where you will fix your focus.

Blessings or curses. Life or death. The choice is ours.

I choose life!

"This day I call the heavens and the earth as witnesses against you that I have set before you life and death, blessings and curses. Now choose life, so that you and your children may live and that you may love the Lord your God, listen to his voice, and hold fast to him. For the Lord is your life, and he will give you many years

in the land he swore to give to your fathers, Abraham, Isaac and Jacob" (Deuteronomy 30:19-20).

~Rae Lynn DeAngelis

Walk with Me

Isn't it funny how the Lord reveals himself to us sometimes? Yesterday, I was feeling very alone. I came home and my apartment was empty. That is nothing new. I live alone. But it was just different. It was right before the holiday weekend. I was off the next day and had zero plans. All of my friends were out and about with their own families, and there I was on July 4th weekend alone and nothing to do.

All I wanted to do was lay down on my couch and go to sleep so I didn't have to think about the fact that I felt very alone. The Lord had other plans for me though. He wanted to go on a hike in the woods with me. He wanted to show me that I was not alone and that He was with me the entire time. He wanted to show me how much He loved me and that even though the enemy was trying to take me out with my thoughts, He was there to pick me back up if I would just let Him. I just needed to lean on Him and not my own thoughts and feelings.

So what did I do? I got off the couch and first reached out to a group of amazing women that He placed in my life, a group that He is building to be amazing prayer warriors. I let them know my feelings and I asked to be covered in prayer. I felt those prayers last night, because I was able to pull myself together, change my clothes, and head over to the park. It was just me and God, and we walked together through the woods.

The first way He showed me He was with me was when I was getting in my car. I realized I did not have any cash on me. I had

my card, and I didn't want to go back in to get cash to park. It should be fine I thought. Most people don't carry cash anyway. I for sure should be able to get in. Nope, it was heavy on me to go in and get cash. So, I left my car running and ran down to my apartment and got the cash I needed to get in the park.

When I arrived, I met the lady working the gate. She let me know that it was $5 for a one-day pass or $10 for the whole year. No brainer. $10 for the year, please. Then she went on to say, "Here's the kicker. We only accept cash to get in. There is no WIFI out this way to be able to accept a card." That put such a big smile on my face. I let her know, I had a funny feeling about that and actually went back into my apartment just in case, to pick up cash. She said, "Well it's a good thing you listened to yourself."

Without even thinking I said, "Nope, I listened to the little God voice, He is the one who made me go back." She smiled so big and said, "funny how He does that, huh?" You could tell she was happy to be able to be around another Sister in Christ.

I left and went to find my trail. I pulled up, put in my ear buds and off we went. It was just me and God trucking along. As I got further into the woods, I lost signal and was unable to listen to my music, but I could listen to one song that was no mistake for that time. Praise Before My Breakthrough by Bryan & Katie Torwalt played over and over again as I walked. Part of the lyrics are, *"When I'm living out my faith, when I'm stepping out to sea, I know you take my hand and walk with me."*

Those words could not have come at any more perfect of a time. I held out my hand and I asked Him to walk with me, and He did. We walked up the hill, made it to the top, and I was able to really look around again and see all of His beauty and creation. Then as I was coming around the bend, I saw a card sitting on a nature sign. It had a verse written on it that I know could have only come from the Lord. It was Isaiah 43:19, "See, I am doing a new thing! Now it springs up; do you not perceive it? I am making a way in the desert and streams in the wasteland."

I lost it right then and there. I just began to praise and worship Him right in the middle of the woods. He knew. He knew I would be walking there right at that very moment, and He knew I would need encouragement. To whoever placed that card there, I am

forever grateful. They may never know what it meant to me, but just the fact that it was there was so comforting.

We are not alone. The Lord is always with us, saying, "Walk with me child. Take my hand. I will guide you. I will make all things new. Just trust me and believe."

~Lindsey Jones

Judging a Book by Its Cover

A s an author, I like to keep up with the latest marketing trends in the book publishing industry.

I recently read through an article that talked about the importance of a book's cover and its relation to book sales. The article explained that if a cover is not striking enough to draw the attention of the consumer, it will be passed over for something more interesting on the shelf.

Covers offer potential readers an idea of what they will encounter if they were to actually read your book. According to the article, if a cover is sloppy or unappealing, it greatly impacts the sales of that particular book.

When it comes to people, we are told not to judge a book by its cover. Yet it seems our brain automatically default to this setting, making judgment calls concerning everyone we meet based on appearances alone.

For example, when someone looks dirty and unkempt, we automatically assume they have low income.

When a person is dressed provocatively, we assume they are immoral.

If a person wears a cross around their neck, we instinctively assume they are a person of virtue.

But here's the thing. When it comes to people, we can't judge people by outside appearances because people are more than one dimension. What we see on the outside is not the summation of who they are. When God made us in His image, He created us with three parts: mind, body, and spirit.

All three factors must be added into the equation before forming an opinion about someone. In addition, we need to recognize that sometimes people don a façade to intentionally mislead others into believing what they want them to believe. (Been there, done that.) Unfortunately, it is only when we take time to truly know a person and look at them through the lens of our Heavenly Father that we are able to realize this fact.

Anytime we make assumptions about a person based on what we see on the outside, we are dismissing an opportunity to learn what he or she is all about.

Anyone can create a fancy cover with intriguing headlines and subtitles. But just like any book, we can't know the content if we don't take time to open up the manuscript and read what's inside.

Be intentional. Take time to get to know people inside and out.

"For in the same way you judge others, you will be judged, and with the measure you use, it will be measured to you" (Matthew 7:2).

Despite what the article says, *try not to judge a book by its cover.*

~Rae Lynn DeAngelis

Don't Ignore It

J esus says, "I am the true vine, and my Father is the gardener" (John 15:1).

We were going to replace the diseased weeping cherry tree in our front landscaping bed that was removed, but as so often happens, time got away from us and we left the space empty.

Then one day I noticed a small burgundy colored bush beginning to take shape where the tree used to be. It was growing all on its own. And since it was such a beautiful color, we let it stay. Over the course of the next few years, the once small bush got bigger and fuller. It even produced little flowers in the spring.

The bush was lovely at first. But after a while, it started intruding on some of the other plants in our landscaping. It was definitely time to prune it back. As my husband and I began trimming, we noticed the bush was covered with thorns. They kept poking us every time we tried to cut away one of the branches. (I started the project wearing flip flops but immediately changed over to tennis shoes because the thorns on the ground kept puncturing my foot.)

That whole experience reminds me of my battle with an eating disorder. Like that bush, I allowed bulimia to take root, ignoring the fact that it was taking over my life. At first, I thought the bulimia was helping me. After all, I was finally able to achieve a body size that was in line with what the medical charts recommended. Not only did I lose weight through my disordered behavior, I was able to keep it off too. Everyone complimented me on how great I looked. I finally felt accepted and loved.

Unfortunately, like that thornbush in our yard, eventually my eating disorder behavior grew out of control and took over my life. I was in bondage to the number on the scale. I counted fat grams

and calories. After a while, it felt like everything I ate needed to be purged. I began withdrawing from others and went to great lengths to hide my disordered eating secret. By the time I finally addressed the problem (two and a half decades later), my eating disorder was both challenging and painful to remove.

God took me on an amazing healing journey and pruned away all those toxic thoughts and destructive behaviors that had kept me in bondage. It was a painful process at first but so very worth it in the end. Every lie God pruned from my life was replaced with the truth of His Word. Seeds of truth were planted and watered until they were deeply rooted in my heart. He taught me that what's on the outside is not nearly as important as what's on the inside.

"The Lord does not look at the things people look at. People look at the outward appearance, but the Lord looks at the heart'" (1 Samuel 16:7).

God has taught me over the years that when I allow Him to cut away the things in my life that have become gnarly and out of control, the subsequent growth that takes place is beautiful. The new growth that takes place is life-giving. I produce fruit, not thorns, fruit that lasts and never spoils, fruit that not only nourishes, but is used to nurture the growth in others as well.

What about you? Are there some areas of your life that need to be trimmed away by God? Don't ignore the Spirit's prompting any longer.

"I am the true vine, and my Father is the gardener. He cuts off every branch in me that bears no fruit, while every branch that does bear fruit, he prunes so that it will be even more fruitful. You are already clean because of the word I have spoken to you. Remain in me, as I also remain in you. No branch can bear fruit by itself; it must remain in the vine. Neither can you bear fruit unless you remain in me" (John 15:1-4).

~Rae Lynn DeAngelis

Obedience Is Important

My husband and I are empty nesters and "dog people." Who isn't a dog person—*dog spelled backwards is god!* (Okay... so maybe not everyone is a dog lover.) Our dogs have always been our "kids." We were blessed to have two dogs live to the ages of fourteen and fifteen. Sadly, they both went to heaven nine months apart.

After mourning our losses, my husband and I decided it was time to look for a puppy. (We live on a ranch and love Australian Shepherds and Border Collies.) Boy, has purchasing a puppy changed compared to fourteen years ago. And dare I say, raising a puppy is *much harder* when you're 14 years older!

The first advertisement I came across described this shepherd puppy as "biddable." I had to look the word up. It means "willing to do what is asked; obedient; a desire to please." I thought, that should be a Christianese word if I ever heard one.

One of the character traits of God made evident throughout the Old Testament is His justice. Because God is just, He couldn't allow His rebellious people to claim the Promised Land (see Numbers 13 and 14). Thankfully, for us, faith in Jesus alone is enough to satisfy God's wrath against our sin. But God still expects obedience from His children—to be "biddable." In this culture we seem to have a disdain for the words "obey" and "submit," don't we?

Why is obedience to God important?

It proves our love for Him. 1 John 5:3-4 states, "Loving God means doing what he tells us to do, and really, that isn't hard at all; for every child of God can obey him, defeating sin and evil pleasure by trusting Christ to help him" (TLB). Obedience demonstrates our faithfulness to Him. It glorifies Him in our

worlds, and opens avenues of blessings for us. Jesus said, "Now that you know these things, you will be blessed if you do them" (John 13:17, NIV).

Is obedience easy? No. It's impossible to be obedient in our own strength. This is why He gives us the empowerment of the Holy Spirit once we trust in Jesus as our Lord.

If I asked those close to you if you are biddable, how would they answer?

~Kimberly Davidson

Childlike Wonder

One summer evening while staring into the glowing embers of our back-yard fire pit, I suddenly realized how seldom we took opportunities to be outside after dark. Why didn't we do this more often? Sure, life gets busy; but we're not *that* busy. We seem to have enough time to stare mindlessly into the television screen.

When I was a kid, we rarely spent time *indoors*, especially during summer months. Our days were consumed with outdoor activities like biking, swimming, playing in the woods, and climbing trees. When we got tired, we didn't go inside. Instead, we would lie down on the soft, warm grass and comb the sky for clouds conspicuously shaped like animals. Evenings were spent running barefoot through cool grass, catching lightning bugs or playing "Ghost in the Graveyard." *Ah, the good old days.*

Sometimes I wish I could recapture that childlike wonder again, everything exciting and new, with days and nights simple and carefree.

I believe we can get there to some extent. But we might need to be more deliberate in our quest. We can (and probably should)

make a conscious effort to stop every now and then to take life in so it doesn't whiz by us at the speed of lightening. We may not have the same amount of free time as we did when we were kids, but I would be willing to bet that you (like me) fritter away more moments than we care to admit in a day.

I'm all for modern conveniences, but sometimes I wonder. Has technology made our lives easier... *or just busier?*

Today was one of those picture-perfect days. The sky was a clear blue, and the temperatures hovered in the low seventies. I wasn't about to let another opportunity pass me by, so I went for a long walk.

When I got home, I spent a good hour and a half enjoying the outdoors. Even though I was doing yard work, pulling up weeds from the landscaping and clearing away gnat filled spider webs from the eaves of our home, I still had the opportunity to feel a cool breeze across my face and hear a chorus of song birds ushering in a new day. It felt really good to slow down and take it all in.

Like twinkling lightning bugs on a warm summer evening, life still holds flickers of childhood wonderment. If only we would stop and take it all in, we just might capture more of those moments. And when we do, we can tuck those moments into our hearts like fireflies in a jar.

"But Jesus called the children to him and said, "Let the little children come to me, and do not hinder them, for the kingdom of God belongs to such as these. Truly I tell you, anyone who will not receive the kingdom of God like a little child will never enter it" (Matthew 18:16-17).

"My heart, O God, is steadfast; I will sing and make music with all my soul. Be exalted, O God, above the heavens; let your glory be over all the earth" (Psalm 108:1, 5).

~Rae Lynn DeAngelis

The Pace of Grace

"**S**o for a whole year Barnabas and Saul met with the church and taught great numbers of people. The disciples were called Christians first at Antioch" (Acts 11:26).

When God brought me to this Scripture, I immediately thought about my dear friend Cherie and her husband Scot, who have been missionaries in Papua New Guinea for twenty plus years.

One day Cherie and I spent the day together, reminiscing over the good old days from childhood and catching up on the things God's been doing in each of our lives. (Since we only get to see each other every few years, we had a lot of catching up to do!)

At one point in our conversation, we began talking about the many challenges of mission work and how things often take much longer than we anticipate. She agreed that God's timing and our timing may vary greatly but God's timing is always best.

She then reached into her purse and pulled out the 'fruit' of their twenty-three years on the mission field. It was a New Testament Bible translated into Mato—the language of the people whom they served.

I was in awe! To see the fruit of your labor in such a tangible way must be incredibly rewarding, however, this fruit didn't appear overnight. It took years of hard work: tilling soil, watering seeds, and pruning branches. Cherie and Scot had to first learn the language of the Mato people. Then they had to put the language into written form. After they had it written down, they had to translate the NT Bible into the Mato people's language. When Scot and Cherie said yes to becoming missionaries, they said yes to a lifetime of service.

In much the same way, when you and I say yes to spiritual transformation, we say yes to a lifetime of sanctification. "Do not conform to the pattern of this world, but be transformed by the renewing of your mind. Then you will be able to test and approve what God's will is—his good, pleasing and perfect will" (Romans 12:2).

In faith and obedience, we must continue to take step after step. Like it was with my missionary friends, challenges will come our way, but we shouldn't give up. God is with us every step of the way.

Stand on the promises of God, walk in His truths, and run your race, steady and strong. As Pastor Michael Todd from Transformation Church so often says, God will move us at the pace of His grace. His timing and our timing may vary greatly, but God's timing is always best.

> Therefore, since we are surrounded by such a great cloud of witnesses, let us throw off everything that hinders and the sin that so easily entangles. And let us run with perseverance the race marked out for us, fixing our eyes on Jesus, the pioneer and perfecter of faith. For the joy set before him he endured the cross, scorning its shame, and sat down at the right hand of the throne of God. Consider him who endured such opposition from sinners, so that you will not grow weary and lose heart" (Hebrews 12:1-3).

Lord Jesus, thank you for this timely reminder that both ministry and healing takes time. When I feel discouraged and think things are not moving along at the pace that I think they should, help me to focus on You and remember that You will bring the increase when the time is right. Amen

~Rae Lynn DeAngelis

It's a Process

I had a toothache that hurt *a lot*. After a visit to the dentist, it looked like a root canal was needed. Bummer. And of course, insurance didn't cover it.

So I scheduled and had it done, however, a week later, the ache returned. I went back to the dentist and he said I needed a root canal. A week later, I was still in pain, but even worse because of the infection. The solution was to remove the tooth completely, put in an "implant," and put in a "new" tooth.

The process would be something like this. Take the tooth out, wait for the gums to heal and infection to go away. Three months later, put in the post, then wait six months for the bone to grow around the post, then get the tooth put in.

It was a long, painful, and costly process, but my new "implanted" tooth, will never get cavities or infections. I have to floss around it with a little more intention so my gum doesn't grow up around it. But it's my favorite tooth, so pretty and white. I love it.

I couldn't help but parallel this with how God takes care of the infections with my soul.

I feel a little angst and pain, do a little work with God and then think I'm good. But it doesn't go away. Sometimes it takes a while and the pain gets worse, so I keep coming to Him for what's next. He doesn't want to just clear up the infection; He wants something even better for me. He wants to completely remove the root of the problem so I have true and complete healing. He takes my pain and misery and replaces it fully, with something better.

The most recent infection is the feeling that I will always feel a little lonely. Even in a room full of people, I often feel like I don't belong. I've had to sit in my loneliness, not fill it with

temporary medicine (comforts of many forms), but sit and feel it. Lay it all before God during my "checkups" and let him remove the lie that I am alone and have no deep connections.

Like my infected tooth, that loneliness didn't just go away. There's been a process and intentionality to getting better. God leads this process. Through His faithfulness and restoration, I now believe that I belong everywhere because I know WHO I belong to—Jesus. He paid a great price for me, and I'm His. No matter where I am, I'm never alone. The Holy Spirit fills me up. I'm placing Christ at the throne of my heart which is my daily medicine. The Lord is keeping me grounded in Him, helping me recognize the lies. Through His Holy Spirit I have the power and strength to fight off the future 'infections'.

"Be strong and courageous. Do not be afraid or terrified because of them, for the LORD your God goes with you; he will never leave you nor forsake you" (Deuteronomy 31:6).

"The LORD your God is among you; He is mighty to save. He will rejoice over you with gladness; He will quiet you with His love; He will rejoice over you with singing" (Zephaniah 3:17).

~Alison Feinauer

What's Lurking Beneath

During a recent family vacation to New Smyrna Beach, Florida, I learned that this quaint little town is the shark attack capital of the world. No kidding... look it up for yourself. Needless to say, after I found out about this information, I was much more cautious going into the ocean.

During the first few days of our vacation, the ocean was clear. If there were any threatening creatures in the waters below, I would have been able to see them. Thankfully, I saw nothing more

than a few small fish darting about and, every once in a while, a small jellyfish floating by.

A few days into our vacation, however, a hurricane hovering off the coast of Florida began to stir up the once clear and turquoise waters, creating rough and cloudy conditions.

I must admit that swimming in the ocean when I couldn't see what was lurking beneath was a bit more intimidating. I enjoyed the ocean a whole lot more when I could see what was all around me.

Whether we swim in the ocean or walk with God, we must accept the fact that we are not always going to have a clear line of vision.

"For we live by faith, not by sight" (2 Corinthians 5:7).

"Now faith is confidence in what we hope for and assurance about what we do not see. This is what the ancients were commended for" (Hebrews 11:1-2).

Sometimes God allows us to clearly see the things that He's doing in our lives, especially when we are newer Christians. But as we grow in our relationship with Jesus (at least this has been my experience), God more often asks us to walk by faith, not by sight.

Thankfully, it becomes a little less intimidating to charge forth blindly when we have walked with God a long time, simply because we can draw upon past experiences and be encouraged in knowing that God is faithful. He is watching out for us, and His vision is far better than 20/20. He not only sees the here and now, but God sees the outcome for the future as well. I don't know about you, but that brings me great comfort.

"And we know that in all things God works for the good of those who love him, who have been called according to his purpose" (Romans 8:28).

Does it seem like you're swimming in an ocean of uncertainty? Are you afraid to wade into deeper water, convinced that it's unsafe?

Take courage! God will never ask you to step out in faith alone. He is always by your side. And, just remember, any menacing creatures lurking about are no match for the Almighty!

"Ah, Sovereign Lord, you have made the heavens and the earth by your great power and outstretched arm. Nothing is too hard for you" (Jeremiah 32:17).

Pray for God's direction, wait for affirmation (often given through God's Word), and then take the plunge and trust His higher ways.

"'For my thoughts are not your thoughts, neither are your ways my ways," declares the Lord. 'As the heavens are higher than the earth, so are my ways higher than your ways and my thoughts than your thoughts'" (Isaiah 55:8-9).

~Rae Lynn DeAngelis

Risky Business

"To be or not to be... *That is the question!"*
This simple, yet, thought-provoking question can be applied to so many dilemmas of life:

- To be or not to be in a relationship
- To be or not to be in a new job
- To be or not to be in treatment
- To be or not to be a parent
- To be or not to be in college

And then there this one... To be or not to be KNOWN.

I believe this is one of the deepest desires of the human heart, to be known, to be understood. But here's the thing, to be known is risky business. Once people get to know the real us, they could reject us, or even worse, abandon us. If we allow others to see the real us, they might run for the hills and never look back.

Not long ago, I exposed some of my deepest fears and doubts with my ministry team concerning my ability to continue leading Living in Truth Ministries. I was feeling exhausted and wondered if it was time for me to close up shop.

Fully exposing myself in this way was risky. What if my team rejected me for having such thoughts? What if they abandoned me? Perhaps they would even validate my thoughts and feelings, agreeing that I really *don't* have what it takes to be a good leader.

During the days up to my confession, the enemy whispered in my ear that my team would think I was weak and incapable. But that's not what happened at all. In fact, when I exposed my deepest fears and insecurities to my team, they said they respected me all the more because it made me more relatable.

We all have fears and insecurities. But when we go around acting like we have it together we place unrealistic expectations on everyone around us. They think we are something we are not. We need to be open and real with people. We need to expose the real us if we truly want to be known.

Sweet Sisters, it's not only okay to be known, it is an absolute necessity for our overall health mentally, emotionally, spiritually, and even physically. It's downright stressful, keeping up the façade that we have it all together. Guess what? When we remove our masks, the most wonderful thing happens. We give others permission to do the same.

God created us in His image. He wired us with a desire to be known by others much like He has a desire to be known by us.

"And we all, who with unveiled faces contemplate the Lord's glory, are being transformed into his image with ever-increasing glory, which comes from the Lord, who is the Spirit" (2 Corinthians 3:18).

"You will seek me and find me when you seek me with all your heart. I will be found by you," declares the Lord, "and will bring you back from captivity" (Jeremiah 29:13-14).

~Rae Lynn DeAngelis

Choose Which Way

The day begins as usual: that annoying sound persists until feet hit the floor; the mind remains dormant until a fabulous invention called coffee enters your system and the process begins to prepare for the day ahead. With everybody ready to go, you hit the door running.

The morning flies by, consumed with phone calls, errands, paperwork, emails, etc. Time arrives for a break. Back to work after enjoying a meal and some quiet time (yeah right, what is that?). THEN, it happens. . .

You know, the moment that has transformed the day into a terrible nightmare, a tragic, horrifying, very bad, no good moment that leaves an indelible mark in your thoughts. It changes the anatomical structure of your body by transplanting the heart into the pit of the stomach. It could be a mistake made, phone call received, health concern exacerbated, or another event marking tragedy in your story.

The moment already occurred and no eraser exists big enough to clear the page of this written story. The more our thoughts dwell on the moment, the worse it seems and the more anxiety develops. Anxiety begins driving the rest of our day, leading to possibly more mistakes, diminished attitudes, shame, guilt, and an open door for the enemy to come and steal any positive left to the day.

The further removed from that moment, the clearer life appears. We stand at the fork in the road and have an important decision: step right – hold God's hand to heal from such a moment, or step left – allow the enemy to finish the story.

Stepping right allows God to hold our hand and begin the process of healing. He helps us take every thought captive and replace it with His truth. Dwelling on the mistake, tragedy, or

event only deepens the wound. Healing occurs when proper ointment is applied to the wound. He holds the truth to heal any and every wound.

Stepping left allows the enemy to set up shop. Worry is the brick and mortar. Negative emotions or words become graffiti on the wall of our heart, and into the pit we fall. These moments create an open wound with no healing in sight.

God waits patiently with open arms. Take a moment, send up a word of surrender and lay it down at the foot of the cross. The situation will be too much for us to face ALONE. Only through Him will our mistakes transform into knowledge, tragedies into strength, illnesses into deeper faith, and experiences into closer relationships with our Father. Which way will you choose?

~Sheree Craig

Eminent Peril

I was swimming in the ocean with my niece and sister-in-law, riding bigger than usual waves caused by hurricane Arthur. Although the tropical storm waited offshore, it still caused choppy conditions up and down the coastline. Some of the waves became so strong that they nearly knocked us off our feet.

When I heard the shrill sound of the lifeguard's whistle and saw him waving his flag, I was on high alert. I called out to my sister-in-law. "Do you think they spotted a shark or something?" She seemed unconcerned, but I wasn't taking any chances. I looked towards the shoreline to get my bearings and noticed we were no longer parallel with our beach umbrella and chairs. In fact, we had drifted a good distance away from them.

Heading back to shore, a strong current kept pulling me sideways. It really made my progress towards shore difficult.

When I finally made it back to ankle deep water, I noticed the lifeguard swimming towards our direction. My niece shouted, "Mom, get out of the way! The lifeguard is trying to save someone!"

Little did she know that the lifeguard was there to save them.

We later learned that my sister-in-law and niece had been caught in a riptide and didn't even realize it. That was why it was so difficult for me to reach shore. After they had been pulled to safety, the lifeguard explained how he was able to tell they were in trouble because of the movement of the waves. If he had not come to their aid, they would have likely been pulled further and further out to sea.

Sometimes life's challenges cause us to drift further and further from God's original plan for our lives. Blinded by uncertainty or indecision, we may not even realize our condition until it's too late. And because we are oblivious to our perilous state, we end up ignoring the life-saving measures God keeps throwing our way.

Are you struggling to see God is in the midst of your circumstance? Do you doubt whether He sees or even cares what happens to you?

I can promise you this: "The Lord is close to the brokenhearted and saves those who are crushed in spirit" (Psalm 34:18).

Reach out for God's hand, accept His help, and cling to His promises. He will keep your head above water until you're safely back on solid ground.

"Do not fear, for I have redeemed you; I have summoned you by name; you are mine. When you pass through the waters, I will be with you; and when you pass through the rivers, they will not sweep over you" (Isaiah 43:1-2).

"He lifted me out of the slimy pit, out of the mud and mire; he set my feet on a rock and gave me a firm place to stand" (Psalm 40:2).

"[Jesus] got up, rebuked the wind and said to the waves, "Quiet! Be still!" Then the wind died down and it was completely calm" (Mark 4:39).

~Rae Lynn DeAngelis

Comfort, Control, Comparison

"The devil prowls around like a roaring lion looking for someone to devour" (1 Peter 5:8), but he's not very creative with his tactics of deception. As a matter of fact, his temptations pretty much all fall under one of three categories: *Comfort, Control, or Comparison.* Name a temptation and I bet you could place it under the umbrella of one of these Cs. Although we are susceptible to all three of these Cs most of us tend to be more vulnerable in one area over the others.

They say ignorance is bliss; but not in this case. Friends, we need to be self-aware when it comes to our personal areas of weakness. The enemy has been watching us a very long time. He knows our area of weakness and sets traps for us all day long. Awareness is the first step to warding off the enemy's incoming attacks.

For me personally, I've come to realize that *comfort* is a pretty big factor when making day to day decisions. Here are just a few of the ways I see comfort playing a big role in my life:

- *Physical pain?* Get rid of it.
- *Emotional pain?* Numb it.
- *Exercise?* Ugh! So many reasons to avoid it! Too hot, too cold, out of breath, sore muscles, sweat
- *Hunger?* My pantry and refrigerator are overflowing. You never know when a famine might hit.
- *Sleep?* Four mattresses in 16 years. *Need I say more?*

- I'm an introvert by nature, but when I'm in a situation where I have to be an extrovert (leading, speaking, socializing) I feel exhausted.
- I steer clear of conflict whenever possible.
- I don't like it when my schedule is too busy because I need time alone to process.

I could go on and on, but I think you get the picture. These tendencies are not sin in-and-of themselves, but you could see how the enemy might try to use my areas of weakness to tempt me into sin. For example:

- Trying to relieve pain could lead to addiction.
- Avoiding exercise could lead to laziness.
- Stock piling food could lead to waste.
- Dodging conflict could lead to unforgiveness.
- Seeking alone time could lead to selfishness.

"Watch and pray so that you will not fall into temptation. The spirit is willing, but the flesh is weak" (Matthew 26:41).

Ever since I came to the realization that comfort is my biggest area of weakness, I try to consciously lean into <u>dis</u>comfort. When I do, the enemy's deceptions and temptations are less effective. I have also found that my greatest comfort comes through my time alone with God. My daily time with Jesus is absolutely critical to my overall health.

I'm a work in progress. Sometimes I get it right. Sometimes I don't. The human will does not die easily, but I believe we are called as Christians to die to self and live for Christ. "For me, to live is Christ and to die is gain" (Philippians 1:21).

Progress not perfection. It's a day-to-day battle to overcome areas of weakness, but we are not in this battle alone. God is with us every step of the way.

~Rae Lynn DeAngelis

Through the Storm

Do you ever wish God would just "air lift" you out of your current distress?

Sometimes God delivers you out of the storm. Other times, He delivers you *through* the storm.

"Into your hands I commit my spirit; deliver me, Lord, my faithful God" (Psalm 31:5).

So many times, we pray for God to swiftly lift us out of trials and tribulations. (No one wants to experience pain.)

In situations like this, I've learned that God is love. His will is what's best for us, which often includes experiencing the turbulence and raging winds of life.

God uses our time in the storm to grow and mature us in faith, to bring fierce lighting to those areas of unbelief. He grows our understanding of who He is and how He works.

His Word, the Holy Spirit, is our lighthouse in these storms. It is the light that guides us each leg of the journey. In order to see the light through your present storm, you must be ever so watchful. Trials and tribulations are exhausting and painful; but you must remain awake.

"Be on guard! Be alert! You do not know when that time will come" (Mark 13:33).

Do not hide in isolation and depression. God wants to teach you, grow you, and use you to guide others as they experience similar storms. As they see your faith at work their faith will grow just by seeing God working in and through you.

God wants to mature us to be captains who keep our eyes on Him and obey Him. Others are watching to see if your ship fares through life's rolling waves, high winds, fierce lightning, and never-ceasing rain.

Keep your eye on God and follow His leading. He is the Master of the wind on life's troubled sea. He may not deliver you out of the storm, but rest assured, He will deliver you through it to still waters of refreshment.

"In this world you will have trouble. But take heart! I have overcome the world" (John 16:33).

Just as God delivered Noah and company through the worldwide flood, His promises stand true forever. One man believed God, and the one true living God delivered man. God gave a sign to all mankind that He would never again destroy all living things by a worldwide flood.

"Whenever I bring clouds over the earth and the rainbow appears in the clouds, I will remember my covenant between me and you…" (Genesis 9:14-15).

A rainbow is waiting for the faithful and courageous!

"[Jesus] replied, "You of little faith, why are you so afraid?" Then he got up and rebuked the winds and the waves, and it was completely calm" (Matthew 8:26).

~Rhonda Stinson

Getting Uncomfortable

Before we left on our trip to New Smyrna Beach (NSB), my husband Gerry had to remind the communion coordinator that he was not going to be there for the next two Sundays to serve. One of the guys on the serve team overheard the conversation and mentioned his family was going to be on vacation during that same time. They were going to Orlando, Florida for the first part of the week, but then wanted to spend a couple of days at a nearby beach. Gerry recommended New

Smyrna Beach and even suggested that we get together with them at some point if they ended up there.

You have to know something about my husband. He is one of the friendliest guys you will ever meet. The word stranger is not part of his vocabulary. My personality is quiet and reserved. Gerry is the complete opposite. He will start up a conversation with anyone. *And I do mean anyone.*

When Gerry began to explain how Steve and his family (who I didn't know at all) were coming to NSB to spend some time with us, my stomach started churning. Sharing part of our vacation with complete strangers was way out of my comfort zone!

I knew Gerry was doing the right thing by inviting them to spend time with us, but because I'm an introvert, I was very nervous about the whole thing. Anxious thoughts kept floating around in my mind. What if his wife and I don't click? What if our time together is awkward? After all, they were a family of six, but it was just Gerry and me.

As the day drew closer, I became more and more anxious but didn't share my feelings with anyone. Like I said before, deep down I knew my husband was doing the right thing; I just needed to get over it. So, I did what I always do when I'm stressed about something. I went to God and asked Him to calm my fears and give me courage to step out of my comfort zone.

"Fear of man will prove to be a snare, but whoever trusts in the Lord is kept safe" (Proverbs 29:25).

Although I had originally dreaded the whole experience, I was pleasantly surprised by the outcome. Not a single one of my fears had materialized. Steve's wife was a sweetheart, very friendly, and their kids were a joy to be around, a true blessing. We never felt like a fifth wheel. In fact, we had a great time and grew very fond of their family.

Afterwards, I shared with Gerry how grateful I was for the time we had spent with our newfound friends. I also confessed the feelings I had about the situation beforehand. My husband wasn't the least bit surprised by my admission. After thirty-plus years of marriage, he knows me pretty well. But he was glad to know that I didn't allow fear to immobilize me to the point of missing out on a great time.

This experience was yet another reminder to me that I need to step out of my comfort zone more often. Getting uncomfortable almost always brings about positive growth.

"For I am the Lord your God who takes hold of your right hand and says to you, 'Do not fear; I will help you'" (Isaiah 41:13).

~Rae Lynn DeAngelis

The Swinging Pendulum

"Woah! What's this?" I asked my friend upon entering her dad's home office. I carefully leaned over to get a closer look but hadn't a clue as to what it was. The room was filled with all kinds of modern artifacts. This was just one of them.

"It's a pendulum," my friend offered matter-of-factly. "It's really cool! Here, let me show you." She lifted one of the weighted spheres hanging by thin wire, and let it go. As the ball swung back down and smacked into the others, something strange happened. The center spheres remained motionless while the spheres on the opposite sides swung out with great force. This back-and-forth motion repeated for some time until it finally slowed and came to a stop. My mind was sufficiently blown. This was the coolest thing my seven-year-old eyes had ever seen.

When I got a bit older, I learned that this particular type of pendulum is called Newton's Cradle. It is propelled by kinetic energy and momentum. Because the spheres in the center of the pendulum are so close to each other, the kinetic energy flows through them, but it doesn't move them.

During a recent conversation with a friend, I was reminded of that pendulum. She talked about how before she became a

Christian, she lived one way, but after she became a Christian, she lived a completely different way. (Nothing wrong with that, right? We should be living differently after becoming Christians.)

But for her it was not just different. It was like she had swung too far in the other direction and was burdened by all the religious dos and don'ts. Some of which had no scriptural basis.

Sweet sisters, God gave us His Word (the Bible) so that we could know the truth. Truth that is meant to set us free—not put us in further bondage. "Jesus said, 'If you hold to my teaching, you are really my disciples. Then you will know the truth, and the truth will set you free'" (John 8:31-32).

Jesus condemned the Pharisees, on more than one occasion, for putting heavy yokes of religious rules onto His people. "Jesus replied, 'And you experts in the law, woe to you, because you load people down with burdens they can hardly carry, and you yourselves will not lift one finger to help them'" (Luke 11:46).

Jesus teaches us through His Word that it's not about following rules. It's about following Him. The Lord doesn't want us to be like a pendulum, swinging back and forth from one extreme to the next. He wants us to trust in His promises and come to a place of peace and rest through following Him.

"Come to me, all you who are weary and burdened, and I will give you rest. Take my yoke upon you and learn from me, for I am gentle and humble in heart, and you will find rest for your souls" (Matthew 11:28-29).

So, how do we get there—to that place of peace and rest?

Remember the spheres in the center of the pendulum? Because they were so close together, they were not swayed by the outside forces coming against them.

The same is true for us. We need to link arms with Christians that are steadfast in their faith.

Friends, the forces coming against us have never been more intense, but we don't have to be moved by them. Link arms with other Christians while standing firm and strong on biblical truth.

"Take up your positions; stand firm... Do not be afraid; do not be discouraged. Go out to face them tomorrow, and the Lord will be with you" (2 Chronicles 20:17).

~Rae Lynn DeAngelis

Shut it Down

I was on my way to the funeral of a dear, sweet lifelong friend who had passed away too soon. I had an overwhelming sense of anxiety, unsettledness, and fear. And something else I couldn't quite put my finger on.

I hadn't seen her family in 20 years. I was honored to be invited to the funeral and knew that I needed to go. I wanted to go but knew it would be awkward. What funeral isn't?

She was 40, so young. It was sudden too. She was getting better, recovering from a surgery that had gone bad. We all thought she was out of the woods, but the day before Valentine's Day, her heart had had enough. It gave out.

Bravely and prayerfully, I asked the Lord to use me how He wanted. Perhaps I could be His Light to her family, reminding them of what she said about them, sharing memories of our times together with her young sons, and reflecting on the beautiful person she had been to me. She was someone who forgave quickly, never judged, and welcomed everyone just as they were. She had enough love for everyone to go around.

After the funeral, as I was driving home (3 hours), I realized what was bothering me. I was giving a little voice named Shame space in my head. This voice was whispering that I wasn't a good enough friend, if I had just shown up a little more, if I had just... fill in the blank. When I finally recognized the voice, it was clear that I had to SHUT IT DOWN, speak truth, and put it in its place. I could have let this paralyze me, keep me from going to the funeral, keep me from showing up and sharing her story, keep me from all the things she wanted me to say to her loved ones, keep me from being the Light Jesus wanted me to be. But thankfully, I didn't.

How many times do we allow shame to dominate us and scare us into not showing up for the important things? I love being able to see it and stop its destruction in my life. You can do the same.

I had opened my Bible a few days after she had passed and this Scripture came to my attention.

> I waited and waited and waited some more, patiently, knowing God would come through for me. Then, at last, he bent down and listened to my cry. He stooped down to lift me out of danger from the desolate pit I was in, out of the muddy mess I had fallen into. Now he's lifted me up into a firm, secure place and steadied me while I walk along his ascending path (Psalms 40: 1-2 TPT).

It was one of those times you read it, and think, "This is the answer I was looking for."

Maybe this had been her cry. She was firm in her faith, secure now in the arms of Jesus. I longed for my friend to be here, to text, to talk and laugh with again. But I was also reassured she was with God and ok.

I then remembered it on my drive home. I waited for the Lord in my shame, my desolate pit, and He came through, stooped down, and put me in a firm, secure place. That is Love. God is good.

If you are stuck in some shame or in a waiting period for God to come through for you, read through that verse above and make it your truth. He will lift you to a firm and secure place. He will steady you on the path you walk on. Trust HIM.

~Alison Feinauer

Moving Day

It's funny how certain memories stick out in your mind. I remember, when I was three years old, climbing into my parent's bed in the morning after my brother and sister had left for school. Mom would invite me to nestle into the curve of her body so we could snuggle. The faint smell of my dad's aftershave on the pillow and the rhythmic sound of mom's breathing would sometimes lull me back to sleep. (Being the youngest in our family had its advantages. I treasured moments when I had Mom all to myself.)

Once I knew mom was fully awake, I would ask her to tell me, once again, about the new house we were getting ready to move into. Mom grabbed the picture from her nightstand drawer and began pointing to different rooms like the bedroom my sister and I would share. Mom talked about every part of the house and described it in detail. I loved getting a visual in my mind of the place where we would live out the next chapter of our lives, but my imagination was limited. And because of my limited understanding, I wasn't able to fully appreciate what our new home had to offer until we had moved in and I was finally able to see it in person.

You and I can read about heaven and imagine what it will be like. We can even gather stories of those who claim to have been to heaven. But we will never fully appreciate our eternal home with Jesus until we are there to see it for ourselves. Our human mind cannot conceive what God has prepared for those who love Him. *I don't know about you, but I can't wait!*

> Do not let your hearts be troubled. You believe in God; believe also in me. My Father's house has many

rooms; if that were not so, would I have told you that I am going there to prepare a place for you? And if I go and prepare a place for you, I will come back and take you to be with me that you also may be where I am (John 14:1-3).

I saw the Holy City, the new Jerusalem, coming down out of heaven from God, prepared as a bride beautifully dressed for her husband (Revelation 21:2).

It shone with the glory of God, and its brilliance was like that of a very precious jewel, like a jasper, clear as crystal. It had a great, high wall with twelve gates, and with twelve angels at the gates (Revelation 21:11-12).

The foundations of the city walls were decorated with every kind of precious stone. The first foundation was jasper, the second sapphire, the third agate, the fourth emerald, the fifth onyx, the sixth ruby, the seventh chrysolite, the eighth beryl, the ninth topaz, the tenth turquoise, the eleventh jacinth, and the twelfth amethyst. The twelve gates were twelve pearls, each gate made of a single pearl. The great street of the city was of gold, as pure as transparent glass (Revelation 21:19-21).

Then the angel showed me the river of the water of life, as clear as crystal, flowing from the throne of God and of the Lamb down the middle of the great street of the city. On each side of the river stood the tree of life, bearing twelve crops of fruit, yielding its fruit every month. And the leaves of the tree are for the healing of the nations. No longer will there be any curse. The throne of God and of the Lamb will be in the city, and his servants will serve him. They will see his face, and his name will be on their foreheads. There will be no more night. They will not need the light of a lamp or the light of the sun, for the Lord

God will give them light. And they will reign for ever and ever (Revelation 22:1-5).

~Rae Lynn DeAngelis

The Journey—Not the Destination

I t was the perfect day with clear blue skies, low humidity and temperatures hovering in the mid-seventies, the kind of day that channels your inner child to come out and play. My husband and I called another couple and asked if they would like to join us for an impromptu bike ride along the river near our home. I was delighted when they said yes.

We live in a quaint little town called Lawrenceburg, IN. Over the years, the city has done a great job of revamping old buildings and sprucing up the streets, making it more family friendly. They even added a beautiful bike path which meanders along the Ohio River to the next town.

Our friends met us at the bike rental area by the levy, and within minutes we were on our way. Lori and I pedaled at a more leisurely pace, taking in our beautiful surroundings. The river to our left glistened with flecks of light that sparkled like diamonds. As we coasted down a small hill, the bikes picked up speed. The cool breeze felt good against my skin. I felt so free. At one point, there was a tree lined area which canopied the path like a tunnel. The smell of earth and forest reminded me of my youth and the many summers spent building forts in the woods with my friends.

Each one of my senses was awakened; I felt so alive. But then we suddenly realized how far we had lagged behind our husbands.

In fact, they were so far up ahead of us, we could barely see them. Bill and Gerry were on a mission—a mission to reach a destination. Lori and I (on the other hand) were savoring every moment of our enchanting journey. I thought to myself... *What's the rush, guys?*

Almost immediately God spoke to my heart... *Yes, Rae Lynn, what's the rush?*

For several months I had been running hard and fast where the ministry was concerned. I could see the destination up ahead and felt pressured to get where I thought God was taking me as fast as I could. The pace was making me weary. I felt miserable, and my passion was beginning to wane. At times, I even felt like I should give up and close down the ministry.

God has a way of teaching me deep spiritual lessons through ordinary life experiences. This time God taught me through our fun-filled day with our treasured friends, riding along a bike path.

I sensed God whispering to my spirit that day... *Rae Lynn, you will enjoy life a lot more if you slow down and embrace the beauty that I have for you along the way. I'm much more interested in growing you than having you arrive at a particular destination.*

Not long after this timely object lesson, I began slowing things down where the ministry was concerned. I started striding instead of striving—taking long decisive steps in a specific direction. I was beginning to feel a sense of peace.

"Her ways are pleasant ways, and all her paths are peace. She is a tree of life to those who take hold of her; those who hold her fast will be blessed" (Proverbs 3:17-18).

Today I am walking at a much slower pace. I call it the pace of God's grace. Whether it's here and now or there and then, God has made it abundantly clear. *It's about the journey, not the destination.*

"He makes me lie down in green pastures, he leads me beside quiet waters, he refreshes my soul. He guides me along the right paths for his name's sake" (Psalm 23:2-3).

~Rae Lynn DeAngelis

Choose More Fruit

Fruit helps us more than we realize. Fruit is rich in vitamin C which is important in the growth and repair of body tissues, especially collagen since it plays a key role in collagen formation. Collagen is not only the most plentiful protein in your body, it is also a major component of connective tissue from tendons and ligaments to skin and muscles. Want your skin to look its best? Healthy collagen helps that happen, and vitamin C is vital to its creation. In its natural form, fruit is low in fat, sodium, and calories and absent of cholesterol. This allows us to enjoy it with limited worry about worsening health conditions. At the same time, it is rich in potassium, dietary fiber, and folate. Each of these protect different parts of the body and aid in proper bodily function.

So, what about other types of fruit? What about the fruits of the Spirit and their impact on our emotional well-being? Ever given much thought to their upward, outward, and inward qualities? In Galatians 5:22-23, Paul lists nine important fruits the Holy Spirit produces in each believer. *"But the fruit of the Spirit is love, joy, peace, forbearance, kindness, goodness, faithfulness, gentleness and self-control. Against such things there is no law."*

Let's take a look at each of the key "nutrients" for these fruits a little closer.

Love is declared in 1 Corinthians 13:13 to be the greatest of all virtues. It is essential and must be put into practice in everything we do regardless of how others are acting and behaving. It is a primary characteristic that identifies a follower of Christ. Love is also the tree from which all other fruit are produced.

Joy is a deep-rooted happiness regardless of what is going on around us. It can be hard to explain the feeling of true joy to others since it is different from happiness. Being happy is based on circumstances while joy is an expression of God's goodness and grace. It is a peace that passes all understanding that grows from love.

Peace is described in Philippians 4:7 as that which transcends all understanding and will guard our hearts and minds. Much like joy, this feeling can be difficult to explain especially during difficult and uncertain times. When harmony and calm exist in chaos and divided factions, that is peace.

Forbearance is also known as patience. We need the ability to show restraint and tolerance today more than ever. We need to hold our tongues, scroll past hateful posts on social media, or offer a smile at unkind words. It is a quiet willingness to accept and persevere in difficult situations.

Kindness is an ability to be friendly, generous, and considerate toward others especially when they are not offering the same to us. It is a selfless expression of compassion and mercy to everyone regardless of who they are, what they believe, or how they act.

Goodness is having an upright heart and life of moral excellence. It is living in obedience to God's commands and seeking the good for others over ourselves.

Faithfulness is being unswerving, unchanging, dedicated, and trustworthy regardless of the whims of society. Being steadfast and loyal to the word of God in all seasons.

Gentleness is also known as meekness or the ability to control responses and reactions to difficult people and situations. It isn't being weak but rather having an inner strength through a clear mind with response counter to expectation.

Self-control is an expressed ability to say no to self through restraint and self-denial of inappropriate passions and appetites. It is living to please God instead of the desires of self.

You can see why the "nutrients" in this fruit are so critical for our emotional health. Love, joy, and peace provide upward qualities from above and are not things we can work harder at creating by ourselves. Forbearance, kindness, and goodness are outward qualities that are easily seen by others. Faithfulness,

gentleness, and self-control are inward qualities we must draw on to live and love as Christ in any and every situation.

We all need to regularly choose more fruit to improve our physical and emotional health and well-being.

~Tanya Jolliffe

Cost of Convenience

My how everyday life has changed! Years ago, if you needed a new pair of shoes, you called a friend and headed to the nearest shopping mall. If you needed to deposit or withdraw money, you hopped in your car, stood in line at the bank, and waited for the next available teller. Today, via the Internet, we can shop our favorite store and pay bills without ever leaving the house. We can even get a diploma online! In fact, just about everything is available through the click of a computer mouse.

These so-called 'conveniences' are supposed free-up time and make life simpler and more efficient. But has life really become more simplified? Do we really have more free time? Recent studies reveal that our lives are busier and more stressful than ever before. And our hectic, stress-filled schedules are not the only problem. Many express feelings of loneliness.

Is it any wonder?

These convenience options that were originally designed to make life easier, oftentimes, remove human interaction from the equation. We pay at the pump, order online, and communicate by text message. In the face of advanced technology, our human connection is diminished. We have less opportunity to smile, say hello, and ask how someone is doing. And the increasingly rare

occasion when we do ask someone how they're doing, we seldom stop long enough to hear their reply.

God created us in His image, in His likeness (Genesis 1:28). Part of that likeness is our desire for relationship. I believe this is one of the reasons God created man—to satisfy his deep desire for fellowship. "The Lord God said, "It is not good for the man to be alone" (Genesis 2:18).

Our basic need for companionship and human touch has been wired into our DNA. Children who are raised in orphanages with limited human touch and stimulation are much more likely to develop a serious, and sometimes life-threatening, condition called "failure to thrive." In essence they lose their will to live.

Adults might be able to survive in a bustling metropolis for weeks on end without human interaction, but we would be doing just that—surviving—not truly living. Before long, depression and despair would set in.

Of course, not all loneliness is a consequence of convenience. But I certainly believe it plays a role.

Don't ignore your basic need for connection. In light of our cultures trend towards solitude, when possible, let's forego convenience and comfort to nurture the God-given need we have to interact with others, face to face and heart to heart.

To be continued...

~Rae Lynn DeAngelis

Feeling Disconnected

I n my last post I talked about the pandemic of loneliness infiltrating our society and how, to some degree, our quest for convenience has been aiding this problem. Just because our world is changing doesn't mean our basic need for human

interaction has to be kicked to the curb in the face of progress. If we are not careful, we just might cultivate a society that's emotionally, spiritually, and relationally desolate. Some may say we are already there.

I don't profess to have all the answers. I'm just someone who's feeling lonelier by the minute and decided to investigate what might be contributing to my deficit.

Some parts of my life create solitude, and I have little control over the fact. For example, my husband travels for his job and can be gone for days at a time. With our kids grown and out of the house, the emptiness in my spirit each time Gerry gets on a plane is even more obvious. Managing a non-profit organization requires me to spend many hours in solitude, which doesn't help my situation. I have a many close friends but still feel sad and disconnected.

I start each morning with God, so it's not a lack of connection with Him that's making me lonely. He is always with me. I wholeheartedly believe that. "The Lord himself goes before you and will be with you; he will never leave you nor forsake you" (Deuteronomy 31:8). I'm not feeling disconnected from God; I'm feeling disconnected from people. "The Lord God said, "It is not good for the man to be alone" (Genesis 2:18). God created us. He understands our need for human connection.

Some may say we are more connected than ever with the invention of things like cell phones and social media, but are we? No matter how many parentheses you put around a cyber-hug (((((hug))))), it's still just a word typed across a computer screen. No matter how lovingly we try to construct a sentence with just the right sentiment or emotion, written words will never completely fill the deficit in our soul.

God created us to need physical touch and face to face communication. We need spoken words accompanied by body language, physical touch, or a warm embrace. Counterfeit replacements might pacify us for a while, but eventually we all feel the void.

Although loneliness has reached epidemic proportions in our culture, the cure is easier than we might think. We simply need to make a conscious effort to spend more 'facetime' with our friends over a cup of coffee, sharing a meal, or taking a walk together.

Let's be more proactive about getting together in a literal sense, scheduling times of rich fellowship, laughter, sharing a hug, or wiping away tears. Doing life together, not apart.

It's not necessary to shut down our social media accounts. But perhaps we could all benefit from spending a little less time with the counterfeit so we have more time for the real thing.

"Two are better than one, because they have a good return for their labor: If either of them falls down, one can help the other up. But pity anyone who falls and has no one to help them up" (Ecclesiastes 4:9-10).

~Rae Lynn DeAngelis

Going Without the Mask

I have never been able to go out of the house without makeup. It is definitely a rarity in my world. Many of us use foundation, eyeliner, mascara, and lipstick as a mask to hide what we really look like.

One morning while I was getting ready for work, the Lord placed it on my heart to trust Him and go in without the mask, to go in just the way He made me. He wanted to show me something, and that is exactly what He did.

I fought it at first. I wanted nothing more than to put on the foundation, eyeliner, and mascara, turn out the bathroom light and drive on into work. Nope, the Lord brought me to my knees that morning. He wanted me to see me through His eyes. He wanted me to find my beauty from within, and not worry how I looked on the outside.

So, what happened next you may ask?

He won. He always wins. I dried my hair and didn't even straighten it, got dressed, and went to work.

I saw things differently that day. I can't say it was easy. I have a mirror by my desk. Every time I got up, I would see myself and remember, oh yeah, no mask today. Then I got a little nudge. "What does it matter what they think? I made you just the way you are, and I think you are beautiful."

1 Peter 3:3-4 says, "Your beauty should not come from outward adornment, such as elaborate hairstyles, and wearing of gold jewelry or fine clothes. Rather, it should be that of your inner self, the unfading beauty of a gentle and quiet spirit, which is of great worth in God's sight." Nowhere in that passage does it say you must have a pretty face or the perfect body before God will love you. Rather, it says a gentle and quiet spirit is of great worth in God's eyes. That puts a big smile on my face and lights up those big brown eyes He gave me.

Can I be honest with you ladies? Before COVID-19, I never really had to do a Zoom meeting or facetime or any other virtual meeting for that matter. I am old fashioned in the sense of I would much rather meet in person rather than over a screen. So, meeting via a screen was hard for me. I would be looking at myself on that small screen and thinking, eww, your hair isn't right, your face is too fat, the whole time trying to move the camera to make a better picture.

That is not what the Lord wants us to do. He wants us to find our beauty from within and know that He made us just the way we are. We need to embrace it instead of hiding from it. The Lord loves each and every one of us so much more than we can imagine. He wants us to see through His eyes. Each time I would look in the mirror and try and put myself down, it didn't work. I would then remember whose I was, and it didn't matter what anyone else thought, not even me, because the one who created me thinks I am beautiful.

One of my favorite songs right now is *Scars to Your Beautiful* by Love & the Outcome. The chorus is this, "There's a hope that's waiting for you in the dark. You should know you're beautiful just the way you are. You don't have to change a thing. The world can change its heart." That is so refreshing to me. We don't have to change a thing. He loves us just the way we are. He sculpted us. He knew what we would look like and when we would have pimples on our chins that we can't seem to leave alone. He knew

it all. He knew you would be sitting here right now, reading this and hearing how beautiful you are. Not because you say so.... But because He does.

I was reading Proverbs 31, and I wanted to go more in depth with the passage. I began to read the cliff notes. They made a very good point. One thing that is so amazing about Proverbs 31 is how the author portrays an amazing woman, wife, and mother. Nowhere in the passage does it say anything about her outward beauty. What it does say is this: "She is clothed with strength and dignity; she can laugh at the days to come. She speaks with wisdom, and faithful instruction is on her tongue. She watches over the affairs of her household and does not eat the bread of idleness. Her children arise and call her blessed; her husband also, and he praises her: Many women do noble things, but you surpass them all. Charm is deceptive, and BEAUTY IS FLEETING; but a woman who fears the LORD is to be praised" (Proverbs 31:25-31 emphasis added).

~Lindsey Jones

Warrior or Worrier

The temptation to worry threatens my peace of mind every day. When my husband leaves to get on a plane for work, the thought crosses my mind... *What if this is the last time I see him?* When our son and daughter graduated from college, I wondered... *What if they can't find a job in their field of study?* When our son-in-law asked for our daughter's hand in marriage, the thought crossed my mind... *Will he love and cherish our baby girl as much us?*

What about you? What causes anxious thoughts to surface in your mind? Your spouse? Your children? Your job, health,

finances, or something else? Maybe it's an uncertain future that keeps you up at night.

Regardless of what triggers your unrest, God offers a perfect antidote for that which interrupts your peaceful rest—prayer. Instead of being worriers, God calls us to be warriors—the kind who fight on bended knee. "Do not be anxious about anything, but in every situation, by prayer and petition, with thanksgiving, present your requests to God. And the peace of God, which transcends all understanding, will guard your hearts and your minds in Christ Jesus" (Philippians 4:6-7).

Like a soldier heading into battle, we must confront our anxious thoughts head on. Our arsenal looks very different from the world's. In humble submission, with our face to the ground, we must assume a posture of surrender, placing the battle into the capable hands of the Almighty. "You will not have to fight this battle. Take up your positions; stand firm and see the deliverance the Lord will give you, Judah and Jerusalem. Do not be afraid; do not be discouraged" (2 Chronicles 20:17).

List out each and every anxious thought that's been weighing you down and surrender them to Jesus. He knows exactly what you need. He is all-knowing, all-powerful, and ever-present.

> Therefore I tell you, do not worry about your life, what you will eat or drink; or about your body, what you will wear. Is not life more than food, and the body more than clothes? Look at the birds of the air; they do not sow or reap or store away in barns, and yet your Heavenly Father feeds them. Are you not much more valuable than they? Can any one of you by worrying add a single hour to your life (Matthew 6:25-27)?

Place your burdens upon His shoulders and you will find rest for your soul. Be a warrior, not a worrier.

~Rae Lynn DeAngelis

Move or be Moved

I have been doing intensive Bible study together for the past few years with a young a friend and sister-in-Christ. We simply pick a book of the Bible and start reading it verse by verse. Then we share our insight and inspiration through text messages. Most days we only read three or four verses at a time. Slowing things down makes the Bible come to life all the more.

I've done a lot of Bible studies over the years and have learned from countless teachers, but taking time to hear from God, alone, has grown me in ways I never expected. It feels like I'm putting together a familiar puzzle but the picture God reveals is even more beautiful than before.

When we seek God with all our heart, He meets us where we are and tells us great and unsearchable things we do not know (Jeremiah 33:3). I often begin my time with God praying the following prayer, "Speak, Lord, for your servant is listening" (1 Samuel 3:9).

Recently our scripture focus took us to the story of the Tower of Babel. After the flood ended and Noah and his family left the ark, God told all of them to be fruitful, increase in number, and fill the earth. In other words, make babies, spread out, and make more babies.

Somewhere along the way, however, mankind dug their heels, gathered in a clump, and settled in one place. *Have you ever done that—settled?* I know that I have.

Not only did our early ancestors settle for far less than God's original plan, they also tried to make a name (and way) for themselves. "Come, let us build ourselves a city, with a tower that reaches to the heavens, so that we may make a name for ourselves;

otherwise, we will be scattered over the face of the whole earth" (Genesis 11:4).

Spoiler alert: *They didn't want to move, so God made changes so that they would have to move.* "'Come, let us go down and confuse their language so they will not understand each other.' So the Lord scattered them from there over all the earth, and they stopped building the city" (Genesis 11:7-8).

Move or be moved. Is there an area of your life where you've stopped moving forward? What's keeping you stuck in that place?

I recently read a Bible commentary with an interesting take on what may have motivated the people of Babel to build the tower in the first place. They speculated that perhaps the people of Babel did not believe God's promise to never again flood the earth; therefore, they took out a little insurance policy by building a waterproof tower for themselves. You know... *just in case God didn't come through on His promise.*

What about you? Which of God's promises are you struggling to fully believe and embrace? His provision? His protection? His peace? *Something else?* Could it be that you haven't moved forward because you're still trying to make a way for yourself... in case God doesn't fulfill His end of the deal?

Sweet sister, God is faithful. You can take His promises to the bank and trust Him with your life. He really does know what's best for you, so keep moving forward (baby steps if necessary), walking in obedience, and filling your spirit with His unchanging truths.

"In the same way, faith by itself, if it is not accompanied by action, is dead" (James 2:17).

~Rae Lynn DeAngelis

Attitude of Gratitude

Several years ago, shortly before Christmas, my mom had knee replacement surgery. She gave us money and asked us to go buy our presents and bring them to her to wrap with instructions to act surprised on Christmas.

One of the things I picked up was a set of 1800 thread count Egyptian cotton sheets. I didn't even know sheets were made with that high of a thread count!

Christmas evening, I washed and dried them. I wasn't about to sleep on my old sheets now that I'd waited and acted surprised! I slipped into bed that night and satin felt rough by comparison. As I lay there more comfortable than I could ever remember being in my life (the mattress has been purchased earlier that year too), it occurred to me that literally billions of people would never sleep as comfortable one night as I got to sleep every single night. And I cried.

I cried and apologized to God for every complaint I had ever leveled against my house or how much work it needed. It was mine. He gave it to me. And I was more comfortable every single day than billions of people would ever be for just one day. I felt like the most ungrateful child in the world. But that phase of my life was over right then and there.

Since then, I've trusted God with things that seemed insurmountable, and never once has He failed me. I have no reason to believe He ever will.

With a simple set of $20 sheets picked up on a whim, God taught me to be more grateful.

May we recognize all the gifts in life that money cannot buy and realize their true value.

"Give thanks to the Lord, for he is good, for his steadfast love endures forever. ... for his steadfast love endures forever (Psalm 136:1-3 ESV).

"The one who offers thanksgiving as his sacrifice glorifies me; to one who orders his way rightly I will show the salvation of God" (Psalm 50:23 ESV)!

"... give thanks in all circumstances; for this is the will of God in Christ Jesus for you" (1 Thessalonians 5:18 ESV).

~Melody Moore

Edge of Tomorrow

Have you seen the movie *Edge of Tomorrow*? Reminiscent of the movie *Groundhog Day*, the main character must repeat a particular day over and over until he is able to accomplish his mission to save the world from human extinction. It's a science fiction movie, so of course there's nothing terribly realistic about the storyline. However, the movie conveys a powerful message about learning from our errors, never giving up, and pressing on until we fulfill our life-purpose.

Every time the main character slips up, he dies and has to repeat the day all over again. By repeating the day over and over, he is able to learn from his mistakes and move closer towards accomplishing his goal.

I'm not going to lie. There are days that I would like to do-over. For example: when I lose my temper or say something I shouldn't, when I miss an opportunity to share God's love or to be a blessing to someone, when I fall into temptation and sadden God with my sinful choices. At the end of the day, I wish I could hit the rewind button of my life and give it another try.

While we can't rewind a bad day, I believe God does provide similar scenarios/opportunities so that we can apply past lessons to future tests. Like taking a college prep exam for a second time hoping to better our score, we can keep taking God's tests as long as we are willing to put forth the effort.

Sometimes we get it right. Sometimes we don't. But God doesn't give up on us. He is always patient. "The Lord is not slow in keeping his promise, as some understand slowness. Instead he is patient with you, not wanting anyone to perish, but everyone to come to repentance" (2 Peter 3:9).

Jeremiah 29:11 reminds us that God has a plan and purpose for our lives. He is on our side. He wants us to succeed. For this reason, God takes us through test after test, hoping we pass with flying colors.

Are you having feelings of déjà vu? Pay attention. Common scenarios that keep popping-up just might be God's way of giving you an opportunity to try again.

Remember, God works all things together for good—especially our bad day do-overs.

~Rae Lynn DeAngelis

Something We Get to Do!

I remember it so distinctly, my dangling legs swinging nervously from the church pew. The smell of recently lit candles wafted past my nostrils, a reminder that I was on holy ground. The magnificent sanctuary was nearly empty. My classmates were spread a good five feet apart, no doubt a barrier to keep us from needless chatter while we waited for our first confession—the sacrament of Penance.

I remember feeling very anxious. *What if I forget what to say?* Or worse yet, *what if I say something out of order?* I shuddered at the thought and rehearsed more vigorously what I was supposed to say... *Bless me, Father, for I have sinned. This is my first confession...*

The confessional door closed; the sound reverberated off the marble walls. Muffled voices followed. I secretly wished I could hear. When the door reopened, my classmate looked no worse for the wear. That was encouraging! Some confessions were quick. Some took a long time. Maybe some had more to confess than others, I reasoned.

Finally, it was my turn. I wanted to run out of the church and never look back, but I couldn't. I had to face my fear like everyone else. As I entered into the closet-like confessional, I noted an unexpected smell, a combination of musty wood and men's aftershave. I was thankful to see a privacy screen between myself and the priest. With my identity hidden, I sat down, swallowed hard, and began my rehearsed confession. I painted with broad strokes to ensure I covered all the bases. After all, seven years is a long time.

When I ran out of things to confess, I fell silent and waited for my penance. (Or as my mind processed it—punishment.) If memory serves me correctly, two Our Father's and three Hail Mary's were sufficient to wipe the slate clean. I went back to my seat, kneeled down, and began to pray.

Once back in the classroom, we compared our penalties. We decided more prayers equaled greater sin... *or at least that was our understanding of how it worked.* Forgiveness had to be earned, and prayer was the punishment, a mindset that took years to overcome.

It was not the church's intention to warp my perception of prayer, but it was the enemy's!

Why?

Prayer connects us to the Power Source. Prayer fills us with Peace. Prayer helps us walk in our Purpose. Here's the truth. Prayer is not something we have to do. It's something we get to do!

I didn't understand it as a child, but I know it now. Prayer following confession was not a form of punishment. It was a way to turn away from our sin and turn back to God.

Now prayer is a special time of intimacy with my Heavenly Father. It is the means through which I get to develop an abiding relationship with Jesus. No fancy words. I just talk to God like He's my best friend, because He is. And when I combine my words with God's Word in the Bible, my devotion time becomes even more meaningful. It has become one of my favorite ways to pray.

Lord, you are my all in all, my Rock and my Redeemer (Psalm 19:14). Before a word is on my tongue you know it completely (Psalm 139:4). Your love and forgiveness know no bounds (Romans 8:39). When I come before you in humble submission and confess my sin, no payment is required because you marked my debt paid in full (John 19:30). Search me, O God and know my heart; test me and know my anxious thoughts. See if there is any offensive way in my and lead me in your ways everlasting (Psalm 139:23). I can't get enough of you, Jesus. I am like a broken cistern that leaks. Pour into me each and every day. (Jeremiah 2:13) Give me an undivided heart, that I may fear your name (Psalm 86:11). I am yours, Lord, now and forever. Forgive me, renew me, and transform me. Thank you, Lord, for answered prayer.

~Rae Lynn DeAngelis

Lost Treasure

You know how it feels when you've lost something and you think it's gone forever?

About a year ago, I got my nose pierced and purchased a few little 14K diamond studs for it. On two different occasions, my shower towel got caught on it and pulled it out. I searched high and low for them but could not find them. I was bummed and frustrated. I thought maybe it was time for me to take my nose piercing out. I said to God, "If you don't want me to have this, let me know, and I'll give it up for you." I loved having it pierced but wondered if it was not what He wanted. I kept it in and moved on. I didn't feel that He was asking me to take it out at the time, but was glad that my heart had come to a place of surrender.

For two months after I lost my piercings, I went through a journey with the Lord of really surrendering. I felt desperate for something more and disappointed in myself for giving into temptations and trying to handle life on my own. I was trying to keep up the image that I had it altogether, but when I got alone, I was a huge pile of brokenness.

During this time, I thought maybe He had forgotten me, just like I had forgotten about losing my piercings. After my shower one morning, I looked down at the rug and saw a sparkle. I bent over and saw it, my diamond stud. I couldn't believe my eyes. I had combed through that rug and did not find it two months before. It appeared when I wasn't even looking. The next day in the shower, I looked down by the drain and found the other one. Three people had been showering in there for the past two months every day. I was blown away. Within a 24-hour period, I found both.

Crying, I felt the Lord say to me, "I'm giving you treasures. As you surrender, I have treasures I'm doing in you. You won't see them or understand them until you're ready:

- The treasure of understanding how much He loves me and that he has chosen me.

- The treasure that He was teaching me that He hadn't forgotten about me.

- The treasure that even in my struggles and suffering, He was present and refining me. (He often does things in the Physical to reflect what's happening in the Spiritual.)

He exposes treasures that He put in our souls when He formed us in our mothers' wombs, when we allow Him to comfort us, to be our strength when we're weak, to be our hiding place when we're afraid or ashamed. Our Father goes deep to the root of our hearts and does some refining and sometimes painful work, but then He exposes the beauty that He created inside us. Let Him. Let Him go there. He will redeem what we think is gone forever. His treasure is IN you!

Are you disappointed or feeling forgotten? Are things falling apart around you? Is there something you think is gone forever? Ask Him to remind you of the work He is doing. He will never leave you nor forsake you. You are His treasure, His chosen little one. "Be strong and courageous. Do not be afraid or terrified because of them, for the Lord your God goes with you; he will never leave you nor forsake you" (Deuteronomy 31:6). "The Lord will perfect that which concerns me; Your mercy, O Lord, endures forever; Do not forsake the works of Your hands" (Psalm 138:8).

> For God, who said, "Let light shine out of darkness," made his light shine in our hearts to give us the light of the knowledge of God's glory displayed in the face of Christ. But we have this treasure in jars of clay to show that this all-surpassing power is from God and not from us. We are hard pressed on every side, but not crushed; perplexed, but not in despair; persecuted,

but not abandoned; struck down, but not destroyed. We always carry around in our body the death of Jesus, so that the life of Jesus may also be revealed in our body. For we who are alive are always being given over to death for Jesus' sake, so that his life may also be revealed in our mortal body. So then, death is at work in us, but life is at work in you (2 Corinthians 4:6-12).

~Alison Feinauer

Back in the Saddle

When my parents moved from Cincinnati to rural Indiana, I wondered how the transition would impact my social life. In the suburbs, everything was walking distance—stores, friends, school. But in our new home, you needed a car to get anywhere. At age thirteen, with no means of independent transportation, I was stuck at home more than I liked.

Our new home was situated on a five-acre lot, which meant my dad was able to board our horses at home for the first time. To fill my lonely days, I spent a lot of time with the horses.

Horses are majestic and gentle creatures. I'm amazed at how easily they submit to the humans who dwarf in comparison. As a budding teen, I felt a special connection with Ranger and Snip. They seemed to understand me in ways no one else did. I processed my secret fears and dreams, and they listened without judgment or lecture.

Riding gave me a sense of freedom. It became something my dad and I did together. Our common interest in horses nurtured a special father/daughter bond between us.

One time, while riding through some nearby woods, my dad and I came to a big open field. The horses saw an opportunity to release their pent-up energy. As soon as my dad gave Ranger the okay, it was game-on. Ranger took off in a full gallop, igniting the competitive spirit in my own horse. When Snip leaped forward to run, I was caught off guard and lost my balance. The next thing I knew, I was lying on the ground with a confused horse staring down at me.

As soon as my dad realized what had happened, he turned around and rushed to my aid. Physically, I was fine. Mentally was another story. As I staggered to my feet, trembling in fear, realization set in. I was very lucky I had not been seriously hurt. We were far from home, and I was terrified to get back on my horse. After a few minutes of encouragement, my dad convinced me that I needed to get back in the saddle. If I didn't, fear might keep me from riding ever again. I took a few deep breaths and got back on the horse. Snip seemed eager to regain my trust and walked gingerly the rest of the way home.

My little life experience has been a profound lesson to this day. Every time I 'fall' or feel like giving up, I remember how important it is for me to get up, dust myself off, and try again.

"The Lord makes firm the steps of the one who delights in him; though he may stumble, he will not fall, for the Lord upholds him with his hand" (Psalm 37:23-24).

"Even youths grow tired and weary, and young men stumble and fall; but those who hope in the Lord will renew their strength. They will soar on wings like eagles; they will run and not grow weary, they will walk and not be faint" (Isaiah 49:30-31).

~Rae Lynn DeAngelis

Stolen Identity

On more than one occasion, my husband and I have gone through the drudgery of canceling a credit card or changing a password because someone took the liberty of stealing our identity. Sadly, this kind of thing happens in the world every day. Perhaps you know how violating it feels to have someone take what's rightfully yours and use it for their own personal gain.

The truth is we are all at risk of having their identity stolen. And I'm no longer referring to credit cards, bank accounts, or personal ID. *"Be alert and of sober mind. Your enemy the devil prowls around like a roaring lion looking for someone to devour"* *(1 Peter 5:8).*

There is a cultural epidemic in our society of not just stolen identity, but also misplaced, mistaken, or even misunderstood identity. Since the very beginning, Satan has been whispering his cunning lies: "You will not certainly die," the serpent said to the woman. "For God knows that when you eat from [the tree] your eyes will be opened, and you will be like God, knowing good and evil" (Genesis 3:4-5).

When Adam and Eve ate from the tree God commanded them not to eat, their eyes did not open, as the enemy so cunningly deceived. Instead, their eyes became closed to the truth of who they had been all along, *image bearers of their Creator.*

Our 10-week healing program, *Eyes Wide Open,* is focused on helping women get back to the truth of who they are and helping them embrace their unique identity. The process we use is biblical; it's called renewing the mind (Romans 12:1-2). Renewing the mind is kind of like resetting your password so the thief no longer has access.

Living in Truth Ministries has been ministering to women struggling with disordered eating, poor body-image, and low self-esteem (often a consequence of misplaced identity) for many years. But recently, God opened our eyes to a new outreach opportunity when we were asked to speak at one of the local Pregnancy Care Centers. At first, we wondered if this was a good fit for our organization. It certainly wasn't our normal audience. But what better way to prevent stolen identity than to fortify the enemy's entry point by ministering to mothers? As we pour into each mom, we inadvertently pour into her child. Mom embraces her true identity and she communicates healthy identity to her child.

What about you? Are you ready to embrace your unique identity and fortify the next generation? Don't be a victim of stolen identity any longer.

"So God created mankind in his own image, in the image of God he created them; male and female he created them" (Genesis 1:27).

"Impress this truth on your children. Talk about it with them when you sit at home and when you walk along the road, when you lie down and when you get up. Tie it as symbols on your hands and bind it on your foreheads. Write it on the doorframes of your houses and on your gates" (Deuteronomy 6:7-9).

~Rae Lynn DeAngelis

Measure of Worth

E ach year, goals are created around improving one's image. The goals usually focus on the outside appearance, growth of bank accounts, and moving up in the world. Society influences our goals by setting a standard for acceptance. If you

do not measure up to the standard, don't even think about trying to be successful in this world. Crazy!

When we base our worth on the world's standards, we end up with depression, anxiety, shame, guilt, addiction, etc. When we base our worth on God's standards, we end up with purpose and peace.

I must confess, in the past I measured my worth against the world's standards. I looked for approval at work to feel worthy. I conformed to the standards created by employees. I worked diligently to lessen the load of employees. I walked out the door every evening measuring the day's success against the reaction of employees. Day by day, my standards moved further away from God's and closer to approval of others.

Guess where I ended up within months of living like this? Yep, depressed, anxious, shame-filled, and searching for peace in all the wrong places. Triggered by the stress of never measuring up to the world's standard, I began looking to outward appearance for acceptance. Eating Disorder thoughts crept in, tempting me to use old habits to handle disappointments.

I hit rock bottom. Sounds like a bad thing, right?

Actually, hitting rock bottom was exactly what I needed to get out of God's way. All along, I tried to live each day on my terms. I planned the way I thought the day should look and pursued that vision. I prayed in the morning on the way into work, but then lived the day as if I were on my own.

Enough is enough! I took a hard look at the results of living by the world's wavering standards. I asked myself a question, "For am I now seeking the approval of man, or of God? Or am I trying to please man? If I were still trying to please man, I would not be a servant of Christ" (Galatians 1:10).

My friends, I must confess that this is not the first time in life I have presented this question to myself. I am weak in the area of people pleasing. I want to be accepted and deemed worthy in this world. I can easily get distracted when multiple opinions, ideas of others, and harsh words enter my path. I am not suggesting we do not consider others' ideas and accept their opinions; but we cannot allow their opinions to change our beliefs, faith, or plan God created.

Though the enemy loves when our weakness is tested, God can use these moments to shine through brightly. "For the sake of Christ, then, I am content with weaknesses, insults, hardships, persecutions, and calamities. For when I am weak, then I am strong" (2 Corinthians 12:10).

In a dark moment, the whisper of God's voice reminded me who I am. His hand reached out, held mine, and pulled me from the dark pit in which I sat.

He is there for you as well. He will bring clarity to your situation. He will strengthen you as the world works to weaken you. He will exemplify a solid, unwavering standard to base every decision upon. He will provide peace among chaos and love that never ends. Read His Word daily and focus on the Truths He presents in each chapter. He deems you worthy. Search His Word for everlasting peace!

~Sheree Craig

Friendly Fire

When you and I signed up to follow Jesus, we signed up for the infantry because we are living in a war zone. "For our struggle is not against flesh and blood, but against the rulers, against the authorities, against the powers of this dark world and against the spiritual forces of evil in the heavenly realms" (Ephesians 6:12).

As soldiers for Christ, we are called to clothe ourselves with the full armor of God. We are also called to take our stand against the devil's schemes and remember, our battle is not against flesh and blood, but against the rulers, powers, and spiritual forces of evil in the heavenly realms.

Unfortunately, during times of intense combat, we can sometimes become confused and end up mistaking the opponent for one of our very own. The military has a term for this. It's called "friendly fire."

Before we even realize it, fiery darts project from our hearts and inflict lethal wounds onto our comrades. Words spew forth like venom, leaving lasting scars on our relationships. Misunderstandings and lack of communication create a great divide between us and the ones we love. And as if that's not enough, festering wounds from past injuries incite negative thought patterns, flooding our nervous system with poisonous toxins that can cause permanent damage to our health.

"Be alert and of sober mind. Your enemy the devil prowls around like a roaring lion looking for someone to devour" (1 Peter 5:8).

Our true enemy (Satan) is very good at cloaking his identity. He hides behind a mask that looks an awful lot like our spouse, co-worker, or friend. We are like pawns in his game of deception. Missiles flying back and forth eventually hit their target, but they rarely inflict damage on the one responsible for it all. During the crossfire, our true enemy sits back and revels in the knowledge that he has, once again, turned hearts against each other. After the conflict is over and while we're waiting for the smoke to clear, our real adversary escapes without a scratch.

It's time that we identify the real enemy in battle and save our deadliest weapons for him alone. Recognizing our adversary before we aim and shoot will help us minimize the risk of fallen comrades getting injured by friendly fire.

"With this in mind, be alert and always keep on praying for all the Lord's people" (Ephesians 6:18b).

We are not in this fight alone. The Lord goes before us and drives out the real enemy. Our job is to armor up, stand firm, pray for all the saints, and be strong in the Lord's mighty power.

"The horse is made ready for the day of battle, but victory rests with the Lord" (Proverbs 21:31).

~Rae Lynn DeAngelis

Give it Time

My husband fertilizes our yard in early spring, long before leaves appear on the trees and tulips begin to bud. At least that's the plan. During one year, however, we got a late start on our lawn, and the end result was a plethora of not-so -lovely dandelions taking over our usually manicured lawn. The ensuing weeds seemed to appear overnight. So of course, my husband made an impromptu trip to the hardware store, invested in a few bags of Weed and Feed, and began spreading it across our lawn.

In years past, the results of our lawn treatment could be seen almost instantaneously. This year, however, perhaps because we had let things get a little out of control, the chemicals seemed to have no effect. We began to wonder if the product was defective, or perhaps it was leftover product from the previous year. All I know is the lawn was not greening up, and the dandelions seemed impervious to our treatment.

Just about the time we were ready to head back to the store for another round of chemicals, the dandelions began to disappear and the lawn turned a deep shade of green. Lesson learned: the longer something is left untreated, the longer it takes to see results from our efforts to impact change.

"There is a time for everything, and a season for every activity under the heavens...a time to plant and a time to uproot, a time to kill and a time to heal" (Ecclesiastes 3:1-3).

What's true in nature is true in life, especially when it comes to things like the toxic thoughts or destructive behaviors we neglect to address. The longer we allow these damaging traits to fester, the harder they are to remove. Like unwanted weeds across our lawn, neglected sin grows deep roots and spreads to unwanted

places. Sin can even obstruct positive growth in our lives, much like unwelcome dandelions choke out grass.

Breaking free from long-standing strongholds in our lives is challenging to say the least, but not impossible. I often tell women coming through the Living in Truth Ministries healing programs, "You didn't get here overnight, so it's unlikely that you will break free overnight. Healing takes time."

Of course, we want instant gratification. We don't like to wait, and we want it now. Can you relate? I most certainly can! When I started on my journey towards freedom from bulimia, I had no idea how much time and effort it would require of me before I would be able to break free. Perhaps limited knowledge of the future is a good thing, God's blessing in disguise. It took more than a year of intense mind renewal before I was able to break free from the destructive behaviors and even longer before I was free from the destructive thoughts. Changing unwanted behaviors is a struggle to be sure, but just like it was for me, give it time.

> "As the rain and the snow
> come down from heaven,
> and do not return to it
> without watering the earth
> and making it bud and flourish,
> so that it yields seed for the sower and bread for the eater,
> so is my word that goes out from my mouth:
> It will not return to me empty,
> but will accomplish what I desire
> and achieve the purpose for which I sent it" (Isaiah 55:10-11).

Has sin crept in and started taking over your life? Stay the course, and keep replacing worldly lies with biblical truth. Your efforts will prove fruitful in the end.

~Rae Lynn DeAngelis

Power of Choice

My husband used to tell me more times than I'd like to admit, that I have the power to decide how I'm going to react to a situation. It doesn't matter if the situation is large or small, my reaction is still mine.

I used to think that I couldn't choose anything other than feeling anxious, upset, or angry. I literally thought I didn't have the choice to turn away from a negative emotion that came up.

A lot of times the power of choice doesn't seem possible because the enemy wants us to believe that that's our truth. He wants us to believe that there's only one way to react to a situation. He wants our identity to be rooted in his lie. Believing that lie is letting the enemy have power over us.

About a year ago, I had an epiphany about myself. I had been believing the lie that I was a hothead. This identity had been spoken over me as long as I can remember. "You don't have patience." "Your son looks like his dad but acts like you" (a little hothead). It seems a little silly, but it seriously didn't occur to me that I could choose another way, another identity. I just thought that that's who I was – someone with a short fuse and little patience. Then I realized I have the power to choose how I will react. I could actually change my identity. I didn't have to be the hothead person who blew up on a dime.

Are you letting other people speak a negative identity over you? Or are you subconsciously holding onto an identity from years ago? It's not easy choosing the road you've never traveled. It's not easy making the choice to turn against what the world says is right, but it's been incredibly freeing to do a one-eighty and move in another direction. I'm a better mom, a better wife, friend, sister and more because I'm making the daily decision to live

differently. Life is so much richer when we're trying to be more like Jesus.

"But you, Lord, are a compassionate and gracious God, slow to anger, abounding in love and faithfulness" (Psalm 86:15).

Time and time again it's repeated in the Bible that God is compassionate and slow to anger. We all have the power to choose, especially in how we react to situations. Let's choose to be more like him.

~Kelsey Klepper

My Over-Packed Life

Standing in line at the airport terminal, we patiently waited to check our luggage. When it was my husband's turn, he placed his suitcase on the airline scale and waited for the number to register. Seconds later the number popped up. It was actually ten pounds under the weight allowance. Whew!

Next it was our daughter and son's turn. They followed suit, falling within the carrier's weight restriction for luggage.

Finally, it was my turn. *The moment of reckoning.*

As Gerry heaved my very large suitcase onto the platform, his eyes nearly popped from the strain. "Rae Lynn, what the heck do you have in here?"

Before I could answer, the bag's weight registered across the screen—sixty pounds—exactly ten pounds over the weight limit.

Yikes!

The airline attendant explained in a matter-of-fact tone, "I'm sorry, Ma'am, but your bag is over the weight limit. You will need to remove some items.

Really?

I looked up at Gerry with pleading eyes. Again, my husband questioned me… "Rae Lynn, what do you have in that suitcase that is so heavy?"

It was time to fess up.

I had cleverly stowed away two five-pound weights in the side pockets of my suitcase, hoping to keep in shape while we were on vacation. I reasoned, ten pounds in my suitcase was better than ten pounds on my thighs.

Since my husband's bag was ten pounds under the weight limit (you guessed it) he opened up his suitcase and redistributed the load. My hero! Problem solved.

Sometimes, in day-to-day life, we can take on more than we were ever intended to carry.

Can you relate?

I sure can. It seems to be a reoccurring problem. I over-pack my suitcase, and I over-pack my life. Running a non-profit organization that is comprised of 100% volunteers is challenging to say the least. Since everyone is working in their spare time (and let's be honest, who has much of that these days) it's impossible to distribute the workload evenly.

Since God has given me the charge of leading this ministry, when something needs to get done and there is no one else to do it, it becomes my responsibility. Most of the time that's not a problem—ministry is my passion and something that brings me great joy. However, every once in a while, the workload becomes more than I can bear. That's when I have to cry out to God and confess that I have once again over-packed my life.

Like my husband in the airport that day, God comes to my aid. He helps me recognize the unnecessary burdens I'm carrying around and shows me ways to redistribute the weight.

Whether you're working a full-time job with benefits, caring for your family at home, or working in ministry like me, you don't have to carry the weight alone. Sharing one another's burdens helps to ensure that no one person is tipping the scales.

"Carry each other's burdens, and in this way, you will fulfill the law of Christ" (Galatians 6:2).

"Let us not become weary in doing good, for at the proper time we will reap a harvest if we do not give up" (Galatians 6:9).

~Rae Lynn DeAngelis

Don't Get Disqualified

When our son, Ben, made up his mind to do something, there was no stopping him, a trait that exasperated me when he was a toddler. (Ladies if you have a strong-willed child, be encouraged. It can work to their advantage down the road.)

Ben loved sports when he was young and was always involved in some kind of physical activity. One year he decided to join the local swim team. After working hard at each practice, Ben came to his first swim meet ready to win. His first event was the 200-freestyle race.

The swimmers were crouched in the starting positions waiting for the signal to start. When the buzzer went off, Ben pushed off the block and dove into the pool. He was off to a great start, but when he came up out of the water, I noticed his goggles had slipped down the middle of his face. He quickly adjusted them back into position over his eyes and took off swimming, hoping to make up for lost time. With each lap, Ben began passing other swimmers. Gerry and I cheered from the sidelines, "Go Ben, go!!" As he pushed off the wall for his last turn, Ben was in second place and gaining ground quickly. He and his competitor were side by side and it looked like it was going to be a tie. But at the last second, Ben extended his arm for the wall and finished the race in first place. My husband and I were jumping up and down with excitement.

A few minutes later, the announcer began listing the swimmers who had placed. Ben did not win after all! In fact, he had been disqualified from the race because he had adjusted his googles. Apparently, a big no-no. (Now I understand why swimmers spend so much time adjusting their goggles before they dive into the pool.)

Months later when Ben's goggles slipped down his face, he kept on swimming... all 200 meters of the medley. As a parent, it was agonizing to watch our son struggle, but Ben wasn't about to give up or be disqualified. He never touched his goggles, not even once, even though he could barely see. In the end, not only did Ben finish the race, he actually placed 3rd overall! We were so proud, not because Ben placed, but because he had pushed past the pain and kept on going.

"I have fought the good fight, I have finished the race, I have kept the faith" (2 Timothy 4:7).

What about you? Are you pushing past the pain when things get tough, giving it all you've got?

"You were running a good race. Who cut in on you to keep you from obeying the truth" (Galatians 5:7)?

The enemy may throw obstacles along your path in the form of trials, tribulations, or temptations, but just like it was with our son, keep moving forward, steady and strong. God has something amazing for you on the other side.

"Do you not know that in a race all the runners run, but only one gets the prize? Run in such a way as to get the prize" (1 Corinthians 9:24).

> Therefore, since we are surrounded by such a great cloud of witnesses, let us throw off everything that hinders and the sin that so easily entangles. And let us run with perseverance the race marked out for us, fixing our eyes on Jesus, the pioneer and perfecter of faith. For the joy set before him he endured the cross, scorning its shame, and sat down at the right hand of the throne of God. Consider him who endured such opposition from sinners, so that you will not grow weary and lose heart" (Hebrews 12:1-3).

Don't let obstacles along your path disqualify you from the race. You've got this!

~Rae Lynn DeAngelis

Watch and Pray

My friends and I decided to embark on a trip to Red River Gorge in Kentucky. We packed up our tent, food, clothes, and hiking gear and excitedly drove to the mountains. As soon as we got there, we picked a flat place to pitch the tent, but decided we'd put it up after we returned from our hike.

We were having so much fun sightseeing, repelling, and cliff diving into the water that we didn't get back to the campsite until about 8:00 p.m.

My friend unpacked the tent and we all helped in trying to assemble it. Nothing was coming together as easily as we'd anticipated. We were missing some rods and pegs, so we decided to just camp out without the tent. What a beautiful night under the stars… that is until the howling began; and rather too close for comfort I might add! Coyotes??? We unanimously decided to sleep in my friend's car. Five girls trying to comfortably sleep in an old white Caddy was not exactly what I had in mind that night. Let's just say we all learned from our experience to thoroughly check our gear beforehand and not procrastinate pitching the tent.

Similarly, I find myself procrastinating in my spiritual life, putting off my prayer time and Bible study until evening. I'm more tired in the evening and find my brain has drifted into autopilot mode. My eyes are working, but my brain is not. Some people function better in the evening or others in the wee hours of the morning. What is your peak time? The most vital part of our

lives should be our "God Time." When we put God off until later, just like my friends and I did when pitching our tent, it may be too late. Have you ever been so tired that you begin to doze off while praying or reading your Bible? Not the best time for devotion, is it? God wants to meet with us when we're at our best—not when we're going to sleep. There has to be two present to call it a relationship and God doesn't want to be the Lone Ranger.

Quiet time with God is when He talks to you and you to Him, a time of refreshment, of filling, armoring yourself for the day's battle.

Consider your time with God. Is it what you want it to be? If not, begin making changes. The time is now; don't put it off until the coyotes begin to howl!

> "Then He said to them, 'My soul is exceedingly sorrowful, even to death. Stay here and watch with Me.'"
>
> "He went a little farther and fell on His face, and prayed, saying, 'O My Father, if possible, let this cup pass from Me; nevertheless, not as I will, but as You will.'"
>
> "Then He came to the disciples and found them sleeping, and said to Peter, 'What? Could you not watch with Me one hour?'"
>
> "Watch and pray, lest you enter into temptation. The Spirit indeed is willing, but the flesh is weak" (Matthew 26:38-41 NKJ).

~Rhonda Stinson

Paid in Full

My husband picked up the ringing telephone, and I could tell from the look on his face, it wasn't good. "Gerry, I don't want to cause trouble between us… but we need to talk about your son." Definitely not the kind of phone call any parent wants to receive.

Our next-door neighbor was usually cordial, but not today. He was obviously distressed about something, but what? Gerry assured our neighbor that whatever concern there was about our son, we would deal with it accordingly, just as soon as we knew what happened.

"I'll tell you what happened!" Ron fumed, "Your son drew all over the side of my brand-new car with a rock!"

This was certainly out of character for our son. Ben wasn't in the habit of destroying other people's property.

Trying to discern the situation, Gerry prodded a bit further. "Ron, I can tell that you are very upset and given the situation, I can certainly understand why, but how do you know that it was *our* son who drew on your car? Did you see him do it?"

"No, I didn't see him do it; but I know it was him!" Ron shot back adamantly.

"Well, if you didn't actually see our son do it, how do you know it was him?" Gerry pleaded for our son's innocence.

Ron countered matter-of-factly, "I think you should come over and see for yourself."

Gerry walked over, and sure enough, right there in big, bold four-year-old penmanship was the incriminating evidence… B-E-N. Our son had signed his artwork. There was no denying it.

Needless to say, we had a little talk with our boy, explaining the dos and don'ts of cars and gravel driveways.

After a stern lecture, Gerry escorted Ben over to our neighbor's house where Ben confessed his fault in-person. And after apologies were made, Gerry accepted full responsibility and made right what our little boy had done wrong.

Sound familiar?

I know another Father who accepts full responsibility for His children's errors.

When you and I confess our sins and turn away from wrong doings, Jesus makes right what we have done wrong.

"God made him who had no sin to be sin for us, so that in him we might become the righteousness of God" (2 Corinthians 5:21).

Just like our little boy, you and I could never make restitution for our sin. The cost is just too great. That's why we need the help of our Heavenly Father. He takes our sin debt and marks it "PAID IN FULL!"

"When he had received the drink, Jesus said, "It is finished." With that, he bowed his head and gave up his spirit" (John 19:30).

~Rae Lynn DeAngelis

Freedom Fighters

Before I ever started Living in Truth Ministries and while I was still trying to work up the courage to step into the unknown territory of helping women find freedom, I was invited to a secular based eating disorder support group to share my story of recovery. (I thought this would be good practice in case I decided to take the leap of faith by stepping into full time ministry.) The woman who led the group was a believer, but most of the participants in the group were not. I cannot share my story of recovery without talking about God since it was Jesus who set me free through the truth of His Word.

As I poured out my heart to the group, I was met with blank stares. My heart sank. I walked away from that experience feeling defeated. How was I supposed to start a support/healing group ministry if I couldn't even make an impact on an already established group?

The woman who led the group must have sensed my discouragement because she called me the following day. I will never forget what she told me. She said, "Rae Lynn, all you can do is hold up the light. It's God's job to make them see it."

I took her words to heart and have uttered similar encouragement to leaders who now help carry the torch to the women coming through *Eyes Wide Open* (our 10-week healing program that helps women break the chains of food and body-image through the renewed mind). Whenever a leader becomes discouraged because she isn't seeing the growth she'd hoped to see in her group, I gently remind her that women are a lot like flowers. They bloom at different times. Our job as leaders is to plant seeds and water them; it's God's job to make them grow. Some flowers pop up through the ground quickly and even begin bearing fruit shortly after. Others need more time. Some must first develop deep roots so that when they do begin to grow above ground, they can draw water from the nutrient rich soil during times of drought. I tell them that if they are not seeing growth, it could be that growth is taking place beneath the surface where they cannot see. Because this ministry is built upon biblical truth, we can be confident in God promises. His Word will never go void.

> "As the heavens are higher than the earth,
> so are my ways higher than your ways
> and my thoughts than your thoughts.
> As the rain and the snow
> come down from heaven,
> and do not return to it
> without watering the earth
> and making it bud and flourish,
> so that it yields seed for the sower and bread for the
> eater,
> so is my word that goes out from my mouth:

It will not return to me empty,
but will accomplish what I desire
and achieve the purpose for which I sent it" (Isaiah
55:9-11).

To the many beautiful women who have experienced freedom themselves and now shine the light of Jesus so others can find freedom too, thank you for all you do. You are a vital part of the Kingdom of God!

~Rae Lynn DeAngelis

Feeling Stressed Out?

Have you ever experienced stress? Silly question, right?
Our bodies have a natural fight, flight, or freeze response that is put into action when there is a perceived threat of any kind. Stress causes a chain of reactions with our brains being one of the primary links. When we experience something stressful, whether that is a bird flying at us or a Tweet we read, an area of the brain called the amygdala contributes to the emotional processing of it and sends a signal to the hypothalamus that something needs to be done. This command center of the brain sends signals throughout the body via the nervous system to ensure we have everything we need to fight or flee.

Chronic stress is the most harmful type of stress. It is defined as constant stress that lasts for a long period of time. Ongoing family issues, money concerns, chronic illness, an unhappy marriage, and a pandemic are examples of things that cause chronic stress. It happens when there doesn't seem to be a viable escape from the cause of the stress. Many times, it is viewed as

normal or "just life" and becomes a stress threshold that acute stress builds on top of.

Ongoing chronic stress can have a variety of emotional, mood, and behavioral responses. There are a number of emotional and physical disorders linked to ongoing chronic stress such as depression, anxiety, heart attacks, stroke, hypertension, immune disturbances, and gastrointestinal dysfunction. According to a 2015 American Psychological Association (APA) finding, adults in the United States average a stress level of 5.1 on a scale of 1 to 10. In a time of pandemic, this emotional tension and mental strain has become very common to many of us. Sadly, many of us are experiencing physical and emotional consequences as a result.

The first step in taking control and managing chronic stress is to become mindfully aware of how it is influencing you in four different areas – emotionally, mentally, physically, and behaviorally. Mindfulness is the psychological process of bringing attention to the external and internal experiences happening in a given moment.

There are three main components that can be applied to stress:

- Understanding what is happening
- Discovering how you are responding
- Determining what steps are needed to manage and cope with the stressor and response

One way to cope with stress is to turn to Scripture. One of the best Scriptures to reference in stressful times is Philippians 4:8 "Finally, brothers and sisters, whatever is true, whatever is noble, whatever is right, whatever is pure, whatever is lovely, whatever is admirable—if anything is excellent or praiseworthy—think about such things."

Here in this one verse, we have a lot of tools to help us mindfully regain focus during stressful situations. Think about what is true, noble, right, pure, lovely, and admirable. In taking some time to consider if there is anything excellent or praiseworthy, we can shift attention toward those things and begin to lower blood pressure, reduce tension, and calm our minds. Add in some slow abdominal breathing to replace the shallow chest breathing that usually comes with stressful situations, and you

should find some immediate relief from the stress you are experiencing.

If you are having elevated issues coping with chronic stress, The National Alliance on Mental Health has a 24-hour helpline you can call for extra support. Don't hesitate to reach out for help. Sometimes talking is just the coping tool needed to gain a new perspective.

~Tanya Jolliffe

Spoiled Fruit

When I brought home a bunch of slightly green bananas and placed them on kitchen counter with bananas from the previous week, the new bananas turned brown within a few days. They didn't even have the chance to turn yellow. Perplexed, I decided to investigate the phenomenon to see if there was a logical explanation as to why the fruit spoiled so quickly. After reading through a few articles on the Internet, I learned that as fruit matures it releases ethylene, a gas which accelerates the ripening process. Apparently, ethylene gases from the older bananas caused our new bananas to brown before their time.

I now understand the meaning behind the saying, "One bad apple spoils the whole bunch."

It's true for fruit, and it's true for our relationships too.

Have you ever noticed how quickly optimism spoils in the presence of a naysayer or how hopefulness fades in the company of despair?

"Do not be misled: 'Bad company corrupts good character'" (1 Corinthians 15:33).

Negativity can be toxic to relationships, robbing people of joy. The enemy thrives on pessimism and knows how to use it to his advantage. *"I don't mean to be negative but..."* or... *"I just need to vent for a minute..."* Intro statements such as these provide fertile soil for the enemy. I can almost imagine Satan and his minions dancing around our destructive conversations, eager to fuel more misery. Before we know it, toxicity levels escalate to lethal proportions, slaying all hopes for positive objectivity from those around us.

We all need a listening ear now and then, so how can we keep our pessimism from infecting others?

We need take it to Jesus first.

Submit your dejected heart to Jesus and you will receive empathy and godly wisdom to lift your spirit from despair. God truly understands our human challenges and weaknesses because He experienced them Himself when He was here on earth.

"For we do not have a high priest who is unable to empathize with our weaknesses, but we have one who has been tempted in every way, just as we are—yet he did not sin" (Hebrews 4:15).

Jesus not only experienced our challenges and weaknesses; He also knows how to overcome them.

"Come to me, all you who are weary and burdened, and I will give you rest. Take my yoke upon you and learn from me, for I am gentle and humble in heart, and you will find rest for your souls. For my yoke is easy and my burden is light" (Matthew 11:28-30).

The Lord is not adversely impacted by our negativity like the people around us. Therefore, as we openly and honestly share our feelings with God, He is able to listen with compassionate objectivity and direct our minds towards positive, life-affirming thoughts.

Positive thoughts lead to positive speech, and positive speech leads to a positive attitude.

"Thus, by their fruit you will recognize them" (Matthew 7:20).

~Rae Lynn DeAngelis

Numbing the Pain

After my husband's gallbladder surgery, he was hesitant to take prescribed pain killers. He worried that they might make him too loopy, but intense pain eventually convinced him otherwise. The medicine was a blessing because it helped him manage his discomfort while the healing process took place.

In today's world people use many different methods to manage pain. Everything from substance abuse to shopping. Even scrolling through social media is an avenue to numb out. Stress, anxiety, grief, heartache: these are just a few of the uncomfortable feelings that we would just as soon forget. Even if it's only for a little while.

According to mental health professionals, serotonin, among other things, plays an important role in the control of our emotions and can act as a buffer for pain, physical or otherwise. Dopamine is another powerful brain chemical that makes us feel good. It is released when we do things that are enjoyable like eating, drinking, or engaging in sex. It is also released when we see someone like our social media post… or when we buy something new or scratch off a winning lottery ticket.

Some people can walk away from these kinds of experiences feeling satisfied, while others feel a strong urge to repeat the dopamine induced activity over and over again. Unfortunately, future attempts to replicate the "feel-good" response require more and more of the numbing induced agent to achieve similar effect. It is this physiological reaction that drives many types of addictions that can even become a wedge between us and God.

So, what do we make of this? Are we to simply "suck it up" and suffer needlessly? Absolutely not. God provides other ways

for us to cope and minimize pain which are not harmful but helpful. Here are some that helped me:

- I cry out to God through prayer and journaling – *"The righteous cry out, and the Lord hears them; he delivers them from all their troubles" (Psalm 34:17).*

- I meditate on God's truths through Scripture – *"Keep this Book of the Law always on your lips; meditate on it day and night, so that you may be careful to do everything written in it. Then you will be prosperous and successful" (Joshua 1:8).*

- I look for a way to serve others – *"Each of you should use whatever gift you have received to serve others, as faithful stewards of God's grace in its various forms" (1 Peter 4:10).*

- I praise and worship God – *"Sing joyfully to the Lord, you righteous; it is fitting for the upright to praise him" (Psalm 33:1).*

- I do something fun with family and friends – *"But be glad and rejoice forever in what I will create, for I will create Jerusalem to be a delight and its people a joy" (Isaiah 65:18)*

- I get outside and enjoy God's creation – *"You alone are the Lord. You made the heavens, even the highest heavens, and all their starry host, the earth and all that is on it, the seas and all that is in them. You give life to everything, and the multitudes of heaven worship you" (Nehemiah 9:6).*

- I write devotions like this one – *"Write down the revelation and make it plain on tablets so that a herald may run with it" (Habakkuk 2:2).*

- I listen to inspirational podcasts or Christian music – *"Get wisdom, get understanding; do not forget my words or turn away from them" (Proverbs 4:5). "Shout for joy to the Lord, all the earth, burst into jubilant song with music" (Psalm 98:4).*

Healthy activities such as these release that same brain chemical, dopamine. The more we do them; the more we want to do them. And here's the best part; they are guilt-free, healthy coping mechanisms.

~Rae Lynn DeAngelis

God's Business Card

Not too long ago, I got "nabbed" at the mall by a beautiful Puerto Rican woman selling skincare products at a kiosk. I've always had the willpower to smile and walk by, but not on this occasion, nor my friendly friend who stopped to talk to her. Long story short, we got talked into a 2-hour facial. Then the sales pitch came out—a strong sales pitch. This woman had to have sold timeshare units in Puerto Rico! She was that hard to resist. (If you've ever been on the end of a timeshare sales pitch, you know what I'm talking about).

She basically said, "I can sell you this line of products at such a great price because your face will be my business card. When your friends see how vibrant and youthful you look, they'll want to buy my products."

I think we sometimes forget that we are God's business card. Not merely do our faces represent Him, but our entire selves, particularly our attitudes. If we desire to be God's business card,

leading others to the real fountain of life and youth, then we've got to first make sure we're connected to the source ourselves.

When we represent God, we represent Love itself. This can be tough for many of us, especially if we grew up feeling unloved or loved with strings attached. Someone once asked me, "Since I've never in my life experienced real love, how can I love someone else like God does?" The Bible tells us:

- God is Love: *"Whoever does not love does not know God, because God is love" (1 John 4:8).*

- God pours His love into you: *"And hope does not disappoint us, because God has poured out his love into our hearts by the Holy Spirit, whom he has given us" (Romans 5:5).*

- God lives in you: *"Don't you know that you yourselves are God's temple and that God's Spirit lives in you?" (1 Corinthians 3:16); "In him you too are being built together to become a dwelling in which God lives by his Spirit" (Ephesians 2:22).*

- God's love is never leaving you: *"For I am convinced that neither death nor life, neither angels nor demons, neither the present nor the future, nor any powers, neither height nor depth, nor anything else in all creation, will be able to separate us from the love of God that is in Christ Jesus our Lord" (Romans 8:38-39).*

Let's put these together: If you are a believer, you know God, who is the definition of Love. And Love (God) lives in you and has poured His love into you. Therefore, you have the ability to love another person and to be loved the way God created you to love and be loved—and nothing can separate God's love from you. The clincher is: We need to first learn to love God and allow Him to love us. This is how we become God's business card of love to other people.

~Kimberly Davidson

One-Way

Driving through a busy metropolis is risky business for someone who is directionally challenged like myself. I've never been comfortable driving in the city, especially when it involves confusing thoroughfares and one-way streets.

When I was in my early twenties, I had a job interview with a company located in the heart of downtown Cincinnati. Talk about a stressful situation. I wasn't sure which was more taxing—going on a job interview or driving through the inner city.

I did not have access to GPS in the 1980's, so getting to my destination required that I follow a set of ambiguous directions provided by the person who set up the interview. The directions were not particularly helpful.

At one point while cruising down a small connector street, a vehicle heading straight towards me blew its horn. As the car passed by, a man inside gestured a not-so-nice hand signal and hollered out his window … "ONE WAY!" A rude awakening to be sure, but not the only time I've found myself barreling down a one-way street in the wrong direction.

Although I grew up in the church, somewhere along the way I came to believe that my ticket into heaven hinged on my obedience to a strict set of rules taught by the church. Unfortunately, following the church's code of conduct was an impossible task. I failed miserably. However, I took a bit of comfort in knowing I wasn't engaging in some of the "big" sins. Surely lying, cheating, and disobeying my parents would be considered misdemeanors in God's eyes. (Or so I hoped.)

Whenever I missed the mark, I tried tipping the scale back in my favor with a good deed or penance, hoping to soften God's impending judgment. I hoped all my offerings would appease

God, but I never knew for sure. The end result was a constant state of quandary, wondering if I had done enough good to outweigh the bad.

It was a skewed perception of our Heavenly Father. Friends, God does not tally up our offences and atonements like entries in a checkbook. Trying to earn our salvation through good deeds and sacrifices is a one-way street in the wrong direction. We cannot possibly do enough good to undo all the sin in our lives. "All of us have become like one who is unclean, and all our righteous acts are like filthy rags; we all shrivel up like a leaf, and like the wind our sins sweep us away" (Isaiah 64:6).

God knew from the very beginning that we could not keep His law perfectly. "Therefore no one will be declared righteous in God's sight by the works of the law…" (Romans 3:20). Because we could never keep His law perfectly, the Father who loves us set into motion His ultimate plan of redemption. Essentially, God was saying: You can't do this, but I can! God Himself would pay the penalty for our sin debt.

"For God so loved the world that he gave his one and only Son, that whoever believes in him shall not perish but have eternal life. For God did not send his Son into the world to condemn the world, but to save the world through him." (John 3:16-17)

There is only one way into heaven. "Jesus answered, "I am the way and the truth and the life. No one comes to the Father except through me" (John 14:6).

When we accept the covering that God Himself provided through His Son, our sins are forgiven, wiped clean by the precious blood of our Redeemer. We don't have to wonder if we're going to make it into heaven. God's got us covered!

~Rae Lynn DeAngelis

Life After Death

It's intriguing to hear stories of near-death experiences where someone dies but is brought back to life. A friend of mine had a near death experience a couple of years back. She went into the hospital for routine surgery but had a severe reaction to the anesthesia. It stopped her heart. Thankfully, the medical team was able to revive her, but her encounter with death left a lasting impression, as you can imagine.

Death changes everything. Not just physical death like when we pass from this life and into eternity, I'm referring to things like the death of an unhealthy relationship, lifestyle, mindset, or addiction.

Jesus said, "Whoever wants to be my disciple must deny themselves and take up their cross daily and follow me" (Luke 9:32).

As a Christ follower, I encounter fleshly desires that war against my soul each and every day. I bet you do too. "Although I want to do good, evil is right there with me. For in my inner being I delight in God's law; but I see another law at work in me, waging war against the law of my mind and making me a prisoner of the law of sin at work within me" (Romans 7:21-23).

The desires of the flesh conflict with the heart of God. Day by day and truth by truth, God is working to remove unwanted traits in us like:

- Addiction
- Toxic thoughts
- Selfishness
- Greed
- Unforgiveness

- Control
- Fear
- Pride

As a Jesus follower, we should be experiencing death on a regular basis.

In preparation for this post, I called my friend to talk to her about her near-death experience and she graciously gave me permission to share her story.

I asked if she had any memory of what took place that day. She said that she didn't see a bright light nor did she hover over her body like some people experience. Instead, she experienced indescribable peace. She further explained that she felt a loving presence with her, asking if she would like to stay. She said it was very tempting, but she felt it wasn't her time and her family needed her. As soon as the decision was made (as she described it), she was pulled back into the chaos with the doctors and nurses working on her and she woke up. She then said something that I thought was profound. She said, "I no longer fear death because I know what follows—peace."

The same is true when we put to death toxic thoughts, destructive behaviors, and ungodly character traits. Peace follows. Peace that passes all understanding. Peace that we will never want to leave. The kind of peace that is a bold reminder, there's no need to fear death in the future. "No eye has seen, no ear has heard, no mind has conceived what God has prepared for those who love him" (1 Corinthians 2:9).

Die to self, live for Christ, and don't let the enemy pull you back into the chaos. "For me, to live is Christ and to die is gain" (Philippians 1:21).

~Rae Lynn DeAngelis

Clean Out the Junk

You know when you feel like an issue is under control because it doesn't bother you the way it used to, then you realize that you're just controlling it a different way? That's how it's been for me lately.

When I receive hurtful words from some people who are close to me, my family, friends, coworkers, etc., it's super hard. Usually, they don't realize the weight of the words that they're saying to me. But it re-opens an old wound that is on the mend. My way of controlling this is shelving those hurts and putting them to the side, like in the junk drawer. Eventually, when you go to put something in it, it's too full. You have to clean out the junk drawer. That's when you realize all the junk that is in there that you need to put back in its place.

A few weeks back, I cleaned my car out. I was so proud of it. My husband loves a clean, swept out, dusted car. I was super excited to tell him what I did. When I saw him that evening, I opened the door and showed him the job I'd done. The first thing he said, pointing to the seat was, you missed this spot here. Seriously!!! Not a good job, or looks great, or anything, just pointing out the wrongs. I brushed it to the side, "stuffed in in the junk drawer" and went on my way.

The next day, these words kept coming up and the Lord showed me that I've been shelving all of these hurts. I needed to do some work and deal with them. I found some quiet time and chose a few people that have been hurting me lately and I forgave them through writing a forgiveness letter. I was at a women's camp, so after writing the letters, I went to receive prayer. I shared what I was experiencing.

They said, "Well, we would like to hear you forgive them out loud." I was like, I already did that in my letter. Again, they really wanted me to SAY IT OUT LOUD. I thought, OK I'll do that, no big deal.

But it was. It was a BIG deal. As I was repenting for agreeing with these hurts, forgiving these people out loud and blessing them, something BIG broke in me. It was an incredible feeling and weight lifted! There is power in saying these words out loud.

I had this vision that there were no roots in my life and they had been black and dark and just growing. All of a sudden, after I had forgiven these people out loud, the black was suctioned and the roots were illuminated with this white bright light. It was like this transforming healing that happened in that moment with the Lord because I chose to speak them out loud.

We live in a spiritual world. Through God, there is power in our words. When we speak them out loud and declare them, the enemy knows exactly where he stands and he loses his power.

From this experience, I have two challenges for you this week. Clean out your junk drawer and speak out loud forgiveness. Take some time to reflect on issues, or hurts you've been avoiding and need to address. Then find a friend or even just some time with God and out loud speak your forgiveness. This could even be reading a forgiveness letter out loud.

It's hard, dirty, raw work. But girl, it's worth it! I'm living proof!

"If we confess our sins, He is faithful and just to forgive us our sins and to cleanse us from all unrighteousness" (1 John 1:9).

"If you confess with your mouth the Lord Jesus and believe in your heart that God has raised Him from the dead, you will be saved" (Romans 10:9).

"Create in me a clean heart, O God, and renew a right spirit within me" (Psalm 51:10).

"Above all else, guard your heart, for everything you do flows from it" (Proverbs 4:23).

~Alison Feinauer

Unwelcome Guests

Out of the corner of his eye, my husband noticed something scurrying across the kitchen floor. Further investigation revealed that the something was a mouse. Eek!!

Believe it or not, in our entire twenty-nine years of marriage, this was the first time a mouse had sought refuge in our home. We had plenty of other critters over the years: ants, spiders, crickets, even a chipmunk once, but never a mouse (at least none that we were aware of, lol).

The tiny ball of fur seemed harmless enough, so rather than destroy the little guy, we decided to implement a more humane plan—*catch and release*. After an hour-long chase, we finally caught the little guy and set him free in the wooded lot across the street from our house. (A decision we would later regret.)

A few weeks later, Gerry noticed mouse droppings in his office. Upon closer examination, it became increasingly evident we had a mouse problem. Apparently, they moved into our home after a recent excavation project in the lot next door had disturbed their natural habitat, sending the varmints scurrying for a new place to live. I'm guessing our home was an upgrade from their previous living quarters.

Eventually, it became necessary to send our unwelcome visitors packing. Mice carry disease, chew through electrical wires, and raid pantries, not to mention the fact that they reproduce rather quickly. Two mice become an infestation in relatively a short amount of time.

"Do not ignore the clamor of your adversaries, the uproar of your enemies, which rises continually" (Psalm 74:23).

Gerry returned home from the hardware store equipped and ready. He purchased enough traps to snare an army of rodents. Operation elimination was underway, and one by one, our unwelcome guests were eliminated.

Looking back, I realize that we could have saved ourselves a whole lot of trouble if we would have just taken appropriate action in the first place. Releasing the original mouse across the street wasn't moving it far enough away. After he found his way back into our home, he must have invited his closest family and friends to join him.

Negligence, laziness, and even ignorance are precursors to future hardships when we don't take proper action to tackle the problems at the onset. "Diligent hands will rule, but laziness ends in forced labor" (Proverbs 12:24).

Our little mouse problem became a good reminder to be diligent and proactive, to take care of problems when they are small. Procrastination and carelessness are also unwelcome guests because they can create bigger problems down the line.

"Do what is right and good in the Lord's sight, so that it may go well with you and you may go in and take over the good land the Lord promised on oath to your ancestors..." (Deuteronomy 6:18).

~Rae Lynn DeAngelis

Dress for Success

My sister and I are very close. Even though she lives several states away, we still talk on the phone a couple of times a week. During one of our recent conversations, she was talking about how her clothes no longer fit comfortably and she was feeling discouraged. (Menopause can wreak havoc on

the body.) Determined to lose weight, she went on a strict diet and started exercising more regularly. After several weeks, she hadn't lost a pound. The weight just wasn't coming off. And, as you can imagine, she grew increasingly frustrated. Upon hearing her growing frustration, I made a suggestion, "Why don't you buy yourself some new clothes that fit you more comfortably?"

She had several reasons why that was a bad idea: *I can't afford to buy new clothes; I don't have time to go shopping; That's wasteful; I have a closet full of perfectly good clothes; I just need to lose a few pounds and they will fit again, etc.*... Sound familiar? I'm not judging. I've been there too. I know how hard it is to accept change, especially when it comes to our body. (Don't forget. I struggled with bulimia for many years.)

But God has taught me over the years that in order to remain free, I need to set myself up for success. Wearing clothing that fits me is one of the ways that I set myself up for success. I have learned that I can feel beautiful and confident, regardless of my body size. Here are a few tips that help me embrace my current body:

- I fill my mind with truth about who God says I am every single day. (The voice of God needs to be louder than the voice of the world.)

- I thank God for the things my body is able to do regardless of my size. (Help a friend, hug my family, serve in ministry, and worship God.)

- I wear clothing that I feel comfortable in and helps me feel confident and beautiful. (I love ruffles, lace, bling, and colors that make me happy.)

True beauty and confidence come from within. How we feel on the inside is often displayed on the outside.

I'm reminded of a comedian who said, "Yeah, I'm on a diet... trying to get back to my original weight— 7 lbs. 4 oz.!" Of course, it's funny when we hear it put this way, but how often have we said or thought, "I just need to lose a few more pounds; then I'll be happy?"

The truth is our body is constantly changing, from the moment of our conception and every moment thereafter. But because our culture has placed such a high value on youth, many women feel immense pressure to look a certain way: thin/tone body, smooth skin, hair without gray.

While we can't control every change taking place in our body, we can control how we will respond to that change. If you find yourself staring into a closet full of clothes that no longer fit, do yourself a favor. Find clothes that fit more comfortably so you can feel more confident in the body you have right now. Even if that means going to a second-hand shop.

We only get this one body and this one life. Don't waste another minute pining over clothes that no longer fit. Dress for success and embrace life!

"She is clothed with strength and dignity; she can laugh at the days to come" (Proverbs 31:25).

~Rae Lynn DeAngelis

A World of Distraction

When my son started driving, I warned him about some possible distractions: Keep the cell phone off while driving. Keep your eyes on the road. Look out for drivers swerving, possibly over correcting the vehicle in the other lane. Keep the radio at a minimum volume. Adjust mirrors to see all surrounding views. The list goes on and on.

We have a daughter too. As she grows up and begins determining her place in life, we discuss even more distractions. She is in the phase of increased hormones and being strongly affected by the opinions of others. We also talk about the distraction boys create. A boy can change a girl's focus quickly

(and vice versa). Another distraction in life includes placing worth/value in a sport or perfect grades. The list grows as the years pass.

It seems distractions can follow us in life despite our age. Take a moment, look around and notice the distractions in your life. Cell phones constantly seek our attention. Busy itineraries steal our moments. Opinions of others override truth. Social media comparisons diminish joy, etc. Distraction is everywhere and has the potential to destroy relationships.

Is this the way of the world? Must we embrace it?

"I appeal to you therefore, brothers, by the mercies of God, to present your bodies as a living sacrifice, holy and acceptable to God, which is your spiritual worship. Do not be conformed to this world, but be transformed by the renewal of your mind, that by testing you may discern what is the will of God, what is good and acceptable and perfect" (Romans 12:1-2 ESV).

Easy enough, right? Not quite. This world surrounds us with temptations to conform, fit in, and veer away from God. Temptation, as defined by Merriam-Webster, is a state of or act of being enticed especially to evil. Now, I am not saying that cell phones are evil, social media should be banned, or we need to wipe our itineraries clean. I am saying that we must prepare ourselves to live amongst temptations.

As I teach my children to be alert to distractions in life while driving or making decisions, I need to heed my own advice. I find it easy to become entangled amongst the opinions of others, allowing their words to determine my worth. My thoughts continually battle temptations to compare the outside appearance or filtered image on social media to how I view my own image. Comparisons will lead to jealousy which leads to self-destructive thinking. Distractions lurk around every corner. How can we avoid falling into these traps?

The Scripture explains it perfectly (as all do). Transform your spirit with the renewal of your mind. Renew the mind with Truth. His Truth will build discernment required when facing this world. Discernment provides protection. We can live in this world and avoid being of this world. God desires for us to go and be His hands and feet, standing firm on His Truth.

My son must keep his mind and eyes focused while driving. My daughter must stand firm on Truth and renew her thoughts when the world throws opinions her way. Both children will remain strong, focused and peaceful in life when avoiding distractions.

The same rings true throughout all stages in life. Keep your mind focused on Truth. Our worth remains in God. He created each of us with a purpose and plan. Any distraction that creeps into our paths must be shut down immediately. Stay focused dear friends. Let's live by Truth and stand firm when distractions creep into our paths.

~Sheree Craig

Who Am I?

Graduation is a time filled with mixed emotions: excitement, relief, a sense of accomplishment, anticipation, apprehension, and fear. Some students are left with questions like: *What now? Where do I go from here?*

The world's answer: Find a job in your field of study, apply things you've learned, gain experience, climb the company ladder, and live the American dream.

Sounds good, but surely there's more to it than that, right?

The problem with the world's way is that several years down the road of life, people struggle because they've learned to define themselves by what they can or cannot do instead of who they are. Our sense of identity and worth grow murky when we too closely identify ourselves with our jobs, families, friends, or even hobbies.

I'm just now beginning to have a clearer understanding of my identity and purpose in life. In the past, I defined myself by the

roles I've played or the accomplishments I've made. But here is what God has been teaching me lately: We should never hang our identity or self-worth on accomplishments or roles because all of these things will eventually change with the ebb and flow of life. Kids grow up. Couples get divorced. Jobs come and go. Seasons change. And in case you haven't noticed, *the world is fickle.* One minute you're a hero; the next minute you are a zero.

I'm a wife, mother, daughter, sister, friend, ministry leader, author, and speaker. But these things are not the core of who I am. I've been married for thirty plus years, mothered and homeschooled two children, started a non-profit organization, and have even wrote and published several books. Yet, these accomplishments are not the summation of who I am.

To understand ourselves at our core, we must first seek the One who created us.

"You have searched me, Lord, and you know me. You know when I sit and when I rise; you perceive my thoughts from afar. You discern my going out and my lying down; you are familiar with all my ways" (Psalm 139:1-3).

God took great care when He created us, making each person unique from the other.

"For you created my inmost being; you knit me together in my mother's womb. I praise you because I am fearfully and wonderfully made; your works are wonderful; I know that full well" (Psalm 139:13-14).

Who I am (*who I really am*) is the summation of that which is unique to me: my personality, traits, gifts, talents, life experiences, hopes, and dreams.

"My frame was not hidden from you when I was made in the secret place, when I was woven together in the depths of the earth. Your eyes saw my unformed body; all the days ordained for me were written in your book before one of them came to be" (Psalm 139:15-16).

As we reflect on the deeper issue of who we are apart from what we can or cannot do, we begin to have a clearer picture of our true selves and unleash our God-given influence to leave an impact in the world.

The core of who we are does not change like fashion trends. Yes, we grow and mature as God molds and shapes us into clearer

image-bearers of Himself, but the centrality of ourselves, the person God created us to be (which is a unique reflection of our Creator) is always there. As we embrace this profound truth, everything else (roles and accomplishments) are simply icing on the cake.

~Rae Lynn DeAngelis

Naked and Unashamed

When our daughter was little, she spent every moment she could get away with running around the house in her undies. (It's true. We have the home-movies to prove it.) I can't tell you how many times I'd have to say, "Heather, you need to put on your clothes!"

Apparently, clothing was far too restricting for our Pretty Little Princess. Not to mention, pants and shirts made her hot and sweaty (or so she claimed).

When it came to parenting styles, my husband was more relaxed; I was more structured. When mommy went out for the evening and daddy was left to babysit, it was play time! Heather and Ben loved it when daddy was on duty because he got down on the floor and played too. He even set up the camcorder so I could see just how much fun they were having without me. (Wink.) Heather in her "Underoos" and Ben in his diaper…it was a naked and unashamed free-for-all.

"Then the eyes of both of them were opened, and they realized they were naked; so they sewed fig leaves together and made coverings for themselves" (Genesis 3:7).

Sadly, something happens when children grow up and become adults. Inhibitions, embarrassment, and shame replace carefree fun and innocence. I personally started picking apart the things I

didn't like about my body as early as kindergarten. Contrary to our spirited daughter who at the same age felt no shame, I remember feeling horribly embarrassed when I wore a dress to school because I was worried someone might see my underwear.

In the beginning, before sin entered the world, there were no hang-ups concerning our bodies. Inhibitions didn't exist. "Adam and his wife were both naked, and they felt no shame" (Genesis 2:25).

I believe Adam and Eve's self-acceptance went beyond feeling comfortable in their skin. They had self-awareness that was pure and unstained. They believed what God said about them... that is until Satan told them otherwise:

> "You will not certainly die,' the serpent said to the woman. 'For God knows that when you eat from it your eyes will be opened, *and you will be like God*, knowing good and evil.' When the woman saw that the fruit of the tree was good for food and pleasing to the eye, and also desirable for gaining wisdom, she took some and ate it. She also gave some to her husband, who was with her, and he ate it" (Genesis 3:4-6).

The irony in Satan's temptation is the fact that Adam and Eve were already 'like' God. They were made in His image (Genesis 1:27). We too have been made in God's image. The innocence of children proves we do not come out of the womb with our body-image hang-ups. Deception begins a little at a time with each bite of the lie-filled 'apple'.

While we can't go back to Eden and undo what's already been done, we can start fresh today, believing what God says about us and accept the covering Jesus offers us through His finished work on the cross—forgiveness of our sins: past, present, and future. I've heard it said this way, *"Jesus slapped a price tag on our souls, declaring, 'Beloved, you are worth all of me!'"*

This is why we can stand before the Father now, and for all eternity, holy and blameless, forgiven and redeemed -- *naked and unashamed.*

~Rae Lynn DeAngelis

Tempted and Fallen

I am Eve, tempted and fallen, naked and hiding from God.*

What a grand entrance for the first lady of all human creation, deceived by the serpent, delivering herself and all of humankind to a world of sin. I'm sure this isn't exactly how Eve would like to have started off Chapter 1 in the history book of all history books. After all, how could she have known how far-reaching this one seemingly small act of disobedience would be? I say this would make front page news in the media today. But wouldn't you know it, there the account is smack-dab in the Bible in Genesis Chapter 3.

The serpent began with a very sly question: *"Has God indeed said...?"* Oh, isn't this serpent the devious doubt dealer? Eve, are you sure this is what God said? Could it be you misheard or misunderstood God's command to not eat of the fruit of the tree of the knowledge of good and evil? Then the serpent said, *"You will not surely die. For God knows that in the day you eat of it your eyes will be opened, and you will be like God, knowing good and evil."* This is a pretty convincing statement. Satan (the serpent) wasn't trying to convince Eve to just eat a piece of fruit; it was much deeper than this. He merely used the fruit as luring eye candy to the big fish; to be like God, knowing good and evil.

Eve's story is very similar to that of many today, myself included. I ate of Satan's eye candy many years ago. It began as a

gentle wave, which over time became more and more harsh until it became an all-encompassing tidal wave. The lure was a thin body like the slender models who graced the runway. The "big fish" was what I was really after. I wanted to be noticed, to be told I was beautiful, to fit in, to be treated like I didn't have a disease (juvenile diabetes), to not have to feel like an outcast for holding to Christian values, to be outgoing, secure, etc… I was convinced that I could attain all of these things simply by slimming down. The slim down turned into knock down, which eventually led to tap out.

Little did I know I would be locked in an addiction with lifelong consequences. It is of utmost importance that we instruct the younger generations on who they are and how significant they are because they were made by God and for God. When we are trying to find our significance outside of God's original plan we will fall to destruction.

The good news is that God restores beauty for our ashes once we have truly repented and deemed ourselves doomed without His hand of mercy. It was at my point of no return that God stepped in and asked me to return. It was like my Groom holding out His hand of unconditional love and saying, "I know what you've done, but I'm still here waiting for you with expectant anticipation. Will you marry me, Rhonda?" After being all-consumed in the temporary lust of addiction, I was ready to take God's hand and let Him lead.

There are many "big fish" in the world we may be focused on. For Eve it was to be like God, knowing good and evil. For me it was love and acceptance; but the only "big fish" that will fully and eternally satisfy is God. He fills our voids completely and leads us on a path of hope and a bright future (Jeremiah. 29:11-14). God now has my heart hook, line, and sinker.

How about you?

~Rhonda Stinson

The Magnifier

A s a child, I remember being fascinated with my grandfather's magnifying glass. It was used to read small print. I loved playing with it anytime the adults were occupied in the other room.

My grandpa had a couple of magnifiers, if my memory serves me correctly. One was round, the other was rectangular in shape with a light. Pressing the button would engage a small beacon of light to illuminate tiny subject matter. Of course, I wasn't using it to enlarge print on a page. I was more interested in looking at things like the worn leather on grandpa's chair or the carpet fibers beneath my feet. After playing with it for a while, I discovered something interesting. The further I held the magnifying glass away from an object, the more warped the image appeared.

As an adult, I often find myself looking at life through what seems like a magnifying glass. I have very high expectations, especially for myself—a quality I'm not particularly proud of because it makes my life miserable at times. I spend hours on a task that should only take minutes. For example, I can write, rewrite, proof, and write again devotions like this one, trying to formulate words to meet the high standard of excellence I've set for myself.

It's a curse! I waste precious moments trying to redo that which was (in all likelihood) done well-enough the first time.

As I think about what drives my passion for perfectionism, I have to be honest; it stems from pride and insecurity—two qualities that are unbecoming of a Jesus follower.

In all honesty, I'm looking for the approval of others and seeking to control the world around me, all in an effort to

experience more peace. Unfortunately, it's a farce—a ruse cleverly deployed by the enemy.

While peace and security are honorable qualities to aspire towards, I'm going about it all wrong. Human control leads to chaos. That's because our perception and judgment are warped by a broken worldview, much like the distortion created by my grandfather's magnifying glass. Peace (the kind that is lasting) can only be found in one place—Jesus.

"Peace I leave with you; my peace I give you. I do not give to you as the world gives. Do not let your hearts be troubled and do not be afraid" (John 14:27).

There is a way to experience peace on earth, but the way to discover it is to shake off our human impulse to control the world around us and, instead, surrender to the One who knows how to handle every detail of our lives.

"Submit to God and be at peace with him; in this way prosperity will come to you" (Job 22:21).

~Rae Lynn DeAngelis

The Learning Circle of Life

W hen our kids were little, family vacations often included a trip to the local go-kart track. I love go-kart racing! I suppose I'm a little bit competitive. What can I say? I like to win.

I remember one go-kart track in particular. It had a helix which circled around, slowly ascending, until you reached the next level of the track. That got me thinking. Oftentimes, Scripture

parallels our faith journey to a race. "Do you not know that in a race all the runners run, but only one gets the prize? Run in such a way as to get the prize" (1 Corinthians 9:24). "I have fought the good fight, I have finished the race, I have kept the faith" (2 Timothy 4:7). "You were running a good race. Who cut in on you to keep you from obeying the truth" (Galatians 5:7)?

While I was reading the book of Nehemiah, I began to notice certain words and phrases kept being repeated, so I felt prompted to circle all the phrases that began "You" and "they." "You" represented God and "they" represented His people. Looking back, I began seeing a theme. See if you can detect it.

You found. You made. You saw. You sent. You knew. You made. You divided. You led. You came. You spoke. You gave. You made known. You gave. You brought. You told them to go. (Nehemiah 9:7-15).

They became arrogant. They did not obey. They refused to listen. They failed to remember. They became stiff-necked. They rebelled. They returned to slavery. (Nehemiah 9:16-17).

But... You did not desert. You did not abandon. You did not withhold. You gave. You made. You told. You subdued. (Nehemiah 9:18-24).

They captured. They took. They ate. They reveled. They disobeyed. They killed. They committed awful blasphemies. They were oppressed. They cried out. (Nehemiah 9:25-27a)

You heard. You gave. You rescued. (Nehemiah 9:27b).

They did evil. You handed them over to their enemies. They cried out. You heard. You delivered. They became arrogant. They sinned. You were patient. They paid no attention. You handed them over. But in your great mercy, you did not put an end to them or abandon them, for you are a gracious and merciful God" (Nehemiah 9:29-31).

It seemed like God's people were wandering around in a circle, not making any progress at all because they kept circling back to old ways. But as I was pondering that thought, God showed me something significant. Like that go-kart helix, each cycle of the Israelite's rebellion that was followed by repentance took the Israelites to a higher elevation with God. *I call it the learning circle of life!*

Don't let the enemy deceive you into thinking you are not making any progress. As long as you keep turning back to God, He will take you to the next level of spiritual growth. Onward and upward, Christian Soldier; onward and upward!

~Rae Lynn DeAngelis

Balancing Act

I often hear people say: "Your health is at its best when life is balanced." "Your stress levels would decrease if your life was more balanced." "We all have the same 24 hours in a day; you need to figure out how to fit it in and balance it all."

We are told we need balance in our lives. At the same time, we are given skewed images and stories of what balance truly looks like. We're shown that balance is figuring out how to have the time for everything – food prep, exercise, career, volunteering, friendships, family time, dates with our significant others, quiet time with Jesus, cleaning the house, kids' activities, 8 hours of sleep, pursuing dreams, reading before bed, and doing it ALL while feeling happy, fulfilled, stress-free and balanced.

Wow, I don't know about you, but I feel stressed just reading that list and thinking how in the world I could possibly fit it all in and still feel sane.

Here's the thing, if you're only adding things to your life to try and create balance and better health, you're ultimately creating more stress and less health.

Balance is *not* trying to do all the things, trying to fit all the self-care into your current routine, increasing unnecessary stress and then feeling exhausted day after day. Balance is more about seeing what season of life you're currently in, deciding what your

top priorities are in that season, and then doing those things without feeling guilty for saying no to the others.

Currently, I'm in a season of mothering a young toddler with another baby coming in February. I went from working and having a lot of time for myself to staying at home with a toddler and not being able to use the restroom by myself. I went from zero sleep distractions to sleepless nights; easy to schedule quiet time or time with others to having to be more intentional with alone time with Jesus and every other relationship.

None of these shifts are bad in any way. I want balance because I want less stress and better health.

That's the point, correct?

I'm still figuring out exactly what priorities God wants me to have during this season (besides being a mama), and that's ok. I know that my health thrives when I'm juggling less and putting God first before it all.

Ask God what he wants you to be seeking and what he wants you to be letting go of to find your balance. It's less about doing all the things and more about focusing on the few He wants for you in your particular season.

"Answer me quickly, O LORD! My spirit fails! Hide not your face from me, lest I be like those who go down to the pit. Let me hear in the morning of your steadfast love, for in you I trust. Make me know the way I should go, for to you I lift up my soul" (Psalm 143:7-8).

~Kelsey Klepper

Because You're Worth It!

Perhaps you've heard the slogan, *"Because You're Worth It."* What a great marketing catchphrase, and what a remarkable statement about our true identity and value as children of God. Unfortunately, we often believe the opposite. We believe we are unworthy and undeserving of love, blessings, and accolades.

I can certainly relate to feeling unworthy and undeserving, especially when it comes to accolades. I honestly don't know what to say or how to react when someone gives me a compliment. Of course, I say thank you, but deep down I don't believe the statement is true.

I remember when my husband and I were newly married and he held me accountable for my moments of self-deprecation. I thought my lack of confidence was discreetly hidden, only to discover the truth— self-doubt was written all over my face. One day my husband said, "Every time I give you a compliment, you roll your eyes." (Wow, I had no idea that my lack of confidence was so blatantly displayed.) Then he said, "When you roll your eyes like that, it hurts. It's like you don't value what I think or how I feel about you."

OUCH! His words cut straight to my heart. I felt horrible. I had no idea my involuntary reaction was causing him pain. "As a prisoner of the Lord, then, I urge you to live a life worthy of the calling you have received" (Ephesians 4:1).

God has blessed me with this amazing and wonderful husband, a husband who to this day loves me unconditionally and

truly believes I'm beautiful. So much so that he calls me his Pretty Little Princess.

Here I am the luckiest bride in the world, and I was throwing his compliments (and ultimately his love) right back in his face. It was a hard lesson for me to learn but one that I will never forget.

I'm not going to lie. I still struggle to believe compliments when they come from others. But I can honestly say I now believe my husband's accolades as coveted words of truth, spoken directly from his heart.

God also has words of truth for His Bride too—you and me. Drink-in the love of God and truly *receive* His words of truth. Why? *Because you're worth it!*

- You are beautiful. (Psalm 45:11)
- You are chosen as God's special possession. (1 Peter 2:9)
- You are treasured. (Deuteronomy 7:6)
- You are set-apart. (Psalm 4:3)
- You are priceless. (1 Peter 1:18)
- You are strong. (Habakkuk 3:19)
- You are loved and worth dying for. (John 3:16)
- You are anointed. (2 Corinthians 1:21-22)
- You are God's delight. (Psalm 147:11)

~Rae Lynn DeAngelis

Stop Worrying

Our son gave me a bouquet of flowers for my birthday one year. It was a variegated rainbow of Alstroemeria, which is a type of lily. While I was feasting my eyes upon their beauty one morning, I was reminded of a Bible verse from the passage of Scripture called The Sermon on the Mount. "See how

the flowers of the field grow. They do not labor or spin. Yet I tell you that not even Solomon in all his splendor was dressed like one of these" (Matthew 6:28).

If you've followed Living in Truth Ministries for a while, you've likely heard us use the analogy that women are a lot like flowers; they come in different colors, shapes, and sizes and add unique fragrance to the world.

In that moment of appreciation for my vase of flowers, God whispered into my spirit, *Rae Lynn, tell my daughters to stop worrying. Worry has become an all-consuming mindset, and it is destroying their lives. It was never meant to be this way.*

Intrigued, I decided to look up this verse for its context. What I found blew my mind. "Therefore I tell you, do not worry about your life, what you will eat or drink… Is not life more than food, and the body more than clothes" (Matthew 6:25)?

Sweet sisters, we can be mindful of what we eat in the sense that we pay attention to our body's ques relating to our nutritional needs, but food is not something that we should stress, worry, or become anxious over. Food is a blessing from God. It is meant to be enjoyed. After all, God did give us taste buds. "Worship the Lord your God, and his blessing will be on your food and water" (Exodus 23:25). "Everything that lives and moves about will be food for you. Just as I gave you the green plants, I now give you everything" (Genesis 9:3).

If food is a blessing from God, why do we so often we act like it's a curse? "Some became fools through their rebellious ways and suffered affliction because of their iniquities. They loathed all food and drew near the gates of death" (Psalm 107:18).

I don't know of any other verse in the Bible that more accurately describes an eating disorder than Psalm 107:18.

Whether you are someone who loathes food, loves food, or has a love/hate relationship with food; remember; food is a blessing from God. It is meant for our good and is fuel for our body so we can live out the calling God has on our lives.

If food is something you continually stress over, I encourage you to commit this Scripture to memory.

> "Trust in the LORD with all your heart
> and lean not on your own understanding;

in all your ways submit to him,
 and he will make your paths straight.
Do not be wise in your own eyes;
 fear the LORD and shun evil.
This will bring health to your body
 and nourishment to your bones" (Proverbs 3:5-8).

And I encourage you to check out the resources Living in Truth Ministries has to offer. Our mission (represented by the acronym SEED) is to support, encourage, empower, and disciple women through the truth of God's Word. We will help you embrace your unique identity and bloom where you've been planted. To learn more, go to www.livingintruthministries.com.

~Rae Lynn DeAngelis

Let's Talk

I magine God pulling up a chair beside you. He looks straight into your eyes and says, "Let's talk. Tell me what happened. I really want to hear your side of the story. I care."

How secure do you feel about being brutally honest with God? (God already knows our hearts; see Psalm 139.)

It's okay for us to not be okay with what happened to us. Often, we need to confront or even forgive God, if we're angry with Him. If we want to move forward with God, we need to get honest and ask Him the tough questions, expressing how we truly feel. Injustices are all around us, and they're not going away. If we're to have an honest relationship with God, we can cry out, "Where are (or were) you? Why have (or did) you abandoned me?" "Why?"

Athol Dickson wrote, "I do not have the answers, God does. Sincere questions give God respect. They acknowledge his power. They honor him."

David, the fear-filled author of Psalm 22, and other psalmists were honest with God. They weren't afraid to tell Him what they thought in their songs and poems that put Him on trial.

Study the Psalms. When we do, we can't help but notice the Psalms seem to indicate that the long-awaited promise God's people have been waiting for will only be fulfilled through a time of intense suffering. Despite feeling dejected by God, the psalmists always believed God would lead them out of despair and looked forward to the future when God would rule over the entire earth. "He trusts in the LORD; let the LORD rescue him. Let him deliver him, since he delights in him" (Psalm 22:8).

We are given the psalms, and the book of Lamentations, I believe, so we can pray them, ourselves, out of our own pain and impatience. God knows we need to express ourselves. When times were tough, the psalmists pulled up what I call "God monuments'" out of their memory banks. They would look back at the great moments—monuments—of the past in order to re-frame the pain and puzzlement of the present, all within the hope of what God would one day do in the future.

The Bible is a record for us about how God has been faithful to His people throughout history so that our own faith and trust in Him can be strengthened. Keep your eyes and heart open: God shows up in ways we don't expect.

I guess if I'm going to ask to be more like Jesus, more Christlike, I have to be willing to endure hardship and pain. But I will hold onto His promise to guide me through my times of crisis and change.

"I will be with you; and when you pass through the rivers, they will not sweep over you. When you walk through the fire, you'll not be burned; the flames will not set you ablaze" (Isaiah 43:2).

"The LORD hears his people when they call to him for help. He rescues them from all their troubles" (Psalm 34:17).

~Kimberly Davidson

Filling Up

The gas gauge on my car was nearing empty, so I looked for the closest gas station. As I pulled up to the pump and rolled down my window, the attendant asked me, "Can I help you?" I reached down and pulled the release lever on the floor by my seat and said, "Yes, fill it up please?"

At that moment the trunk popped open. Apparently, I had pulled the trunk release instead of the gas tank release.

I apologized to the gas station attendant and explained how my car was new and I was still getting used to everything. He gave me a wry smile, but obviously didn't find the moment nearly as amusing as me.

I couldn't stop laughing! The idea of filling the trunk of my car with gas makes me giggle to this day.

Cars are fueled by gas, but people are fueled by God's Spirit. Unfortunately, when many people find themselves running on empty, they go to the wrong place to find fulfillment. They fill their lives with material possessions, money, substances, careers, relationships, and even food. Yet, fulfillment continues to elude them.

"Blessed are those who hunger and thirst for righteousness, for they will be filled" (Matthew 5:6).

We can never satisfy the longing in our hearts with the things of this world. True fulfillment comes from a relationship with Jesus. We need to recognize when our spiritual tank is running low and head to the place where we can be filled with what truly satisfies—*living water.*

"Jesus answered, "Everyone who drinks this water will be thirsty again, but whoever drinks the water I give him will never thirst. Indeed, the water I give him will become in him a spring of water welling up to eternal life" (John 4:13-14).

Have you spent adequate time filling-up on living water today? Don't go another day trying to quench your God-sized

thirst on the things of this world. Jesus is all you need to keep your spiritual tank running full speed ahead.

~Rae Lynn DeAngelis

Take Off Your Sandals

"**D**o not come any closer," God said. "Take off your sandals, for the place where you are standing is holy ground" (Exodus 3:5).

The last time I read the account of Moses and the burning bush, I wondered about God's unusual request to have Moses remove his sandals before coming any closer. While meditating on this thought, I was reminded of the year 2002—the most transformative time of my life so far.

By most standards, I was living the American dream: married to a loving husband, the mother of two great kids, had a beautiful home and terrific friends. I was even living my own personal dream of being a stay-at-home mom while caring for my family.

Even though I had all these wonderful things going on in my life, I still felt like something was missing. I was raised in the church and worshiped on Sundays, but I didn't start seeking God with all my heart until my mid-thirties. "You will seek me and find me when you seek me with all your heart" (Jeremiah 29:13).

By age 36, my relationship with God grew more intentional. I was like a sponge, soaking up every last drop of teaching that I could gather from Bible studies and sermon messages. I was even getting up extra early in the morning to spend time alone with God, uninterrupted. I was amazed at how relevant the Bible was to my everyday life, even though it was written thousands of years ago. Day by day, I grew closer to God and started to experience the many positive effects that result from a close relationship with

Him. But after a while it was as if I hit a plateau. I wanted to go deeper with God, but for some reason I couldn't get there.

Then God revealed to me why. I had been holding a 25-year secret, and it was getting in the way. It was as if God was saying, *Rae Lynn, the place where you are standing is holy ground. Before you can come any closer to me, there is something you must "take off." Something which is keeping you from experiencing the full measure of my presence.*

The sandals were a symbolic gesture, signifying something profound: the purest encounters with God require total abandonment, complete transparency, and the removal of that which is unholy, profane, or has become a stronghold over our lives (something which we feel powerless to overcome on our own).

In addition to being a stronghold, my eating disorder behavior displayed a complete disregard for God's temple—my body. "Do you not know that your bodies are temples of the Holy Spirit, who is in you, whom you have received from God? You are not your own; you were bought at a price. Therefore honor God with your bodies" (1 Corinthians 6:19-20).

Deep down I knew what I was doing was wrong, but it wasn't until the scale tipped (no pun intended) and my desire for a deeper relationship with God outweighed my desire for the love and approval of others that I had proper motivation to get well.

Is there something in your life God is asking you to remove, something that has kept you from experiencing the full measure of God's life-transforming power?

Sweet friend, let Jesus help you remove those "sandals" once and for all.

"Come to me, all you who are weary and burdened, and I will give you rest. Take my yoke upon you and learn from me, for I am gentle and humble in heart, and you will find rest for your souls" (Matthew 11:28-29).

"I will give them an undivided heart and put a new spirit in them; I will remove from them their heart of stone and give them a heart of flesh" (Ezekiel 11:19).

~Rae Lynn DeAngelis

Are You Regular?

R egular? *What's that about?* Yes, it's exactly what you think…

I was getting ready to run a half marathon with 5 other friends, and we were staying in an Airbnb in Nashville, TN. Being girls who are pretty open, we talk about this stuff. Part of the strategy around running a race is planning when and if you'll have to stop and use the port-o-pot. No one wants to do that. So you try to time your bathroom break before your run, or at least hope to.

I started pondering this – call me weird, but I think God uses pretty much everything in our lives to point us to Him and I invite Him to do so. I thought about what happens when we go. We rid our body of all the useless stuff we don't need, mostly toxins and waste. If our body doesn't do this regularly, then we could be in hot trouble or even die.

I thought about this and how I have toxic, useless, and even deadly stuff enter my mind on a daily basis: some from others, some by accident, some on purpose, some by sight, some from lies, some from thoughts that aren't pure or pleasing to the Lord, and some from words that stumble out without thought. And if I don't take time each day to clear my head, get rid of the junk, repent for believing the lies, and confessing my sin, then it builds up and can even kill me – spiritually and emotionally.

When I choose to compare my body with others, look at the world's standards of beauty, and keep believing that I'm not enough until I reach "perfection," then I will be stuck, sitting in the pit during the Race that He's called us to run with everything we've got.

So it has to be an intentional practice that I plan each day to clear my mind and get rid of the toxins. I need a strategy, a plan. I

have to be in training. I can do this by ingesting the Word (Truth), being with the Holy Spirit (Living Water), Praying (repenting and blessing), and Worshiping (giving God the glory He deserves).

If I'm not careful and am not intentional with my life, I will die a slow spiritual death, get numb and complacent and maybe give up on healing. And I might NOT even know it's happening.

So, I ask you one question? Are you regular? Are you spending time with the One who can cleanse us from the inside out and who died for us? Do it. Prioritize it. And I guarantee, you will run this race. It will be the best part of your day, and He will say well done good and faithful servant.

"Therefore, since we are surrounded by such a great cloud of witnesses, let us throw off everything that hinders and the sin that so easily entangles. And let us run with perseverance the race marked out for us, fixing our eyes on Jesus, the pioneer and perfecter of faith. For the joy set before him he endured the cross, scorning its shame, and sat down at the right hand of the throne of God. Consider him who endured such opposition from sinners, so that you will not grow weary and lose heart" (Hebrews 12: 1-3).

"Then he said to them all: "Whoever wants to be my disciple must deny themselves and take up their cross daily and follow me" (Luke 9:23).

~Alison Feinauer

Dress Rehearsal

There's much preparation that goes into planning a wedding. Months and sometimes even years before the celebration takes place, details are meticulously considered and set in place to ensure the day is encumbrance free. As the wedding day quickly approaches, a bride and groom ready

themselves to share the rest of their lives together. One of the most important preparations for the ceremony is the rehearsal. The rehearsal is a 'dry run' of sorts that usually takes place the night before the wedding. During this practice time, each person in the wedding party gains a better understanding of their part in the ceremony.

"Let us rejoice and be glad and give him glory! For the wedding of the Lamb has come, and his bride has made herself ready" (Revelation 19:7).

Scripture often refers to the blessed union between a man and woman as the dress rehearsal for what is to come when we meet Jesus face to face in heaven. We are told in God's Word that the church is the bride of Christ. Over and over, Scriptures contrast our relationship with Christ as a type of marriage.

"As a young man marries a maiden, so will your sons marry you; as a bridegroom rejoices over his bride, so will your God rejoice over you" (Isaiah 62:5).

"Jesus answered, 'How can the guests of the bridegroom mourn while he is with them? The time will come when the bridegroom will be taken from them; then they will fast'" (Matthew 9:15).

"I saw the Holy City, the new Jerusalem, coming down out of heaven from God, prepared as a bride beautifully dressed for her husband" (Revelation 21:2).

"One of the seven angels who had the seven bowls full of the seven last plagues came and said to me, 'Come, I will show you the bride, the wife of the Lamb'" (Revelation 21:9).

Inspired by God, Paul explains God's desire for earthly marriage. "Wives, submit to your husbands as to the Lord" (Ephesians 5:22). Submission takes an enormous amount of trust. We have to believe that the other person has our best interests at heart. Unfortunately, in our earthly relationships, this is not always the case. Even so, I still believe marriage is intended to

help teach us this concept so that we can better understand Christ's desired relationship with us. He wants us to trust Him completely.

Likewise, Paul gives instructions to husbands: "Husbands, love your wives, just as Christ loved the church and gave himself up for her to make her holy, cleansing her by the washing with water through the word, and to present her to himself as a radiant church, without stain or wrinkle or any other blemish, but holy and blameless" (Ephesians 5:25-27). Husbands are called to love their wives as Christ loved the church.

How did Christ love the church? To put it bluntly, He died for her. He gave up His life for her so we could have eternal life with Him. The sacrificial love that is intended for marriage helps us better grasp the love Jesus has for His Bride—the Church.

Marriage is the dress rehearsal, preparing us for the day when we see our Groom face to face.

"Blessed are those who are invited to the wedding supper of the Lamb" (Revelation 19:9a).

~Rae Lynn DeAngelis

Making Space for God

When my smartphone didn't have a lot of internal storage, I often had to delete or upload files to my computer so I could free up space for other things.

Before our trip to Florida, I realized I wouldn't have computer access while we were on vacation, so I decided the best thing for me to do was to temporarily delete a few of my apps. In doing so, I could free up space to take pictures and videos while we were gone.

Normally, I listen to all kinds of uplifting and encouraging messages through my Podcast app, but it was one that needed to go, because it was taking up way too much space on my phone.

At first, I was hesitant to delete it. But then I reasoned that I could easily upload it again when I got back from vacation. As the saying goes… *out of sight, out of mind.*

A few weeks after we had returned home, it felt like I was 'coasting' spiritually. Even though I was reading my Bible and praying each morning, there was still something missing. I couldn't quite put my finger on what it was until my friend sent me an inspiring sermon message by Holly Furtick of Elevation Church. It was so uplifting!

All at once it hit me as to why I was feeling so depleted. My Podcast app was still missing from my phone. As a result, I hadn't been filling up with the great teachings like I usually do.

Recognizing the problem, I immediately re-uploaded the app and began listening to all my favorite preacher and teachers again.

Whether I'm heading to a meeting, or out running errands, listening to Christian podcasts in the car is one of my favorite ways to be encouraged in my journey with God. And it makes my drive time feel much more productive.

Friends, we live in unprecedented times with more opportunities to grow spiritually than ever before. No more coasting as Christians, and no more excuses. Take advantage of this technological age and carve out some much-needed time and space for God (even if it means taking up valuable real estate on your phone).

"Teach me your way, Lord, that I may rely on your faithfulness; give me an undivided heart, that I may fear your name" (Psalm 86:11).

"You will seek me and find me when you seek me with all your heart" (Jeremiah 29:13).

~Rae Lynn DeAngelis

Embrace the Next Chapter

Recently, I closed a chapter of my life and opened a clean page of a new one. The following pages of this chapter remain blank and the title unknown to me. The pen remains in the hand of God. I am walking one step at a time and completing one day at a time without a clue how this will turn out.

Just a year ago, I would have run in the opposite direction of such uncertainty. The unknown sent anxiety racing through every fiber of my being, because I like having a plan or knowing the outcome. I like to strategically follow the plan to a T and see predicted results come to fruition.

Over the past year, multiple layers of my "old self" were shed. Life threw situations into my path that hurt deeply. This hurt turned into positive change and growth in spirit. I've realized that life is more than outward appearance, approval from others, accomplishments posted on social media, or money in the bank. Life is about shining the Light of Jesus in every place you enter. Life is about loving others as they are in that moment. Life is about grace, forgiveness, and standing strong on God's Word.

The way of Christ is to put off your old self, which belongs to your former manner of life and is corrupt through deceitful desires, and to be renewed in the spirit of your minds, and to put on the new self, created after the likeness of God in true righteousness and holiness (reference: Ephesians 4:20-24).

I cannot explain in words what has changed, but I can tell you that my God-Confidence continues to rise. I hold a strong passion to leave this world better than I entered it. Okay, so I may not

change the world in a big way, but I do want to change every place I enter for the better. This new chapter in life gives great opportunity to spread His Light.

I walk through the open door with confidence. Not because I believe success is guaranteed. I walk through with confidence knowing that God is holding my hand. He has proven time and time again to remain by my side. He is asking that I walk confidently with Him, putting old ways behind, old ways of fear, failure, demeaning self, and living safe. A recent quote I read on Pinterest (Don't judge. I love Pinterest.) said, "Don't fear failure. Fear being in the exact same place next year as you are today." ~anonymous

Life is challenging. Failure is inevitable. We are not perfect. These facts do not mean we need to play it safe. Take that leap of faith. Try that new adventure. Grow in spirit. Above all else, walk in God-Confidence. If He leads you to an open door, He will provide all you need along the path. Knowing if He is the one who opened the door is the difficult part. Prayer, listening, prayer, and listening some more must come before walking through an open door. Opportunities happen every single day, but Satan may be the one opening a door to the opportunity. The world could be the one pressuring you to walk through a door of opportunity. Proceed with prayer through any open door.

God will provide discernment. God will lead you down a path He paved for you. He holds a mighty purpose along your journey in this life. Listen closely to hear the direction He chooses. It may mean walking forward without a plan, seeing blank pages in this chapter of life and with uncertainty of outcome. I can guarantee you that if God guides you to a new chapter/opportunity in life, He knows the plan, what to write on the pages each day, and the outcome. He will see you through dear friend.

~Sheree Craig

Time is Running Out

In football, as long as there are minutes on the game clock, points can be scored. In the last three and a half minutes of one particular game that my husband and I were watching, there were five changeovers between the two teams. That's crazy. The game was nearly over; yet, I saw more excitement in the last three minutes of the game than the three previous quarters combined. It seemed that neither team grew serious about winning until the game was nearly over.

Sometimes we take on a similar attitude in this game called life. It's not until we realize our years are nearly over that we suddenly get serious about living.

"Show me, O LORD, my life's end and the number of my days; let me know how fleeting is my life" (Psalm 39:4).

Several years ago, there was an endearing movie called *The Bucket List,* which depicted two terminally ill men who decided to live their final moments doing all the things they wished they'd done earlier in life.

Why is it that we often put off until tomorrow the things that we could just as easily do today?

I have more than a few years under my belt at this point in life and am becoming more and more aware of my own mortality. According to statistics, my life is more than halfway over. That's a sobering thought!

"For my soul is full of trouble and my life draws near the grave" (Psalm 88:3).

We're all going to die—that's a given. It's the one thing that we all have in common. Why not make the most of the time we have on earth and leave an impact that lasts long past our departure. As long as we have breath, let's live life to its fullest.

I don't know about you, but I still have plenty of places to go and people to meet.

Are there things you would still like to do in life? Don't wait for the final moments of the game to get serious about living. Time is running out. Start living life to the fullest today while you still have a couple of quarters left in the game.

After all, Jesus said, "I have come that they may have life, and have it to the full" (John 10:10).

~Rae Lynn DeAngelis

Removing the Labels

Do you have a pet peeve, something that irritates you or gets on your very last nerve? I have a few. Clutter is one. Commercials are another. But the thing that I despise most, that which drives me absolutely insane, is something that perhaps you haven't given much thought or attention to—*tags on clothing.*

Tags have grown to be such a huge pet peeve that the first thing I do when I purchase new clothing is cut them out. Size, designer label, care instructions—I cut every one of them out.

Why?

It's more than just the way labels are scratchy and irritate the back of my neck. And it's not just the aggravation I experience when a tag flips up and hangs outside my shirt. What I hate most about tags on clothing is the way they make me feel on the inside, like my character is somehow flawed because of what the label says in relation to size.

The labels that society places on people greatly frustrate me too: fat, thin, tall, short, rich, poor, smart, dumb, black, white… you name it; our society has a label for it.

Sadly, some of these labels follow us all the way through life. We allow them to define us, and in some cases, they become self-fulfilling prophecies. We don't just believe what society says. We act upon it too.

The children's book by Max Lucado, *You Are Special,* holds a profound truth about humanity. We are special, and our value and worth have nothing to do with what society says. Our true value, worth, and identity can only be defined by the One who made us—God.

"For you created my inmost being; you knit me together in my mother's womb" (Psalm 139:13).

When we truly believe what God says about us versus what man says about us, the labels no longer stick.

My favorite line in the story of Punchinello (a boy who's feeling downtrodden by the ugly dot stickers given to him by the other Wemmicks) is when Eli the Woodcarver tells him, "The stickers only stick if they matter to you."

You and I are *not* the sum of a tag on our shirt, the number on a scale, or the careless comments of our ill-informed peers. You and I are daughters of the King, made in His image, and we are precious in His sight.

Like tags on a brand-new shirt, remove the label and *only* focus on the identity God has given you.

~Rae Lynn DeAngelis

Buyer Beware

"Buyer beware!" has become a well-worn phrase. At one point or another, we've probably all been led to believe that a product will leave us 100% satisfied, but after we have purchased the item, we found out otherwise.

There was a woman who wanted a nose job, but didn't have the money to get it done. She found out about a "doctor" in South America who did plastic surgery at minimal cost. She had a preliminary phone consultation to get an appointment. The doctor explained what the surgery involved, and this woman excitedly underwent the procedure. After she woke up from the anesthesia, she said she was in a great amount of pain, and then.... the horror. She said it was like waking up to her worst nightmare, a mutilated face. As I watched the interview my heart went out to her. Her face was extremely disfigured. The so-called physician was later incarcerated for illegally posing as a doctor. Not only did he botch the procedure, but the tools used were not sterilized and this woman developed an infection.

Take caution, Satan is a master liar, poser, and thief. He can use seemingly harmless things, people, or situations to lure us in. It might look good and sound good at first, but after we've bought into the lie, we're in a horrible mess.

I bought one of his lies many years ago, and believe me, it has been a nightmare! Thankfully, God makes beauty out of ashes! Satan used the combination of wanting to lose weight, feelings of loneliness and confusion, and pent-up anger and bitterness to lure me in. I thought that if I could lose weight, I'd be happy and everything would fall into place.

Totally wrong! At first, I got compliments and felt good about the weight loss, but the only thing the "seller" (Satan) didn't reveal was that my fall into temptation came at a high price. It cost me my health, relationships with God and others, happiness, freedom, and it could have even cost me my life.

We may be tempted in areas and not even realize we're being lured in. Has someone enticed you to take "just a peek" at pornographic materials? Are you gambling more and more each day? Did a coworker invite you to go out after work hours, yet you are married? Has a friend's spouse looked at you lustfully, and it made you feel good? Has a friend invited you to a wild party with drugs?

There are so many temptations out there and Satan knows the exact ones that will snag us. Satan makes no exceptions; if you are human, you will be tempted!

"Be sober, be vigilant; because your adversary the devil walks about like a roaring lion, seeking whom he may devour" (1 Peter 5:8 NKJ).

"Watch and pray, lest you enter into temptation. The spirit is willing, but the flesh is weak. The same sufferings are experienced by your brotherhood in the world" (1 Peter 5:9 NKJ).

God will make a way out and strengthen you to resist each temptation that comes your way. "No temptation has overtaken you except such as is common to man; but God is faithful, who will also make a way of escape, that you may be able to bear it" (1 Corinthians 10:13 NKJ).

~Rhonda Stinson

Be Still

The other day my bible study instructed me to walk outside and spend some time absorbing the beauty of God's creation. "Do it right now," the author prompted, "because if you wait until later, you'll never do it."

She was probably right! My intentions may be good, but all the distractions and daily activities would get in the way, and I would surely forget.

I'll be honest with you, at first, I thought to myself... *Okay, let's get this thing over with so I can check it off my list; I've got a lot to do today.* (Frankly, it seemed like a waste of time to simply sit and do nothing.) And yet being the obedient student that I am, I followed my teacher's instruction to the letter.

It was early morning when I stepped outside, and there was a brisk chill in the air. I sat down on my front porch step to take in all the sights, smells, and sounds. At first, I didn't hear, see, or notice much of anything. But... the longer I remained quiet, the

more perceptive my senses became. The time that I spent being still, slowly developed into a peaceful time and quiet worship to the Lord.

"Be still before the LORD, all mankind, because he has roused himself from his holy dwelling" (Zechariah 2:13.)

During those times when we are not feeling God's presence or hearing His voice, perhaps it is because we are not taking time to be still before Him. I learned a valuable lesson through my experience that day.

It seems that the prophet Elijah learned a similar lesson many years ago.

> "The LORD said, "Go out and stand on the mountain in the presence of the LORD, for the LORD is about to pass by. Then a great and powerful wind tore the mountains apart and shattered the rocks before the LORD, but the LORD was not in the wind. After the wind there was an earthquake, but the LORD was not in the earthquake. After the earthquake came a fire, but the LORD was not in the fire. And after the fire came a gentle whisper. When Elijah heard it, he pulled his cloak over his face and went out and stood at the mouth of the cave" (1 Kings 19:11-13).

Like it was with Elijah, we must quiet ourselves long enough to distinguish God's voice above all the others.

I encourage you to take some time today to be still before the Lord. I promise you; it's not a waste of your time, and you will be blessed.

If it's possible for you to do it right now, go outside and take in the beauty of God's creation. Listen closely for God's gentle whisper, and when you sense His presence, give Him the praise and worship He appropriately deserves. Do it now, because if you wait until later, you probably won't do it at all.

"Be still, and know that I am God; I will be exalted among the nations, I will be exalted in the earth" (Psalm 46:10).

~Rae Lynn DeAngelis

My Dreams Are Me

Our dreams and aspirations can be so tightly woven into the fabric of our existence, we mistake them for our core identity. It's one of the reasons anorexics continue to restrict, bulimics purge, and over-exercisers workout despite failing health and strained relationships.

What drives these unhealthy behaviors includes a yearning for approval and acceptance, the ideal body, or ultimate self-control. One mistakenly thinks: *My dreams are me.*

The song "Surrender" by Barlow Girl sheds light into our human condition. Like poetry, the lyrics of this song reach deep into the soul and illuminate the unspoken truth of our heart's desire.

> *My hands hold safely to my dreams*
> *Clutching tightly not one has fallen*
> *So many years I've shaped each one*
> *Reflecting my heart, showing who I am*
> *Now you're asking me to show*
> *What I'm holding Oh so tightly -*
> *Can't open my hands; can't let go*
> *Does it matter?*
> *Should I show you?*
> *Can't you let me go?*
>
> *Surrender, surrender*
> *You whisper gently*
> *You say I will be free*
> *I know but can't you see*
> *My dreams are me. My dreams are me...*

Dreams propel us through life with careful precision. They direct our experiences and influence our decisions. It's okay to chase dreams, but let's be wise. Let's make sure that *what* we are holding "oh so tightly" lines-up with God's ultimate plan and purpose for our lives. "For I know the plans I have for you," declares the Lord, "plans to prosper you and not to harm you, plans to give you hope and a future. Then you will call on me and come and pray to me, and I will listen to you. You will seek me and find me when you seek me with all your heart" (Jeremiah 29:11-13).

The Holy Spirit will reveal whether our longings are part of God's good, pleasing, and perfect will for our lives. If our dreams are truly from God, we have His permission to pursue them. If they are born from the flesh (brought on through this broken world's deception) we need to unclench our fists, let go, and trade our dreams for His.

"Those who live according to the flesh have their minds set on what the flesh desires; but those who live in accordance with the Spirit have their minds set on what the Spirit desires" (Romans 8:5).

"Do not conform to the pattern of this world, but be transformed by the renewing of your mind. Then you will be able to test and approve what God's will is—his good, pleasing and perfect will" (Romans 12:2).

Holy Spirit, have your way in me. Lead me towards Your dreams, goals, and aspirations. I want to fulfill your perfect plan and purpose. Me in You and You in me; only then will my dreams be me.

"He fulfills the desires of those who fear him; he hears their cry and saves them" (Psalm 145:19).

~Rae Lynn DeAngelis

Seasons of Waiting

Am I the only one that feels like I'm constantly in a season of waiting? I'm waiting for the family vacation so I can have a break. I'm waiting for Friday, so I can have the weekend. I'm waiting for prayers to be answered. I'm waiting for my mind to slow down, for the overwhelm to cease. I'm waiting for bed time and a hard day to be over. I'm waiting on a text from a friend. I'm waiting for the day that I can figure this mom thing out. I'm waiting for less sleepless nights.

When I was in the depths of my disordered eating and negative body image thoughts, it was always about waiting for the weight to come off, my body to look a certain way, the 'willpower' to say no to food... I was always waiting to live my life, always waiting for freedom.

During the Christmas season, I'm also waiting, waiting for the parties and the giving of presents. I'm waiting for days of celebration with family and friends, but I'm also waiting for it to be over so I can rest.

And in the midst of all the waiting, I lose sight of what I am really waiting for. I'm waiting for Him and all that he provides: a full heart, overwhelming peace, joy, contentment, freedom... But I don't need to be waiting on Him at all because He's already come and given His life for me. He's the One who has been waiting for me to choose Him.

Friends, Jesus is here right now waiting for you to say yes to Him every day. He's waiting on you to find peace through Him. He's waiting on you every second of the day to turn to Him. He's offering to us what we're really waiting for—freedom. We don't need to feel like we're in a constant state of waiting any longer. We do not need to wait on what has already come and is here now.

Stop waiting on the lies of the world to determine your life and start living His truth. He's waiting and will always wait for you.

"May the God of hope fill you with all joy and peace as you trust in him, so that you may overflow with hope by the power of the Holy Spirit" (Romans 15:13).

~Kelsey Klepper

Leave a Trail

I am someone who would much rather sit back and follow orders than take the lead. However, as I grow in my relationship with the Lord, God repeatedly takes me out of my comfort zone and places me into positions of leadership.

If you would have asked several years ago if I could see myself leading a ministry to help women break free from disordered eating and grow in their relationship with God, I would have said, "No way!" This would be partly because I was still in bondage to an eating disorder myself, but also because I was fairly new in my relationship with God. I believed that I needed to rely on my own strength and resources if I was going to accomplish whatever God was asking me to do. That was so very far from the truth.

I have since learned that God seldom uses people who have the best ability to fulfill his grand purposes. In fact, He almost always uses people who have absolutely no earthly credentials to carry out a specific task. In this way, God receives all the glory for what He accomplishes through you.

> Brothers, think of what you were when you were called. Not many of you were wise by human standards; not many were influential; not many were

of noble birth. But God chose the foolish things of the world to shame the wise; God chose the weak things of the world to shame the strong. He chose the lowly things of this world and the despised things—and the things that are not—to nullify the things that are, <u>so that no one may boast before him</u>. It is because of him that you are in Christ Jesus, who has become for us wisdom from God—that is, our righteousness, holiness and redemption (1 Corinthians 1:26-30).

Every step that God leads me on this journey is completely uncharted territory. Honestly, most of the time, I have absolutely no idea what I'm doing. I am genuinely surprised to see what God accomplishes through my meager offering.

It's not about our *ability*. It's about our *availability*.

Are you ready to take that leap of faith? "Do not follow where the path may lead. Go instead where there is no path and leave a trail." ~George Bernard Shaw

Perhaps God is asking you to travel a road where there is no path so you can leave a trail for others to follow. Jesus will go before you and be your guide, and He will clear away any obstacles you encounter. Then, when you look back and see how far you have come and see others following behind, be sure to give God all the glory because it's only possible through Him.

"Therefore, as it is written: 'Let him who boasts boast in the Lord'" (1 Corinthians 1:31).

~Rae Lynn DeAngelis

Never Let Them See You Sweat

Being vulnerable goes against every inclination of the human heart. From the time we are very young, we are encouraged to be tough, hide behind our true feelings, and as the tag line for Gillette's roll-on antiperspirant touted—*never let them see you sweat!*

The idea behind this axiom became an unspoken catchphrase in my life—never let people see the real you, the broken you, the disordered you. But by the time I'd hit my mid-thirties, God began teaching me a new life mantra—*authenticity.*

Authenticity was in stark contrast to the through-line I'd clung to for years—secrecy and shame. The new refrain implored me to break down my self-built walls and come out from behind my carefully crafted cover girl mask. God was asking me to stop hiding and start living—to show the world the real me.

The first time I'd had a chance to see this kind of truth played out in real life was through a woman I grew to love and respect greatly. Her name is Anita. We met at Bible study and attended the same church together, but it wasn't until sometime later that I would hear her whole story—a story that rocked my world and changed my perception of being "real" forever.

Anita shared her testimony in front of our entire church congregation and held nothing back. She was raw, real, and relatable. She talked authentically about her teenage daughter's death and how, if she had not received Christ's healing and forgiveness before her daughter's death took place, she probably would have believed God was punishing her for an abortion she

had when she was a teenage girl herself. Her powerful story revealed that our God is a God of forgiveness, love, and grace—not condemnation.

"Therefore, there is now no condemnation for those who are in Christ Jesus, because through Christ Jesus the law of the Spirit who gives life has set you free from the law of sin and death" (Romans 8:1-2).

I had never heard anyone be so forthright about the intimate details of her life before, especially with such sincerity. I remember being surprised by my emotionally charged reaction afterwards. Instead of seeing Anita as weak, I saw her as the strongest woman I'd ever met.

God used this woman's testimony to pave the way for my own public unveiling at a women's retreat when I chose to talk openly about my battle with bulimia for the first time. With my feet planted firmly on the road to freedom, I was eager to talk about the faithfulness of God and how He had set me free through the truth of His Word.

Many are afraid to remove their masks and be real because they fear rejection or chastisement that will most certainly follow. But that's a lie straight from the pit of hell. That's what the enemy wants you to think.

But here is the truth: Broken does not mean branded for life—not in God's economy.

So… go ahead, girlfriend. Remove that mask, and let them see you sweat.

"[God] heals the brokenhearted and binds up their wounds" (Psalm 147:3).

~Rae Lynn DeAngelis

God's Bigger Plan

My husband and I didn't have any children by choice. He had two boys from a previous marriage and didn't want any more children. I, being a people-pleaser, coupled with the desperate 'urge to merge,' went along with his request. *I don't want to lose him! Plus, I'm almost 37-years-old. I mean, I'm getting too old to be running around after babies*—I rationalized.

I created a nice, pretty Band-Aid I could put over my feelings of grief, of not experiencing the joy of parenthood. I drowned my voice and heart in order to preserve the relationship. Denying and burying my feelings was the easiest course.

We each have plans and dreams. And maybe that is what you're facing now—the loss of a dream. You planned on being a mom by now; you planned on having your degree; you planned on being happily married; you planned on your kids being happy and healthy; you thought God would be for you and not against you … the list goes on.

I don't know what your dreams are or were, but dear friends, rest assured—God's got something good planned for you.

In the Old Testament, through a prophet named Jeremiah, God revealed that it was He who allowed His people to be taken into exile in Babylon. They had grossly disobeyed God repeatedly. Worse, they'd have to be there for 70 years! That's a whole generation. I'm sure they scratched their heads, *Not what we planned!*

Because God is love and goodness, He also gave Jeremiah some good news to relay to His people. Scripture reads,

> This is what the LORD says: "You will be in Babylon for seventy years. But then I will come and do for you

all the good things I have promised, and I will bring you home again. For I know the plans I have for you," says the LORD. "They are plans for good and not for disaster, to give you a future and a hope. In those days when you pray, I will listen. If you look for me wholeheartedly, you will find me. I will be found by you," says the LORD. "I will end your captivity and restore your fortunes. I will gather you out of the nations where I sent you and will bring you home again to your own land (Jeremiah 29:10-14).

God had a plan. So, they had to decide whether they would have faith in God's plan, and wait it out, or throw up their hands up in despair and disappointment.

Thankfully, God has a plan for all of us, even when we are unfaithful. As you navigate your way through God's transformation journey, consider it an opportunity to trust God with the bigger plan. He has never had any desire to harm you— only to prosper you—to give you a hope and a good future.

~Kimberly Davidson

Stay Faithful and Obedient

The Lord never called any of us to be successful – only to be faithful. My obligation is to do the right thing. The rest is in God's hands ~God's Little Devotion Book for Leaders.

Many times, this little quote has kept me in-check. It is so true; we are only called to be faithful and obedient. If we have sincerely carried out the task to the best of our ability, then we needn't fret about the outcome. God will take our offering and use it for His glory and purpose. Here's another quote that helps to keep me in-check:

> The snare in Christian work is to rejoice in successful service, to rejoice in the fact that God has used you. You never can measure what God will do through you if you are rightly related to Jesus Christ. Keep your relationship right with Him, then whatever circumstances you are in, and whoever you meet day by day, He is pouring rivers of living water through you, and it is of His mercy that He does not let you know it. ~Oswald Chambers, *My Utmost for His Highest*

"Be diligent in these matters; give yourself wholly to them, so that everyone may see your progress" (1 Timothy 4:15).

"So do not throw away your confidence; it will be richly rewarded. You need to persevere so that when you have done the will of God, you will receive what he has promised" (Hebrews 10:35-36).

"Then Jesus said to his disciples, 'If anyone would come after me, he must deny himself and take up his cross and follow me. For whoever wants to save his life will lose it, but whoever loses his life for me will find it'" (Matthew 16:24-25).

"So we fix our eyes not on what is seen, but what is unseen. For what is seen is temporary, but what is unseen is eternal" (2 Corinthians 4:18).

We may never know the full impact of our obedience to each of the Lord's commands or how our faithfulness is being used in the Kingdom of God. We also may never see the fruit it bears. But this we can know: God doesn't waste anything; He uses it all.

The great thing to remember is that we go up to Jerusalem to fulfill God's purpose, not our own. ~ Oswald Chambers, *My Utmost for His Highest*

~Rae Lynn DeAngelis

Dear Younger Me

C onfession time. There are days (probably more than you might expect) that I work in my pajamas. If I don't have to leave the house and no one is at home (not even my husband), it just doesn't make sense to change out of something that's so comfy. Those who know me well are probably a little shocked by my admission, especially since I'm often complimented on being so "put-together". (If they only knew.)

Being over fifty has its advantages. It seems my accumulation of trips around the sun has changed my perspective and priorities. Well, that and a little encounter I had with God.... *Hi, my name is Rae Lynn, and I'm a recovering approval addict.*

I had spent the last five decades of my life worrying about what others think of me way too much. I've finally come to the realization that it's just not a good use of my time.

"Am I now trying to win the approval of people, or of God? Or am I trying to please people? If I were still trying to please people, I would not be a servant of Christ" (Galatians 1:10).

Staring back at my reflection early one morning, I saw a glimpse of younger me. It was surreal. It was as if God had wanted to take me back to a time when I felt intense pressure to be perfect so that He could bring healing to my soul.

As a young adolescent I would spend hours each day putting on makeup, fixing my hair, and getting dressed... even when I didn't have to leave the house! As the song says, perfection was

my enemy. I felt deep discontentment with who I was and believed that if I could somehow get the outside right, the inside would feel right too. It didn't work. I grew increasingly dissatisfied with who I was and even turned to bulimia as a means to gain control.

Looking in the mirror one particular morning, I felt a wash of God's love and acceptance. It was as if He was saying, *Rae Lynn, you are beautiful just the way you are—no makeup, tousled hair, wrinkled pajamas and all. Beauty that I esteem has nothing to do with outward appearance. Your beauty radiates from within; it cannot be measured by human ideals, so quit trying to quantify your worth by the world's broken standards.*

"The Lord does not look at the things man looks at. Man looks at the outward appearance but the Lord looks at the heart" (1 Samuel 16:7).

It all happened in a split second; yet in that brief exchange, God brought forty-plus years of healing to my soul.

I pray you do not struggle with feelings of unworthiness like younger me. I pray you can look in the mirror and see what God sees—beauty—*even when the world says you're at your worst.*

Here's the truth: The more we try to be perfect on the outside, the less fulfilled we feel on the inside. Take it from someone who knows. Don't let another year go by without finding internal peace with the past, present, and future you.

Dear Younger Me, I'm sorry that I allowed the world to dictate your worth. I release you from those worldly pressures and I want you to know that I love you just the way you are—no makeup, tousled hair, wrinkled pajamas and all. You are beautiful and worthy. Oh, and one more thing... don't let anyone tell you that you can't stay in your pajamas every now and then. It's totally okay!!

~Rae Lynn DeAngelis

Fear of Not Enough

I don't know about you but when I go on a trip, I pack everything but the kitchen sink. I start making my list, and then after I make my list, I grab a few more things I "may" need. We go camping quite a bit. I like it because, basically, I can take my whole house. I start by packing all the food, then all the clothes I may need to wear, including 3 different bathing suits, then all the electronics and the cables we may need to charge all the devices and maybe a few movies for the ride. I can't forget my husband's sleeping pills. And, oh yeah, I may need a few more shoes. I also take pictures of my devotionals so I don't have to actually take the books. The list goes on and on.

It's overwhelming. By the end of packing, I don't even want to go. My husband looks at my seat and asks, "Where are you going to sit?" I just chuckle. I don't actually need to put my feet on the floor, do I?

I asked a friend to go to the store for me and get some extra tortilla shells because I didn't think we had enough for a party we were having. I asked for three packs of ten shells. He came back with seven packs of ten shells. I also asked for fifty paper plates. He came back with two packs of one-hundred paper plates. I was quickly frustrated that he thought what I asked for was not going to suffice and spent even more money.

I started thinking about what drives this behavior: fear. It's very clearly the fear of not having enough. This to me also translates into my deep fear of not being enough.

Fear has a way of driving our behaviors and leading us into irrational thinking, packing, planning, buying, you name it. It produces many things in us. Left unnoticed, it will suck the life

and joy right out of you. Self-sufficiency is the enemy of God being the all sufficient one for us.

He is a God of abundance who provides for all of our needs. He is more than enough. He is the God of resupply. He knows exactly what we need, and is more than happy to provide for us: physically, emotionally, in all ways.

I'm a work in progress on this. I wonder what would it look like if I feared less, and trusted Him more. What if I trusted that his perfect love is more than enough for me?

Is there an area you are relying on yourself more than God to provide?

Are you overdoing an area where you can ask God to help you trust him more?

God, thank you for your love and provision. We need you to help us trust you more. Take us beyond ourselves into relying on you more. Help us to identify fears we have so that we can bring them into the light. Help us to pack light and simply. Give us wisdom we need for our day. In Jesus' Holy name I pray. Amen.

"And my God will meet all your needs according to the riches of his glory in Christ Jesus" (Philippians 4:19).

"Look at the birds in the sky! They don't plant or harvest. They don't even store grain in barns. Yet your Father in heaven takes care of them. Aren't you worth much more than birds" (Matthew 6:26 CEV)?

~Alison Feinauer

The Lord Provides

During a time when I was overwhelmed and stressed, I started making a lot of careless mistakes; my mind was in a bit of a fog. Thankfully, God knew my heart and recognized that my mistakes were not intentional, so like a knight in shining armor, the Lord came to my rescue. Allow me to explain…

I had just ordered some books for our new class I was leading. It should not have been a difficult task; I order books all the time. But this time it became a bit of a nightmare.

I had an opportunity to take advantage of a free shipping program Amazon was implementing. It would help reduce our costs, but I wasn't sure how it worked, so I called and spoke with a representative to make sure I was signing up properly. The helpful Amazon representative stayed on the line and walked me through the process. Together, we looked at the books I needed to order online, and I noticed there were a couple of different options for ordering, and one of them was considerably less than the other. When I asked the representative about the difference, he said the price reflected the location from which the books were being shipped.

Trying to be a good steward of our ministry finances I decided to order the lower priced books. As an extra bonus, because we ordered so many books at one time, we received an additional price break. Wow, things were really working to our favor! With the free two-day shipping program in place, the books were scheduled to arrive a few days before our class was to begin.

The books had been delivered on a Friday, but I didn't notice them because I had to leave for a retreat at my church. When I got

home Saturday afternoon, I was so exhausted that I crashed and took a nap in the recliner.

Later that evening, I noticed the two packages in our bedroom and thought, *great, the books are here!* One of the packages had a single book in it, and when I picked it up, I got a sick feeling in my stomach. The package was light—too light. I tore open the package, and my fear was confirmed. *It was the wrong book!* The book was only a study guide.

Now I was in a real panic! I immediately cried out, *Lord, please help me! What am I going to do?* I rushed upstairs to my computer and got online to reorder the right books, but the two-day shipping option was going to be too late. The one-day shipping would have cost us and additional $80!

I called Amazon and asked to speak with a supervisor. I explained to him the situation and God bless him; he was extremely kind and sympathetic. He explained to me that since the representative had helped me order the wrong books in the first place, he would give me a credit to cover the cost of the one-day shipping.

Praise God! The books arrived on my front porch just 2 ½ hours before my class was to begin. "And my God will meet all your needs according to his glorious riches in Christ Jesus" (Philippians 4:19).

"Because [she] loves me," says the LORD, "I will rescue [her]; I will protect [her], for [she] acknowledges my name" (Psalm 91:14). [Gender emphasis mine]

"I am still confident of this: I will see the goodness of the LORD in the land of the living. Wait for the LORD; be strong and take heart and wait for the LORD" (Psalm 27:13-14).

"The LORD will fight for you; you need only to be still" (Exodus 14:14).

Thank you, God! You are my Knight in Shining Armor!

~Rae Lynn DeAngelis

Puzzle Pieces

lthough sunshine poured through the glass window panes, the room was anything but bright and cheery. The cold, sterile physician's office was filled with downcast patients awaiting treatment. CANCER—that six-letter word that strikes fear into the hearts of those given its diagnosis.

It was my first time to accompany my mother-in-law to one of her chemo treatments. I had no idea what to expect. Walking into the somber waiting room, I was taken aback by the obvious signs of suffering. A wave of nausea washed over me, and for a split second, I felt as though God allowed me just a tiny glimpse into their misery. My heart swelled with compassion for these brave men and women who had no choice but to face their goliath on a day-to-day basis.

Finding a seat by the window and settling in for a lengthy stay, my eyes were drawn to a table in the corner of the room. On it was a work in progress—a puzzle. It struck me as somewhat odd to see a puzzle in the waiting room of a doctor's office. Surely no one was there long enough to complete the work.

But then I began to imagine the many different patients coming in for treatment, walking over to the table and locking one or more piece into place. Bit by bit, the picture would take form, yet most never had an opportunity to see the completed work.

It's kind of like that in life. Each one of us, although our influence in this world is small, is an intricate part of God's grand design. It may not seem like we have a whole lot to contribute to this great big world, but when each one of us offers up what little we have—our portion—no matter how small—is important to the picture as a whole.

While we no longer live in the perfect world that God spoke into creation at the beginning of time, make no mistake; Jesus is coming back. And when He does, He will liberate us from this fallen world and the picture will be truly complete.

> Then I saw "a new heaven and a new earth," for the first heaven and the first earth had passed away, and there was no longer any sea. I saw the Holy City, the new Jerusalem, coming down out of heaven from God, prepared as a bride beautifully dressed for her husband. And I heard a loud voice from the throne saying, 'Look! God's dwelling place is now among the people, and he will dwell with them. They will be his people, and God himself will be with them and be their God. He will wipe every tear from their eyes. There will be no more death or mourning or crying or pain, for the old order of things has passed away.' 'He who was seated on the throne said, 'I am making everything new' (Revelation 21:1-5)!

Until that day comes, let us continue to live in God's truth, day by day.

~Rae Lynn DeAngelis

Seasons Change

I love the change of seasons. Winter provides a blanket of white snow, warm hot chocolate, comfy clothes, and a good Hallmark movie. Spring offers the freshest air to breathe (for those without allergies), the greenest grass, the sweet sounds of birds singing, and the blooms of Bradford Pear trees. Summer

allows for exploring the outdoors by hiking, swimming, playing late into the evening, and the clearest view of a night sky. Fall brings hoodies and jeans, fires by night, beautiful foliage, and the best temperatures of the year in my opinion.

The seasons exemplify the very creations of God. Amongst all the beauty, we were the most beautiful creation that He touched and designed. "For you formed my inward parts; you knitted me together in my mother's womb. I praise you, for I am fearfully and wonderfully made. Wonderful are your works; my soul knows it very well" (Psalm 139:13-14).

In the seasons of our life, we change. Each season holds a beautiful experience to look forward to and enjoy. However, when the chaos of life and rising emotions steal our beautiful experience, we become blind to the beauty around and within us. If we allow the enemy the slightest foothold in our thoughts, he will run with it. The enemy will devour any positive thought, beautiful emotion, or peaceful moment. I know this tactic of his all too well.

The enemy found an opening into my thoughts when I was young. He found the moment when I was most vulnerable and crept in ever so slowly. One thought at a time, he took over. I felt defeated and powerless to overcome the negative thoughts replaying like a broken record, expecting the worst in each situation, and deeming myself unworthy of this life.

God held a mighty plan, a plan bigger than any tactic the enemy could conjure up. God breaks through any dark season in our lives and pulls us into the light. He speaks louder than the enemy. He opens our eyes so we can begin seeing clearly and enjoy the beauty in each season we encounter. God moved in as I laid down in surrender. He began fighting the enemy when I surrendered the battle. We are not strong enough on our own to defeat the enemy's tactics. God sees the bigger picture, and he holds the plans for each season.

The enemy will continue to prowl around, looking for a foothold into our lives. Be on guard, prepare your mind before the enemy can attempt a conniving lie. "Be alert and of sober mind. Your enemy the devil prowls around like a roaring lion looking for someone to devour" (1 Peter 5:8).

Fight with truth, prayer, worship songs, and sharing love with others. This kills the enemy's efforts, silences his words, and sends him running with his tail tucked between his legs.

Oh, but he will try to return. We must remain on guard. Put the armor on daily that God provides. Prepare for the spiritual battle of each day. The enemy does not choose favorites. He will try to steal everyone from God. Currently, the enemy works diligently on my sweet, beautiful daughter. He sees how beautiful her spirit shines and works to dull her light. The enemy is using the same tactics he did on me to try and steal my beautiful daughter's thoughts.

The enemy does not discriminate. He will move in on any foothold and work to steal a sweet spirit from God. The enemy has no limits. He will use any tactic to tear down a relationship between us and God. "Resist him, standing firm in the faith, because you know that the family of believers throughout the world is undergoing the same kind of sufferings" (1 Peter 5:9).

The good news, dear friends, is that God has already defeated the enemy. He can squash all efforts of the enemy's attempts to steal our spirits. God wins every time. Remain in His Word daily and He will be louder than the devil.

"I have told you these things, so that in me you may have peace. In this world you will have trouble. But take heart! I have overcome the world" (John 16:33).

~Sheree Craig

The Great Physician

I had spent the entire day at the hospital with my dad when he was having surgery on his back. (One thing is for sure; a day at the hospital puts things into the proper perspective.) There is so much pain and suffering going on in the world; our problems can seem pretty insignificant in comparison.

My dad had been suffering with back pain for quite a while and was growing more and more restless. He had gone through all the recommended treatments: physical therapy, steroid injections, etc., but eventually, he needed to find a more permanent solution to his pain. Surgery became his only viable option left. That or just deal with the pain. And who wants to do that?

Not me, that's for sure. I've had my own battles with back pain and I can tell you from personal experience, it can be life-debilitating when you can no longer escape the torment brought on by physical pain. Perhaps you have your own experience with pain to draw upon.

While we don't want to see our loved ones suffer, it can be a helpless feeling to place them into the hands of someone who literally holds their life in the balance.

Going through surgery can be scary, but it makes a world of difference when you know that you can trust the one holding the scalpel.

"Jesus went throughout Galilee, teaching in their synagogues, preaching the good news of the kingdom, and healing every disease and sickness among the people" (Matthew 4:23).

Although I had confidence in the doctors and nurses caring for my dad that day, I had even more confidence knowing my dad was also in the hands of the Great Physician, Jesus Christ.

If you or your loved ones are being treated by doctors and nurses, be sure to pray to the Great Physician, the one who is giving the care-givers wisdom and discernment along the way.

Remember God is all-knowing, all-powerful, and ever-present. When you feel overwhelmed with worry, peace of mind is just a surrendered prayer away.

~Rae Lynn DeAngelis

Farmer Trouble

During a long car ride, my husband and I were listening to a book on tape. After some time listening, my husband hit the pause button and asked, "I'm confused. Why does she keep saying that God will give us double for our farmer trouble? That makes no sense."

I chuckled and said, "She's not saying *farmer* trouble, silly. She's saying *FORMER* trouble!"

The light bulb went off as his realization set in. Then he said... "Oh! That makes so much more sense!!" Now it's an inside joke between us that God is going to give us double for our *"farmer"* trouble, lol.

Isaiah 61:7 says, "Instead of your shame you will receive a double portion, and instead of disgrace you will rejoice in your inheritance. And so you will inherit a double portion in your land, and everlasting joy will be yours." My whole life bears witness to this truth. Here's one of the more recent times God gave me double for my trouble.

2020 was a crazy year! I'm guessing you might agree. Even before COVID-19 hit, I was going through a slump. I had been dealing with a lot of health issues that were taxing my overall resolve. We have a very real enemy who uses every opportunity

to bring us down and make us feel hopeless. By March, I was physically, emotionally, and spiritually spent.

It was certainly not the first time I had felt this way, but this time I was at an all-time low. So low, in fact, that I began to question my life-purpose. *Was God done with me? And if He was, what would happen to the ministry?* I was hit with the sudden realization that if anything ever happened to me, Living in Truth Ministries would cease to exist. There was no one in the cue ready and willing to take my place. I had spent more than a decade of my life planting seeds of faith, watering them, and watching God make them grow. *Would it all go to waste?*

Disheartened by that prospect, I did the only thing I could; I cried out to God in prayer: *Lord, I'm depleted of strength. I don't know how much longer I can keep serving as the leader of this ministry. Please, Gracious Lord, either reignite my passion and give me more energy to continue on, or bring someone forth to carry the ministry forward.*

In my mind, there were only two plausible answers. Reignite my passion and energy to keep going, or raise up someone who could continue to carry the torch. I was expecting either/or but God's answer was yes and yes.

True to His character, God gave me double for my former trouble. Or should I say… "farmer" trouble. At Living in Truth Ministries, we have a saying: "The seed of truth planted by the Spirit through the Word can only grow and blossom as an outworking of God's perfect love."

Lord, I'm so thankful that you have reignited my passion and energy to keep serving your daughters. I love serving you and I love seeing your daughters learning and growing in your truth. But I'm also thankful that one day, when you say it's time for me to pass the baton, you have someone waiting in the cue, ready and willing to keep running the Living in Truth Ministry race.

What about you, sweet sister? Are you growing weary, wondering how you will ever reach the finish line? Cry out to the Lord and be open and honest with Him about where you are and how you are feeling. Lay it all out on the line, and then sit back and wait for His provision. Just like He did with me, God will give you immeasurably more than all you can ask or even imagine (Ephesians 3:20). Keep putting one foot in front of the other and

run with perseverance the race marked out for you. The Spirit of the Lord is not only with you, He is for you, cheering you on every step of the way.

"Do you not know that in a race all the runners run, but only one gets the prize? Run in such a way as to get the prize. Everyone who competes in the games goes into strict training. They do it to get a crown that will not last, but we do it to get a crown that will last forever" (1 Corinthians 9:23-24).

~Rae Lynn DeAngelis

Rooted in the Word

Towering water maple trees reside in my backyard. A couple of them were cut back many years ago, but they continuously grow up and out. The majority of roots are within the top twelve inches of soil and extend out three times the branch spread, so digging or tilling can be quite challenging. Thick roots can be found in almost any area of the backyard. I once again found this to be true when I was clearing a spot for a fire pit. I had to use an axe to chop these monsters out of the ground! Ahh, the feeling of hard-earned victory!

We also can become stubbornly rooted: rooted in our families, finances, addictions, religiousness, worries, complaining, and on it goes. But how rooted are you in God's Word? Are you so stubbornly rooted that no one, not even Satan, can chop you off from reading the living and breathing Word of God?

"For the word of God is living and powerful, and sharper than any two-edged sword, piercing even to the division of soul and spirit, and of joints and marrow, and is a discerner of the thoughts and intents of the heart" (Hebrews 4:12 NKJ).

When our roots are cut, we begin to rot. Our walk with God begins to slow down and we eventually end up at a complete stop. Not only do we suffer, but our leaves (those to whom we witness and disciple) become dry and withered also. When the roots of a tree die, the leaves on that side of the tree also die.

"But his delight is in the law of the LORD, and in His law he meditates day and night. He shall be like a tree planted by the rivers of water that brings forth its fruit in its season, whose leaf also shall not wither; and whatever he does shall prosper" (Psalms 1:2-3 NKJ).

"…that Christ may dwell in your hearts through faith; that you, being rooted and grounded in love, may be able to comprehend with all the saints what is the width and length and depth and height to know the love of Christ which passes knowledge; that you may be filled with all the fullness of God" (Ephesians 3:17-19 NKJ).

"…rooted and built up in Him and established in the faith, as you have been taught, abounding in it with thanksgiving" (Colossians 2:7 NKJ).

Study the Word that you may become rooted and immovable in truth.

Heavenly Father, I pray that You will give us spiritual wisdom and insight into Your Word this day.

~Rhonda Stinson

Proper Punctuation

When proper punctuation is added to a compelling story-line, a playwright is able to unlock the mind's movie reel within a few short sentences. Talented authors are able to paint pictures using far less words than the old

saying (a picture is worth a thousand words) gives them credit. I don't know about you, but I love journeying to foreign lands and faraway places without ever leaving my home. Well-written books afford me that privilege.

As a writer myself, I've come to appreciate the skills of other authors. I love to see how they string together words, emotions, and ideas. I aspire to learn from those more experienced that myself to help improve my own writing performance.

Although I love to write, I always need an editor to review my work before it goes public. Let's just say I'm a work in progress when it comes to punctuation. There are so many rules; I can't keep them all straight.

I'm not going to lie. I get a little comma happy. Thank goodness for my editor! She has a Master's degree in English and knows all the dos and don'ts of the English language.

Putting a comma where it doesn't belong can trip-up a reader. Eliminating a period, question mark, or exclamation point at the end of a sentence creates confusion and could even misdirect the reader's interpretation.

I love this quote from Pastor Mark Batterson, "We must be careful that we do not put a comma where God intended a period, or a period where God intended a comma."

Now that's some great advice!

I wonder how many times I've stopped short of God's original plan simply because the path became too difficult to travel, or worse yet, I gave up altogether, thinking the path was leading me nowhere.

Sadly, I am far too easily persuaded to stop, turn back, or go in a different direction.

You too?

Thankfully, our God is a God of second chances. He eventually offers up another opportunity to get it right. (Let's just hope we don't have to wait forty years like the Israelites.)

I must admit that Mark Batterson's advice inspires me to live differently. I want to live my life with intentionality, paying careful attention to detail. After all, the One I live for (Jesus) deserves my very best.

Instead of charging ahead, assuming I know God's timing, will, or direction, I need to slow down, be less reactive, and spend time seeking God's step by step instructions along the way.

"You make known to me the path of life; you will fill me with joy in your presence, with eternal pleasures at your right hand" (Psalm 16:11).

Reading a book and following God's will are both more enjoyable when all the periods and commas have been put in their proper place.

Do you find yourself getting discouraged or stopping short of the goal God has placed before you? Are you prone to impulse, bypassing heartfelt conversations with God, assuming you already know the way?

Allow God to edit your life journey. Like my editor does for my writing, God will bring your story much needed clarity along the way.

~Rae Lynn DeAngelis

When Life's Cut Short

My husband and I had just arrived back home from the funeral of a cherished family member. Although Tony was a cousin by genealogy, he was more like a little brother. My husband's mom raised Tony from the time he was twelve years old after his mom had died of breast cancer. (His dad had been killed in a car accident when Tony was just a baby.)

Gerry and I were already married with one child when Tony came to live with Beverly. He became a permanent fixture in the family from that time on, and sometimes he came to stay with us during the summer months. I remember one time in particular when he was about fourteen, I asked Tony to help me move a

couple of small trees. Neither of us had experience transplanting trees, so we were a little naive about the amount of work it would require. Needless to say, the project was a bust. After hours of digging, the poor tree looked like it had been through a massacre. A few roots dangled from the base of the tree without a trace of dirt. Tony joked about it for years, claiming I had subjected him to child labor. Of course it gave us all a good laugh.

Seeing someone you love lying lifeless in a coffin at only forty years of age just doesn't make sense. "Pay careful attention, then, to how you live, not as unwise people but as wise" (Ephesians 5:15). "Why you do not even know what will happen tomorrow. What is your life? You are a mist that appears for a little while and then vanishes" (James 4:14).

Tony's battle with diabetes began in his thirties, but he never quite accepted his fate. As a result, he didn't take care of himself and began having complications: amputated toes, failed kidneys, detached retinas. It caused us great distress to watch him suffer needlessly. We encouraged Tony to follow his doctor's orders, but our concern for his health was perceived as judgment and meddling in his personal affairs.

Only God knows the number of breath-filled days we have left here on earth. How will you spend yours? "However many years anyone may live, let them enjoy them all" (Ecclesiastes 11:8).

Are you treasuring the life you've been given or are you, like Tony, standing at the precipice, barely hanging on because you're not caring for the body God has given you? I'm not standing in judgement. Just asking the question before it's too late. "Wake up, sleeper, rise from the dead, and Christ will shine on you" (Ephesians 5:14).

Friends, I urge you to take care of the body you've been given. Don't let the enemy rob you of one more moment of this precious thing called life.

> "There is a time for everything,
> and a season for every activity under the heavens:
> a time to be born and a time to die,
> a time to plant and a time to uproot,
> a time to kill and a time to heal,
> a time to tear down and a time to build,

a time to weep and a time to laugh,
a time to mourn and a time to dance,
a time to scatter stones and a time to gather them,
a time to embrace and a time to refrain from embracing,
a time to search and a time to give up,
a time to keep and a time to throw away,
a time to tear and a time to mend,
a time to be silent and a time to speak,
a time to love and a time to hate,
a time for war and a time for peace" (Ecclesiastes 3:1-8)

~Rae Lynn DeAngelis

Chosen and Loved

A counseling client asked me what I believed was the primary wound I carried from my past. After thinking for a moment, I answered, "*I wasn't chosen.*" In school I was regularly left out of groups, and chosen last to be on a sports team.

This particular experience remains upfront in my memory bank. In college, every freshman in my dorm was assigned a sophomore or junior "mom" to guide and mentor her. The ceremony usually took place 3-months after school started so the "match-makers" could pair the freshman girl up with a person she had a good connection with.

The committee would go through the freshman list and the potential "mom" would tell the committee she wanted to be mom to the girl. Sometimes several girls would ask to be mom to one particular freshman. Then the committee made the decision. When

the "matching ceremony" took place, it was usually no surprise that these girls were paired up.

Sara Madsen, my chosen mom, was a girl I barely knew. It was so clear to me that no one chose me. Sara got stuck with me. I wish I could say the story had a happy ending—that we became BFF's. Sara's obsession with her boyfriend meant I rarely saw her. Other mom-daughters did things together, not me and Sara. This was the closest I came to feeling like an orphan.

Today, there's only two people in my life who have chosen to stay with me through thick and thin and forever—God and my husband.

The truth is, I have been chosen: "Even before he made the world, God loved us and chose us in Christ to be holy and without fault in his eyes. God decided in advance to adopt us into his own family by bringing us to himself through Jesus Christ. This is what he wanted to do, and it gave him great pleasure ... And when you believed in Christ, he identified you as his own by giving you the Holy Spirit ... you were marked in him with a seal, the promised Holy Spirit" (Ephesians 1:4-5,13).

John referred to himself several times as "the disciple whom Jesus loved" (John 13:23, 19:26, 21:7, 21:20). Over the centuries, he's been criticized as being an egotist. I'm among a group who believes the opposite. I believe John's self-expression came out of an unspeakable depth of awe and surprise. Try to imagine how astonished John was the day he fully realized that the love of Jesus turned out to be the love of God.

It was his way of saying, "The only way to understand how I came to be who I am now—a radically changed man—is to acknowledge that the most amazing life-changing thing that ever happened to me was receiving Jesus's love and undeserving grace." This knowledge has built up my self-worth, and it will yours. I have no idea what your childhood, adolescence or adulthood has been like. I do know that life works all of us over. Yet before any human hand touched us or tragedy forsook us, God called us His beloved—the daughter whom Jesus loves.

Our greatest need is to make God's love for us our foundation. We need to know that we are completely loved—not because of anything we've done, but because of who God is. This is the extraordinary gift that Jesus gave to John. It is the life-changing

gift He has for you and me. All we have to do is open our hearts and receive.

~Kimberly Davidson

Beyond Your Comfort Zone

Growing up, my friends and I used to play games like *Simon Says, Red Light/Green Light,* and *Mother May I.* Each of these games required a leader that would command a set of instructions for the others to follow. We were all eager to be the leader so we could boss everyone around. (We obviously had a skewed understanding of what it means to be a leader.)

Many adults aspire to be leaders too, but I'm not one of them. I have to be honest; I am a follower by nature. Leading is not something that comes naturally to me, and yet, over and over, God continues to place me into positions of leadership.

Why is that?

It's actually become a little joke between me and God. I'll enter into something thinking, *thank goodness, I get to be a participant for a while.* And then it happens; the leader has to step down for some reason, or there's no one else to lead, and I find myself right back into the leadership role.

I have come to learn that much of my discomfort in being a leader is due to the fact that I am insecure in my abilities. But I eventually figured out something about being a leader. Working outside of my natural ability is a great place to be. I get to see God

at work and learn things about myself that perhaps I never would have if I had stuck to playing it safe.

Bottom line: *When we move beyond our comfort zone, we grow.*

God seldom uses people in the ways they feel most comfortable. He's all about pushing us out of our comfort zone. When we step out of our element and into God's, we are forced to rely on His strength, His wisdom, His ways, and His power.

Do you see a common theme here? When we work in our own strength, we get the glory. When we work in God's strength, He gets the glory.

I don't know about you, but I want my life to point to Him. In fact, I have an ongoing prayer that goes something like this: *Lord, may it be all of you and none of me.*

"He must become greater; I must become less" (John 3:30).

Although we may not understand what God is doing in the moment, we can trust His higher ways and know that He has our best interests at heart. God sees the big picture; we only see a small part.

"For my thoughts are not your thoughts, neither are your ways my ways," declares the LORD. "As the heavens are higher than the earth, so are my ways higher than your ways and my thoughts than your thoughts" (Isaiah 55:8-9).

"And we know that in all things God works for the good of those who love him, who have been called to his purpose" (Romans 8:28).

Has God been taking you out of your comfort zone lately?

Step up to the plate, swing with all your might, and trust God's higher ways. You will be glad you did.

"Give me wisdom and knowledge, that I may lead this people, for who is able to govern this great people of yours" (2 Chronicles 1:10).

~Rae Lynn DeAngelis

Heart Song

I can't tell you how many times this has happened to me. I wake up from a deep sleep and have a sing-song melody playing in the background of my mind. And here's the cool part: It's almost always a praise and worship song. (It's as if my subconscious mind is praising God all night long.)

"The whole earth is filled with awe at your wonders; where morning dawns, where evening fades, you call forth songs of joy" (Psalm 65:8).

I've become intrigued by this occurrence and noticed it is happening more and more.

The technical term for this phenomenon is 'earworms' which is defined as a catchy song or tune that continually runs through a person's mind.

Perhaps the most memorable depiction of this peculiarity can be found in Pixar's animated film *Inside Out*. In this memorable film, Joy, Fear, Anger, Disgust, and Sadness are endearing characters that are tucked away into a little girl's subconscious mind. They help navigate and archive emotionally charged memories that take place throughout the little girl's life. Every once in a while, however, an earworm hijacks the little girl's mind and annoys her subconscious counterparts to the tenth degree. The motion picture may have been intended for kids, but I must say… *adults have been equally entertained.*

It seems that the deeper I grow in my relationship with God, the more compelled I am to praise Him. Even in my sleep!

"By day the Lord directs his love, at night his song is with me—a prayer to the God of my life (Psalm 42:8).

I would imagine that our subconscious praise songs to God are just as pleasing as our praises poured forth when we are fully

awake. "My soul yearns for you in the night; in the morning my spirit longs for you" (Isaiah 26:9).

I can't think of a better way to start the day than with the sweet praises of my soul, reverberating across the strings of my heart. "Sing joyfully to the Lord, you righteous; it is fitting for the upright to praise him" (Psalm 33:1).

May the heart songs of God's people join in with the chorus of Heavenly Hosts who we are told, both day and night, make a joyful noise unto the Lord.

"Holy, holy, holy is the Lord God Almighty,' who was, and is, and is to come" (Revelation 4:8).

~Rae Lynn DeAngelis

Dry Rot

I was reading a book the other day. The illustration in it really rocked me. A man bought an old boat and had it rehabbed. He paid tons of money to have it made it all shining and new looking. It was beautiful. He was so proud of his new (old) boat. He took it out on the water so all of his friends could see it and see him in it. He made sure that his first appearance with the boat was very visible.

During his first outing on the lake, it started to fill with water and began sinking, they hurried to get all the water out and get it to shore to see why it was filling with water.

The boat was all shiny and new on the outside, but it had dry rotted on the inside. There was a huge hole in it. No matter how great and new they made the boat look, it was rotted from the inside out. It was structurally broken. He was angry and ashamed when he realized there was a major problem. His image was at risk. His pride was damaged.

This really hit home for me because, more often than not, I'm worried about the way I look and my image: how I appear as a mom, a wife, or worker. I'm making sure that my house looks great, my kid behaves, or that my marriage is "seen" as blissful. I'm consumed with what it all looks like from the outside.

"Am I now trying to win the approval of human beings, or of God? Or am I trying to please people? If I were still trying to please people, I would not be a servant of Christ" (Galatians 1:10).

What I should really be concerned with is my inside. Am I rotting from the inside out? When the storms come or when people really get to know me, will they find dry rot? Or will they find a strong foundation?

Healing comes from the inside out. Taking care of the dry rot: the unforgiveness, the bitterness and resentment, the selfishness and greed, that so quickly create the holes in my foundation, should be where I'm putting my time and energy. There is Hope and true Restoration in Jesus.

You and I can do this by inviting the Lord in on a regular basis. Saying to him, "Put a finger on any part of my heart that You want to redeem and transform, and make new. I'm ready, Lord. Deal with me. Kindly and quickly, deal with me and heal me."

"I have been crucified with Christ and I no longer live, but Christ lives in me. The life I now live in the body, I live by faith in the Son of God, who loved me and gave himself for me. I do not set aside the grace of God, for if righteousness could be gained through the law, Christ died for nothing" (Galatians 2:20-21)!

Friend, there is restoration for every part of your story. Don't hide it, mask it, or make it "shiny," bring it in the Light and He will restore!

Lord, you know the places in my heart that are stealing my joy and peace. You know that I want others to think highly of me, but I don't want that if it's not them knowing you are who has changed me. I repent of pride and ask you to be honored in my life. You know all the things that are eating me from the inside out. I want to turn those over to you. Please give me a new heart, one that reflects you. When I go through a difficult time, a tragedy, a disappointment or a loss, I want my first response to be to run to you for strength. I don't want my first response to be to blame, or

fear, or defense. I want to have my foundation fixed on your Love. I can't do it on my own, but I know that you are in the repair business, and I'm turning it all over to you. Please help me, Lord Jesus, the way that only you can. Amen.

~Alison Feinauer

Book Referenced: *Spiritual Slavery to Spiritual Sonship* by Jack Frost

Dressed and Ready

Have you ever slept with your clothes on so you could be ready at a moment's notice to get up and go to the place you needed to go? Some people do this on a regular basis, especially those in particular professions, such as firemen or on-call physicians.

"Be dressed ready for service and keep your lamps burning" (Luke 12:35).

"You also must be ready, because the Son of Man will come at an hour when you do not expect him" (Luke 12:40).

Scripture tells us to keep ourselves dressed and ready for the Lord's coming because we do not know the hour of His impending arrival.

Obviously, this isn't an admonition to sleep with our clothes on. However, it is a forewarning to us that we need to be dressed spiritually speaking—clothed with Christ—so that we are ready for Christ's second coming.

"For he has clothed me with garments of salvation and arrayed me in a robe of righteousness, as a bridegroom adorns his head like a priest, and as a bride adorns herself with her jewels" (Isaiah 61:10).

God refers to the church as His Bride. In biblical times, as soon as a couple became engaged, even though they did not yet live together, it was as if they were already married.

When a couple became betrothed to one another, the groom would go back to the home of his father and begin preparing a place for his bride to come and live with him. Since the bride never knew when her groom would come back for her, she needed to be ready at a moment's notice.

"In my Father's house are many rooms; if it were not so, I would have told you. I am going there to prepare a place for you. And if I go and prepare a place for you, I will come back and take you to be with me that you also may be where I am" (John 14:2-3).

As Christians we are the Bride of Christ. We need to be dressed and ready for our Bridegroom because (spoiler alert) *Jesus is coming back for us!*

"As a bridegroom rejoices over his bride, so will your God rejoice over you" (Isaiah 62:5).

~Rae Lynn DeAngelis

Birth Pains

P ain. It's something we've all experienced to some extent, and we have Adam and Eve to thank for it.

"To the woman [God] said, "I will make your pains in childbearing very severe; with painful labor you will give birth to children" (Genesis 3:16). This miserable judgement came on the heels of the couple's defiance over God's one and only command. "You are free to eat from any tree in the garden; but you must not eat from the tree of the knowledge of good and evil, for when you eat from it you will certainly die" (Genesis 2:17).

I like to think that I would have taken God's warning more seriously than my human counterparts in the Garden of Eden. But if I'm being completely honest with myself, I'm guessing I would've been just as insubordinate as them. *How do I know?*

Put me on a diet and I start craving foods I hadn't thought about in months.

Tell me I can't accomplish a task and I'll spend every last effort proving you wrong.

I'm finding it is part of our deeply entrenched sin-nature to challenge authority and go our own way. We shake our fist at religious or societal norms. *Why?* Simply stated: we don't like others telling us what to do.

Unfortunately, mutiny often ushers us into a season of discomfort or pain. "We know that the whole creation has been groaning as in the pains of childbirth right up to the present time" (Romans 8:22.)

We live in unprecedented times. Pain and suffering are everywhere. Using the analogy of childbirth, God forewarns us that our misery will only increase as "end times" draw near.

> As Jesus was sitting on the Mount of Olives, the disciples came to him privately. "Tell us," they said, "when will this happen, and what will be the sign of your coming and of the end of the age?" Jesus answered: "Watch out that no one deceives you. For many will come in my name, claiming, 'I am the Messiah,' and will deceive many. You will hear of wars and rumors of wars, but see to it that you are not alarmed. Such things must happen, but the end is still to come. Nation will rise against nation, and kingdom against kingdom. There will be famines and earthquakes in various places. All these are the beginning of birth pains" (Matthew 24:3-8).

I remember when we welcomed our first born into the world. It was a full eight days past my due date. It seems that even in the womb, our daughter, Heather, challenged the constructs of norm. My contractions were supposed to come more frequently with time, and when they got down to five minutes apart, I was

supposed to head to the hospital. But after three agonizing days laboring at home with no consistency to my contractions I began to wonder if I would ever give birth. My doctor assured me that I was in false labor, but my impromptu visit to his office the following morning proved otherwise. He confirmed that I was in full-on labor and immediately directed us over to the hospital.

Friends, regardless of whether or not you believe we have entered into the last days as described in the book of Matthew, we can at least agree that we are closer today than we were yesterday.

"The Lord is not slow in keeping his promise, as some understand slowness. Instead he is patient with you, not wanting anyone to perish, but everyone to come to repentance" (2 Peter 3:9).

Like the intensified pains of childbirth, our increasing discomfort in this world is a constant reminder that life anew is just around the corner.

May we be ever ready!

"For in this hope we were saved. But hope that is seen is no hope at all. Who hopes for what they already have? But if we hope for what we do not yet have, we wait for it patiently" (Romans 8:24-25).

~Rae Lynn DeAngelis

Let Go of the Past

I often find myself drifting back in the past, thinking about tough times I've experienced. A few short years ago, I would feel the exact same emotion, vividly reliving the moment, and the burden would weigh heavy on my shoulders for the day. Each time I relived the past, the wound began to bleed again.

Over the years, I began to face the emotions, place them in God's hands, and replace them with His Truth. I began to see His presence in that moment in time. I realized I'd never dealt with the emotion. I'd buried it all in the past, numbing it with my eating disorder, exercise, alcohol, or any other measure. I realized that I must face these emotions, work through them with God holding my hand and heal. . . finally heal.

Dealing with all the emotion from the past can be overwhelming. Multiple times tears fell as if the event was happening at that very moment. Even still, God asked me to forgive the hurt caused by others. He asked me to pray for those individuals. I can recall the first time I sat to pray for one individual that caused much pain in the past. The emotions welled up inside with great force. I felt sick to my stomach and the only word I could speak was the person's name. With each conversation to God, it became easier.

Wound by wound, God brought true healing. I still have some lingering history that can stir emotion. I have found the hardest person to forgive in my past is me. I needed to forgive the girl in those memories. I needed to forgive her for choosing the path of destruction seeking mere survival. The girl in the past did the best she knew how in that moment to survive floods of emotions.

The same goes for you, dear friend. The same goes for those who hurt you in the past. Human nature seeks to survive. When human nature lives each moment void of God, a high risk for destruction and sin exists. I knew there was a God from my Catholic upbringing; but I sat Him on a shelf and placed His Word far away from my heart. I thought I had the answers to survive in life. I thought I did not need help. I gauged success on euphoria. To attain such success, I buried every emotion. I numbed out daily.

My dear friends, hindsight is 20/20 and revealed I was completely wrong. Emotions are good. Emotions allow us to feel, approach the Cross and mature in spirit. Our emotions are valid. God cares about our emotions and can use them for His good. They can become a part of His plan for your life. Allow yourself to feel them and not bury them. Life is not mere survival. God desires for us to truly live.

"For I know the plans I have for you, declares the Lord, plans for welfare and not for evil, to give you a future and a hope. Then you will call upon me and come and pray to me, and I will hear you. You will seek me and find me, when you seek me with all your heart" (Jeremiah 29:11-13).

The enemy knows the exact tactic to distract us from God's plan. For me, it was fear of feeling emotion, carrying the burden of making peace and fixing the pain in other's lives. I carried shame, guilt and self-hatred day by day. My thoughts replayed, "You are a failure." I never felt worthy enough to carry out God's plan. I controlled emotions by numbing them. I focused solely on making everything in my surroundings perfect to avoid facing the storm just in the distance.

Face the storm, dear friends. But don't face it alone. Drown your thoughts with His Truth. Reach out to a trusted friend as you heal all emotions buried deep inside. You are worth healing. You are worth living your life. God has mighty plans and purpose for you. He will use every emotion from the past and bless those placed in your path. Trust Him. Ask Him into your moment. Feel your emotion as He comforts, loves and guides your heart to healing. You are beautiful, dear friend, and you are worth joy.

~Sheree Craig

Believing God

When I was struggling to overcome my twenty-five-year bondage to bulimia, I faced a long uphill battle, but I didn't face it alone; God was by my side every step of the way. I can't imagine trying to overcome something like an eating disorder without the strength and support of my Heavenly Father.

Although I didn't go through the traditional means of recovery with a doctor or therapist, I did have the Great Physician and Wonderful Counselor, Jesus Christ. I also had the support of godly women who encouraged me and spoke truth into my life.

Throughout my recovery process, God's most effective ministering came to me through the study of His Word. He used two bible studies to guide my journey to freedom—*Breaking Free* and *Believing God*—by Beth Moore. These bible studies became instrumental in my healing process.

Breaking free from a stronghold is difficult. It feels as though you are a prisoner in your own body, unable to break free from the chains that bind you. Thankfully, God helps us find the key to unlock our chains. The key to my own freedom was found in the book of Mark, chapter nine. In this story, a father brings his demon possessed son to Jesus to be healed.

> Jesus asked the boy's father, "How long has he been like this?"
> "From childhood," he answered. "It has often thrown him into fire or water to kill him. But if you can do anything, take pity on us and help us."
> "'If you can'?" said Jesus. "Everything is possible for him who believes."
> Immediately the boy's father exclaimed, "I do believe; help me overcome my unbelief" (Mark 9:21-24)!

As soon as I read this passage, I realized that like the boy's father, I had some deep-rooted unbelief in my heart. I believed God could, and had, healed other people. But I didn't really believe God could, or would, heal me.

I've heard it said that the longest journey man will ever take is the seventeen inches from his head to his heart. How very true!

Later, the disciples asked Jesus why they were unable to drive the demon out of the boy. Jesus replied, "This kind can come out only by prayer" (Mark 9:28-29).

Verse 29 leaped off the page and into my heart. In that moment I realized; prayer was the key to my freedom. So, I began praying every day—*God, help me overcome my unbelief.*

Guess what? Little by little I began trusting God with my eating disorder. Eventually, I said, Alright God, I'm going to take you at your Word here and *believe* you can heal me.

He was always capable of healing me; He was just waiting for me to believe it.

Since that day it has no longer been my burden to carry. I have given it over to God—the only one capable of taking it from me.

Perhaps there is something you are struggling to overcome. Take that long journey from your head to your heart. God will help you overcome your unbelief. I promise!

~Rae Lynn DeAngelis

Global Warming

While I love the change of seasons in the Midwest, winter is my least favorite time of the year. With temperatures dipping into the single digits (and even past the below zero mark) the frosty months are unbearable for warm-weather enthusiasts like myself. If global warming truly exists, we have yet to see it hit the Cincinnati tri state area.

I tolerate cold weather through the holidays. But after December 25th, I'm ready for spring. That's because the drudgery of winter causes my bones to ache, my skin to dry, and my happiness to fade. I'm beginning to understand why seniors migrate south for the winter.

In an effort to make frigid temperatures more bearable, my husband made a change to our home's central heating system. When we had our home built thirteen years ago, we realized the builder had not installed return vents on the finished side of the basement. While the absence of return vents was not a code violation, it was *not* the most efficient way to heat our home.

It seemed that no matter how much warm air was pumped into the space, the basement still felt cold. One day my husband explained to me the reason why. He said that without the proper exchange of air circulation (pumping warm air in and pulling cold air out) the furnace was inefficient.

Like a heating/cooling system in a home, when it comes to our spiritual lives, we are most effective in our walk with God when we have the proper balance of *in* and *out*.

We can spend time praying to God, reading our Bibles, and growing in Christ, but if we aren't taking time to pour ourselves out by loving and serving others, we lose our ability to impact the world around us.

That which we learn, we should teach. That which we experience, we should impart. That which we receive, we should extend: love, mercy, and grace. What God gave to us; we should give to others.

Who knows! The great exchange of love, mercy, and grace might just bring about the kind of global warming this world *really* needs.

"As I have loved you, so you must love one another" (John 13:34).

"Bear with each other and forgive one another if any of you has a grievance against someone. Forgive as the Lord forgave you" (Colossians 3:13).

Give, and it will be given to you… For with the measure you use, it will be measured to you" (Luke 6:38).

~Rae Lynn DeAngelis

Hurry, Hurry, Hurry!

"**C**'mon pokey", I mumbled, following behind a very cautious driver. As soon as it was clear, I hurriedly passed the driver as if a huge emergency was awaiting my attention.

Truth was… I just wanted to go faster than the driver in front of me and became impatient in the waiting. A quick glance in my rear-view mirror showed that I'd left him in the dust.

Just as I slowed down and put on my blinker to turn left into my house, a stream of cars started coming from the other direction. They were bumper to bumper with no room between. "Oh great!" I disgustedly said to myself. "You just had to pass him up and look where it got you." (Self-talk helps me cope in situations like these.)

The pokey driver that I had just passed now had to sit behind me and wait until I could pull into my driveway. I felt like crawling under the seat of my car! My impatience had gotten me nowhere but into a humbling and embarrassing mess.

Waiting has never been one of my strong points, but I am getting a little better at it. Waiting on God's timing is an essential element in a Christian's life. God has every aspect of our lives in place, from beginning to end. Think of a Tetris game. The blocks moving down the screen have different shapes, but at just the right time, they turn and fall into place.

God knows every detail of our lives. Like a Tetris game, when we are patient, He sets the pieces into place—one by one.

Are you trying to rush ahead of God? If so, you're destined to miss something important that He wants to show, teach, or give you.

"But those who wait on the LORD shall mount up with wings like eagles, they shall run and not be weary, they shall walk and not faint" (Isaiah 40:31 NKJ).

"My brethren, count it all joy when you fall into various trials, knowing that the testing of your faith produces patience" (James 1:2-3 NKJ).

"But let patience have its perfect work, that you may be perfect and complete, lacking nothing" (James 1:4 NKJ).

Like my pokey driver experience, impatience sometimes results in another needed godly trait—humility.

~Rhonda Stinson

Rise Above It

I was outside playing with my friends when out of nowhere a ferocious grizzly bear materialized and started chasing us. Terrified, I began running as fast as I could, but the bear was gaining on us! Just when the bear was about to take a swipe at me with his intimidating claws, I jumped up and began flying through the air (which looked more like swimming). Once I was out of harm's way, I called out to my friends and instructed them to jump up and take flight with me. They too began flying and narrowly escaped the clutches of death. (It felt real at the time, but of course it was only a dream.)

Dreams can have spiritual significance, both in biblical times and still today. For this reason, God has made it possible for some people to interpret dreams. Perhaps the two most profound dream interpreters in the Bible were Joseph and Daniel.

"Pharaoh said to Joseph, "I had a dream, and no one can interpret it. But I have heard it said of you that when you hear a dream you can interpret it" (Genesis 41:15).

"The king asked Daniel (also called Belteshazzar), "Are you able to tell me what I saw in my dream and interpret it?" Daniel replied, "No wise man, enchanter, magician or diviner can explain to the king the mystery he has asked about, but there is a God in heaven who reveals mysteries" (Daniel 2:26-28).

I don't know if I'm a dream interpreter like the Bible talks about, but there have been times when God has given me insight into the meaning of certain dreams, even dreams that friends or family member's share with me.

I truly believe that some of our dreams can contain spiritual messages for our lives. "For the LORD gives wisdom, and from his mouth comes knowledge and understanding" (Proverbs 2:6).

I was thinking about that dream from my childhood and began to think about any spiritual significance it might have held.

In that dream, my friends and I were completely caught off-guard. We were simply having a good time, minding our own business, when the bear appeared and began chasing us.

Isn't that often when calamity takes place—when we least expect it?

Immediately I began running from the bear, but no matter how fast I ran, the bear continued to gain on me.

In real life, we often find ourselves running from our problems rather than facing them head on. Unfortunately, no matter how fast we may run, our problems eventually catch up with us.

As a last resort, I jumped up into the air and began flying to escape the danger below.

Oftentimes in life, we first try to handle things on our own, convincing ourselves that we don't need to bother God with our problems. But as soon as we humble ourselves and cry out for God's help, He lifts us to new heights—out of harm's way.

Friends, whatever calamity faces you today, *let God help you rise above it!*

"He lifted me out of the slimy pit, out of the mud and mire; he set my feet on a rock and gave me a firm place to stand" (Psalm 40:2).

"O LORD, see how my enemies persecute me! Have mercy and lift me up from the gates of death" (Psalm 9:13).

"They will soar on wings like eagles; they will run and not grow weary; they will walk and not be faint." (Isaiah 40:31)

~Rae Lynn DeAngelis

Scattered Seed

Our daughter and son-in-law (Heather and David) love to garden and have turned the side yard of their home into a summertime field of greens. During one of my visits, Heather was eager to show me her thriving garden. She made sure I experienced her garden up close and personal by having me pluck the edible delights off the vine and pop them into my mouth. She said no washing was needed. I must admit I was thankful to know my grand pups didn't have access to the garden (if you know what I mean). She then went on to explain how some plants returned year after year—they are called perennials, while others were only harvested for a season—annuals. I pointed to a few plants growing up between the garden boxes and asked if they were weeds. She explained that they were not weeds but "volunteers," plants growing on their own from seeds that had dropped the previous year.

God wasted no time in giving me a spiritual lesson for the day. Perhaps it will encourage you too.

When I said yes to God and started Living in Truth Ministries, I had no idea things would go this far. I've been amazed to see God at work year after year. Although it's thrilling to see the ministry grow, it's also a lot of work. Recruiting worker bees has been challenging to say the least. I was growing discouraged by the lack of help and began wondering if I had come to the end of my ministry journey. I prayed to God, telling Him that I wanted to be in His will. If He said it was time to close up shop, I would,

but if He wanted me to keep going, I would persevere through. Shortly after that prayer, God brought me to the following Scripture.

> When he had finished speaking, he said to Simon, "Put out into deep water, and let down the nets for a catch." Simon answered, "Master, we've worked hard all night and haven't caught anything. But because you say so, I will let down the nets." When they had done so, they caught such a large number of fish that their nets began to break. So they signaled their partners in the other boat to come and help them, and they came and filled both boats so full that they began to sink. When Simon Peter saw this, he fell at Jesus' knees and said, "Go away from me, Lord; I am a sinful man" (Luke 5:4-8)!

After reading this, I felt confident God was calling me to push through the obstacles and keep moving forward, even though I couldn't see how it was possible without more help. Shortly after I committed to staying the course, God began opening doors, bringing forth women who helped grow the ministry and share the workload.

"Still other seed fell on good soil. It came up and yielded a crop, a hundred times more than was sown" (Luke 8:8).

Like scattered seed bursting forth from the ground, God alone has brought women forward. He alone has grown this ministry, and He alone gets the credit.

Moving forward with eyes fixed on Jesus, I'm filled with hope and pressing on.

Take a moment to reflect on your own life. Look for ways that God has scattered seed and cultivated a bountiful harvest without your help.

Lord, may it continue to be ALL OF YOU and none of me.

~Rae Lynn DeAngelis

Handmade by God

The elephant is the largest most powerful land animal on earth. Yet it takes only a strong rope to restrain one. It works like this: When the elephant is a baby, he is tied to a large tree. For weeks, he will strain and pull to get loose, but the rope holds him tightly. Eventually, he gives up. When he reaches full size and strength, he doesn't struggle to get free. You can take the rope off and he won't break away.

Our minds play a similar trick on us.

As we move from childhood onward, we soak up like crazy what we see, hear, and are told—by our family, peers, teachers, and mass media—molding our belief system which becomes second nature to us. The cultural context we soaked up so innocently in our preschool years is there in the background of our adult lives all the time, operating in our minds behind the scenes, like the "great and powerful wizard of Oz"—before he was exposed by Toto the dog. Everyday experiences are triggered by those older deeply ingrained beliefs and values.

Many of us are carrying around negative messages from those years about ourselves. If a parent or teacher told us we weren't very smart, or just average, or worse, their words exerted a powerful influence. Even when we become adults, the messages are so ingrained, we don't question them.

These toxic labels we give ourselves are swirling around in our minds. They are our *inner abuser:* the unconscious voice that calls us names today, *incompetent, ugly, fat, stupid, unlovable, worthless.* The inner turmoil will continue to lower our self-worth and intrude unless we get rid of the inner abuser. It's not easy, and it takes time. But God's power can prevail.

What I am still in the process of learning is that as long as the focus is on what our body *isn't,* then we'll continue to struggle and suffer. We'll continue to spend thousands of dollars on diet programs, cosmetic products, and plastic surgeons. Recognize that this is their business: to get us to focus on what our body isn't. I wish I could say I've got this mastered, but I don't. The problem is, I believe that when we're dissatisfied with ourselves, we lose the opportunity to know the joy God has for us.

A Randy Glasbergen comic says, "Your resume here says that you are created in the image of God. Very impressive!" Someone else misusing us to satisfy his or her own selfishness does not negate or change who we are—valuable human beings—worthy of love and respect. God wants us to know the wonder of being made in His image.

When God made every human being, "God saw all that he had made, and it was very good" (Genesis 1:31). In other words, *you* have been made "very good" and "excellent in every way." You wear a spiritual label, "Handmade by the Lord." Because we are made in the amazing image of God. *What we already are* is adequate to meet our needs and any crisis we may confront. By the way, being made in the image of God, and therefore, labeling myself as ugly (or other negative thought/belief), is saying that God is ugly.

Claim God's Word, "I belong to Christ and have become a new person. The old life is gone; a new life has begun" (2 Corinthians 5:17)!

~Kimberly Davidson

Keep Moving Forward

Our son Ben is a determined individual. Definitely our strong-willed child back in the day. We had many battles-of-the-will with our little guy, that is until he finally figured out mommy and daddy were not going to give in to his temperamental demands.

After surviving those terrible twos, threes, and fours, we finally began to see our son's determination working in his favor. I remember how Ben would fixate on achieving a particular goal and spend countless hours practicing his skill until he finally mastered it.

Being able to walk all over the house on your hands (including stairs) may not seem like a particularly useful skill, but the perseverance it took for our son to accomplish such a feat was impressive. In addition to learning to walk on his hands, Ben taught himself to write and speak Japanese (one of the most difficult languages to learn). He also trained himself on the guitar, taught himself how to 3-D sculpt on a computer, and most recently, he started his own business.

What about you? Are you determined to push through difficult times and overcome challenges coming your way?

"Let us not become weary in doing good, for at the proper time we will reap a harvest if we do not give up" (Galatians 6:9).

Whether you're striving to live a healthier lifestyle, looking to get out of debt, or facing an uphill battle with an uncertain future, perseverance and determination will get you through.

It's very important to envision your goal, see it in your mind, and believe it. The mind is powerful. Visualize where you want to be, and keep the faith. Day by day, you will grow stronger. Morning by morning, God's mercies will be new and help you

remain steadfast. Celebrate small victories along the way and let go of yesterday's mistakes. Keep moving forward, and when you start to grow weary, fix your eyes on the prize.

"Forgetting what is behind and straining toward what is ahead, I press on toward the goal to win the prize for which God has called me heavenward in Christ Jesus" (Philippians 3:13b-14).

You've got this!

"Jesus looked at them and said, 'With man this is impossible, but not with God; all things are possible with God'" (Mark 10:27).

Keep moving forward.

~Rae Lynn DeAngelis

Counting the Cost

As I write today's post, the sword of truth pierces my side with increasing conviction. Once again, I've allowed out of control emotions to steer the words of my own mouth.

"Likewise, the tongue is a small part of the body, but it makes great boasts. Consider what a great forest is set on fire by a small spark" (James 3:5-6).

How many times must I stumble over this critical life lesson? Like mom used to say, "If you can't say anything nice, don't say anything at all."

My flesh-nature gets me into trouble every time, and the enemy is all too willing to stoke the flames of my unchecked emotions. Allowing feelings to direct our actions is like charting a course through stormy seas with half a rudder. Sooner or later the ship is going down.

"They sharpen their tongues like swords and aim cruel words like deadly arrows" (Psalm 64:3).

I hate hurting the ones that I love, so why do I do it?

"... Although I want to do good, evil is right there with me. For in my inner being I delight in God's law; but I see another law at work in me, waging war against the law of my mind and making me a prisoner of the law of sin at work within me" (Romans 7:21-23).

This morning after a recent outburst of unrestrained words that had been directed at my husband, God brought me to the following Scripture. "Out of the same mouth come praise and cursing. My brothers and sisters, this should not be. Can both fresh water and salt water flow from the same spring" (James 3:10-11)?

Do you know what happens when fresh water and salt water collide? The water becomes brackish and murky; it's no longer clear.

I want my witness to be unstained and pure. I want the overflow of my heart to speak good, not evil, but I am not perfect. I struggle with sin like everyone else. "Not many of you should become teachers, my fellow believers, because you know that we who teach will be judged more strictly" (James 3:1).

The Scripture concerning teachers being judged more strictly simply means that because we have influence, we better use it wisely. Others are watching. How I respond to the sin in my life can be a teachable moment.

With conviction burning in my heart, I wrote a letter to my husband, apologized, and asked for his forgiveness. Thankfully, he extended me mercy (yet again) and said I was forgiven.

As God teaches me, He teaches you. As I teach you, God teaches me. So, here's the lesson I learned this time. By counting the cost of my words, before I speak, I can save myself and others from a whole lot of heartache down the road.

Lord Jesus, I'm trying hard to be the woman you want me to be, but I still fall short. I'm sorry for being weak in my flesh and not allowing the fullness of your Holy Spirit to direct my thoughts, words, and actions all the time. I need your help, Lord. Please forgive me when I fall short, and help me convey sincere, heartfelt sorrow to those I've hurt and love. May the words of my mouth

and the meditation of my heart be pleasing in your sight, oh LORD, my Rock and my Redeemer. Amen.

~Rae Lynn DeAngelis

You Are Enough

When I met with a friend, all of the things she said felt like judgement and rejection over and over. It wasn't what she said; it was how she said it. I felt criticized and cut down. Every single time I'm around her, I get this sense that I'll never measure up, that she'll never really let me in.

I came home and was sharing this with my husband. He asked me, "Why are you letting this get to you? Why do you care so much about what she says?"

I couldn't put my finger on it. Then it occurred to me that I haven't spent much time with My Maker. Have you ever read the book by Max Lucado called, *You Are Special?*

It's about a little wooden boy named Punchinello who lived in a village where people got stickers (dots and stars) put on them. The dots were given for "bad" things people thought, and the stars were given for "good" things people thought. Punchinello only got dots. Then he noticed his friend Lucia didn't have any stickers on her. She said she went to see Eli, the woodcarver, every day. So, Punchinello went to see Eli too. He was surprised that Eli knew his name. Eli said that he made Punchinello and was glad he came, that he'd been waiting for him. Punchinello asked how to become like Lucia, his friend, to not have any stickers. Eli said, Lucia knows that the only thing that matters is what I think of her so the stickers don't stick. Punchinello asked, "How do I get that way?" Eli said, "come see me every day." He said that he would, and as Punchinello was leaving, a sticker fell off.

Like Punchinello, the more time we spend with our Creator, the less we will care about what others (or the enemy) say about us. Soon, our Creator's love will be all that matters. We are made with a desire to feel known, loved, and that we belong. Too often we go to the wrong things to fill that desire. It could be food, social media, a friend, or even a spouse. We can only truly get our needs met in one place, with our Maker.

Not sure if you've heard this song called "He Knows My Name" by Tommy Walker, but I love the lyrics:

> *I have a Maker, He formed my heart*
> *Before even time began, my life was in his hands*
> *He knows my name, He knows my every thought*
> *He sees each tear that falls, And He hears me when I call*
> *I have a Father, He calls me His own*
> *He'll never leave me, No matter where I go*
> *He knows my name, He knows my every thought*
> *He sees each tear that falls, And He hears me when I call*

These are the words that I need to hear over and over. This will remind me that I am enough with Him and that someone else's opinion of me doesn't matter compared to the way I'm known and loved by my Creator.

Have you felt alone lately, or unknown? Does everything feel like rejection and hurt? Are you fawning for someone's acceptance or affection? Make some space, and sit with our Maker to remind you Whose you are.

Father, Maker, Creator. Remind me who I am. Remind me of Your love for me. Help me to be able to receive and believe more of your love for me. I know that You could never love me more or less, but my ability to receive that love grows the more I spend time with You. Help me to prioritize my time with You – I'm longing for it. I know that You are the source of my life. I love and trust you. Amen

"The Lord appeared to us in the past, saying: "I have loved you with an everlasting love; I have drawn you with unfailing kindness" (Jeremiah 31:3).

~Alison Feinauer

You've Got Mail!

I n this technological age, we see more and more daily practices becoming streamlined for efficiency. We can do our shopping online, we can upload and print photos from the comfort of our own home, and we can take a virtual tour of a hotel before we ever visit in person. For goodness sake, we can even get a degree without ever stepping onto a college campus.

Many of these contemporary efficiencies have made life easier. While I agree that it can make life easier, I'm not convinced that easier equates to better, at least not all the time. The personal touch can make all the difference when it comes to our day-to-day interactions with others.

In my line of work (ministry) I often send notes of encouragement to people. The personal touch in ministry is not just a nicety; it's a necessity. Living in Truth Ministries is all about pouring into women, speaking truth into their lives, and growing relationships.

When a new healing group begins, I often to write a personal note to each participant to welcome them and let them know what a blessing it is to share their healing journey with them over the coming weeks. Throughout the course of a session, I send other notes of encouragement. And if someone is carrying a heavy burden, struggling in some way, or has shared a distressing prayer request, I take time to send them a personal handwritten letter to let them know I care and am praying for them.

I know that it would be a whole lot easier (and cheaper) to send a text message or email through cyberspace, but because of the nature of God's call on my life with ministry work, I'm not necessarily looking for the most time efficient or inexpensive way. I'm looking for ways to encourage others that will make a lasting impact.

"See what large letters I use as I write to you with my own hand" (Galatians 6:11)!

It is important to let these women know how much they are valued. I want them to know they are worth the time it takes to send a handwritten note (through an actual mail carrier) stamp and all.

"I felt compelled to write and urge you to contend for the faith that was once for all entrusted to God's holy people" (Jude 1:3).

Is there someone that could benefit from a little encouragement shared through a handwritten note or card? Perhaps you could take a few minutes today to ascribe unsurpassable worth to another at cost to yourself. It will likely make their day and encourage you in the process too.

"Therefore encourage one another and build each other up, just as in fact you are doing" (1 Thessalonians 5:11).

~Rae Lynn DeAngelis

Even to Your Old Age

I had a conversation with one of my dear friends who, after seeing herself in a video, made the comment that she hated seeing the wrinkles on her face. She made it sound as if getting older was an abomination leading to desolation. Keep in mind, this friend I'm referring to is gorgeous! And she truly looks younger than her driver's license reveals. So why is she so hard on herself?

Sadly, she's not alone in her mindset. In the United States, our culture places such a great importance on youth (or the appearance thereof) that we practically vilify the aging process. The beauty industry drives much of this kind of thinking. Wrinkles must be smoothed. Fat cells must be burned. Gray hairs must be covered. The products associated with our obsession are part of a multi-billion-dollar enterprise which promises to defy the biological clock and turn back the hands of time.

But here's something interesting. Many other cultures around the world do not have this same mindset. In fact, some nations such as France, Italy, China, India, and Korea actually embrace the aging process. Elders are respected. People in these countries understand that great wisdom and experience are the result of many trips around the sun. "Seasoned" men and women have much to offer: wrinkles, fat pads, gray hairs, and all.

I wish women everywhere could embrace the life stage they are in right now, realizing that each season offers unexpected gifts and treasures to behold. I have to be honest. I love being over fifty. Yes, my body, skin, and hair have changed, but I'm okay with it. I really am!

Here's what God has to say about the aging process:

"Therefore we do not lose heart. Though outwardly we are wasting away, yet inwardly we are being renewed day by day" (2 Corinthians 4:16).

"Is not wisdom found among the aged? Does not long-life bring understanding" (Job 12:12).

"Gray hair is a crown of splendor; it is attained in the way of righteousness" (Proverbs 16:33).

"Even to your old age and gray hairs I am he, I am he who will sustain you. I have made you and I will carry you; I will sustain you and I will rescue you" (Isaiah 46:4).

Let's embrace each year, and know that every wrinkle and gray hair has been earned through a life well-lived. Getting older

can be a beautiful thing. We don't need to change our outward appearance, just our mindset.

~Rae Lynn DeAngelis

The Exact Moment

It is crazy how one pivotal moment in history can lay the foundation on which we view the world, build relationships, and make decisions in life. I can remember the exact moment that solidified the foundation on which I based my thoughts for so long.

For years I created a life based on this foundation. Each moment in time created walls, closed doors, and locked multiple portions of memories up. I felt like the life being built was the one I deserved. Year after year, the life I created portrayed a solid exterior while the interior was a complete mess.

Eventually a house built on an unsteady foundation will crumble. That exact thing happened in my life. The foundation I had built upon was made up of lies heard from others, false beliefs about myself based on other's opinions, rejection from someone I looked to for approval, and chaos in the world surrounding me.

> Therefore everyone who hears these words of mine and puts them into practice is like a wise man who built his house on the rock. The rain came down, the streams rose, and the winds blew and beat against that house; yet it did not fall, because it had its foundation on the rock. But everyone who hears these words of mine and does not put them into practice is like a foolish man who built his house on sand. The rain came down, the streams rose, and the winds blew and

beat against that house, and it fell with a great crash (Matthew 7:24-27).

Well, the rain came, streams rose, and the winds blew with extreme force countless times. I crumbled and fell with a great crash. Thankfully, God sent His mighty angels in to help pick up the pieces He desired for my life and toss the lies. I knew God. I heard His Truths at church every Sunday growing up. The problem arose when I did not allow them to sink into my foundation. I did not build a life on His Truth. Instead, I tried to fit His Truth into the life I created.

His angels helped me build a foundation saturated with Truth. God's Truth provided steady ground to repair the damage from my past. He began to create a beautiful picture from all the broken pieces from my past. He loved me as I processed buried emotions, replaced lies with Truth and grew in strength. I began to walk the path laid for my life.

Do you have a pivotal moment in life? A moment in time you just can't shake off? A time that remains vivid in memory and leads to damaging emotions? My dear friends, God is here to take your hand and guide you through the process of healing. It does not happen overnight. Triggers arise along the path that send you right back to the moment, feeling the emotions stir and tempted to use old ways of coping. God wants to take that memory and remove all the enemy's lies. He wants to use each emotion for His good. He desires healing for your heart and in turn will use you as a vessel to help others living the same moment.

Is it easy? Absolutely not! I still stumble along the path when triggered to relive the pivotal moment in time which damaged my spirit. The enemy used that moment to manipulate my thoughts, define worth and destroy self-confidence. God speaks louder than the enemy. I can hear God speaking to my spirit now. The enemy continues to use evil tactics attempting to change my thoughts. With prayer, sharing emotions with others and speaking my testimony, the enemy remains defeated.

"Finally, be strong in the Lord and in his mighty power. Put on the full armor of God, so that you can take your stand against the devil's schemes" (Ephesians 6:10-17).

~Sheree Craig

Life Interrupted

Have you ever had one of those days when things just aren't going the way you had planned? God has such a sense of humor. He is always giving me real life experiences to drive home a particular lesson He's trying to teach me. For example…

One early morning, I realized I had the entire day to be at home (something I hadn't had in a while) so I mapped out a mental plan of all the things I needed to accomplish. I had much to do.

As always, my morning routine began with me sitting in my comfy recliner poised and ready to meet with the Lord. This is my favorite time of day, and I am very blessed to be in a season of life where I can linger in my quiet time with God for as long as I need.

Shortly after I sat down, the phone rang. It was a dear friend who I hadn't talked with in a while, so I answered it. While we were talking, another call beeped in; I could see that it was my sister. After I got off the phone with my friend, I tried to call my sister back, but she was almost at work and said she would call me later. That was fine with me because I needed to get back to my time with God. I had a jam-packed day ahead.

I opened up my devotion book and the phone rang again. This time it was my daughter, so of course, I answered it. (Any time that I can get with my adult children these days is priceless.) She needed me to check on something for her, which I did, and then

we chatted for a few minutes. After my call with her, I went back to my study materials.

Now becoming engrossed in what I was reading, the phone rang again… another dear friend. Knowing her time is limited and we may not get another opportunity to talk in a while, I put down my book and settled in for a lengthy conversation. An hour later, I returned to my bible study.

The day was more than half over and I hadn't accomplished a single thing on my "to do" list. It became the pattern for my entire day—one interruption after another.

"I know, O LORD, that a man's life is not his own; it is not for man to direct his step." (Jeremiah 10:23).

Ironically, my study that morning talked about how we can sometimes get frustrated when our plans get interrupted. I am the first to admit that each and every one of these calls was very important; they just didn't fit in with *my* plan for the day. Just about the time I was becoming slightly frustrated, God set me straight with the following reading in my bible study lesson:

> When we signed up to follow Christ, we automatically signed up to be open to "Divine Intervention" – God interruptions. While His "call" might not always be convenient or easy, responding to it should not just be a duty, but our joy. We are getting the honor of partnering with the Lord in His purposes for this generation…. Partnering with Him doesn't mean having no plans and ambitions of your own. It means holding them loosely, always leaving room for "the work of the Lord" reshaping your purposes and aligning them with His own. ~Priscilla Shirer, *Jonah – Life Interrupted*

God never wastes an opportunity to bring His lessons to life. Okay, Lord, I got it. Lesson learned. From now on I'm hanging on to my plans a little more loosely.

"I desire to do your will, O my God; your law is within my heart" (Psalm 40:8).

"Send forth your light and your truth, let them guide me; let them bring me to your holy mountain, to the place where you dwell" (Psalm 43:3).

~Rae Lynn DeAngelis

Throwing Stones

"Let any one of you who is without sin be the first to throw a stone at her" (John 8:7). The story of the adulteress woman caught in the act of her sin makes me cringe. Not because I can relate to her particular iniquity, but because I, like her, yield to temptation and miss the mark on a daily basis. My sins may look different, but they are no less damaging. "For all have sinned and fall short of the glory of God" (Romans 8:23). Let's slow things down and read this story with a fresh pair of eyes.

> At dawn [Jesus] appeared again in the temple courts, where all the people gathered around him, and he sat down to teach them. The teachers of the law and the Pharisees brought in a woman caught in adultery. They made her stand before the group and said to Jesus, "Teacher, this woman was caught in the act of adultery (John 8:2-4).

Can you imagine the humiliation; caught in the act of adultery and then hauled off to be judged by the equivalent of one's church pastor? After they brought her to Jesus they said, "In the Law Moses commanded us to stone such women. Now what do you say?" They were using this question as a trap, in order to have a basis for accusing him" (John 8:5-6).

Did you get that? The religious leaders had ulterior motives. They had no empathy or concern for this woman slumped over in shame. She was merely a pawn in their game of power, and she was easily expendable. But Jesus, knowing their true motives, already had His countermove in place. *Why?* Because this woman mattered immensely to Jesus. He loved her.

While the law reveals God's standard for holy living, Jesus reveals God's character and love for His people. "The Lord is not slow in keeping his promise, as some understand slowness. Instead he is patient with you, not wanting anyone to perish, but everyone to come to repentance" (2 Peter 3:9).

John tells us in verse two that Jesus had gone to the temple courts to teach... *and did He ever teach!* "But Jesus bent down and started to write on the ground with his finger. When they kept on questioning him, he straightened up and said to them, 'Let any one of you who is without sin be the first to throw a stone at her'" (John 8:6-7).

The original Greek word used here for writing is *grapho.* One of its meanings caught my attention because it said: Things not to be forgotten; those things which stand written in the sacred books of the OT (Old Testament). I began to wonder if Jesus was referencing the Ten Commandments when He wrote in the sand, simply implying, *if you are going to judge this woman on the seventh commandment (do not commit adultery) it would be wise for you to see how you fare against the other nine. Take a look in the mirror at your own sins before you throw stones at someone else.* The purpose of God's law is to reveal mankind's brokenness and need for a Savior. Jesus came to heal our brokenness and be that Savior. "Jesus said, "It is not the healthy who need a doctor, but the sick" (Matthew 9:12). Praise God! Jesus is able to forgive each and every sin, no matter how heinous.

"Again he stooped down and wrote on the ground. At this, those who heard began to go away one at a time, the older ones first, until only Jesus was left with the woman still standing there" (John 8:8-9).

One by one the religious leaders left. They got the message. Their sin was no different than the woman they were condemning. "Jesus straightened up and asked her, "Woman, where are they? Has no one condemned you?" "No one, sir," she said. "Then

neither do I condemn you," Jesus declared. "Go now and leave your life of sin" (John 8:10-11).

Have you felt the sting of judgement, coming from those claiming to be less sinful? Do you fear that others would abandon you if they knew what went on behind closed doors? Bring into light that which is hidden in darkness, and start walking in a different direction. Jesus is ready, willing, and more than able to bestow on you a crown of beauty instead of ashes, the oil of joy instead of mourning, and a garment of praise instead of a spirit of despair. You will be called an oak of righteousness, a planting of the Lord for the display of His splendor (Isaiah 61:3).

~Rae Lynn DeAngelis

Clorox Clean

Clorox is a marvelous cleaning and disinfecting agent. The vinyl siding of our house had fallen off in several areas, so I picked them up and washed the dirt and grass off with a Clorox/water mix. After putting them back up, they were visibly whiter and brighter than the rest of the siding. I decided to mop just that section of the house with my cleanser and guesstimated a 30-minute project.

Boy was I wrong! The more I cleaned, the more visible the dirt became on the rest of the house. This "small" project ended up taking two days with the help of my wonderful father.

Have you ever noticed something small in your character or behavior that needed a bit of cleaning, but when you began working on that area, other "dirty" areas began surfacing? The Bible shows us that as we begin studying and examining our own lives we see our need for cleansing.

"Therefore by the deeds of the law no flesh will be justified in His sight, for by the law is the knowledge of sin" (Romans 3:20 NKJ).

For example, I gossiped about someone and was deeply convicted through my devotion time with God that day, but I also found that the reason I gossiped was due to pent up anger and bitterness.

We must "cleanse" our mind with God's Word each day. This saves us from having to spend grueling days, hours, or even years trying to clean up the filth and grime left by unrepentant sin. It will also give us freedom and joy in knowing that we are pleasing God by walking in obedience.

"Wash me thoroughly from my iniquity, and cleanse me from my sin" (Psalm 51:2 NKJ).

"How can a young man cleanse his way? By taking heed according to Your word" (Psalm 119:9 NKJ).

"...as obedient children, not conforming yourselves to former lusts, as in your ignorance; but as He who called you is holy, you also be holy in all your conduct, because it is written 'Be holy, for I am holy'" (1 Peter 1:14-16 NKJ).

Are you ready to begin cleaning up the dirty places?

Let's examine our thoughts and actions, compare them to the way God has instructed us to think and act as His followers, and then begin making needed changes.

~Rhonda Stinson

Gotta Have It Now!

With a sister five years older than myself, I was privy to all the crazy fashion trends of the 70's: culottes, hip-huggers, bell-bottom pants, all in psychedelic patterns. It was the year 1978 when I was bit by the latest fashion bug—clogs. I became sick with envy each time I saw someone wearing them. I just had to have them. And of course, it seemed like I was the *only* one who didn't have a pair. "A heart at peace gives life to the body, but envy rots the bones." (Proverbs 14:30).

Every time I went to the mall there they were, perched in the store widow, begging me to take them home. The chocolate brown open-heeled shoes with leather uppers sported a two-inch platform heel. Just the boost I needed to elongate my 5 foot, 2-inch frame. There was only one thing standing in my way of taking them home—money.

At $44.99, I couldn't afford them. It was a small fortune to a teen with no steady source of income. So, I did the only thing I could do. I saved up months of allowance and babysitting money. Unfortunately, by the time I could afford to make the purchase, the fashion trend was on its way out.

Oh well... such is life!

Looking back, I'm grateful that my parents didn't indulge my brother, sister, and me in every fad that came our way. Something new was only purchased after the old had either been worn out or outgrown. If we wanted something special, we had to purchase it ourselves. Through this principle, we learned the value of a dollar. Let's just say, I thought long and hard before shelling my own hard-earned money to make a purchase. Later, my husband and I passed this same value on to our own children.

At times, I still feel the temptation to satisfy the longings of my heart. In some ways the lure is even more acute because, as an adult, I often have the means to actually indulge myself.

But as I mature in my walk with God, I'm learning to say no to myself more often. God is teaching me that I can have contentment in any and every situation, whether I have a little or a lot. "I know what it is to be in need, and I know what it is to have plenty. I have learned the secret of being content in any and every situation, whether well fed or hungry, whether living in plenty or in want. I can do all things through him who gives me strength" (Philippians 4:12-13).

Through Christ we can overcome the "gotta have it now" desires of our flesh and find true and lasting contentment, regardless of our finances, cravings, or circumstances. We simply need to remember that "...in all these things we are more than conquerors through him who loved us" (Romans 8:37).

> For this very reason, make every effort to add to your faith goodness; and to goodness, knowledge and to knowledge, self-control; and to self-control, perseverance; and to perseverance, godliness; and to godliness, mutual affection; and to mutual affection, love. For if you possess these qualities in increasing measure, they will keep you from being ineffective and unproductive in your knowledge of our Lord Jesus Christ (2 Peter 1:5-8).

~Rae Lynn DeAngelis

Take Your Mat and Go

I recently heard an inspiring teaching on a passage of Scripture found in the book of Luke. Perhaps it will encourage you too. It's the story of a paralyzed man who had been brought to Jesus by his friends.

Because there was such a large crowd gathered around Jesus that day, entering through the roof seemed to be their only plausible point of entry. They were desperate to reach Jesus, knowing He had the power to heal their friend. Apparently, Jesus loved their enthusiasm as well as their willingness to think outside the box. "When Jesus saw their faith, he said, 'Friend, your sins are forgiven'" (Luke 5:20).

It may seem like a strange declaration for Jesus to announce that his sins were forgiven, especially since the man was hoping to walk, but this passage expresses one of the most amazing truths about God. He can do immeasurably more that all we can ask or even imagine (Ephesians 3:20).

Like the man on the mat, you and I might *think* we know what we need; but through our own encounter with Jesus, we discover that, just like the paralyzed man, our deepest need is not physical healing, but spiritual cleansing.

> Then, "[Jesus] said to the paralyzed man, "I tell you, get up, take your mat and go home." Immediately he stood up in front of them, took what he had been lying on and went home praising God. Everyone was amazed and gave praise to God. They were filled with awe and said, "We have seen remarkable things today" (Luke 5:24-26).

There is another beautiful truth in what Jesus says to the paralyzed man, "Get up, take your mat, and go home." The mat was the man's connection to his old way of life; it was something the man could hold up as a visual aid to demonstrate what Jesus had done for him. He could say, "This is what my life used to look like, but now, look at me. Look how my life has changed for the better. What Jesus did for me, He can do for you!"

By asking the man to take up his mat, Jesus was giving the paralyzed man the same commission that He gives to you and me today: *Go, now, and minister to others. Show them the same love and mercy I have shown you.*

What is your mat—your visual aid to prove how Jesus has transformed your life? A redeemed marriage? Healed illness? Freedom from an addiction? Pregnancy after years of infertility?

Maybe you're still waiting for your miracle. Don't lose hope. Don't give up. Seek Jesus with all your heart, and like the friends, carrying the parlayed man, be bold in your approach.

And after you receive your miracle, remember to take up your mat and go. Your mat is now your ministry!

> For I know the plans I have for you," declares the Lord, "plans to prosper you and not to harm you, plans to give you hope and a future. Then you will call on me and come and pray to me, and I will listen to you. You will seek me and find me when you seek me with all your heart. I will be found by you," declares the Lord, "and will bring you back from captivity (Jeremiah 29:11-14).

~Rae Lynn DeAngelis

Do You Believe?

I can't tell you how many times, when I get a new appliance or gizmo, I fail to see the protective plastic coating. It's so clean and tight you don't even notice it. Eventually, I figure it out. Other times I choose to leave the wrap on to protect the appliance against my klutzy antics. I also figured out that in the past, I've been pretty good at wrapping myself in a thick plastic coating. I make sure it's very clean and tight so no one can see it. That plastic coating did a good job of deflecting my issues and flaws onto others and protecting me from seeing my true self. You see, if I couldn't see myself, then I didn't have to fix myself.

I didn't know Jesus very well back then. I had absolutely no clue that I had hordes of negative thinking beliefs that had to be identified and changed. God encourages us to look inward, to identify areas of weakness, pain, and illness so we can address them: "... *you should examine yourself" (1 Corinthians 11:28).* In other words, take off the protective-wrap!

Self-examination is an important part of living as an authentic Christian. But by nature, we prefer self-deception; it's easy and comfortable. We don't always know our own hearts (Jeremiah 17:9)—not as God does. True self-examination and healing must be done with God. Romans 12:2 says, *"let God transform you into a new person."* Try as we may, true transformation requires a Helper. We need God to continue His sovereign work in us. Warning: He will be thorough! He's not in the business of slapping on a band-aid. He wants to evaluate, assess, and examine our lives. Then with skill and precision, He will give us the perfect prescription for a comprehensive treatment plan that will lead to healing.

As followers of Christ, we are "new creations." We've been empowered to live a new kind of life. God is all about revealing the stuff from our "old creation" which is hindering us from participating in the abundant life He came to give us (John 10:10). Even if we grab on with just a mustard seed of faith, it will be enough for the Power Source to accomplish this seemingly impossible task. He breaks through the chaos, "Anything is possible through me."

"When he had gone indoors, the blind men came to him [God], and he asked them, "Do you believe that I am able to do this?" "Yes, Lord," they replied" (Matthew 9:28).

Do you believe, really believe, Jesus can help you heal? Turn your response into a prayer.

~Kimberly Davidson

God's Perfect Timing

S ome time ago, I spoke to a local MOPS (Mothers of Preschoolers) group about inner beauty. As I was packing up my things to leave, I was approached by a woman who came to the meeting as a representative for *Mary Kay*. She thanked me for my presentation, and we talked about the importance of inner beauty and seeing ourselves through God's eyes. Before leaving, she asked for my card and said she would be in touch.

About a week later she gave me a call and said that she couldn't stop thinking about my talk and had already shared my core message with some other people. She felt compelled to meet with me personally so we could talk about how our missions might unite.

I knew she was a Christian so for that reason alone I wanted to get to know her better, but I honestly couldn't imagine how

Mary Kay and Living in Truth Ministries had anything in common. In my mind, Living in Truth is about inner beauty, and Mary Kay is about outer beauty. Although I couldn't imagine how the two might connect, I was obedient to God's leading and followed through with our meeting.

Was I ever humbled! As I sat listening to this woman's appeal, I learned so many things, things like Mary Kay is a Christian based organization and the entire structure is Christ-centered. They keep Christian values and principals at the center of all they do. I was shocked. I had no idea Mary Kay had Christian roots.

This woman is a successful senior sales Director for Mary Kay and through her position of influence has many connections. She felt compelled to help me connect with some of her contacts to help spread Living in Truth's message. She felt that our ministry was something that really needed to get out there. Wow, I was amazed that a total stranger would take such an interest in what I was doing—so much so that she would take time from her busy schedule to meet with me and begin brainstorming about how this ministry can reach even more people.

"You hear, O LORD, the desire of the afflicted; you encourage them, and you listen to their cry" (Psalm 10:17).

The timing of it all was so perfect because I had been feeling overwhelmed at the prospect of growing our ministry and was feeling kind of stuck—not knowing where to go next. God totally took over and provided me with some much-needed encouragement and incentive to get moving again.

"Therefore encourage one another and build each other up, just as in fact you are doing" (1 Thessalonians 5:11).

The fact that a total stranger had such confidence in this ministry gave me the confidence and needed courage to take this ministry to the next level.

"They approach and come forward; each helps the other and says to his brother, "Be strong! The craftsman encourages the goldsmith, and he who smooths with the hammer spurs on him who strikes the anvil" (Isaiah 41:5-7).

With each new day may we seize the opportunities God places in our path.

"I took you from the ends of the earth, from its farthest corners I called you. I said, 'You are my servant; I have chosen you and

have not rejected you. So do not fear, for I am with you; do not be dismayed, for I am your God. I will strengthen you and help you; I will uphold you with my righteous right hand" (Isaiah 41:9-10).

~Rae Lynn DeAngelis

On High Alert

One summer, our once peaceful neighborhood became an impromptu playground for a few rogue adolescents with too much time on their hands. My husband and I, along with our neighbors, were on high alert each summer weekend because that's when the vandals would usually strike.

You never knew what you would find the following Saturday or Sunday morning. The destruction ranged anywhere from slashed tires to smashed mailboxes. Our community police had been unable to catch the offenders in the act, and without witnesses, there wasn't much anyone could do. My husband and I grew increasingly frustrated.

Out of desperation, we decided to go on the offense and invested in a couple of security cameras that we installed on the front of our house. Perhaps we could get a glimpse of the delinquents in action. Our hope was to get them off the street and make our neighborhood safe again.

Sure enough, they struck again, only this time it was really bad! Our neighbors across the street heard a loud smashing sound outside their house late one night. They were horrified to find their garage and front porch light fixtures completely destroyed. After calling the police, they came over and asked us if we could check our video tape to see if our cameras had caught anything.

Not only had we captured two teen boys smashing our neighbors outside lights with a baseball bat, we also caught them

breaking into one of our cars on the driveway. They were becoming increasingly more audacious.

The police posted the fuzzy image of the teens on the front page of our newspaper and asked if anyone could identify them. Several people identified one of the boys, but the police were never able to prosecute because the mom gave her son an alibi. After posting the picture of the vandals in the local paper, we started seeing a decline in activity. Thank goodness!

Security cameras rolling 24/7 may be a good deterrent to wayward teens, but neighborhood vandals are not our only threat. "Be alert and of sober mind. Your enemy the devil prowls around like a roaring lion looking for someone to devour" (1 Peter 5:8).

Satan and his minions are an ongoing threat to our peaceful existence and are familiar with our areas of weakness. Like a thief scoping out his next heist, the devil watches and waits for just the right moment to strike, when we least expect it. "With this in mind, be alert and always keep on praying for all the Lord's people" (Ephesians 6:18).

We must be on high alert with our feet planted firmly on the promises of God. And let us not forget,

"Our struggle is not against flesh and blood, but against the rulers, against the authorities, against the powers of this dark world and against the spiritual forces of evil in the heavenly realms" (Ephesians 6:12).

Thankfully, we are not alone on this spiritual battlefield. "The family of believers throughout the world is undergoing the same kind of sufferings. And the God of all grace, who called you to his eternal glory in Christ, after you have suffered a little while, will himself restore you and make you strong, firm and steadfast. To him be the power for ever and ever. Amen" (1 Peter 5:9-11).

~Rae Lynn DeAngelis

Mixing Bowl of Life

- 1 cup butter, melted
- 2 cups white sugar
- 1/2 cup cocoa powder
- 1 teaspoon vanilla extract
- 4 eggs
- 1 1/2 cups all-purpose flour
- 1/2 teaspoon baking powder
- 1/2 teaspoon salt

Take notice of all the ingredients in here. None of them by themselves would you put directly in your mouth, well, maybe the sugar. But alone these ingredients are bitter, salty, tasteless, or bland. But together with a little heat and time, they all have a purpose. The end result is yummy, oh-so-good brownies.

This is how God put our lives together. He promises to work everything to the good for those who love him. That's you and me, my friend. So maybe my recipe for life looks a little bit like this:

- 1 cup of disappointment
- 2 cups of grace
- 1/2 cup of blended family
- 1 teaspoon rejection
- 4 ounces of infertility
- 3 teaspoon sexual mistakes in college
- 1/2 cup of church hurt
- 1 sprinkle of disordered eating

All of these standing alone may make my life look hopeless, worthless, or impossible to be useful. But put them together with

a little heat and time, and I start seeing a sweetness come out of my life that has purpose and a plan that only my Creator could cook up!

"Taste and see that the Lord is good; blessed is the one who takes refuge in him" (Psalm 34:8).

So, what's in the mixing bowl of your life? Are you ready to surrender and turn over to Jesus? I challenge you to lay it all at His feet and watch what He can do. Maybe there's extremely hard stuff that you've tucked deep down: sexual abuse, an affair, an abortion, another binge/purge episode... Whatever it is, HE CAN HANDLE IT. In His faithfulness, in His perfect timing, and in His power, He will bring warm, fresh goodness out of your situation. Believe this verse with me:

"So we are convinced that every detail of our lives is continually woven together to fit into God's perfect plan of bringing good into our lives, for we are his lovers who have been called to fulfill his designed purpose" (Romans 8:28 TPT).

Father, you know every detail of my life, the things I've done, and the things that have been done to me. You know my fears, my hurts, my sins, my weaknesses, and I believe with all my heart that you are weaving all of those things together for good. You love me, and You created me. Please help me to trust that You will take care of me. Change me from the inside out. I can't wait to see what You make of all of my life. I want to fulfill the purpose You have designed for me. I love and trust You. In Your Holy, Faithful Name, Amen.

~Alison Feinauer

Living for Today

As my husband and I began crossing over from Indiana to Kentucky, we saw a long line of traffic stopped along the bridge. Obviously there had been an accident of some sort, but what kind we had no idea. As we approached the scene and saw the police cars, fire truck, and ambulance, it became evident—this was a very serious situation.

Nothing could have prepared Gerry and I for what we saw. Sandwiched between the many emergency vehicles and rescue workers was the charred ruins of a semi-truck melted into a distorted heap of metal and underneath the truck was the remains of another vehicle almost unrecognizable.

The flow of traffic had stopped for miles, and since the accident was on a bridge and there was no way for people to turn around, cars were trapped on the highway for hours.

My heart sank into the pit of my stomach at the sudden realization that lives had been changed in an instant that day.

Later that evening, our local news station reported about how a 59-year-old woman and her 18-year-old daughter (for reasons that may never be known) had stopped in the middle of the highway's bridge. The first semi-truck following behind the car had swerved to miss the vehicle, but the second truck behind the first truck didn't have time to react and barreled into the car. The impact caused an intense explosion, melting both vehicles before fire workers were able to contain the flames.

This terrible accident was a bold reminder to me how fragile life can be, and how, in an instant, things can be changed forever.

I thought about this woman and her daughter getting up that morning. I pictured them having morning coffee together and

getting ready for the day ahead, never realizing that day would be their last.

I wondered: Were they believers? Did they know Jesus? What about their loved ones left behind? I can't imagine their pain. Their loved ones didn't get to say goodbye. No one had time to prepare for such a tragedy. The news of their death was surely a crushing blow to all those left behind. My heart ached for their loss.

"Now listen, you who say, 'Today or tomorrow we will go to this or that city, spend a year there, carry on business and make money.' Why, you do not even know what will happen tomorrow. What is your life? You are a mist that appears for a little while and then vanishes" (James 4:13-14).

Life is fragile. We are not promised tomorrow. We have only this day, this moment, this one life to make an impact on the world and people around us. So, the question is, what are you doing with this day, this moment, this life?

"This day I call the heavens and the earth as witnesses against you that I have set before you life and death, blessings and curses. Now choose life, so that you and your children may live and that you may love the Lord your God, listen to his voice, and hold fast to him" (Deuteronomy 30:19-20).

I don't know about you, but I'm going to be more proactive about living in the here and now.

"But encourage one another daily, as long as it is called today…" (Hebrews 3:13).

~Rae Lynn DeAngelis

Who's the Fairest?

“For now we see only a reflection as in a mirror; then we shall see face to face. Now I know in part; then I shall know fully, even as I am fully known” (1 Corinthians 13:12).

Mirror, mirror on the wall, who's the fairest of them all? What little girl hasn't twirled in front of the mirror, seeking answer to this rhetorical question? Barely out of the womb, children unwittingly seek the applause of others. It's as if our desire for sanctioned approval is part of our DNA.

And perhaps it is.

Deep within the heart of every young girl is a desire to be beautiful, cherished, and loved. We want others to stand in awe. Our quest for significance is not sinful. It only becomes problematic when we seek to find significance apart from God.

Unfortunately, because we live in a broken world and are influenced by the enemy's deception, rather than embrace our God-given purpose and individualism (that which sets us apart from others), we instead gather crumbs of leftover accolades from our self-absorbed society. Through a warped perception of ourselves and others, we quickly realize, we can never quite measure up to the standards of this world.

An impressionable young teenager, I got up early every morning and spent three grueling hours getting ready for school. Thick layers of makeup and hairspray became a makeshift armor of sorts. I'd hoped it would safeguard me from the harsh judgment of others. Oh, how I wish I could travel back in time. I would pay a visit to my adolescent self, pull her close, and speak tenderly to her heart:

- *Rae Lynn, you don't need all that makeup.* "Your beauty should not come from outward adornment, such as elaborate hairstyles and the wearing of gold jewelry or fine clothes. Rather, it should be that of your inner self, the unfading beauty of a gentle and quiet spirit, which is of great worth in God's sight" (1 Peter 3:3-4).

- *You are a one-of-a-kind daughter of the King. Quit trying to be like everyone else.* "Do not conform any longer to the pattern of this world, but be transformed by the renewing of your mind" (Romans 12:2).

- *Do not compare the inside of yourself with the outside of others.* "Charm is deceptive, and beauty is fleeting; but a woman who fears the Lord is to be praised" (Proverbs 31:30.)

- *God has a plan and purpose for your life and it is more amazing than you can imagine.* "For I know the plans I have for you," declares the Lord, "plans to prosper you and not to harm you, plans to give you hope and a future" (Jeremiah 29:11).

- *Hold on to the teachings of Jesus. His truth will set you free!* "The KING is enthralled by your beauty. Honor Him for He is your Lord" (Psalm 45:11).

Sweet sister, perhaps you need to hear these words of truths for yourself. Never forget, in the eyes of the One who fashioned you in His likeness, you are indeed beautiful, cherished, and loved—*the fairest of them all!*

~Rae Lynn DeAngelis

Irritant or Pearl?

Pearls are beautiful to the eye and very costly, especially natural pearls. A pearl is formed through an amazing process. An irritant, such as a grain of sand or parasite is embedded into the soft inner layer of an oyster. This triggers a defense mechanism in the oyster, thus releasing a substance called nacre to encapsulate the irritant. It will continue to release nacre forming layer upon layer around the irritant to create a pearl.

Pearls may form within 1-20 years, depending on whether the oyster is in saltwater or freshwater. A true pearl cannot be formed outside of an oyster. Man can introduce his own irritant into the oyster and it will produce a pearl called a cultured pearl. God's creation is amazing and cannot be re-created!

Irritants in our lives can be made into pearls if we so choose. My physical infirmities have produced the pearls of understanding and perseverance; unresolved anger has yielded humility and self-control; uncertainty has yielded faith and trust in God.

Is something or someone continually irritating you? Would you rather take action and produce a pearl or let the irritant continue to irritate?

Paul had to deal with an irritant in his life. He called it his thorn in the flesh.

"Concerning this thing (thorn in the flesh) I pleaded with the Lord three times that it might depart from me. And He said to me 'My grace is sufficient for you, for My strength is made perfect in weakness.' Therefore most gladly I will rather boast in my infirmities, that the power of Christ may rest upon me" (2 Corinthians 12:8-9 NKJ).

The power of Christ became the pearl of Paul's infirmity!

Like Paul, Christ will cover the pain in our lives with qualities that produce genuine beauty and worth.

"But the fruit of the Spirit is love, joy, peace, patience, kindness, goodness, faithfulness, gentleness, and self-control" (Galatians 5:22-23).

~Rhonda Stinson

Noble Purposes

God ingeniously designed His creation to adapt and change with the environment. As the cooler temperatures of fall set-in and nature prepares for winter, trees go dormant, pelts grow thick, birds fly south, squirrels gather nuts, bears store fat, and fish dive deep.

Long before winter appears, God prepares nature for what lies ahead. And God does the same with you and me. He knows exactly what we need and prepares us for what's yet to come. He even prepares us ahead of time for the call He places on our lives.

"In a large house there are articles not only of gold and silver, but also of wood and clay; some are for noble purposes and some for ignoble. If a man cleanses himself from the latter, he will be an instrument for noble purposes, made holy, useful to the Master and prepared to do any good work" (2 Timothy 2:20-21).

The Lord has a specific calling for each one of us and desires us to produce fruit along the way.

"For we are God's workmanship, created in Christ Jesus to do good works, which God prepared in advance for us to do" (Ephesians 2:10).

Take a moment and reflect back over your life. Can you see how God has been preparing you *"for such a time as this?"*

Every moment from the past is an intricate part of God's divine plan for your life both here and now, and your future. If God has brought you to it—He will get you through it.

"And my God will meet all your needs according to his glorious riches in Christ Jesus" (Philippians 4:19).

Like He does with nature, God will prepare you for the next season coming your way.

"So be careful to do what the LORD your God has commanded you; do not turn aside to the right or to the left. Walk in all the way that the LORD your God has commanded you, so that you may live and prosper and prolong your days in the land that you will possess" (Deuteronomy 5:32-33).

~Rae Lynn DeAngelis

Age-Defying

I'm reminded over and over again that this physical world is in a constant state of disrepair, falling prey to the effects of time and decay. Foundations crack. Cars quit. Sweaters snag. Appliances fail. Roofs leak. Metal rusts. Roads crumble. Décor outdates. Dust covers.

And we haven't even gotten to the body yet.

Skin wrinkles. Hair grays. Boobs sag. Teeth decay. Weight accumulates. Cancer invades. Bones ache. And hair grows everywhere except the one place we want it.

Never fear... the world is here.

Mankind has a policy, potion, program, or pill for just about everything we could possibly imagine: hair color, implants, serums, medications, whitening kits, diets, exercise equipment, health treatments, pain relievers, and hair tonics.

No judgement from me. I've spent more than my share of time, money, and energy searching for the proverbial fountain of youth. Just the other day, I was scrolling through my social media feed and came across an advertisement that promised to remove wrinkles. As I grow older, wrinkles are becoming more prominent. As you can imagine, the promise of a serum to make me look younger was enticing. So, I clicked on the post and began reading. Until I got to the price tag that is. Yikes! It's expensive to look young.

The beauty industry is a multi-billion-dollar market. And that doesn't even include the health portion of the business.

Let me be clear; I'm all for caring for our bodies. After all, our bodies are a temple for the Holy Spirit. But sometimes I wonder. Are we placing more focus on the body, which perishes in the end, than we are the soul, the part that lives forever?

Fellow Believer, this world is not our home. Our body is merely a shell (a tent) and it has an expiration date.

The spirit is another matter. We get to take that with us. Wouldn't it make more sense to invest our greatest time, finances, and resources on the part that never dies?

"Therefore, we do not lose heart. Though outwardly we are wasting away, yet inwardly we are being renewed day by day" (2 Corinthians 4:16).

One day (perhaps very soon) you and I will stand before Jesus. Are you ready? Did you use the time you've been given wisely? Did you invest in your relationship with Jesus? Did you tell others about the One who saves? Did you use your gifts, talents, and resources for God's Kingdom?

Friends, time is running out. The true age-defying remedy is not found in a serum. It's found in a Savior.

"For we know that if the earthly tent we live in is destroyed, we have a building from God, an eternal house in heaven, not built by human hands. Meanwhile we groan, longing to be clothed instead with our heavenly dwelling, because when we are clothed, we will not be found naked" (2 Corinthians 5:1-3).

~Rae Lynn DeAngelis

All About Him

I have the honor of ministering to women with a history of abuse in Oregon's federal prison. The recovery curriculum is set on God's Word, their sole source of real healing. Yet, I'd say 80 to 90 percent of the women never react to the Bible verses and passages; they're often just "blank" which discourages me. The enemy whispers, They're not ready for God's Word. They're not real believers, so if you push this on them, they're going to drop your class.

I'm embarrassed to admit there have been times I've pulled back because I don't want the women to feel "uncomfortable." God continually reminds me of His promise, "So is my word that goes out from my mouth: It will not return to me empty, but will accomplish what I desire and achieve the purpose for which I sent it" (Isaiah 55:11).

This is POWER! God is saying once His Word is out there—whether it's read or heard, it will:

- Accomplish His desire
- Achieve a defined purpose

He sent the Word on purpose to the receiver.

I finally got it—It's not what I do or say. It's what He does and says. It's all about Him! It's not what I write on the pages of a book, or how I present material in a classroom. It's what He does to you through His Word.

Scripture is the foundation on which healing and restoration is built. The prophet Micah declared, "Though I have fallen, I will rise. Though I sit in darkness, the LORD will be my light" (Micah 7:8).

Reading and studying God's Word is how we come to know God more deeply. It's His revelation of Himself to us. If you don't understand a word, look it up. When God speaks, He packs a lot into His words. I encourage you to open up your Bible and press into one verse or a short Psalm each day. Ask, "What is God telling me? How should I respond?"

Something supernatural happens when we read God's Word: our faith grows, our worries diminish, our strength increases, we become empowered, our bodies and souls reap the benefits, and we develop new neural circuits in our brains for compassion and empathy!

You may be feeling guilty because you haven't had time to study the Scriptures or pray as much as you'd like. Stress and trauma and loss does that to us. God understands.

Let this be a new experience between you and God. Pray something as simple as, "God, may your life-giving Word take root in my heart, mind, and soul. I need you to hold onto me tightly today; let your Word feed my soul and sustain me."

Frances Ridley Havergal once said, "The Christian life hinges on one thing—taking God at His Word, believing He really means exactly what He says, and accepting the very words that reveal His goodness and grace."

~Kimberly Davidson

A Living Sacrifice

Take it from someone who knows; sacrificing 'the natural' is not an easy thing to do. However, it is a whole lot easier than living in bondage to sin which feeds off the lies and empty promises of Satan.

Sins of the flesh might make us feel good for a time, but the longer we remain in our stronghold, the emptier we feel and the harder it is to find our way back to God.

If a man cannot get through to God it is because there is a secret thing, he does not intend to give up ~Oswald Chambers.

For years, I rationalized my bulimic behavior by telling myself it was simply a way for me to control my weight. My yearning to be beautiful by the world's standards distorted reality, and I don't mind telling you, I was miserable!

I lived by the number on the scale. If my weight was down, it was a good day. If my weight was up, it was a horrible day. I was convinced that if I achieved the right weight by the world's standards, I would find true and lasting happiness. It was all a lie.

As the number on the scale went down, so did my self-esteem. I was drowning in a pit of Satan's lies and wasted away in more ways than one.

Some of us are trying to offer up spiritual sacrifices to God before we have sacrificed the natural. The only way in which we can offer a spiritual sacrifice to God is by presenting our bodies as a living sacrifice ~Oswald Chambers.

When you plummet into such a deep pit of despair, there's only one way to look—up.

"I waited patiently for the LORD: he turned to me and heard my cry. He lifted me out of the slimy pit, out of the mud and mire; he set me my feet on a rock and gave me a firm place to stand. He put a new song in my mouth, a hymn of praise to our God. Many will see and fear and put their trust in the LORD" (Psalm 40:1-3).

Is there something natural that God is asking you to sacrifice—to hand over to Him? Let go and watch what God can do. Allow the truths of His Word to penetrate your heart and bring healing to your soul.

"Jesus said, "If you hold to my teaching, you are really my disciples, then you will know the truth and the truth will set you free" (John 8:31-32).

Without the Word of God as my daily bread, I would be buried in a pit so deep that I wouldn't recognize daylight ~Beth Moore.

~Rae Lynn DeAngelis

Keys to Success

Overcoming harmful or addictive behaviors and maintaining freedom hinges on three key elements—an ongoing commitment to change, a daily practice of disciplines that are aimed at maintaining success, and time spent nurturing a steadfast relationship with Jesus.

One of the disciplines that helps me maintain freedom from disordered behavior is a daily practice of identifying and weeding out worldly lies so they no longer rule my life. During my time with the Lord each morning, He directs me to biblical truths through various devotion books and bible study materials. When I come to a truth that really speaks to my heart, I write it down on an index card and begin meditating on how it applies to my life. In this way, I choose to focus on what is true, rebuke what is not, and create healthy, life-affirming thought patterns which lead to healthier behaviors and actions.

Regardless of the type of stronghold or oppression one faces, falling into a trap of the enemy begins in much the same way. *Bondage is born in the mind before it is ever played out in real life.*

Anyone living in the modern world knows that smoking is strongly linked to cancer, and yet, 1.1 billion people around the globe continue to smoke. If tobacco is a known carcinogen, why do so many people disregard the warnings and smoke anyway? It is the same reason that billions of people live with other unhealthy strongholds. A person rationalizes the behavior and becomes convinced that they can beat the odds. The enemy whispers his lies: *it won't happen to you; you can stop any time you want; it's just this once; you can quit tomorrow; you deserve this; you're not hurting anyone; it's your life—you can do what you want.*

In our minds we defend, rationalize, and justify the behavior. Before long, the decision is made and we act on the conceptualized belief. This is how substance abuse and other forms of addictions take root. It's how marriages fall prey to adultery and how people end up knee-deep in debt.

The enemy has been around for a very long time and knows our human nature. He knows that if he can whisper the lie and get us to think long and hard about something, we will eventually rationalize and justify the behavior. From there, our flesh nature takes over. Actions align with beliefs and before long our lives spin wildly out of control. Like a train barreling downhill without brakes, forward momentum makes it very difficult to stop.

One of the offenders is dopamine—a powerful chemical in the brain associated with pleasure. As the brain releases this intoxicating chemical into the bloodstream, we experience feelings of exhilaration and euphoria. Because it makes us feel good, the addictive behavior becomes very hard to give up. And because of the nature of addiction, it eventually takes more and more of the thing (whatever it may be) to reach the same level of euphoria.

But like a runaway train, our lives can easily derail when obstacles get in the way. Your health begins to fail; your spouse finds that secret text; your loved one learns of your addiction; your phone rings off the hook from creditors seeking payment. Friends, we don't have to live like this. The enemy is lying to us! It's time to expose his tactics of deception.

The Bible tells us that Satan is the father of all lies; he knows that if he can sidetrack us with counterfeit feelings and experiences, he can keep us from the One who can truly satisfy the deepest longings of our soul—Jesus.

There is a healthy addiction, a stronghold, that is never harmful or destructive. Jesus alone is able to fill the hole in our soul. He is the key to our success. Let the King of kings and LORD of lords unlock your prison door and set you free once and for all.

"So if the Son sets you free, you will be free indeed" (John 8:36).

~Rae Lynn DeAngelis

A Good Place to Start

I was driving through the line the other day to drop my son off at school. I was in a hurry and thought, I'll get him out of the car quickly and go around the long line. As I snuck around the side exit, I got stuck by a teacher trying to back into a spot. So, I sat and waited. Of course, the cars that I "should" have been in front of were now leaving before me.

I was finally released, but I turned a corner too sharply and hit a HUGE pothole that I didn't see. Immediately, my front tire deflated. Ugh! My rushed, get out of the line thinking, quickly turned into an hour waiting for AAA to come rescue me. Then a flood of thoughts came. *Now we will have to pay for a whole new tire since it was a sidewall that I ruined. If only I wouldn't have been in such a hurry. Why did I disobey the rules of the line, what was the rush? I didn't really even have a meeting to get to.*

Yes, all of the self-punishment came rushing in. Shame and anger were now my loudest voices.

I called my sister and, of course, she comforted me, telling me we are all human, and it's OK. At least I was safe and in a parking lot. It could've been worse. I texted my husband, telling him there was no need to be upset with me, I was already punishing myself enough.

It didn't end there. As I was driving to work, the pain got heavier and heavier. I'm in a process lately of trying not to just shove my feelings down and make the "best" of every situation, but to actually pause, say *this hurt,* and invite the Holy Spirit in to reveal truth and comfort me.

Just the day before, I had prayed for God to bring me wisdom and teach me how to receive comfort from the Holy Spirit like Psalm 23:4 says, "Your Rod and Your staff, they comfort me."

What does this look like in real life, the Rod and Staff being comfort, correction, and bringing me safety from my loving Father?

As I processed this and prayed, I had a few revelations. I am a selfish being. I was putting my needs and desires in front of the rules of the school. If I don't want to sit in the line, I need to arrive sooner. And so often in my days, I do act entitled and prideful like I'm "above the law".

This is not OK. It's humbling and good to observe my human actions and see how they line up with what God's truth is for me. What He wants for me: patience, self-control, humility, respect for those in authority, and honor. It brings me to a place of repentance, where freedom is found.

Is there a place where you need repentance? It may be a moment or a behavior that you need to look at and search out some motives that may not be so kind. Ask God to help you see that. Or maybe there are some desires you need to be honest about with yourself? I didn't like seeing this ugly truth about me, but it's there.

Awareness is such a good place for us to start. Bringing it into the light breaks its power and moves us to the next place in our journey.

Father, forgive me for this, for pride and help me to slow down. I need you to help me stop rushing and to stop striving. I want to learn to rest and increase my trust in you, not only in my heart but through my everyday actions. Help me to think before I act. And thank you so much for being my comfort when I feel like I've failed again and when I'm in the pit of hopelessness. Increase my expectations and my trust in You, for You to turn all things into good for those who love You. Amen.

~Alison Feinauer

Pushing the Limit

O bedience is usually one of my stronger suits; however, every once in a while, I find myself tempting fate to see how far I can push the limit without getting caught. If the speed limit sign says 70, I set my cruise control on 75 and take my chances. Of course, there's an added level of stress to my trip because I'm constantly scanning the perimeter for cops so I don't get caught.

As Christians we sometimes approach our journey with God the same way. We subconsciously wonder how far we can cross the line of disobedience and not stir up God's anger.

The Bible says, "You shall not misuse the name of the Lord your God." Yet how many times has the phrase, "Oh my God!" flippantly escaped from our lips?

The Bible says, "Six days you shall labor and do all your work, but the seventh day is a sabbath to the Lord your God" but sometimes we let weeks go by without a day of rest.

The Bible says, "You shall not give false testimony against your neighbor" and yet how many times do we stretch the truth or share information that dishonors others?

The Bible says, "You shall not covet your neighbor's house, spouse, or belongings" and yet, millions of people live outside their means in order to keep up with the "Joneses".

Like disregard for speed limit boundaries, we often treat God's commands like they are guidelines that we can manipulate to serve our purposes. But when we manipulate or modify God's clear-cut imperatives, we really only hurt ourselves.

- Disrespect for God's name discredits our witness
- Disregard for proper rest causes irritability and illness

- A careless word or gossip discredits our character
- Attempts to satisfy every longing of our heart leads to financial ruin

God doesn't put boundaries in place so that He can deny us good things. He puts boundaries in place because He wants us to thrive and flourish. And because God created this world and everything in it, He knows the exact conditions to make that happen.

I am preaching to the choir on this one… *After all, I'm a work in progress too.*

"Do not merely listen to the word, and so deceive yourselves. Do what it says" (James 1:22).

"If anyone obeys his word, love for God is truly made complete in them. This is how we know we are in him" (1 John 2:5).

~Rae Lynn DeAngelis

Tough as Nails

During the 1970's, my parents purchased a sixty-three-acre farm (a vacation home of sorts) with their best friends. This countryside estate became our home away from home. I have such fond memories from our days on the farm, especially playing in the barn. The rickety old structure provided hours of enjoyment for all nine of us kids.

I remember constructing intricate forts with bales of hay, pretending it was our home. Sometimes we jumped off the 2nd floor loft into a soft cushion of straw below. We played kick the can and hide and seek, but one of my most cherished memories was the time we put on a play performance. The loft became our

stage. Our parents and a few unsuspecting neighbors were kind enough to engage in our attempts at stardom. We spent hours preparing for our rendition of the *Sound of Music*—a movie we'd watched so many times; we knew the script by heart.

Although the barn provided endless hours of fun, it included a few inherent risks. Sometimes, beneath the layers of accumulated fodder and hay, fractured boards lay hidden beneath with rusty nails protruding up. Our parents had warned us many times about the possible dangers of playing in a hundred-year-old structure, but sometimes we became so engrossed in playtime activities that we grew careless and paid the price.

Knowing the pain of having a nail in your foot, I cringe at the thought of Jesus impaled to a cross by His hands and feet.

The physical suffering Jesus had endured was horrific for sure, but it did not compare with the mental, emotional, and spiritual anguish that our Savior faced while He hung on the cross. Every sin of mankind (past, present, and future) was thrust upon our Lord, a weight so heavy only God Himself could carry it.

Jesus, God in the flesh, took every bit of our sin and nailed it to the cross.

"Jesus said, "It is finished." With that, he bowed his head and gave up his spirit" (John 19:30).

The King of Glory suffered, died, and was buried. But that was just the beginning. On the third day, that glorious and wondrous third day, our Lord and Savior, *who is tough as nails,* did what only He could do; He rose from the grave and conquered death once and for all!

> Praise be to the God and Father of our Lord Jesus Christ! In his great mercy he has given us new birth into a living hope through the resurrection of Jesus Christ from the dead, and into an inheritance that can never perish, spoil or fade. This inheritance is kept in heaven for you, who through faith are shielded by God's power until the coming of the salvation that is ready to be revealed in the last time. In all this you greatly rejoice, though now for a little while you may have had to suffer grief in all kinds of trials. These have come so that the proven genuineness of your

faith—of greater worth than gold, which perishes even though refined by fire—may result in praise, glory and honor when Jesus Christ is revealed (1 Peter 1:3-7).

~Rae Lynn DeAngelis

Cribbing

While living in Arizona, I helped out on a horse ranch. Chores included feeding, grooming and mucking. One of the horses caught my eye on my first day. It was a beautiful male quarter horse, but it wasn't his beauty that drew me in. The horse had its top incisors hooked onto the wooden fence post, and with its neck arched, he was drawing in large amounts of air.

The owner told me the behavior is called "cribbing". Apparently, this horse liked to do it constantly. Thunder had come from a traumatic home environment and resorted to cribbing as a means to ease his anxiety.

Horses can develop coping mechanisms just as people do. They use different types of behavior to deal with anxiety, boredom, isolation, change of environment, etc. Cribbing releases endorphins into the horse's brain. Side effects of cribbing include enlarged throat muscles and damage to the upper incisors.

Like Thunder, we might develop some coping mechanisms to help us manage stress. These may include exercising, eating, not eating, spending money, substance abuse, excessive working, praying, or reading the Bible. All of these have side effects whether they are positive or negative.

Are you a "cribber?" Do you latch onto things which only temporarily put you at ease? Try talking to someone about what

you're feeling. Start journaling your thoughts or find some other positive outlet. God is only a prayer away.

Cease cribbing and start living. God cannot use you to your full potential while you're still latched onto the fence post.

"Be anxious for nothing, but in everything by prayer and supplication, with thanksgiving, let your requests be made known to God; and the peace of God, which surpasses all understanding, will guard our hearts and minds through Christ Jesus" (Philippians 4:6-7 NKJ).

~Rhonda Stinson

Clinging to Life

There's some beautiful scenery along I-75 through Tennessee where winding mountain passes and rocky peaks offer one spectacular view after another. Some cliffs hug the highway a little too closely. Remnants of past landslides provide ample warning for travelers, passing through.

My husband and I had been in the car for several hours (quickly approaching the slap happy stage) when I saw something unusual. High upon a naked rock-face grew a single large tree. It was such a strange sight because it appeared to be growing right out of the rock. How in the world was the tree able to survive such a desolate condition? Suddenly my mind drifted to thoughts of my friend Rhonda and the first time we met, several years earlier. Her story of survival is inspiring, much like that tree.

Rhonda and I met in 2007. She had learned about my story of breaking free from a twenty-five-year bondage to bulimia through one of her church members. Growing weary from her own fifteen-year battle with an eating disorder (anorexia), Rhonda was clinging to life on the thread of hope that freedom was still

possible. She found my number and gave me a call. We talked for a long while on the phone, and after sensing the severity of her situation, I agreed to meet with Rhonda a few days later. My hope was to speak God's truth into her life, face to face.

"The path of life leads upward for the prudent, to keep them from going down to the realm of the dead" (Proverbs 15:24).

I will never forget the day I opened my front door and saw Rhonda for the first time. She looked extremely frail. I remember thinking it was a miracle that she had been able to walk the short distance from her car to my front porch. A walking skeleton, Rhonda was probably closer to death than she realized. Even her voice seemed frail as she labored to speak.

I welcomed her into our living room and began sharing my story. I peered into her beautiful eyes that seemed larger than usual against her emaciated face and saw a glimmer of hope. (Her eyes revealed that she still had fight left in her; she was not ready to give up.) At that moment, I realized Jesus had placed an immense responsibility on me to be His loving arms and audible voice to Rhonda. In fact, God had brought us together for such a time as this.

I'm amazed at how God works, how He uses our ugly past for good when we surrender it to Him. He brings beauty from our ashes, and then, through our story of redemption, He carries hope to the hopeless.

Although each of our eating disorders had manifested themselves differently, there were definitely some common threads. Those threads tethered us together, forming a special friendship.

We both understood the magnitude of Satan's deception which led to our bondage and the heavy price paid because of it. Deception has been taking place in the lives of women ever since the Garden of Eden. How ironic that the very first sin involved a woman and food. It worked so well the first time; Satan continues to use this tactic to this day. Jesus had shown me the path to freedom, so I was eager to point Rhonda in the same direction.

"Jesus said, 'If you hold to my teaching, you are really my disciples. Then you will know the truth, and the truth will set you free'" (John 8:31-32).

Through our profound understanding of one another's struggles, a deep bond began to form. I was eager for God to redeem my past.

I whispered a prayer long ago, *Lord, I will do whatever you ask; just help me be strong and courageous.* That little prayer had far-reaching implications. Never could I have imagined the incredible journey that would lay ahead for our friendship. It was a long arduous journey to freedom, but today, Rhonda Stinson is free from anorexia and a beacon of light and hope to others.

~Rae Lynn DeAngelis

Flattening the Curve

L ike many of you, I was reeling with disbelief about what we were facing during the world-wide pandemic that was threatening to take us down physically, emotionally, spiritually, and financially. Everyone had been impacted in some way. This invisible enemy was the great equalizer. Talk about flattening the curve! The playing field was leveled like never before. Whether you fought the illness yourself, lost a loved one, found yourself out of work, worried about ones you loved, felt isolated, felt confined, or watched savings or retirement funds dwindle, there is one thing this epidemic had taught us: *This world is more intertwined than we ever realized!* We were truly in it together, and we ALL felt the weight of it. Faith was being tested, challenged, strengthened, and refined.

Individuals were looking for hope and encouragement. As the Church and the Body of Christ, God had called us to step-up and be light amidst the darkness. In times like those, we have a great responsibility to be a beacon of God's love and goodness. We needed to show people that Jesus is the secure anchor they can

cling to in any storm, and that He provides peace that passes all understanding, even in the midst of great chaos. Jesus is in each and every storm with us. He still has command over the wind and waves coming against us.

He is the same yesterday, today, and forever. He is still all-powerful, all-knowing, and ever-present. And He will never leave or forsake us. "Never will I leave you; never will I forsake you" (Hebrews 13:5).

In a world of uncertainty, people start looking for answers. How interesting that in a time of social distancing, we had technology which allowed us to reach out to people all around the world. I believe God used that time to move us out of our comfort zone and into something new. The following verse comes to mind: "Forget the former things; do not dwell on the past. See, I am doing a new thing! Now it springs up; do you not perceive it? I am making a way in the wilderness and streams in the wasteland" (Isaiah 43:18-19). God is always on the move!

Lord God, we don't know what the future holds, but you do. You are already there, waiting in our tomorrow. You know the way forward, and you are there, preparing us for what is yet to come. Lord, everything material could be stripped away, but we still have you, and we still have eternal life with you when you call us home. You have told us, "In this world you will have trouble. But take heart! I have overcome the world" (John 16:33). Help us remember that truth when fear begins to creep in. Help us come together in love during times of uncertainty. Help us encourage one another and bring light into the darkness. Help us to spread faith, hope, and love; the greatest of these is love. Love like you showed us on the cross when you ascribed unsurpassable worth to us at cost to yourself. You call us to that same kind of love. Putting others before ourselves. So, Lord, no matter where we come from, no matter what position we are in, and no matter what trials we face... we ask you to fill us with your peace that passes all understanding. Keep our focus on YOU and your goodness even in the face of a pandemic. Strengthen our faith, increase our

hope, and give us opportunities to love. Thank you, Lord, for answered prayer. Amen

~Rae Lynn DeAngelis

Don't Worry – Be Happy

A woman goes to her doctor and tells him she's stressed and depressed. She tells him that her life seems harsh and cruel, and she feels all alone in a hostile world. The doctor tells her the treatment is simple—she needs to laugh.

He tells her, "The great comedienne Bella is at the Comedy Club tonight. Go see her. Her routine should pick you up.

The woman bursts into tears, "But doctor . . . I am Bella."

There are some lucky people who seem to be naturally happy, but for many of us, happiness doesn't come so easily. Scripture tells us there is a time for sadness and mourning, and a time for rejoicing. God invites us to enter His happiness.

Francis of Assisi said, *Let us leave sadness to the devil and his angels. As for us, what can we be but rejoicing and glad?* Until we go to heaven, pain, sorrow and anger will always be with us. Yet we discover that when we're in a fulfilling relationship with Jesus, we can be happier.

Contrary to what you may have been taught, there's nothing wrong with desiring joy and happiness.

Psalm 37:4 says, "Delight yourself in the Lord, and he will give you the desires of your heart." That's our objective: to delight ourselves in God. Nothing short of this will bring us true joy. And joy is what we're entitled to.

In the Bible, we see that, despite their circumstances, people who followed God had joy and passion for life. We can face adversity and still have joy. Many Christians live with a sad, angry, and anxious heart. They've lost any kind of happiness. They read Scripture with doubt and blinders on. This isn't what God desires. Scripture states,

"The people the Lord has freed will return and enter Jerusalem *with joy*. Their *happiness* will last forever. They will have *joy and gladness*, and all sadness and sorrow will be gone far away (Isaiah 51:11); For I have given rest to the weary and *joy to the sorrowing"* (Jeremiah 31:25).

Happiness doesn't come from our circumstances; it comes from God. And considering God is with us through our trials, then it's possible to have joy in them.

The problem for many of us is that we don't understand the difference between momentary happiness and deep-seated God given happiness. One says, "God, if you give me this, then I'll be happy." The other says, "Lord, if you took this away, I'd still feel joy."

When we feel we've lost control, or when we're sad or depressed or anxious, it's easy to ruminate on joyless thoughts. All that ruminating is muddling our brain circuitry. It's stresses us out and leads to feelings of guilt, condemnation, depression, and other mental and physical disorders.

Don't turn your back on the kind of lasting happiness that could be yours. Remember, the kind of happiness that comes from God = a happy, healthy brain!

~Kimberly Davidson

His Triumphal Entry

I entered church one Palm Sunday and noticed a little boy walking with his mother, waving a palm branch high in the air. Obviously, this little guy's Sunday school lesson was focused on Jesus' triumphal entry into Jerusalem.

Seeing this youth with his mother triggered a series of thoughts about the historical events that took place some two-thousand years ago. I remembered how the triumphal entry of Jesus into Jerusalem riding on a mere donkey had held so much significance. It was the fulfillment of prophecy spoken in the Old Testament.

"Rejoice greatly, O Daughter of Zion! Shout, Daughter of Jerusalem! See, your king comes to you, righteous and having salvation, gentle and riding on a donkey, on a colt, the foal of a donkey" (Zechariah 9:9).

Jesus, the King of kings and the LORD of lords, came proclaiming His coming Kingdom, not on a grand stallion, but on a humble beast—a simple colt in fact.

Once again, I'm reminded that God's ways are not our ways.

"'For my thoughts are not your thoughts, neither are your ways my ways,' declares the LORD. 'As the heavens are higher than the earth, so are my ways higher than your ways and my thoughts than your thoughts'" (Isaiah 55:8-9).

While reflecting on Jesus' triumphal entry into Jerusalem near the end of His life, my mind suddenly switched to thoughts of Jesus' first triumphal entry—His birth. Mary, who was great with child likely traveled those final days of their journey to Bethlehem riding a donkey.

According to an article on the internet, in Eastern tradition, a donkey symbolizes an animal of peace, while a horse symbolizes

an animal of war. When a king rode up on a horse, it showed he was bent on war, but when he rode up on a donkey, it was to show he was coming in peace. Jesus' entry to Jerusalem symbolized his entry as the Prince of Peace, not as a war-waging king.

While Jesus is our Prince of Peace, a day is coming when His next arrival will announce a great war. Once again, Jesus will make His triumphal entry. *Only this time, He will be riding a white horse!*

> I saw heaven standing open and there before me was a white horse, whose rider is called Faithful and True. With justice he judges and makes war. His eyes are like blazing fire, and on his head are many crowns. He has a name written on him that no one knows but he himself. He is dressed in a robe dipped in blood, and his name is the Word of God. The armies of heaven were following him, riding on white horses and dressed in fine linen, white and clean. Out of his mouth comes a sharp sword with which to strike down the nations. "He will rule them with an iron scepter." He treads the winepress of the fury of the wrath of God Almighty. On his robe and on his thigh he has this name written: KING OF KINGS AND LORD OF LORDS (Revelation 19:11-16).

Ready or not… *Jesus is coming back!*

"Hosanna to the Son of David! Blessed is he who comes in the name of the Lord! Hosanna in the highest" (Matthew 21:9)! Hallelujah, Amen!!!

~Rae Lynn DeAngelis

No More!

L ately, I've felt a bit lonely even though most days I never really get to be "alone." Sure, my life is full of busyness, people, activities, and never-ending to-do lists. But I've found that when it comes down to it, I feel very alone, like I'm in this by myself.

One thing I've observed lately, is that when I don't initiate texts, no one is texting me. My phone sits there, with no little red circles of notifications. *Why do I have to be the one to reach out?* Are any of my friends thinking about me or wondering how I'm doing? I guess not. I guess I have to do the work if I want communication and connection.

It feels sad, empty, frustrating, and even hurtful.

These are self-pity thoughts planted straight in my head (from the enemy) to devour and destroy me. If I give them power, they will steal my joy and hope and soon enough, I'm exactly where the enemy wants me.

But I say NO MORE. I know the truth. My friends love me. I have people in my life that deeply care for me. Maybe they are being told the same lies as me. I need to break the silence and reach out. Maybe this is how I'm gifted, and God wants me to be the friend that reaches out and lifts up.

Do you feel this way at times?

I encourage you to recognize it and to reach out to someone. Ask God to give you someone who may need to be encouraged and feel they are known. Let them know you are thinking about them and care for them. This will turn around your day and theirs.

We are wired for connection. After we first connect with our Father, then let's connect with each other. There's healing power,

freedom, and love that we all get to experience when we have each other.

Below you will find a few truths about friendship and why we need each other:

"Some friendships don't last for long, but there is one loving friend who is joined to your heart closer than any other" (Proverbs 18:24 TPT)!

"For the greatest love of all is a love that sacrifices all. And this great love is demonstrated when a person sacrifices his life for his friends" (John 15:13 TPT).

"As iron sharpens iron, so one man sharpens another" (Proverbs 27:17 NIV).

"A dear friend will love you no matter what, and a family sticks together through all kinds of trouble" (Proverbs 17:17 TPT).

~Alison Feinauer

Spring Cleaning

One spring, my husband took some much-needed vacation time to get a few things done around the house. He had a big project planned for the outdoors, but wouldn't you know it, torrential downpours dominated the entire week. Since our outdoor plans were thwarted, we decided to implement Plan B—spring cleaning the basement. *Yikes!*

Every spring we enter this drudgery of going through boxes, bags, and piles of junk in order to determine which items we want

to keep and which items we need to eliminate. The purge is organized into two main categories—Goodwill and trash.

Since we do this every year you wouldn't think there was much to sort through… but sadly, that's not the case. I honestly have no idea where all this stuff comes from. It's crazy!

"Do not store up for yourselves treasures on earth, where moths and rust destroy, and where thieves break in and steal. But store up for yourselves treasures in heaven, where moths and rust do not destroy, and where thieves do not break in and steal. For where your treasure is, there your heart will be also"(Matthew 6:19-21).

I always feel so much better after we eliminate the needless junk. It's kind of freeing.

"Since then, you have been raised with Christ, set your hearts on things above, where Christ is seated at the right hand of God. Set your minds on the things above, not on earthly things. For you died, and your life is now hidden with Christ in God" (Colossians 3:1-3).

The same is true for our spiritual lives. Are you feeling weighed down by all the 'junk' accumulating in your spiritual life? Things like too much time spent on social media or binging Netflix. Perhaps some bad habits have begun to form or your noticing unwholesome talk coming out of your mouth. Maybe some ungodly television shows have crept their way into your day. If you wouldn't feel comfortable watching it, or doing it, with Jesus in the room, you might want to consider switching the channel or replacing it with something less offensive and more God honoring.

Carrying around the needless junk can be a burdensome load, a weight so heavy that one can barely stand, let alone walk with God.

Perhaps it's time to visit the basement of your heart and determine which things can stay and which need to go. Spend some time with God and ask Him to reveal the areas of your life that need sprucing up.

"Search me, God, and know my heart; test me and know my anxious thoughts. See if there is any offensive way in me, and lead me in the way everlasting" (Psalm 139:23-24).

Like it is when we spring clean the basement in our home, purging unwholesome practices will free up some much-needed space in our hearts and lives.

~Rae Lynn DeAngelis

Not Guilty!

F orensic investigation programs have always fascinated me. I love to watch shows such as "Cold Case Files" and "Mystery Detectives." One episode had to do with a man who was accused and arrested for setting a house on fire, resulting in the death of his parents. He pleaded not guilty and his story never wavered. He claimed that his mom had lit a cigarette with a match and accidentally dropped the match onto the sofa. The son, whom I will call Carl, said that he filled a pitcher with water and threw it on the flame, but instead of putting the fire out, the water actually made the fire blow forth into uncontrollable flames.

The lawyer explained that the investigators had based their verdict on past experience. In previously investigated fires, none had worsened when quenched with water. Convinced of his guilt, the prosecutors proceeded to search out the source that Carl had used to set the fire, such as gasoline. They tested the carpet and underlayment, neither of which showed signs of gasoline penetration, but when the wood floor beneath the carpet was tested, it tested positive for gasoline.

Carl was incarcerated one year before his lawyer was able to do mock tests and gather more research to get the undeniable evidence of Carl's innocence. The attorney explained that the sofa was made of polyester. A cigarette would just smolder and leave a burn on the sofa seat, but a match would catch the sofa on fire. More evidence showed the reason why the wood floor contained

gasoline, but the carpet and underlayment did not. Houses built up to a certain year had hardwood floors which were stained with a mixture of stain and gasoline. Laborers used this mixture because it covered much more square footage at a cheaper cost. Carl had spent a year behind bars at a time when he should have been free and mourning the loss of his parents.

This true story reminded me of another true story. During Jesus' ministry here on earth, He spread the gospel, healed the sick, and claimed to be King of the Jews. He continued to witness and was unwavering in His claim to be King of the Jews. Yet He was falsely accused of being a liar, a fake, and even insane. The soldiers and people mocked Him, spat upon Him, and marred Him beyond that which any man had been before. Then they crowned Him with brutal thorns, and nailed Him to a cross of wood.

False accusations nailed Christ to the cross, but His shed blood was that through which the sins of the world are covered. *A Savior for sinners.*

> Now the chief priests, the elders and all the council sought false testimony against Jesus to put Him to death, but found none. Even though many false witnesses came forward they found none. But at last, two false witnesses came forward and said, "This fellow said, 'I am able to destroy the temple of God and to build it in three days.'" Then they spat in His face and beat Him; and others struck Him with the palms of their hands, saying, "Prophesy to us, Christ! Who is the one who struck You (John 26:59-61, 67-68)?

"And they put up over His head the accusation written against Him: THIS IS JESUS THE KING OF THE JEWS" (John 27:37 NKJ). And because of this great act of love, all who have accepted Christ will stand before the Father on judgment day and hear the words—not guilty!

~Rhonda Stinson

Swamp of Regret

I decided to sign up for an overnight retreat at our new church. It was a chance to connect with other Christian women and get to know new people, so I was really looking forward to it.

There were many errands to run before leaving my family for the weekend. As it turned out, there weren't enough hours in the day. When I got home, I barely had enough time to pack a few items and rush out the door.

I learned ahead of time that several of the ladies were planning to meet up at the hotel restaurant beforehand. I was invited to join them. When I finally arrived that evening, I walked into the restaurant feeling flustered because I was late. Every seat at the table was filled except one—*mine.*

I sat down and tried to enjoy the dinner conversation, but my mind was stuck on the fact that I had been late and was not making a very good impression on my new church family.

After dinner, I excused myself so that I could get my overnight bag from the car and check into my room before the first retreat event started. I started to settle down and felt less stressed. I even took a few minutes to freshen up before heading back downstairs.

As the elevator doors opened into the hotel lobby, I noticed a few ladies still lingering at the dinner table, so I walked over to rejoin them. One of the ladies jokingly asked if I had forgotten something, and then she pointed to the dinner check lying on the table where I had been sitting. *My heart sank.*

In my flustered state of mind, I totally forgot to pay my dinner bill. My face was red with embarrassment. I promptly resolved the situation but felt even more like a complete idiot. I tried hard to enjoy the rest of the weekend, but I couldn't get past my feelings of guilt and inadequacy. I wasn't able to focus on all the good God

had for me at the retreat because I was stuck in a cycle of self-blame.

Satan loves to bog us down with guilt and shame over past mistakes. He figures that if he can bury us in a pit of regret, he can keep us from moving forward to take hold of that which Christ has for our future. And oftentimes he's right.

"Forget the former things; do not dwell on the past" (Isaiah 43:18).

Conviction serves its purpose when it motivates us toward repentance (turning away from sin) and keeps us from repeating certain unhealthy behaviors or mistakes. However, we must make a conscious effort to not wallow in the swamp of regret. Instead, we must allow God's cleansing blood to do its work in our lives, to free us from the guilt of our past. In this way, we can move onward toward our future in Christ.

Simply stated—we are not perfect and never will be. But instead of giving the enemy more ammunition for his attacks by wallowing in the swamp of regret, we need to admit the error of our ways, do what we can to make amends, and move on.

'Godly sorrow brings repentance that leads to salvation and leaves no regret, but worldly sorrow brings death" (2 Corinthians 7:10).

"Let us hold unswervingly to the hope we profess, for he who promised is faithful" (Hebrews 10:23).

~Rae Lynn DeAngelis

Comic Relief

A new monk arrives at the monastery. He is assigned to help the other monks in copying the old texts by hand. He notices, however, that they are copying copies, and not the original books. So, the new monk goes to the head monk to ask him about this. He points out that if there was an error in the first copy, that error would be continued in all of the other copies. The head monk says, "We've been copying from the copies for centuries, but you make a good point, my son." So, he goes down into the cellar with one of the copies to check it against the original. Hours later, nobody has seen him. One of the monks goes downstairs to look for him. He hears sobbing coming from the back of the cellar and finds the old monk leaning over one of the original books crying. He asks what's wrong. "You idiots" he says, with anger and sadness in his eyes, "The word is celebrate— *not celibate!*"

It's been said the most wasted day is the one in which we have not laughed.

How much do you laugh in a given day?

Did you know having a good laugh actually strengthens relationship bonds and makes for a stronger heart? Laughter, like water, flushes toxins out of our body. When we laugh, we have the ability to diffuse pain by physically increasing the body's production of endorphins, the body's natural painkillers. Recent studies have, in fact, found the risk of heart attack and stroke is reduced in individuals who laugh on a regular basis, compared to those who never or rarely laugh. A study found that just 15 minutes of watching a funny movie *increased* average blood flow by 22% while watching a serious drama *decreased* blood flow by

35%. The combination of 15 minutes of laughter and 30 minutes of exercise three times a week is good for the vascular system.

We all need to laugh more; have a good belly laugh—even at ourselves. Can you laugh at yourself when you've messed up?

A jolly heart is important for coping and survival. It breaks the ice, lowers blood pressure, reduces the risk of developing heart disease, and improves mood. Someone who laughs, particularly at herself, is a healthy and humble person.

Jesus understood this. He frequently used humor and wit to make His point. Our response may be, "Really? Where?" When we translate any language into another, we will often miss subtle nuances of speech. If we don't have a knowledge of the original language and its idioms, we can miss the humor. Also, different cultures have different ways of being humorous.

Jesus used one form of humor we call sarcasm. In His responses to Herod, for example, He called him a fox. He made other statements that had a touch of humor to them, like when He mentioned a camel going through the eye of a needle. I can't imagine Jesus didn't laugh. After all, He was fully human. Since God has appointed times for laughter, and Jesus always did what was appropriate, it would seem to me that when it was time to laugh, He laughed.

God promises, "He will once again fill your mouth with laughter and your lips with shouts of joy" (Job 8:21).

Is it time for you to laugh?

~Kimberly Davidson

Unjustly Accused

I was five years old the first time witnessed evil up-close and personal. It was in my kindergarten class. Sitting at a table with my classmates, the boy next to me reached over and, for reasons I don't understand to this day, began scribbling all over my pretty picture. Needless to say, I was shocked by his cruel action. Seeing the tears well-up in my eyes, he must have calculated the outcome of his reckless behavior, because at that very moment, he pulled his hand away and proceeded to scribble all over his own paper. I was trying hard to hold it together, but the floodgates burst open. Then to my horror, the boy raised his hand and told the teacher that *I* had scribbled on *his* paper. And the teacher actually believed him! I was sent to the corner, humiliated and unjustly accused.

"But I tell you, do not resist an evil person. If anyone slaps you on the right cheek, turn to them the other cheek also" (Matthew 5:39).

What about you? Can you remember a time when you were unfairly treated or unjustly accused?

"For our struggle is not against flesh and blood, but against the rulers, against the authorities, against the powers of this dark world and against the spiritual forces of evil in the heavenly realms" (Ephesians 6:12).

How we react to unfair or unjust situations just might reveal some things about our character and level of Christian maturity.

"He was oppressed and afflicted, yet he did not open his mouth; he was led like a lamb to the slaughter, and as a sheep before its shearers is silent, so he did not open his mouth" (Isaiah 53:7).

This prophesy about Jesus in the book of Isaiah foretold how our Lord would react to His accusers. God in the flesh could have easily struck a lethal blow to His accusers. But He did not. *Do you know why?*

"Hatred stirs up conflict, but love covers over all wrongs" (Proverbs 10:12).

"Above all, love each other deeply, because love covers over a multitude of sins" (1 Peter 4:8).

The point to be made is not that we become doormats for others to trample, but that we leave judgment in God's hands.

"If someone slaps you on one cheek, turn to them the other also. If someone takes your coat, do not withhold your shirt from them" (Luke 6:29).

Man is not the real enemy. People are simply being used or manipulated by the enemy. If we want to deliver a lethal blow to the real enemy—Satan—our best weapon is to love those who have hurt us and forgive the offense, knowing full-well that the true enemy of our soul is being denied any kind of satisfaction from our retaliation.

The Kingdom of God is built on love, not hatred or bitterness. As heirs of the King, we are called to be a Kingdom people— individuals who love when it doesn't make sense to love, forgive when every fiber of our being wants to hold a grudge, and to remain silent when our voice cries out to be heard. To the best of our ability, through the power of the Holy Spirit, let's be vessels of love and peace, just like our Lord—Jesus Christ.

> Therefore, since we are surrounded by such a great cloud of witnesses, let us throw off everything that hinders and the sin that so easily entangles. And let us run with perseverance the race marked out for us, fixing our eyes on Jesus, the pioneer and perfecter of faith. For the joy set before him he endured the cross, scorning its shame, and sat down at the right hand of the throne of God. Consider him who endured such opposition from sinners, so that you will not grow weary and lose heart (Hebrews 12:1-3).

~Rae Lynn DeAngelis

Snapshots of Your Heart

I used to develop film for a job. In a dark, locked room, I took strips of film, pulled them out of the protective tube and began the process of developing them. I needed water and some solutions. I'd put the film and paper in a machine for a set amount of time and then let it sit out to dry. It was a long process. But if I cut it short at all, the film would not be printed properly.

This memory came to me as I was listening to a podcast. They mentioned something about going into the dark room with Jesus, and I started putting it together.

God made you perfectly in your mother's womb. After birth and younger years, you finally come to an age where you are trying to find out who you are. Other people have told you up until now, and you have all of their "snapshots" on your 35mm roll in your heart. Now it's time for exposure.

What does that look like for me in a practical way? I asked God to remind me of a time when I was exposed to a lie. The memory that came to mind was when I was afraid of the dark. I thought someone could get in my window. It was an awful fear that caused me to not want to go to bed. My 4th grade teacher said, "If you are ever scared of someone taking you, just think, no one would want you anyway." And oddly enough, that became my new comfort.

As a 9-year-old, that moment was when a core belief took root, that I wasn't worth loving. Rejection became a friend and a safe hiding place. How sad for that to be my comfort. But it was on my 35 mm heart film and needed exposed.

I invited Jesus into this memory. I imagined him rubbing my back at bedtime, telling me he's right there, I'm safe, I'm loved,

and He's with me. He's my protector, and He wants me. He won't let anything happen to me. I'm special, and He's my keeper.

He redeemed all those nights that I lay there trying to be still so no one would see me in the window, that scared little girl afraid to fall asleep.

Maybe that's why my disordered eating and rejection have been my "friends." I was always wanting to measure up, never feeling wanted or good enough. "No one would want me anyway," right?

Until I go into the dark room with Jesus, and allow His light to shine on those dark hidden places that no one knows about, (and I had honestly forgotten about) that core belief stays unchanged. But He wanted to redeem that for me. I'm exposed now. I know the truth. I've been put through a process and developed. Now I'm a finished picture of his love and truth. He was able to take the negative of that situation and show the beauty of His unfailing love.

I'm not sure what memory you have. Maybe you've tucked it away or forgotten it. But I ask you to go to the developing room, get in a dark, quiet place with Jesus, and let His light expose the secret places. Let His love and presence give you a new picture of where He was during that time, how He was with you, wants to redeem that memory, and bring truth to the moments of your past.

My prayer for you and me: *God, please expose us, our heart, our soul, the dark places, and bring them into your light. Help us to see your redemption. Put us in the machine. You're THE developer, and you are so careful with the process. If anyone (or thing) opens the door, they ruin it all. So, lock the doors and take us into your Holy of Holies. Expose us so that we can reflect you. Amen*

"You formed my innermost being, shaping my delicate inside and my intricate outside, and wove them all together in my mother's womb. I thank you, God, for making me so mysteriously complex! Everything you do is marvelously breathtaking. It simply amazes me to think about it! How thoroughly you know me, Lord" (Psalm 139:13-14 TPT)!

"When you sit enthroned under the shadow of Shaddai, you are hidden in the strength of God Most High. He's the hope that holds me and the Stronghold to shelter me, the only God for me,

and my great confidence. He will rescue you from every hidden trap of the enemy, and he will protect you from false accusation and any deadly curse" (Psalm 91:1-2 TPT).

~Alison Feinauer

Feeling Discouraged?

W e all have days when things look bleak or are not going quite as we had hoped. So, what does the person who is supposed to encourage others do when she needs encouragement herself?

"The righteous cry out, and the LORD hears them; he delivers them from all their troubles. The LORD is close to the brokenhearted and saves those who are crushed in spirit" (Psalm 34:17-18).

First, I go to God in prayer and cry out for His guidance. Then I go to His Word and ask Him to fill me with His truth. When I'm feeling discouraged, I can usually link my feelings to a specific lie I have come to believe about myself or my circumstances. For example, I might doubt my effectiveness as a ministry leader when someone reverts back to their disordered eating habits. The truth is I can only plant seeds and water them. It's God's job to make them grow.

"Guide me in your truth and teach me, for you are God my Savior, and my hope is in you all day long" (Psalm 25:5).

There are some days, however, when I need an additional boost of encouragement from what I like to call someone with skin—a living breathing human being.

God has placed some wonderful godly women in my life (you know who you are) who help lift me out of the pit of despair and lovingly carry me to Jesus. They offer words of encouragement,

help me see things from a broader perspective, and most importantly, they pray for me.

"Two are better than one, because they have a good return for their work: If one falls down, his friend can help him up. But pity the man who falls and has no one to help him up" (Ecclesiastes 4:9-10)!

Dear Lord, thank you for my dear sisters-in-Christ who shine your light in my darkest days. Please pour out your blessings on them for their faithful support, and help me be as good a friend to them as they are to me. Amen.

~Rae Lynn DeAngelis

Lost and Found

I found out how terrifying it can be to be lost when I was a school aged girl. While attending a family reunion, my younger brother and I set out to "catch up" with family members that had headed into the woods for a short hike before lunch. We had done what we thought was the right thing to do before going with them on the hike. We didn't want to "wander off," so we ran and asked our parents if it was ok to go on the hike.

After receiving permission, we headed back to the trailhead where several of our uncles and cousins had started out. They're certainly only a short way ahead, we thought. We heard voices, certainly that was them. As we walked further and further down the trail into the woods and the voices got fainter and fainter, we realized we were lost. "Give careful thought to the paths for your feet and be steadfast in all your ways" (Proverbs 4:26).

My younger brother was looking to me to find our way to the group. I tried to provide reassurances that we weren't far away,

but inside I was terrified. Instead of turning around, we continued to follow the path even crossing a road since the path continued on the other side. Without anyone to guide us, we used poor judgement that took us further and further away from where we were trying to go. "Plans fail for lack of counsel, but with many advisers they succeed" (Proverbs 15:22).

When our uncles and cousins returned without us, our father set out to find us. Just as panic was about to overtake me, I heard his distinctive whistle in the distance. We had wandered very far away, and it took a lot of whistles from him and shouts from us to find one another. "Whether you turn to the right or to the left, your ears will hear a voice behind you, saying, 'This is the way; walk in it'" (Isaiah 30:21).

I can still remember the look of relief on his face as we ran into his arms. As you can imagine, that look changed once he knew we were safe. The stern glare that followed didn't matter because of the feeling of love and relief that filled me while holding his strong hand as we walked back to the punishment I knew was ahead. "By day the Lord directs his love, at night his song is with me — a prayer to the God of my life" (Psalm 42:8).

Sometimes we can feel lost as we navigate the decisions of life. The panic of physically being lost can become just as real as we long to be found and directed to our destination. Luckily, we have a Heavenly Father waiting to take our hand and guide us if we let him. "I will instruct you and teach you in the way you should go; I will counsel you with my loving eye on you" (Psalm 32:8).

We do have to be careful that we aren't listening to all the voices around us that could take us further off course. "See to it that no one takes you captive through hollow and deceptive philosophy, which depends on human tradition and the elemental spiritual forces of this world rather than on Christ" (Colossians 2:8).

Whether walking in the woods or walking through life, having a guide along the way will keep us from getting off course and becoming lost. When we are found in the Lord, we have someone with whom to stay connected. As we listen to our internal guide, the Holy Spirit, we are able to stay on course toward our purpose according to the plans of the Lord. "Teach me to do your will, for

you are my God; may your good Spirit lead me on level ground"
(Psalm 143:10).

~Tanya Jolliffe

Young at Heart

Have you noticed how our minds never seem to age, yet our bodies drastically do? Interestingly enough, I don't even consciously recognize the fact that I am getting older until I see someone from my past. It's only then that I'm hit with a bold reminder.

My body might be getting older, but I'm still young at heart.

One morning in my devotion time, I came across a Scripture that spoke a wonderful truth to my spirit. "Therefore, we do not lose heart. Though outwardly we are wasting away, yet inwardly we are being renewed day by day" (2 Corinthians 4:16).

With each passing day, our bodies surrender evermore to the effects of aging. Some of us yield to this process more gracefully than others.

Sure, we can buy the latest products to delay the effects of aging, but eventually, if we live long enough, we must all surrender to the fact that we *are* getting older, and we won't have this earthly tent called a body forever.

Even though we may be wasting away on the outside, each day, we can be renewed on the inside when we spend the very first part of our day with God in prayer and Bible study.

God ministers to our spirit through the counsel of His Word and teaches us something new about who He is, who we are, and who He desires us to become.

In His presence we are made new.

Are you making time for God to renew your spirit? It truly is the best anti-aging product around. After all, a relationship with Jesus brings everlasting life!

Think of it this way… with each passing day, we are one step closer to seeing Jesus face to face where there will be no more death or mourning or crying or pain, for the old order of things has passed away (Revelation 21:4).

~Rae Lynn DeAngelis

Faithful Service

When our children were young, before we began to home school, I did what I could to bring in a little extra cash for our family. Money was tight back then, so it was important for me to help bridge the financial gap in any way that I could.

As a stay-at-home mom, God provided opportunities for me to watch children in our home during the early years. As the kids got older, I began cleaning other people's houses to help make ends meet.

"She sets about her work vigorously; her arms are strong for her tasks" (Proverbs 31:17).

Some might argue that scrubbing toilets is not very glorifying work, but I would have to disagree. Speaking from personal experience, mopping floors, dusting furniture, and scouring away grime in a potty is not only honorable work, it's satisfying as well. It's all in how we approach each job and the attitude through which we operate. "Whatever you do, work at it with all your heart, as working for the Lord, not for human masters, since you know that you will receive an inheritance from the Lord as a

reward. It is the Lord Christ you are serving" (Colossians 3:23-24).

While it is true that I like to clean (I'll take cleaning over cooking any day), the delight I experienced while carrying out these services for others went beyond something I enjoyed. It gave me a great sense of accomplishment to know that I was helping another mom manage her workload at home while she carried out whatever call God had on her life. My small contribution would allow her more time to focus on her family, and it brought me great joy to think about her walking into her sparkling home after a hard day at work to find it smelling clean and fresh.

Whenever I took on a new client, I would meet with them to determine their specific needs. Some clients needed only the basics, while others requested a more in-depth cleaning service.

At each appointment, I tried to go beyond my client's expectations, even leaving a pan of freshly baked cinnamon rolls with a kind note. It brought me even greater joy to know the family would enjoy a mouthwatering treat for dessert.

What about you? Are you doing your job to the best of your ability? Are you going above and beyond what is expected, or are you barely scraping by with minimal effort?

As Christians we are called to give it our all, no matter what job God gives us to perform. May we carry-out all jobs to the best of our ability and treat every manner of labor with integrity and character. After all, we are representatives of the King of kings. Let's honor Him with the fruit of our labor.

"May the favor of the Lord our God rest on us; establish the work of our hands for us— yes, establish the work of our hands" (Psalm 90:17).

Whatever you do, work at it with all your heart!

~Rae Lynn DeAngelis

Give Thanks

W hen you wake up in the morning, do you say, "Good morning, Lord. "or "Good Lord, it's morning?" Do you look at your life as a precious gift, or a mundane state that you can do nothing about? Do you see beauty in the world or only evil? Do you appreciate what you have or tend to want more?

There's nothing wrong with feeling sad as we're processing pain and loss, but we don't want to stay sad. One way to begin to move from sadness to happiness is to practice gratitude, and make it a conscious, daily effort.

It's no secret that people who are grateful are healthier, happier, and more optimistic. They have a better functioning brain and heart, and peace of God. It is now one of the treatment modalities for people with depression.

There are several scientific studies stating that thankfulness and gratitude are an essential component of health, wholeness, and well-being. It's harder for seeds of crankiness, criticism, depression, or anger to take root in a grateful heart.

Every night, count your wins for the day and thank God. Maya Angelou said, "Let gratitude be the pillow upon which you kneel to say your nightly prayer."

The psalmist wrote, "This is the day the LORD has made. We will rejoice and be glad in it" (Psalm 118:24).

After the hurricane devastation suffered by the Gulf Coast, a man created this sign: "Rebuild with a grateful heart. You may have lost a house, but you did not lose your home."

Gratefulness—Thankfulness—Humility—what we're talking about here is an attitudinal lifestyle change. When the Jewish people pray, "Bless the LORD, O my soul, and all that is within

me, bless His holy name" (Psalm 103:1) — they acknowledge Him as the source of *all* blessings.

To bless God is to "praise" Him and give thanks for what He's doing in your life and to go beyond the minimum worship. We can make it a habit of blessing God with thankfulness and asking, "What more can I do to please you?" Here is a suggestion: When you wake up in the morning, tell God, "We're going to have a great day today! You've got the perfect plan for me" (Jeremiah 29:11).

Every day, tell God three or more things for which you are thankful.

When your head hits the pillow at night, tell God what went well and what you're thankful for. Here are some suggestions:

As hard as this may be in tough times, we can choose to focus on what we have. We *always* have at least one thing to be thankful for. Embrace God's little blessings: the air you breathe, your family, reliable transportation, groceries, hot water to shower with, a reliable friend . . .

Has God brought hope and healing into your life and demolished some strongholds? Praise Him for that.

When was the last time you thanked God for your salvation and for delivering you from the world's bondage, or thanked Him for your health, intellect, talents, gifts, or for His love and mercy that have covered your past?

I challenge you to read Ephesians 1:1-14. Write down every spiritual blessing God has given you.

~Kimberly Davidson

Change Is on the Way

I 'm not one who particularly likes change, and I tend to hang on to things long past the time when God has made it clear the end is in sight.

Change is hard. At the end of a really good movie, I like to linger until each credit rolls past the screen. When a bible study ends, I anxiously wait for the next to begin. As my children mature, I mourn for the days when they were little, dependent on me for their care. Relationships are especially difficult for me to let go—it's probably where I struggle the most.

Change is imminent. It will come whether we like it or not.

"And God said, "Let there be lights in the expanse of the sky to separate the day from the night, and let them serve as signs to mark seasons and days and years, and let them be lights in the expanse of the sky to give light on the earth." And it was so" (Genesis 1:14-15).

In the same way that autumn leads to winter and winter into spring, seasons of life change, come and go, and transition us to places where God is directing us next.

I love the brilliantly colored leaves, the crisp cool air, and the clear blue skies of fall, but I dread the cold, dreary days of winter. The long, dark nights and bare lifeless trees make winter trying to endure. And yet, without the dead of winter, we cannot fully appreciate and experience the newness of spring.

"He changes times and seasons…" (Daniel 2:21).

One season leads to another and each offers prized moments unique to its own.

Even though winter is my least favorite time of year, I must admit there are moments I treasure during this time. Snuggling under a warm blanket with a good book or watching football while

a pot of chili simmers on the stove are just a couple of things I like about winter. I especially love how freshly fallen snow transforms drab into a dazzling white landscape. *Winter isn't all bad.*

Instead of mourning what was lost when change comes our way, let's embrace what God has ahead. A new season brings new challenges, and it brings new opportunities for growth. Until we are called to our heavenly home with Jesus, we can rest assured, God has a plan, and it most certainly involves change.

"Forget the former things; do not dwell on the past. See, now I am doing a new thing! Now it springs up; do you not perceive it? I am making a way in the desert and streams in the wasteland" (Isaiah 43:18-19).

We may not know what the future holds, but we know who holds our future.

~Rae Lynn DeAngelis

It Matters to God

Glancing down at my sandals, I noticed one of the glittery rhinestone buttons which had transformed my ordinary flip flops into a super cute wardrobe statement was missing. My heart sank to the pit of my stomach. The sandals were purchased during our recent Florida vacation and I'd only worn them a few times. Now they were now ruined.

I scoured the house and car, the places where I'd been most recently, but found nothing. It was time to mentally retrace my morning journey to try and determine where I last saw my shoes intact. I remembered they were in one piece at the grocery store because a fellow shopper commented on their cuteness.

Okay, the button was on my sandal at the grocery; where did I go from there?

Our next stop was a roadside antique market just a few miles from home. All at once it hit me. I remembered seeing something sparkle in the grass while we were walking back to our car. I had a prompting in my spirit to reach down and investigate the object but talked myself out of it. I figured it was nothing but junk. But now I wondered... *could it have been the button off my shoe?*

My husband suggested we go back to the market to thoroughly investigate. I was skeptical we would find it but agreed it was worth a shot.

On the way there, I desperately prayed. *God, please help me find my lost charm.*

Pulling into the lot, I tried to remember the approximate location where we originally parked. I gestured to Gerry where I thought it might be, and then we got out of the car and began looking. Again, I prayed, *God, I know this is a silly thing to pray, but would you please help me find the lost piece of my shoe*? A moment later, I peered into the grassy area several feet from our car and there it was—my rhinestone button. God came to the rescue!

"So I say to you: Ask and it will be given to you; seek and you will find; knock and the door will be opened to you. For everyone who asks receives; the one who seeks finds; and to the one who knocks, the door will be opened" (Luke 11:9-10).

Many of us downplay our day-to-day troubles, seeing them as insignificant, unworthy of God's attention. But that's simply not true. Through this experience God has taught me something beautiful about His character. If it matters to us, it matters to Him.

Our Heavenly Father cares about every detail of our lives. As a matter of fact, I believe God loves it when we come to Him with seemingly small stuff. God delights in revealing Himself to us in ways both big and small.

Like any great father, the Lord desires to give us His very best. We receive all of Him when we give Him all of us. Honestly, it's a pretty sweet exchange.

"Which of you fathers, if your son asks for a fish, will give him a snake instead? Or if he asks for an egg, will give him a scorpion? If you then, though you are evil, know how to give good gifts to your children, how much more will your Father in heaven give the Holy Spirit to those who ask him" (Luke 11:11-13)?

If it matters to you; it matters to God.

~Rae Lynn DeAngelis

Roots of Identity

"**M**om, will you pay me to lose weight? Grant's mom is paying him $10.00 for every pound he loses." All of this from my 9-year-old son. My heart froze. I started this yo-yo not too long after 9 years old, and if I'm honest, one of my fears has been that my son will have to fight some of the same self-worth battles that run throughout my family.

As I sat and thought about this, I was perplexed. After talking with my son, I realized that to him it was more about the money. He didn't really want to lose weight, but still. What roots of identity can I plant deep within him now? At 40 years old, I'm still digging up ground so these truths about my identity can be buried deep within me.

- *I am enough.* ~2 Corinthians 12:9.
- I am made perfectly. ~Psalm 139:14.
- *I am His.* ~1 Corinthians 6:19-20.
- *My body is made exactly how He created me to be.* ~Zephaniah 3:17.
- *I can make healthy choices.* ~Philippians 4:8.
- *God has not given me a spirit of fear, but of power, love, and self-control.* ~1 Timothy 1:7.
- *I am confident.* ~Philippians 4:13.
- *I am worthy.* ~Ephesians 2:10.
- *I am chosen.* ~1 Peter 2:9.
- *I am loved with an everlasting love.* ~ Jeremiah 31:3. ~Romans 8:38-39.

- *I am known.* ~1 Peter 3:4.
- *I am not a slave to fear, but I'm a child of God.* ~1 John 3:1.
- *I'm free.* ~2 Corinthians 3:17.
- *My God supplies all my needs.* ~Exodus 14:14.
- *I am forgiven.* ~Psalm 103:12.
- *I am royalty, an heir.* ~1 John 3:1.
- *I have purpose.* ~Colossians 3:23.

If I believe these things at my core, and if these are my roots in Jesus, then my self-worth is defined by what my Father says about me. PERIOD. And nothing else.

Write down these "I am" statements. Post them everywhere, and read them daily. Ask Jesus to remove old roots that aren't true, and replace them with the identity He alone can give you and help you to believe in your core.

Jesus, we want to love ourselves the way you love and see us. Please remove self-hatred, insecurity, and self-rejection. Please replace it with confidence, trust, and courage to believe what you say about us, your beloved daughters. This is work that we need your help to complete. We give you permission and invite your Holy Spirit to move at your pace in us. We love and trust you, Amen.

"What is man that you would even think about him, or care about Adam's race. You made him lower than the angels for a little while. You placed your glory and honor upon his head as a crown. And you have given him dominion over the works of your hands. For you have placed everything under his authority" (Hebrews 2:6-8 TPT).

"My dearest one, let me tell you how I see you— you are so thrilling to me. To gaze upon you is like looking at one of Pharaoh's finest horses— a strong, regal steed pulling his royal chariot. Your tender cheeks are aglow—your earrings and gem-laden necklaces set them ablaze. We will enhance your beauty, encircling you with our golden reins of love. You will be marked with our redeeming grace" (Song of Songs 1:9-11 TPT).

~Alison Feinauer

Secure Your Mask First

Each commercial airline flight begins in much the same way, with a rapid monologue of instructions intended to assist passengers in the event of an emergency. Since my husband flies for work more often than he drives these days, he's all too familiar with the carrier's safety speech and doesn't pay much attention to it anymore. Not so with me. I pay attention to every word!

Seat belt buckled—check. Emergency exit doors located—check. Flotation device—check. Seat cushion doubles as a flotation device—check. (If I wasn't nervous getting on the airplane before, I am now.) With each safety tip, my mind's eye pictures the terrifying scenarios that would require my need to retrieve such information. (None of them are good.)

It's all helpful information; however, one of the airline's safety instructions seems counterintuitive in nature. It goes a little something like this:

In the event of a decompression in the cabin, an oxygen mask will automatically appear in front of you. To start the flow of oxygen, pull the mask towards you. Place it firmly over your nose and mouth, secure the elastic band behind your head, and breathe normally. Although the bag does not inflate, oxygen is flowing to the mask. If you are traveling with a child or someone who requires assistance, *secure your mask first, and then assist the other person.*

Wait a minute. Shouldn't it be the other way around? Not only does it feel counterintuitive to help ourselves before helping others, it seems pretty darn selfish. What happened to the Golden Rule (do unto others as you would have them to unto you)? Aren't we as Christians supposed to put others before ourselves?

"Do nothing out of selfish ambition or vain conceit. Rather, in humility value others above yourselves, not looking to your own interests but each of you to the interests of the others" (Philippians 2:3-4).

Although it seems contradictory to take care of yourself first, it is absolutely necessary, especially when helping others in need. Think about it. If we are passed-out-cold and lying on the floor, we are of no help to anyone.

As I began to really think this concept through, I realized how much sense it made, especially as it relates to helping the women, we serve through Living in Truth Ministries. For example, while it is not necessary to be completely healed from disordered eating before helping others, it is necessary to be securely tethered in a relationship with God and be on the road to recovery. Before trying to effectively speak God's truth into the lives of others, we want to make sure you are getting a steady flow of God's truth for yourself.

Bottom line. We cannot give what we do not have. *Secure your 'oxygen mask' first, then you can assist others.*

"But seek first his kingdom and his righteousness, and all these things will be given to you as well" (Matthew 6:33).

~Rae Lynn DeAngelis

Getting Used to It

Plunging into the frigid lake at the beginning of each summer takes my breath away. As I struggle to the surface for air, I'm shocked by the frigid waters and shout, "Whew, it's cold!" A few minutes after I swim around, however, I realize the water isn't as bad as I once thought. I just needed a little time to get used to it.

A similar transformation takes place when it comes to worldly influence. At first, we are shocked by the violence, sexual sin, and disregard for God's laws in our secular culture. But the more we are exposed to sinful attitudes and behaviors, the less shock we feel. Overtime, we become increasingly desensitized, and even indifferent, to sin.

"Do not conform to the pattern of this world, but be transformed by the renewing of your mind. Then you will be able to test and approve what God's will is—his good, pleasing and perfect will" (Romans 12:2).

We live in a culture that continually stretches the boundaries of ethical character in the opposite direction of God's moral code. The margins of right and wrong are continually blurred and even redefined. "For this people's heart has become calloused; they hardly hear with their ears, and they have closed their eyes" (Acts 28:27).

As a result, humanity grows more and more complacent towards obvious sin. Even long-time conservative Christians begin to question their once staunch convictions.

"So, if you think you are standing firm, be careful that you don't fall" (1 Corinthians 10:12)!

The secular world directly opposes Christian views and values, and anytime we try to swim against the current of secularism, we are labeled as intolerant. Not wanting to appear narrow-minded, unloving, or even judgmental, we end up saying and doing nothing. As we tolerate sin, we confuse the boundaries of right and wrong, and drift further away from God. Much like jumping into a frigid lake, the longer we tolerate the murky waters of sin, the less we feel the Holy Spirit's stab of conviction.

No one ever said being a Christian was going to be easy. God doesn't want us to be lukewarm Christians. He wants us to stand firm on His truths to the very end.

"You will be hated by everyone because of me, but the one who stands firm to the end will be saved" (Matthew 10:22).

The Word of God is our daily guide for godly living. "Your statutes, Lord, stand firm; holiness adorns your house for endless days" (Psalm 93:5).

Dive deep into God's Word, soak up His unchanging truths, and stand firm when the Spirit convicts your heart to remain true

to His teaching. The One who has called you is faithful and He will help you do it.

~Rae Lynn DeAngelis

Wonderful You

" I 've got a sort of idea," said Pooh, "but I don't suppose it's a very good one." "Probably not," said Eeyore *(Winnie-the-Pooh by A. A. Milne).*

We're familiar with it—rejection. Someone important to us, through either control or lack of social or parental skills implies, "You're not good enough; smart enough—you're not adequate."

Being brought up by a controlling father, I experienced issues with separation, autonomy and individuation—becoming my own person. I received a bag of mixed messages, "Listen to me only and do what I say," "I love you and will support you any way I can," "You can't separate from me, but you can't get too close either."

Dad always won. I'd return to him repeatedly for support for the very problems that began with him. Consequently, I never really knew Kimberly, the person God created me to be. I only knew the "ideal Kimberly"—the young woman who sought to be accepted, loved and good enough.

To move forward and grow I needed to grieve the death of the ideal Kimberly, which the Bible calls the "old self." She was a phony. After saying good-bye and letting go of her, with the help of the Spirit, I needed to learn to *"put on the new self, created to be like God in true righteousness and holiness" (Ephesians 4:24).* In time, God and His people helped me become my real self. The butterfly emerged from her cocoon.

When Michelangelo was asked how he created a sculpture, he said the statue already existed within the marble, giving God credit for creating his work. He believed his job was to get rid of the excess marble that surrounded God's creation. So, it is with us. Our job is to allow the Holy Spirit to remove all toxic thinking and false beliefs that surround our perfect selves.

How cool is it that? The same God that created mountains and oceans and galaxies looked at you and thought the world needed one of you too." ~Unknown

God created us to shine! (Genesis 1:27-28; 31) We have been set apart to do great things. You wear a spiritual label, "Handmade by the Lord." *What you already are* is adequate to meet your needs and any crisis you may confront. Baruch Spinoza once said, "The greatest pride, or the greatest despondency, is the greatest ignorance of one's self."

Colossians 3:12 states, "Therefore, as God's chosen people, holy and dearly loved, clothe yourselves with compassion, kindness, humility, gentleness and patience." God is telling us to do something. Just like a painter puts color on her canvass, God wants you to clothe yourself with His characteristics.

First, we need to learn to be compassionate, kind, humble, gentle and patient with ourselves—then we can connect and pour it out onto others. It's the answer to beginning to feel alive again.

~Kimberly Davidson

Missed Opportunities

After setting up camp at the beach complete with lounge chairs, umbrella, and enough drinks and sunscreen to last the afternoon, my husband and I (hot from the Florida sun) made our way down to the ocean. As we walked down to the

water's edge, I noticed the waves were just right for surfers to hone their skills on a surfboard. Several vacationers were taking advantage of the ideal conditions; the beach was packed with families having fun in the sun. As we waded into waist-deep water, Gerry saw two dark objects in the distance.

"I wonder what that is," he gestured to get my attention.

At first, I couldn't see anything. But after following his pointed finger towards the water's horizon, I eventually saw what he was talking about. I removed my sunglasses to get a better look. I shrugged, "I'm not sure. Maybe it's people on wave runners or something." It seemed like a pretty good assumption, so we directed our attention back to the waves that were now lapping at our feet.

About thirty minutes later, we saw a couple of lifeguards take off on a jet ski. They appeared to be in a very big hurry. Realization set in; we were witnessing a real-life rescue mission, and they were heading straight for the dark objects we saw on the horizon earlier. We later learned two amateur surfers with rented boards got caught off guard by the rough conditions. A strong riptide kept them from making their way back to shore.

Gerry and I, both, felt a pang of regret, realizing our missed opportunity to help someone in need. Thank goodness someone else was proactive and alerted the lifeguards. A wave of nausea hit me when I considered what could have happened if no one had taken action and notified the beach patrol.

I began to reflect on other missed opportunities to help someone in need: the car sitting on the side of the highway with the hood propped up, the man standing on the opposite side of the road with a sign "homeless and hungry", the lonely neighbor who came to our door but was never invited in because I was working. These are just a few of the missed opportunities weighing heavy on my mind.

Even though it pains me to realize how many times I have fallen short, I'm grateful to know that our God is a God of second chances. He provides future opportunities to get it right the next time.

> Therefore, if you have any encouragement from being
> united with Christ, if any comfort from his love, if any

common sharing in the Spirit, if any tenderness and compassion, then make my joy complete by being like-minded, having the same love, being one in spirit and of one mind. Do nothing out of selfish ambition or vain conceit. Rather, in humility value others above yourselves, not looking to your own interests but each of you to the interests of the others (Philippians 2:1-4).

Dear Lord, thank you for your little nudges to be more aware, more proactive, and more compassionate. Help me to be more like you, Jesus, putting others' needs before my own, knowing full-well that you will bless my obedience and make sure my own needs are taken care of too.

~Rae Lynn DeAngelis

Earthly Tent

Eager to expose our kids to a simpler life, we purchased a tent, sleeping bags, and other essential gear and set out on a camping adventure. We decided to 'rough it' at a secluded primitive campground.

Primitive indeed! No water and no electricity... *unless, of course, you count the downpour and lightshow that took place during the weekend-long thunderstorm.* Note to self: The fun factor greatly diminishes when you camp in the rain.

We thought we had adequately prepared for our trip, only to realize we had forgotten a very basic measure—waterproofing our tent.

By the next morning we were soaked to the bone. We got in our car (the only dry place we could find), and tried to wait it out,

but after a few hours, our patience ran thin. With no end in sight, we finally gave up and went home.

Thankfully the trip was not a total loss. The experience provided valuable lessons for our future camping adventures:

- Lesson #1 - air mattresses double as flotation devices.

- Lesson #2 - taking down your tent in the rain and forgetting to air-it-out is a big no, no.

- Lesson #3 - camping is a lot more fun in an air-conditioned camper with running water, electricity, and portable potty.

You will be happy to know the following year we traded our tent poles for a pop-up camper.

So much for primitive camping!

"For we know that if the earthly tent we live in is destroyed, we have a building from God, an eternal house in heaven, not built by human hands" (2 Corinthians 5:1).

Our little camping adventure reminds me that like a leaky tent, our earthly body is ill-equipped to withstand the elements of living in a broken world. Disease, infection, arthritis, virus, cancer, and organ failure are just a few of the unpredictable conditions plaguing our mortal existence.

But there is hope. We who trust in Jesus have an anchor for our souls, firm and secure. As our spirit slips from this world and into the next, God gives us a new and perfect body, void of pain and disease. It is only when we leave this earthly tent that we will experience that which we were created to enjoy. No more tears. No more suffering. No more disease. No more pain.

Truly, it will be a life worth dying to receive.

> And I heard a loud voice from the throne saying, "Look! God's dwelling place is now among the people, and he will dwell with them. They will be his people, and God himself will be with them and be their God. 'He will wipe every tear from their eyes. There will be no more death' or mourning or crying

or pain, for the old order of things has passed away. He who was seated on the throne said, "I am making everything new!" Then he said, "Write this down, for these words are trustworthy and true" (Revelation 21:3-5).

~Rae Lynn DeAngelis

Trust God Wholeheartedly

I signed my son up for church camp, five hours away, for a whole week, with no contact at all. He was seven at the time, didn't like the dark, and still liked his mommy tucking him in at night. I thought for sure he'd back out, but the time came to go and he went for it.

On one hand, I was proud of his bravery. On the other hand, I did not want to leave my baby.

As I said goodbye and we were both crying, I felt the Lord asking me to trust Him, telling me that the week was more about me, than Ashton.

Control and fear crept in at night, during the day, and all the time. I didn't realize the grip it had on me until I had to surrender it over. I had to, literally, turn my precious one over to someone else's care.

It was a choice to let him go. I had to drive away with no communication the whole week. I had to cry out to the Lord in my fear, sadness, and hurting. I had to give away the most precious thing in my life, hand it to God, and tell Him I trust Him. Wow, it rocked me. And it was only for a week.

What I realized is that I'm a lot of talk. I've always said, "Ashton is the Lord's. He's just on loan to me." But when I was forced to put my words in action, I realized the same fear and control I felt over my son is the same fear and control I have over my self-image.

I want to let that go. I say that I trust God with my image, that I bear His image, and He made me wonderfully and perfectly. But I have realized that more often than not, I'm still holding up that mask, the one I want everyone to see me through.

If something bad happened, like I got burned in a fire or lost a limb, I wouldn't be able to "control" my physical image. I want to keep asking God to increase my belief that I am fearfully and wonderfully made, that He formed me in the secret place just that way He wanted me, and that the gifts He's put inside me, He wants and will use. I don't have to hide or live behind a mask.

What fear or control do you need to trust God with wholeheartedly? Fear of failure, of getting fat, of failed marriage? Fear of not feeling valued or that you matter? Fear of poverty or betrayal? Whatever it is, let's let go of it together. He's waiting for us with gentle eyes and a kindness that will lead to repentance. We'll only get freedom when we lay it down by choice.

Father, I lay down my image before you. I lay down the fear of what people would say if I set all of that aside. I repent of still holding up the mask even though, in my head, I know the truth. I want to believe and live it with my heart. I want to be Your image bearer; I want to trust you with my life. I want the air that I breathe to be Your Spirit and to breathe out the joy that you give me. Holy Spirit, come in. Help me not to walk in shame, but in vulnerability and courage that I'm yours and that your opinion is the only one that matters. I'll follow where you lead. Lead me to freedom. I no longer want to be a slave to fear. I love and trust you. Amen.

~Alison Feinauer

Temperature Gauge

My husband and I often wrestle over the thermostat in our home. On a quest for each of us to regulate our personal level of comfort, our home's thermostat fluctuates more than the NY stock exchange. He turns it up; I turn it down. I turn it up; he turns it down.

It seems our bodies function on completely different plains. When he's cold, I'm hot. When I'm cold, he's burning up. However, since my husband is the one paying the bills in our home, he has the final say. I eventually need to either bundle up or strip down.

Although Gerry assumes ultimate responsibility when it comes to heating and cooling our house, after thirty years of marriage, I've come to the conclusion that I wield a lot of influence when it comes to a different kind of temperature in our home.

Perhaps you've heard the old adage: *if momma isn't happy, nobody's happy.* It carries a lot of truth. We as women have been entrusted with a great deal of responsibility to nurture and care for the needs of our family. Part of our responsibility includes the temporal influence we have over our husband and children.

For me personally, anytime I become angry, upset, or stressed, my family quickly follows suit. On the opposite spectrum, when I'm even-keel emotionally, our home is a much more pleasant environment. I've come to realize that my emotions tend to regulate the highs and lows of our home like a barometer. For example, if my husband comes home from work filled with stress, I can soften his disposition with a few carefully chosen words of encouragement, or magnify his anxiety by heaping grudges from my own day.

"A wife of noble character who can find? She is worth far more than rubies. Her husband has full confidence in her and lacks nothing of value. She brings him good, not harm, all the days of her life" (Proverbs 31:10-12).

With great influence comes great responsibility!

Over the years, I have learned to appreciate and respect my position of influence with careful restraint. The moment I begin sensing emotional instability in our home, I do a self-evaluation. I have to ask myself what is the countenance of my own spirit? Am I stoking the fires of discord or fanning the flames of tranquility? Ultimately, my emotional response is my responsibility.

Dear Lord, "May the words of my mouth and the meditation of my heart be pleasing in your sight, LORD, my Rock and my Redeemer" (Psalm 119:14).

~Rae Lynn DeAngelis

Drawn to the Light

E venings spent on our patio, gazing into the glowing embers of our outdoor fireplace while listening to soft music, is one of my favorite pastime activities. Gerry and I have grown to treasure such peaceful moments as these, free of distractions. Relaxing by the fire, we enjoy nature's nighttime song and dance. It reminds us that we are not the only ones drawn to light. Creepy-crawlers of every kind dart into the flames, unaware of the hazards awaiting them, while spiders instinctively craft webs around light fixtures, hoping to attract unsuspecting prey.

Christians can also be lured by flares of deception disguised as counterfeit sources of light. "Satan himself masquerades as an angel of light. It is not surprising, then, if his servants also

masquerade as servants of righteousness" (2 Corinthians 11:14-15). "For false messiahs and false prophets will appear and perform signs and wonders to deceive, if possible, even the elect" (Mark 13:22).

Since even the elect will be seduced by the enemy's web of lies in the last days, how can we protect ourselves from being misled?

One of the best methods to defend ourselves against Satan's increasingly deceptive ways is to test everything against the only reliable source of truth—the Bible.

"All Scripture is God-breathed and is useful for teaching, rebuking, correcting and training in righteousness, so that the servant of God may be thoroughly equipped for every good work" (2 Timothy 3:16-17).

As we study our Bible and fix our eyes on Jesus, God illuminates the darkness, exposes the enemy's identity and motives, and keeps our foot from being snared.

Therefore, as it is written, "For you were once darkness, but now you are light in the Lord. Live as children of light" (Ephesians 5:8).

"'Be alert and of sober mind.' Your enemy the devil prowls around like a roaring lion looking for someone to devour. Resist him, standing firm in the faith, because you know that the family of believers throughout the world is undergoing the same kind of sufferings" (1 Peter 5:8).

Make sure you are being drawn to the One True Light who has come into the world, defeated darkness, and conquered the grave—Jesus Christ, our Lord and Savior.

"The people walking in darkness have seen a great light" (Isaiah 9:2).

~Rae Lynn DeAngelis

When God Seems Silent

I n times of distress or loss, do you feel closer to God? Might you feel He has abandoned you? Perhaps you get so depressed you don't even think about God or church? It's human nature to walk by feelings versus faith. "I have had enough, LORD," he said" (1 Kings 19:4). "He" is the great prophet Elijah—the one who performed miracles. Yet even Elijah experienced profound sorrow and darkness in his soul.

Termed "the dark night of the soul," great believers have experienced bouts of agonizing doubt in God. It is a phrase that describes a time when God seems distant, when our soul seems lost, and when we're convinced God has abandoned us. Our Christian forefathers called it "spiritual desertion." O LORD, why do you stand so far away? Why do you hide when I am in trouble" (Psalm 10:1)?

Brennan Manning once said, "Most of the time my prayer consists in experiencing the absence of God." Most people agree, God's silence can be far worse than getting a no answer. In Matthew 15 we meet a Canaanite woman who came to Jesus, crying out, "'Lord, Son of David, have mercy on me! My daughter is suffering terribly from demon-possession.' Jesus did not answer a word ..." (22-23). Despite Jesus's silence, the woman persisted. In the end, Jesus granted her prayer request (v. 28).

Job wept, "I cry to you, O God, but you don't answer. I stand before you, but you don't even look" (Job 30:20). What did we learn from Job? Silence from God does not mean "no." Sometimes the silences are God's way of preparing us for a deeper blessing. Psalm 10:17 says, "You hear, O Lord ... and you listen to their cry."

God's silence is a matter of perspective. And it just may be us! Let's not overlook that God speaks to us through not just through His Word, but also the church and, yes, the world. We could be missing His voice. Randy Alcorn wrote in an article titled "When God Seems Silent,"

> Trusting God when we don't hear Him ultimately strengthens and purifies us. If our faith is based on lack of struggle and affliction, and lack of doubt and questions, that's a foundation of sand. Token faith will not survive the dark night of the soul. When we think God is silent or absent, He may show us that our faith is superficial. Upon its ruin, we can learn to rebuild on God our Rock, the only foundation that can bear the weight of our trust.

Consider that when you feel God is silent, you can learn to love and trust Him regardless. God's Word promises, "You will seek Me and find Me when you search for Me with all your heart" (Jeremiah 29:13; NASB) ... "he rewards those who sincerely seek him" (Hebrews 11:6).

~Kimberly Davidson

Don't Get Burned

When I was a kid, I loved riding on the back of my dad's motorcycle, feeling the open-air rush past me. It was an exhilarating experience, but dangerous too. As a matter of fact, the danger factor was evident before the bike ever left the driveway. One time in particular, I swung my leg over the motorcycle seat and felt the scorching hot metal singe the skin on

my thigh. Not sure whose bright idea it was to put the exhaust pipe so close to the passenger's leg, but it was definitely a design flaw.

My brother, sister, and I were all given explicit instructions for how to safely mount and dismount the bike, but at some point, each one of us grew careless and paid the price. The result was a nasty burn that took weeks to heal.

Telling us to be careful wasn't enough. We had to experience the pain of getting burned before the lesson fully stuck.

Unfortunately, not much has changed in forty plus years. At times I still grow careless and suffer consequences for my lack of attention.

"Be alert and of sober mind. Your enemy the devil prowls around like a roaring lion looking for someone to devour. Resist him, standing firm in the faith, because you know that the family of believers throughout the world is undergoing the same kind of sufferings" (1 Peter 5:8-9).

God gives us plenty of counsel in His Word to help protect us from danger, but we still live in a fallen world, and as a result, pain and suffering come into our lives.

But thankfully, in the midst of great trial and intense heat, God gives us hope and keeps us from getting burned.

"Do not fear, for I have redeemed you; I have summoned you by name; you are mine. When you pass through the waters, I will be with you; and when you pass through the rivers, they will not sweep over you. When you walk through the fire, you will not be burned; the flames will not set you ablaze" (Isaiah 43:1-2).

Jesus to the rescue! He either pulls us out of harm's way or He helps us walk through. Jesus said, "In this world you will have trouble. But take heart! I have overcome the world" (John 16:33).

~Rae Lynn DeAngelis

After the Storm

It seems that no matter how brown the grass on our lawn becomes during the hot summer months, it greens-up instantly after a storm. Why is that?

The obvious answer would appear to be rain—plants need water to survive. And while it is true that water is a necessary component to developing strong and healthy plants, it is not the only factor.

Through a bit of research, I've learned that there are several elements needed for grass to grow and flourish. The most important element is nitrogen. When lightning flashes during an intense thunderstorm, a chain reaction takes place which converts nitrogen in the atmosphere to dissolvable nitrates that are more easily absorbed into the soil. Nitrates are essential factors for growing greener grass.

I'm always amazed at the vivid illustrations God provides through science and nature.

As I allow the life-giving water of God's Word to soak into my spirit, I grow a little more each day. However, I have found that the intense seasons of growth in my life have taken place after I've encountered an intense storm.

Trials, challenges, and heartaches seem to accelerate the spiritual growth process, much like the transformation of greener grass after a rainstorm. "...rejoice in the Lord your God, for he has given you the autumn rains because he is faithful" (Joel 2:23).

It is a fact of life that some lessons are more readily absorbed into the fabric of our being through pain, struggle, and strife.

Navigating challenging relationships, executing and growing a ministry, as well as shouldering the burden of many heartaches

of this broken world are just a few of the tempests God has been using to mold and shape me into the woman He desires me to be.

Although I do not especially enjoy going through the tough times, I have found they are absolutely necessary. One of the greatest benefits of trials and tribulations is that it enables us to grow stronger and better handle future storms and seasons of life.

The same is true for you.

"Consider it pure joy, my brothers and sisters, whenever you face trials of many kinds, because you know that the testing of your faith produces perseverance. Let perseverance finish its work so that you may be mature and complete, not lacking anything" (James 1:2-4).

So, the next time you see clouds rolling-in or hear the faint sound of thunder in the distance, remember, not only will God bring you safely through the storm, but He will give you greener grass on the other side.

"The rain came down, the streams rose, and the winds blew and beat against that house; yet it did not fall, because it had its foundation on the rock" (Matthew 7:25).

~Rae Lynn DeAngelis

Feeling Numb

Ever have a day when you just feel numb, like you are going through the motions just to get through? Nothing super exciting in the near future to look forward to and nothing really horrible to dread or plan. No big projects and no spectacular parties coming up. Just a lot of flat-line living.

I've been in a bit of a rut lately with the same routine week after week. I've been asking myself, is this what my life is? I've been feeling a little discouraged, and it's starting to wear on me.

Call it the winter blues, a valley, dark days, or a battle in my mind. It's real, and I feel it.

Each morning I wake up and wonder, what kind of day will today be? Do I have energy to get out of bed? How do I self-motivate when I'm feeling empty? The answer? Worship.

I worship. Worship changes the atmosphere, from the inside out. It shows the enemy that my body, soul, and spirit are made for worship and he can't have any part of me.

Is there a valley, desert, or circumstance you need to invite the Holy Spirit into? Is there a new dance you want to set your heart beat to? Every beat of your heart is given by God, so let's worship Him, friends. He is worthy of it all. I encourage you to not let this time pass by, but lean into what God wants to teach you in the dark days, what He wants it to be for you. I'm learning that my circumstances don't have to dictate the hope and joy that I find in Jesus.

"The Lord is my light and my salvation, whom shall I fear? The Lord is the stronghold of my life, of whom shall I be afraid" (Psalm 27:1)?

"I am still confident that I will see the goodness of the Lord in the land of the living. Wait for the Lord, be strong and take heart and wait for the Lord" (Psalm 27: 13,14).

"Do not grieve, for the Joy of the Lord is your strength" (Nehemiah 8:10).

Father, when I'm tired, discouraged or bored, give me Joy and a new Strength. Help me to get out of the pit and to stand firm in what You did for me on the cross. Thank you for giving me purpose and peace and an overwhelming joy in the darkest of days. Help me to remember that each day is a gift and that you want to use me to share your love to others. Lead me, guide me, restore my soul and anoint my head with oil so that my cup runs over like you say in Psalm 23. You are my good shepherd. Help me to hear your voice. I love and trust you, Amen

~Alison Feinauer

The Rich Get Richer

Peasants Revolt is a card game which consists of six players—three positions of royalty and three positions of common folk called peasants. From the very beginning of the game, the royalty players are given an unfair advantage over the peasants because they receive the best cards. The object of the game is to eliminate your cards as fast as possible. The manner in which each person goes out of the game determines the player's position during the following hand. The game gets really interesting when one of the peasants (after catching a much-needed break) gains control of the game and goes out first.

The old adage that the rich get richer echoes an unfortunate reality in this broken world.

"Whoever has will be given more, and they will have an abundance. Whoever does not have, even what they have will be taken from them" (Matthew 13:12).

At first glance, the concept in Matthew chapter thirteen appears to give credence to the axiom, the rich get richer. However, to fully grasp any verse in the Bible we must view it within context.

The passage in question can be found in the parable of the four soils. As we take a closer look at this verse, we see that it is not related to material gain at all. Much like He often did, Jesus was teaching a spiritual concept using something His listeners could relate to in nature.

The premise behind the Lord's parable correlates to how much we desire to learn and grow in our knowledge of God through meditation and study of God's Word—the Bible.

Like the seeds sown on the path, are we claiming Jesus as Lord and Savior without ever taking time to know Him personally?

Perhaps like the rocky soil, we are merely going through the motions, reading our Bible and attending church, but never allow God's truths to sink into the core of our being. We are hearers of the Word but not doers.

Or maybe we identify more with the seeds sown among thorns. Understanding God's truth is being choked out by sin or circumstance.

At different times of my life, I can relate to every one of these soils. It wasn't until I allowed God full access into my life and began seeking Him with all my heart that the Word of God began to take root and bring forth a harvest of fruit.

The more I seek God with intentionality the more fertile and productive God's Word becomes in my life. The result is that even more seeds are scattered. Each seed planted has the potential to cultivate a greater harvest of fruit later on.

Anyone can count the number of seeds in an apple, but only God can count the number of apples in a seed. ~Robert H. Schuller

"Now to him who is able to do immeasurably more than all we ask or imagine, according to his power that is at work within us, to him be glory in the church and in Christ Jesus throughout all generations, for ever and ever! Amen" (Ephesians 4:20-21).

So, if we look at this in the context of God's higher ways, I guess you could say the rich really do get richer!

~Rae Lynn DeAngelis

I Give Up!

I give up! Have you ever uttered those words in a moment of desperation? I'm embarrassed to admit that these words have come from my mouth far too frequently. Just ask my close family and friends. Give up on life? No! Give up on God? Absolutely not! So, what could possibly evoke such hopelessness in my spirit that I would feel like my only recourse was giving up?

M-I-N-I-S-T-R-Y.

There. I've said it. Are you shocked?

Managing a non-profit ministry requires long hours steeped in spiritual opposition with little compensation or validation. Sometimes it feels like I'm wandering around in a thick fog. I take one precarious step after another with no clear vision of the other side. The enemy whispers the lie that I am both too much and not enough, all at the same time. I continue pushing through each obstacle but I often grow weary, especially when I only see what feels like a small amount of fruit coming forth. But then God reminds me of His truth and I muster up enough courage and strength to face a new day. "Let us not become weary in doing good, for at the proper time we will reap a harvest if we do not give up" (Galatians 6:9).

Oswald Chambers wrote,

> *You can never measure what God will do through you if you are rightly related to Jesus Christ. Keep your relationship right with Him, then whatever circumstances you are in, and whoever you meet day by day, He is pouring rivers of living water through you, and it is of His mercy that He does not let you know it.* ~My Utmost for His Highest.

Perhaps you too struggle with feelings of uncertainty and wonder if your life really matters. Maybe you even feel like giving up.

What is it that causes you to stumble, to feel like throwing in the towel? Is it your job? Your marriage? Health? Finances? A relationship? Perhaps it's the fact that you're not seeing much progress concerning changes you've been trying to make concerning toxic thoughts or destructive behaviors.

The truth is, we are all vulnerable to feelings of hopelessness and despair when life gets hard. But we are not helpless victims. When we start falling prey to the enemy's lies, we need to be intentional about rejecting lies and embracing God's truth. If I hadn't taken time to intentionally invest in my relationship with Jesus, being refueled by His transforming truths, I would have quit ministry a long time ago.

We cannot let the enemy win. We must resist the enemy's tactics of deception when feelings of uncertainty creep into our cognitive thought patterns, and we must make a conscious effort to replace worldly lies with God's truth.

Encouragement from others is a blessing and has its place. But when you and I grow especially weary and feel like giving up, only words from our Father in heaven have the power to transform our hearts and strengthen us to face another day.

> Do you not know? Have you not heard? The Lord is the everlasting God, the Creator of the ends of the earth. He will not grow tired or weary, and his understanding no one can fathom. He gives strength to the weary and increases the power of the weak. Even youths grow tired and weary, and young men stumble and fall; but those who hope in the Lord will renew their strength. They will soar on wings like eagles; they will run and not grow weary; they will walk and not be faint (Isaiah 40:28-31).

~Rae Lynn DeAngelis

I'm Still Not...

 ❝ I 'm doing everything right, but I'm still not... [fill in the blank]. What's going on?"

 At one time or another, all of us have been in this predicament ... *I'm still not passing the course ... I'm still not losing weight ... I'm still not thinking straight ... I'm still not avoiding temptation ...* Ever feel, as a follower of Jesus, *I'm still not acting like my new self, a new creation?* I confess, I talk to Jesus about this a lot.

 We live in a culture of impatience and instant gratification. For me, waiting a whole week for a delivery seems like an eternity as I've become accustomed to the immediate satisfaction afforded by technology. Likewise, we want personal transformation to happen *now.*

 Think out of the box with me for a moment. What would you choose to be—a mighty oak tree or a squash? If you said an oak tree, let me remind you that it takes 100 years to grow an expansive oak. It only takes 6 months to grow a puny squash. You get my point.

 In the parable of the sower, Jesus knew most of the people would never produce fruit (or an oak tree) from changed lives because the Word He was teaching them was like seed falling into poor soil (read Mark 4: 1-13). The parable tells of seeds that were erratically scattered, some falling on the road and consequently eaten by birds, some falling on rock and consequently unable to take root, and some falling on thorns, which choked the seed and the worms ate them. According to the parable, only the seeds that fell on good soil germinated producing a crop thirty, sixty, or even a hundredfold of what had been sown. Jesus's point: The seed represents God's Word (Luke 8:11). The sower is us, empowered

by the Holy Spirit to sow God's Word. The soil is the human heart. Our heart must be prepared to receive the seed before it can take root and produce a harvest.

When it comes to maturity—spiritual, relational and emotional—we can't microwave it. It takes time, lots of time. Like a crock-pot, God simmers us on low heat for a long time. It's taken me 16 dedicated years of following Jesus to get to this point in my life, and He's not near done with me—or you. It's important to remember how beneficial patience can be, because the best things in life, and in God's Kingdom, are more than a click away.

~Kimberly Davidson

Catalyst for Growth

M anure, dung, droppings, excrement… they are all labels for the same thing. For the sake of keeping my post PG, I'll skip over the more offensive tags. (I'm sure you can fill-in-the-blanks on your own.)

Without getting too graphic, it's the left-over waste material once nutrients are extracted from ingested food. No longer useful, the odorous byproduct is eliminated.

Where am I going with this? Hang with me here for a minute or two. I actually do have a point.

Humans, animals, plants, insects, and even microorganisms produce some sort of waste material. Some living things produce more waste than others. For example, did you know that the average cow produces 65 pounds of manure in a single day? Now, that's a lot of pooh!

It's amazing to think that something so noxious as manure could actually spawn growth in another living thing, and yet that's

exactly what it does—a principle which holds true in the physical realm, as well as the spiritual.

Amazingly, God is able to take a lifetime of messiness in our lives and use it for good. Past mistakes become agents for growth in us, as well as others.

Unfortunately, the enemy would have us to believe otherwise. He tries to convince us that our messed-up lives and painful life experiences are better off locked away in the dark recesses of our subconscious minds. As a result, we hide behind our carefully manufactured façade which implies that we have it all together. We cannot unveil our imperfect lives because we fear what others might think. And because much of the world is doing the same thing, we end up with a warped sense of reality.

"If we claim we have not sinned, we make him out to be a liar and his word is not in us" (1 John 1:10).

Here's the truth of the matter. People want to know the *real* us, not some watered-down, glamourized version that has been plastered across our Facebook, Twitter, or Pinterest accounts.

Why? Because real people identify with real people.

"For all have sinned and fall short of the glory of God" (Romans 3:23).

There is nothing more alluring than an authentic person who doesn't pretend to have it all together, a person who is honest about their weaknesses, their struggles, and their strife. When you and I share our soiled, not-so-perfect lives with others, God does more than we can imagine through His power that is at work within us. He takes our mess and turns it into a message of hope for others.

"Not only so, but we also glory in our sufferings, because we know that suffering produces perseverance; perseverance, character; and character, hope. And hope does not put us to shame, because God's love has been poured out into our hearts through the Holy Spirit, who has been given to us" (Romans 5:3-5).

It's time to get real and be a catalyst for growth in others.

~Rae Lynn DeAngelis

You Can Do This!

O ne of the biggest lies of the enemy is, "You can't do this." However, his cynicism is often cloaked in less obvious verbiage like: *It's not worth fighting for. You're not strong enough to see this thing through. You're wasting your time. You don't have what it takes.*

Through the enemy's subliminal scorn and our own negative thoughts, we begin to waiver in our resolve, especially when we have trusted in our own strength and abilities.

But as Christians, we do not need to rely on our own strength and abilities. As a matter of fact, we can accomplish a whole lot more through our weaknesses than we can through our strengths.

Why? Because when we are weak, God is strong!

"But he said to me, "My grace is sufficient for you, for my power is made perfect in weakness" (2 Corinthians 12:9).

Did you get that? God's power is made perfect in our weakness.

On a daily basis, I minister to women who are seeking freedom from toxic thoughts, women who have a desire to find contentment in the body they have right now. Regardless of where they fall on the spectrum of poor body-image or disordered eating, each individual faces a similar challenge—overcoming the lies of the enemy and turning their "I can't do this" mentality into *I can do all things through Christ who gives me strength.* "'If you can?' said Jesus. 'Everything is possible for one who believes'" (Mark 9:23).

Remember, the greatest distance you will ever travel is the seventeen inches from your head to your heart. Over the years and through my own personal struggles with an eating disorder, I have

experienced *unbelief* as the greatest antithesis to the "I can" mentality.

For this reason and many others, we need to arm ourselves with the sword of the Spirit, filling our hearts and minds with biblical truths that counteract the enemy's lies, and we need pray every day, *God, help me overcome my unbelief!*

"The Lord is my strength and my shield; my heart trusts in him, and he helps me" (Psalm 28:7).

"Surely God is my salvation; I will trust and not be afraid. The Lord, the Lord himself, is my strength and my defense; he has become my salvation" (Isaiah 12:2).

No matter what obstacles you face today, remember. You *can* do this!

"Jesus looked at them and said, "With man this is impossible, but not with God; all things are possible with God" (Mark 10:27).

When the enemy whispers, "You can't do this!" Counter back with God's truth, "I can do all things through Christ who gives me strength" (Philippians 4:13).

~Rae Lynn DeAngelis

Secrets in the Dark

Have you had something you hoped would go away on its own, with a little time and a little ignoring? It could be a bad image of something, maybe a little lie, maybe a secret about bankruptcy or bed bugs or lice, maybe a relapse of an addiction… You know, those things that have happened to us or we've discounted as small, maybe out of our control or not, but have the potential to rob us of joy or put a cloud of shame over us.

My eight-year-old son asked how to get something bad out of his head. I told him to start by praying.

He replied, "I've done that and it didn't help."

I asked what he wanted to get out of his head, but he didn't want to tell me.

I felt prompted to talk about how Satan, our enemy, uses thoughts and secrets to hold us hostage and isolate us. Secrets put shame on us, and when we keep them in, they have power over us to grow, and that's what the enemy wants. The lie from the enemy is that no one will like us after we share them, or that they aren't that big of a deal, so we keep them in. I told him that in the Bible we are encouraged to confess stuff and the Lord's grace covers and forgives, if needed. I told him that secrets lose their power, if we share them.

My son proceeded to tell me, after a few hours, about something that happened in his class a year ago. A friend asked him to do something that was inappropriate (he told me the details). He didn't do it, but it's been eating at him for a year. It broke my heart. But after he shared and released the anger he had for this kid, he looked free, joy-filled, light again. It was beautiful, but sad for me that it had taken so long.

I too have experienced the shame of secrets. I dealt with a secret sin, and it paralyzed me for years. It literally made me sick. It was awful. Satan was having a field day with me.

I felt the prompting to share with a friend and repent to the person I had wronged. It lost its power. It's the fear of rejection and the compromise of our identity that can creep in. I heard one time, if you share something three times, it frees you.

Maybe you've experienced the shame of secrecy. Find a trusted friend and share it. Get it out! The enemy would love for you to be stuck and discouraged and feel alone. Share it!

"If we confess our sins, He is faithful and just to forgive us our sins and cleanse us from all unrighteousness" (John 1:9).

"The power of life and death is in the tongue" (Proverbs 18:21)!

Father, thank you that there is freedom in you, in confession, and in allowing ourselves to be open, real, and naked before you. Please give us strength and power to speak out our confession. We cry to you for mercy and guidance in conversations you are prompting us to have. Give us courage and hope in the midst of

our secrets. You know everything. Thank you for loving us no matter what. Help us to be humble enough to open up. Maybe our vulnerability can help heal someone else. We want to be free, know our identity is in you, and trust you deeply.

~Alison Feinauer

Maze Runner

Have you seen the movie *Maze Runner*? It was a pretty good science fiction movie, but it was also very stressful, the kind of film that keeps you on the edge of your seat. Without giving away too much, I can tell you that a big part of the action and suspense revolves around a very complex maze.

Have you ever tried to navigate your way through a maze? I have a couple of times. But since I'm directionally challenged, it wasn't fun at all. In fact, it was stressful.

Sometimes life feels like I'm wandering aimlessly through a labyrinth filled with obstacles. I start traveling in the direction I sense God is leading me, only to find after a long time into the journey, I've hit yet another dead end. After setting my course in a different direction, I start to wonder, *"God, don't you see me struggling here? I could really use your help!"*

Does he not see my ways and count my every step (Job 31:4)?

It's during these uncertain and troubling times that I wish God would just give me some clear direction. *Can you relate?*

God is all-knowing, all-powerful, and ever-present. So why do you suppose He allows us to travel such a long time in the wrong direction if He knows it will only lead us to a dead end?

"For my thoughts are not your thoughts, neither are your ways my ways," declares the Lord. "As the heavens are higher than the

earth, so are my ways higher than your ways and my thoughts than your thoughts" (Isaiah 55:8-9).

Perhaps the answer is simpler than we would expect.

I've said it before: *God is more interested in the journey than the end destination.* I'm not referring to our salvation here. Of course, God wants us to be with Him in heaven. (That's why Jesus went to the cross.) I'm referring to the goals, dreams, and aspirations we set out to accomplish for ourselves, even well-meaning goals, directed towards serving God.

Let's say we have an idea, something which we believe God has planted in our heart. We start down a particular path towards that thing, whatever it may be, but then God says, *"That's a really great cause, and I will even bless your efforts, but you need to remember, I'm more interested in developing godly character traits in you along the way, (pruning that which is not of me). My precious child, the end goal is only worthwhile if you are becoming a clearer reflection of my Son Jesus."*

Kind of puts the frustrations we face along the way in a whole new light, doesn't it?

The dead ends we keep running into are there, in part, because God still has refining work He wants to do in our life.

"Because of your great compassion you did not abandon them in the wilderness. By day the pillar of cloud did not fail to guide them on their path, nor the pillar of fire by night to shine on the way they were to take. You gave your good Spirit to instruct them" (Nehemiah 9:19-20a).

"...for the Lord will be at your side and will keep your foot from being snared" (Proverbs 3:26).

Gracious Lord, help me to place more focus on the journey and leave the end destination up to you.

~Rae Lynn DeAngelis

Here and Now

L ike me, do you struggle to keep your thoughts in the here and now? Do you find that the enemy far too easily hijacks your thoughts with regrets of yesterday and fears of tomorrow? Regrets and fears pillage us of peace; they keep us from celebrating and embracing that which God has for us today.

"Forget the former things; do not dwell on the past. See, I am doing a new thing! Now it springs up; do you not perceive it? I am making a way in the wilderness and streams in the wasteland" (Isaiah 43:18-19).

"Therefore, do not worry about tomorrow, for tomorrow will worry about itself. Each day has enough trouble of its own" (Matthew 6:34).

God has given us His great and precious promises to direct our steps through a life that is sometimes filled with heartache and trouble. As we walk closely with God, He pulls us through the hard times and gives us tremendous growth along the way.

"Do not be anxious about anything, but in every situation, by prayer and petition, with thanksgiving, present your requests to God. And the peace of God, which transcends all understanding, will guard your hearts and your minds in Christ Jesus" (Philippians 4:6-7).

Even though we may come against trouble and strife, God knows that all we can really handle is today, right here, right now. Yesterday is gone, so we need to learn from it and go on. Tomorrow is not here yet, so no need to worry. God will give us exactly what we need tomorrow as long as we continue to follow Him and trust His higher ways. As we focus on only today, we acquire a kind of peace that passes all understanding, resting in the truth that God's mercies are new every morning.

Still not convinced?

Here is the best reason yet as to why we should live in the here and now.

"Why, you do not even know what will happen tomorrow. What is your life? You are a mist that appears for a little while and then vanishes" (James 4:14).

This passage is not saying that we are unimportant in the big picture of God's story. Rather, it is saying that we have been given a gift, a gift called today. Open it up. Enjoy it. And ask God to show you how it can be best used to serve and honor Him.

Embrace the present as the gift God intended it to be.

~Rae Lynn DeAngelis

What's Most Important?

S ome things are going to happen no matter how much we would like to stop them from happening. One of them is growing old. My grandma is in a local healthcare facility for people with dementia and Alzheimer's. Lately, she's been scratching herself due to some kind of rash. Today, while waiting for dinner, I told her to let me look at her stomach. She was seated, and when she lifted up her shirt, I saw what looked to be a big mole at the end of a small protruding mass. It was at the same level as her belly button. It didn't take long for me to realize; the protruding mass was her fallen, droopy boobs.

I often find myself gazing at youthful pictures of these old people, which now hang outside each resident's door. One of the women was beautiful, intelligent, and the wife of a now retired doctor. It's been said that she was once snooty because of her wealth and beauty. Today, she sits in a wheelchair with her legs hanging over the side and underwear showing.

"Let the lowly brother glory in his exaltation, but the rich in his humiliation, because as a flower of the field, he will pass away. For no sooner has the sun risen with a burning heat than it withers the grass; its flower falls, and its beautiful appearance perishes. So the rich man will fade away in his pursuits" (James 1:9-11 NKJ).

The things which seem important now usually change with age. We begin to understand that beauty, weight loss, finances, and other such trivial issues begin to dim and things such as family, friends, and making a difference in someone else's life start to step into the spotlight of our thoughts and time.

"The world and its desires pass away, but whoever does the will of God lives forever" (1 John 2:17).

Death is inevitable if we're still here before the Lord's return. Any one of us could pass away at any given moment. God has not given us advance notice of the day, place, and time, but He has told us it will happen. The end is coming, but do you know where you will end up in the end?

"For God so loved the world that he gave his one and only Son, that whoever believes in him shall not perish but have eternal life. For God did not send his Son into the world to condemn the world, but to save the world through him. Whoever believes in him is not condemned, but whoever does not believe stands condemned already because they have not believed in the name of God's one and only Son" (John 3:16-18).

~Rhonda Stinson

Mood Ring

The 1970's were the golden years for me. I was a kid, and life was simple. It was a time when my biggest decisions had involved things like what to pack for lunch, who to hang out with, or what to wear. Every once in a while, though, a really big decision was on the line, a decision that could change the course of my life forever. Standing at the checkout counter of the local tourist shop in Florida, I was faced with one such dilemma. Should I or should I not spend the majority of my vacation money on a ring? Removing the mystical piece of jewelry from its foam case, I held it up to the light. Even though it didn't sparkle or shine, I knew the power it held—power to unlock the hidden sentiments of my heart. Mood rings were all the rave back then. The color-changing gems were said to have special powers, powers to expose the emotions within. Placing the ring on my finger, the color began to change from black to yellow to green. With a simple glance at the color key, I was able to unlock the door to my true feelings.

- burgundy/pink – happy, romantic
- blue – calm, relaxed
- green – average, not much going on with you
- yellow/amber – tense, excited
- brown/gray – nervous, anxious
- black – cold temperature

If only it were that simple! Women have been both blessed and cursed with a wide range of emotions encompassing varying levels of intensity. Thanks to an overabundance of hormones, our feelings have been known to change on a dime. Peace turns to

anxiety. Joy turns to sorrow. Confidence turns to uncertainty. And all it takes is a phone call, a news report, a diagnosis, or a heartbreak. These can be game changers, pendulums that swing our mood into the opposite direction. No wonder the men in our lives walk on eggshells when they're around us; they are waiting for the next expressive shoe to drop. (News flash to all the guys… If you are struggling to understand the female gender, you're not alone. Women are just as baffled.) Peeling back the complex layers of our feelings can take some of us years to decipher.

I'll be the first to admit that I'm far too easily influenced by things around me. My roller coaster of emotions is a ride all too familiar. Thankfully, God's been helping me level out some of those peaks and valleys through the truth of His Word.

When chaos abounds? "Do not be anxious about anything, but in every situation, by prayer and petition, with thanksgiving, present your requests to God. And the peace of God, which transcends all understanding, will guard your hearts and your minds in Christ Jesus" (Philippians 4:6-7).

In times of sorrow? "Consider it pure joy, my brothers and sisters, whenever you face trials of many kinds, because you know that the testing of your faith produces perseverance. Let perseverance finish its work so that you may be mature and complete, not lacking anything" (James 1:2-4).

It is somehow comforting to know that God is cultivating godly traits in us during hard times.

When anger has reached its boiling point? "My dear brothers and sisters, take note of this: Everyone should be quick to listen, slow to speak and slow to become angry, because human anger does not produce the righteousness that God desires" (James 1:19).

When I view life's highs and lows against the truth of God's Word, I find that I'm much more stable.

The true secret to understanding and managing my day-to-day emotions is not found in a ring. It's found in a KING! "… the Lamb will triumph over them because he is Lord of lords and King of kings—and with him will be his called, chosen, and faithful followers" (Revelation 17:14).

"Since we live by the Spirit, let us keep in step with the Spirit" (Galatians 5:25).

~Rae Lynn DeAngelis

At First Sight

I hate getting sick, especially when I'm battling a cold. With my stuffy nose and watery eyes, not only is it hard to breathe, but it's hard to taste food as well. I suppose the nose and taste buds work together more than we realize. Losing my sense of smell doesn't compare to how difficult it would be to lose my eyesight or ability to hear, and yet, many people live with these kinds of disabilities every day.

In the late 1990's a film came out called *At First Sight* with Val Kilmer. The drama paralleled the true story of Shirl Jennings who lost his eyesight at a young age. Shirl had adapted to his disability and lived a fairly normal life. But after living with blindness for forty years, Shirl was given an opportunity to regain his sight through an experimental surgical procedure.

Although the surgery was a success, Shirl had a difficult time adjusting to his new way of life. He struggled to process the information he was receiving through his restored vision. Everything previously learned had been filtered through his other four senses: hearing, touch, taste, and smell. He had to learn everything all over again through his new sensory input—sight.

The adaptations that Shirl endured following his surgery success shadows real life consequences we may encounter when recovering from addiction.

Anyone who has lived with a disability knows that change, even when we know it is best for us, is hard. It requires a

relearning process and a new way of perceiving the world around us.

When I was struggling to overcome my eating disorder, I needed to understand that food is not the enemy but a necessity for my bodies to function properly. Unlike other addictions, food is not something a person can simply remove from their life. I had to allow God to change my attitudes surrounding it. There is a difference between being thin and being healthy.

My sense of value as a person was warped. I had an erroneous perception that people would only love and accept me based on my outside appearance. That was a lie, a lie the enemy used to keep me blind to the truth.

It took some time, but God eventually revealed the truth of who I am and how He sees me through Scriptures like these.

"Listen, O daughter, consider and give ear: Forget your people and your father's house. The king is enthralled by your beauty; honor him, for he is your lord" (Psalm 45:10-12).

"The Lord does not look at the things man looks at. Man looks at the outward appearance but the Lord looks at the heart" (1 Samuel 16:7).

What about you? Is there something you need to start seeing differently? Don't let Satan blind you to the truth any longer. Allow God to transform your mind and start seeing yourself and the world around you through a new pair of eyes.

~Rae Lynn DeAngelis

At War with our Bodies

We are at war with our bodies. This is completely contrary to what God says: "Thank you for making me so wonderfully complex! Your workmanship is marvelous—and how well I know it" (Psalm 139:14 NLT).

Do you thank God for who you are? Or do you resent God for how He made you?

Research shows that 90% of women say that they're dissatisfied with their bodies. 20 million women and 10 million men have had or will have a clinical eating disorder in their lifetime—and I am one of those statistics. This is an area I have struggled with my entire adult life, and it's exactly the place that Satan attacks.

The LORD, speaking to Samuel, said, "Don't judge by his appearance or height, for I have rejected him. The LORD doesn't see things the way you see them. People judge by outward appearance, but the LORD looks at the heart" (1 Samuel 16:7 NLT).

Are we destined to have unhealthy and negative self-talk for a lifetime? As Christians, we say that the Holy Spirit resides within our bodies, but do we honor it by taking care of our bodies?

Did you know that French women don't spend money on cosmetic surgery, Botox, or expensive skincare treatments or products? I find this interesting considering Paris is one of the fashion capitals. What's their secret? Mireille Guiliano, author of *French Women Don't Get Facelifts* and the best-selling *French Women Don't Get Fat*, said,

> America, and some other countries, are youth cultures, so they are obsessed with eternal youth; the

French laugh at that. We are an old culture and have a great sentence in France: *La vie commence à cinquante,* 'Life starts at 50. For French women, the scalpel is the last resort …We look at ourselves in the mirror, no nonsense, and we say, 'Okay, maybe I need a new haircut, maybe a new dress, and then we embrace aging. We still know that we can seduce and flirt, and all we want is to live the second part of our lives as healthy and as well as possible.

Isn't this refreshing! Throughout the Bible, I'm constantly thrilled to see God using people of all ages to accomplish His will. I received a card from a very wise woman who decades earlier made peace with her appearance. It read, "With every breath you take God celebrates your life. He rejoices in who He made you to be and watches over you with wisdom and love." The accompanying Scripture said, "The LORD your God … will take great delight in you, he will quiet you with his love, he will rejoice over you with singing" (Zephaniah 3:17). "Delight" means a high degree of pleasure or enjoyment.

Aging and body re-shaping is inevitable with the passage of time. Do you see a body that is the delight and masterpiece of our Creator God? Or do you find fault with your thighs, stomach, wrinkles, or gray hair? As women, we can choose to fight back by rejoicing in who He made us to be. We can choose to lay down the self-critical weapons, resting once and for all in holy imperfection.

I challenge you to embrace a new thought that is in line with *La vie commence à cinquante!* (Life starts at 50!)

~Kimberly Davidson

Burn the Ships!

On February 19, 1519, the Spanish explorer Hernando Cortes set sail for Mexico with 11 ships, 13 horses, 110 sailors, and 553 soldiers. He was tasked with colonizing the new territory. The odds were stacked against him. Two previous missions had already failed.

Sometimes the greatest obstacle to success is our fear of future failure.

Cortes did something that some might consider radical. After making landfall, he told his men to burn the ships. By doing so, he made a strong statement: *Going back is not an option.*

While I don't endorse taking territory that doesn't belong to us, I do believe there is a whole lot of territory that we as believers can lay claim to yet willingly forfeit simply because we are unwilling to let go of the past.

Friends, living in freedom is a right that's ours for the taking, given to us by our Creator. "And the Lord God commanded the man, *"You are free…"* (Genesis 2:16). God also pronounced, "Be fruitful and increase in number; fill the earth and subdue it. *Rule over* the fish in the sea and the birds in the sky and over every living creature that moves on the ground" (Genesis 1:28).

God not only gave us freedom; He also gave us the right to rule.

If God created us to be both free and to rule, how is it that so many believers are still living in bondage?

You might say, "Well, sin, of course. Sin entered the world and everything changed."

True, sin did enter the world. But then Jesus Christ also entered the world. He died and rose again. Jesus nailed our sin to the cross. As believers, we really can't use that as an excuse. God

made a way for us to come back to a state of freedom. "So if the Son sets you free, you will be free indeed" (John 8:36).

Dictionary.com states it this way: *Bondage* is the state of being bound by or subjected to some kind of external power or control. Whether real or only perceived, suppression can come in many different forms: physical, spiritual, emotional, relational, even financial.

I think Hernando Cortes was on to something here. What if we used a similar mentality to not only live-in-freedom, but to have dominion over our everyday life?

Are you feeling stuck, unable to move forward? Are you stuck in a two-steps-forward, three-steps-back pattern of thinking?

Friends, it's time to burn the ships! Freedom is your right, your inheritance. You simply need to claim it.

Here are a few practical ways to burn the ships that have been making it far too easy for you to go backward rather than forward. It's time to advance into your personal promised land, a land flowing milk and honey, hope and joy, freedom and prosperity.

Financial debt? Cut up your credit cards and stop taking out loans.

Unhealthy relationships? Sever ties with people who are toxic or abusive.

Substance addiction? Remove the temptation? Throw it away and stop buying it.

Are you in bondage to the number on the scale? Stop weighing yourself, or better yet, throw the scale away.

Do you find yourself struggling to let go of anger and bitterness? Write a letter of forgiveness, and let go of past grievances. Remember, forgiveness is a gift you give yourself. You have a faithful Judge who arbitrates fairly. Trust His higher ways.

Friends, the choice is yours. You can stay stuck, or you can burn the ship.

I say, *"Burn Baby Burn!"*

"Now the Lord is the Spirit, and where the Spirit of the Lord is, there is freedom" (2 Corinthians 3:17).

"It is for freedom that Christ has set us free. Stand firm, then, and do not let yourselves be burdened again by a yoke of slavery" (Galatians 5:1).

~Rae Lynn DeAngelis

Jesus Calling

Confession time. I love my iPhone. Maybe a little bit too much. Throughout the day I find myself picking it up, glancing at the screen, scrolling through my apps to see if someone has called, left a message, or posted something interesting on social media.

It's amazing how quickly we adapt, conform, and even depend on the world around us. It wasn't very long ago that I didn't even have a cell phone, let alone a smartphone.

And is it ever smart! I can do so much with this little handheld device: check the weather, get the latest breaking news, create a grocery list, schedule upcoming events, send a message, listen to music, make a purchase, read a book, get directions. Oh, and I make a phone call too!

While I enjoy the benefits just mentioned, I have grown to love my iPhone even more for another reason. My smartphone helps me connect with Jesus.

I have a Bible app that allows me to look up Scriptures in an instant. I can listen to inspiring sermon messages and Christian music throughout the day. I'm able to encourage a friend with God's love through text messaging or find encouragement for myself through my devotion apps.

I have a few of them, but one of my favorites is *Jesus Calling* by Sarah Young. This devotion is written from the perspective of Jesus who is speaking directly to the reader. I have a reminder set

on my phone that pops up first thing in the morning. The reminder simply says *Jesus Calling*.

How cool is that! In the midst of all the hustle and bustle of each morning, the God of the universe calls out to me (on my iPhone, no less) beckoning me to come and spend some time with Him. "Call to me and I will answer you and tell you great and unsearchable things you do not know" (Jeremiah 33:3).

Through our frequent conversations together, Jesus reminds me how much He loves spending time with me. And I love spending time with Him too. In fact, each morning spent reading devotions, studying the Bible, and writing in my prayer journal is the best part of my day.

What about you? Are you intentional about growing your relationship with Jesus? Would you like to hear from God more, get direction, find encouragement, gain wisdom, and develop discernment? Since many of us have technology-based tools like smart phones, notepads, and computers, incorporating technology into our relationship with God makes a lot of sense. There are many ways that we can connect with God using technology. Here are a few suggestions to get you started:

- Subscribe to a devotion through email or download an app like Jesus Calling onto your phone and connect with God first thing in the morning

- Stream sermon messages through the Podcast app when you're in your car, cleaning the house, or going for a walk, etc.

- Download an app called Bible Gateway to have the most popular versions of the Bible at your fingertips. You can even search out Scriptures or topics using keywords in the search engine

- Journal your thoughts and prayers through the Prayer Notes app

There are so many great resources to help us grow in our relationship with Jesus, but we must be intentional.

Friends, Jesus is calling. Don't keep Him waiting any longer.

~Rae Lynn DeAngelis

Stronger than You Think

Do you see what God sees? Do you hear what God is saying? This is what He sees in you, and says to you today:

- You are stronger than you think.
- The power of God is for you.
- I created you to be unleashed and fierce, a warrior, and a world changer.
- I have limitless power for you to use.
- I want you to exchange your fear for courage.
- You are worthy to be a warrior.

Your first calling is to be a daughter of the King, and it comes with power.

Can you hear Him?

Stop waiting; the time of waiting is over. I want you in the fight. Only you can choose to be in the fight. You have the power to be healed, to walk past brokenness, to repent and break bondage, and to live an authentic life. You are a warrior. You have to get off the sidelines.

You are not second best. You don't have just one shot. I am the King of Redemption. I am the Author of the story, and I say it's not over. I put you in the game as a strong warrior, whom I have called and equipped. The more you sit at my feet to train and learn from me and take those thoughts captive, the more I will call you out to do.

You are Worthy, Called, Equipped, Known, Holy, and Mine. You have a Higher Purpose. You are My Daughter. Walk in courage, love, and boldness because you are here for a reason. There will be no more fear, only freedom. I've got armor for you for the battle to Fight the good Fight.

Put on the Full Armor, the Breastplate of Righteousness, the Sword of the Spirit, the Helmet of Salvation, the Gospel of Peace, and the Belt of Truth (Ephesians 6:10-18).

Put it all on. Wrap up in it. It will protect you. I will protect you. This is what I heard from the Lord at a women's camp I attended. These words, straight from our Father and I know He wanted you to hear them today.

Blessings and Courage to you, my sister.

~Alison Feinauer

What Freedom Looks Like

The childhood memory I'm about to share is remembered mostly through my mom's retelling. She said I was about two years old when this event took place. Although I don't remember the details, I do remember the feelings associated with the experience—extreme sadness.

My dad had given my mom a parakeet when they got engaged. She named him Petey. She had grown to love the little green and yellow bird, especially since it was a gift from my dad.

One day my mom took Petey's cage outside to clean it, and since I was just a toddler at the time, I came along. Mom walked back into the house for a brief moment to get something, and when

she returned, the birdcage stood wide open and Petey was nowhere to be found.

For reasons unknown, I opened the cage while my mom was in the house. Petey saw his opportunity and flew away. I don't remember letting Petey out of his cage, however, I do remember my mom's reaction. She was crushed. Petey had been her beloved pet for seven years.

Many who live in bondage to the lies of this world feel as though they are trapped in a cage, unable to escape. The enemy's cunning tactics of deception keep people blinded to the truth, and they no longer see freedom is an option.

When Jesus went to the cross, He not only died for our sins, but He also unlocked the prison doors that are associated with man's bondage. Freedom is ours for the taking, but far too often, the tight grip of fear never allows us to venture outside the cage.

Life outside our barred enclosure seems obscure and uncertain. Bondage is at least familiar and predictable.

Freedom. What does that even look like?

While I can't tell you how freedom will look in your life, I can tell you how it looks like in mine. Freedom means...

- No longer being controlled, manipulated, or influenced by the number on the scale

- Seeing food as nourishment and fuel, not something to be controlled

- Sitting down to a meal and being able to focus on friends, family, and fellowship rather than calories and fat grams

- Looking into the mirror and seeing beauty, not flaws

- Seeking to please and gain the approval of God, not man

- Seeing people and the world around me through God's eyes

- Surrendering my broken dreams for God's incredible adventures

- Shining God's light so others can find their way out of the darkness

- Believing with all certainty God's love is enough

- Knowing God loves me just as I am—and that's all that really matters

"If your law had not been my delight, I would have perished in my affliction. I will never forget your precepts, for by them you have preserved my life" (Psalm 119:92-93).

Freedom is so much better than I could have ever hoped or dreamed. Perhaps those fifty plus years ago, when I was just a child, a primal instinct, buried deep within, told me the truth. Life inside a cage is a poor way to live.

Friends, you and I were meant to be free. It's time to step out of the cage, spread your wings, and never look back. "…where the Spirit of the Lord is, there is freedom" (2 Corinthians 3:17).

"And my God will meet all your needs according to his glorious riches in Christ Jesus" (Philippians 4:19).

~Rae Lynn DeAngelis

Path Most Traveled

I recently attended a seminar which talked about the biological process that takes place when changing toxic thoughts and destructive behaviors into healthy life-affirming ways. The transformation is possible when we retrain the brain.

The seminar was given by a Christian psychologist. Her vivid analogy is one I'll never forget because she used a visual

comparison that made a lot of sense to me, especially when I compared it to my own life experience.

She began explaining that as we go through life, our personality, life experience, and realm of influence play an intricate role in the development of our brain. Firm beliefs about ourselves and the world in which we live take root and create patterns of thinking. The visual aid she used was that of a dirt path that's worn down through frequent use.

She then went on to explain that as our brains mature and develop, the dirt path becomes a paved road. When our mind entertains toxic thoughts the "paved road" quickly turns into an eight-lane highway. Toxic thought patterns turn into destructive behavior patterns, and before we know it, our lives spin wildly out of control.

But here is the good news! She said we can change our thought patterns, head in a different direction, and live in freedom. "He guides me along the right paths for his name's sake" (Psalm 23:3).

It all begins with the acknowledgement that our old way of thinking is unhealthy. After we make this mental declaration, we must consciously choose a different path and redirect our thoughts and ways. "We demolish arguments and every pretension that sets itself up against the knowledge of God, and we take captive every thought to make it obedient to Christ" (2 Corinthians 10:5).

Changed thoughts turn into changed behaviors. Changed behaviors turn into changed lives.

The process of establishing a new way of thinking is difficult at first. Like a path being forged through the jungle, tangled weeds threaten our forward progress. Worldly lies deeply embedded in the mind take some of us years to weed out.

However, if we push through the obstacles and stay the course, in time, healthy brain pathways create new eight lane highways that change us from the inside out. God makes our transformation possible through the truth of His Word. "Your word is a lamp for my feet, a light on my path" (Psalm 119:105).

With each new truth, the path to freedom becomes more evident. Neurons are formed, new brain waves are developed, and healthy behavior patterns are the result.

"You provide a broad path for my feet, so that my ankles do not give way" (Psalm 18:36).

Eventually new brain pathways become easier to travel. Freedom is no longer a dream. It is a way of life. And what happens to our old way of thinking after it has been abandoned? The neglected road becomes cracked, overgrown, and much less desirable to travel.

Are you ready to take God's hand and walk in a different direction? Let Jesus lead you step by step.

"Trust in the Lord with all your heart and lean not on your own understanding. In all your ways, acknowledge him, and he will make your path straight" (Proverbs 3:5-6).

~Rae Lynn DeAngelis

Your Footprint is Unique

As I walked back from the beach, I was stepping very carefully, trying not to get sand in my tennis shoes. As I looked down and noticed the path was worn and flattened by many different shoes and footprints.

In that moment, I heard the Lord say: "Many have gone before you or are on the path with you, but your footprint is unique."

1 Peter 4 came to mind:

> Every believer has received grace gifts, so use them to serve one another as faithful stewards of the many-colored tapestry of God's grace. For example, if you have a speaking gift, speak as though God were speaking his words through you. If you have the gift of serving, do it passionately with the strength God gives you, so that in everything God alone will be

glorified through Jesus Christ. For to him belong the power and the glory forever throughout all ages (1 Peter 4:10-12 TPT)!

I'm not sure what gift you've been given or if you ever feel just like everyone else. But I know you've been created uniquely, and He's put in you a special gift. You have a purpose. You are chosen, loved, and God is using your story to bring glory to Him and encouragement to others.

Do you ever look around and think – I'm just like the rest of them; I don't have anything special to give?

I want you to know that is not true. I want to tell you that with courage and boldness, use YOUR gift. Use your footprint to make an impact on someone's life. Stop comparing yourself to another's path or walk, or their healing journey to yours. God will use what you have in His perfect timing.

Today, I want you to put one foot in front of the other, and see how He will use what He's created in you and what He's called you to be.

Father, you created each of us fearfully and wonderfully. We want You to use us how you see fit today. Remind us of the work you've done in us that you are faithfully going to complete. Open up doors for us to continue to use our grace gifts. We want to serve you to the best of our ability and to honor you with our lives. Thank you for those you've put before us to make the path firm and clear. Thank you for Jesus, your Son and the times that we know He can empathize with our pain because He came to live a human life. Help us to share our story so that others might know You and Your love for them. We ask all of this according to Your name, Amen.

~Alison Feinauer

Reading Between the Lines

I 'm an avid reader and lover of books. In fact, at any given moment, I'm working through two or more volumes at the same time. I enjoy fiction, non-fiction, spiritual growth, self-help, devotionals, and inspirational biographies. My favorite is the Bible.

I've recently discovered, books are not the only collections I study. I spend a good amount of time reading people as well. I scan a person's body language, facial expressions, and tone of voice while listening to what they have to say. These manners of communication can sometimes speak louder than words.

Unfortunately, there is a slight problem with my method. I'm biased. We all are. We discern outward ques through broken glasses. Reality is distorted through a warped lens that is filtered through our emotions, personality, and life experience.

For example, I might see someone agitated or exceptionally quiet and automatically assume I've said or done something to offend them, only to find that their reaction had absolutely nothing to do with me. In reality the person just had a bad day, or maybe they were tired, stressed, or carrying a burden I knew nothing about.

When we factor our own biased assumptions into the readings of others, the tale becomes twisted.

It occurred to me that we might sometimes approach God and His Word in a similar manner, especially when it comes to the more incredible accounts: the six-day creation, Noah's global

flood, the parting of the Red Sea, Jesus' virgin birth, or His bodily resurrection.

"What is written in the Law?" [Jesus] replied. "How do you read it" (Luke 10:26)?

Are we reading the Bible as written, or are we inserting our own fallible views and preconceived ideas into the words clearly written?

The Word of God (the Bible) is trustworthy and unchanging. It is a reliable benchmark for truth. Through it, we are able to understand who God is, what He has done, and the best practices for living in a broken and imperfect world.

No more reading between the lines, sweet sister. It's time to take God at His Word.

"Listen, my sons, to a father's instruction; pay attention and gain understanding. I give you sound learning… Take hold of my words with all your heart; keep my commands, and you will live" (Proverbs 4:1-2, 4).

~Rae Lynn DeAngelis

Puppy Love

The other day I saw something that cut straight to my heart. It was one of the most beautiful expressions of love I've ever seen. And yet, it came from a rather unexpected place. The first time I witnessed this heartwarming scene, I was overcome with emotion.

To fully appreciate this picture, allow me to paint the back story. My husband and I live in a secluded subdivision in rural Indiana. The only cars we see are those belonging to our neighbors who are either heading out to go somewhere or coming home.

Limited traffic is a good thing. Since there are no sidewalks, people walk directly on the road.

The living room windows of our home face the road, so we see a steady flow of people getting in their daily exercise. Some people walk, some run, some ride bikes. Many are accompanied by their dogs.

We often see the same people day after day. There's a middle-aged man we frequently see walking his dog. The two of them look so sweet together. The dog appears to be a black lab mix of some sort. Judging by his lumbered stride, the retriever appears to be well-along in years. The owner is patient with his pup. He frequently stops to let his canine friend sniff lawns, mailboxes, or trees. He never rushes and never scolds. He just takes his time and walks by his side. This daily routine seems to be something they both enjoy.

One day, I saw the same dog with his owner, only this time, the owner held a leash in one hand and pulled an empty wagon with the other. That's when it hit me. The wagon was an added measure, just in case his pup got tired and couldn't keep walking. It brought tears to my eyes.

Day after day, the man walked his dog and pulled the empty wagon. It was endearing and heart-warming.

I hadn't seen the two in a while and wondered if the dog had passed away. It broke my heart to even consider that could be the case. I know all-too-well how hard it is to lose a furry friend. Our golden retriever lived to be 14 (that's 98 in dog years—a well-lived life by any standard). From the time Boe was a puppy, he followed me everywhere I went. He was my constant companion, protector, and friend. When the time came for us to say goodbye to our sweet boy, I cried for days.

Grief is grief. The heart knows no difference, whether man or beast.

Several days passed before I saw the man and his dog again. But when I did, I saw love in action, the kind of love that ascribes unsurpassable worth to another at cost to self, the kind of love that puts others' needs before our own.

Walking at a brisk pace past our house, I saw the man once again walking his beloved dog—not on a leash—but *in the wagon*. (Cue the waterworks!)

His pup just couldn't do it anymore; so love stepped in and did it for him. Every day, I see this man walking his dog by pulling him in the wagon. And every time, I'm reminded of what sacrificial love looks like in action.

Who in your life needs a little love today? Who needs to know you care? Maybe they just can't do it on their own anymore (whatever "it" may be). Could you step up and do it for them? After all, isn't that the message of the cross? Jesus did for us what He knew we couldn't do for ourselves.

Jesus said, "My command is this: Love each other as I have loved you. Greater love has no one than this: to lay down one's life for one's friends" (John 15:12-13 NIV). *Even our furry friends!*

"Love is patient, love is kind. It does not envy, it does not boast, it is not proud. It does not dishonor others, it is not self-seeking, it is not easily angered, it keeps no record of wrongs. Love does not delight in evil but rejoices with the truth. It always protects, always trusts, always hopes, always perseveres. Love never fails" (1 Corinthians 13:4-8a NIV).

"Do nothing out of selfish ambition or vain conceit. Rather, in humility value others above yourselves, not looking to your own interests but each of you to the interests of the others" (Philippians 2:3-4 NIV).

~Rae Lynn DeAngelis

The Rest of the Story

After the devotion *Puppy Love* was originally published to our email subscribers, I received a lot of positive feedback. It obviously struck a chord in the hearts of our readers, including my husband, Gerry.

Gerry is an extrovert, a social butterfly as I call him, and he's super friendly. He takes every opportunity to connect with people. (I love that about him.) He knows most of our neighbors by name, and he often stops whatever he's doing to engage in conversation.

One evening, Gerry walked over to retrieve our mail from the neighbor across the street who had graciously offered to collect it while we were away on vacation. (It was about a week after *Puppy Love* had been published.) Somehow, the conversation drifted to the subject of the man who walked his elderly dog. Gerry shared how I had written a blog about that very thing, and Janet said she would love to read it.

After Gerry sent it, she replied back how much it touched her heart. I thought to myself... *you just never know the full impact of the things we do*. I was encouraged to know she was blessed, but the impact didn't stop there. As the well-known radio broadcaster, Paul Harvey, used to say, "*And now... the rest of the story*."

Fast forward two weeks. It was a beautiful Sunday afternoon and I was eager to get outside to soak up the sun, but Gerry was tired and had his hopes set on an afternoon nap. No problem, I headed off to the pool for a couple of hours while Gerry stayed home and rested.

Later, when I got home, Gerry relayed what took place while I was gone. He said that he was in a deep sleep on the couch when the doorbell rang and jolted him awake. After getting his bearings, he stumbled to the door, peeked through the glass, and saw a man standing on the front porch waiting.

The man asked if I was home. Gerry told him that I'd gone to the pool but would be home soon. Suddenly, realization set in that this was the man I'd written about in my recent blog post.

Jay introduced himself and began recounting the story of how Janet (our neighbor from across the street) shared the blog with him and how much it meant to him. It came at a time when he was in the throes of terrible grief; his beloved dog had just passed away just three days earlier.

Jay then went on to share how he had rescued the lab mix from an abusive owner when he was a year and a half old. He gave him a new name (Cubby) because of his likeness to a bear cub, and in time, Jay was able to rehabilitate his pup to have trust in people again. Cubby was his constant companion for fifteen years until

he died at the ripe old age of seventeen. That's a long lifespan for any canine, especially a bigger breed like Cubby. (I believe Cubby's long lifespan had something to do with Jay's great care for him. After all, look how he cared for him towards the end of his life.)

So many lessons God continues to teach me through the story of Jay and Cubby. I see a beautiful picture of God through their relationship. Like it was for Jay and his dog, God comes to our rescue. He saves us, restores us, and gives us a new way of life. "Therefore, if anyone is in Christ, the new creation has come: The old has gone, the new is here" (2 Corinthians 5:17)!

Scripture says God even gives us a new name. "I will also give that person a white stone with a new name written on it, known only to the one who receives it" (Revelation 2:17).

God loves, cares for, and protects us. "Because he loves me," says the Lord, "I will rescue him; I will protect him, for he acknowledges my name" (Psalm 91:14).

And when we grow weary, Jesus is there by our side to help us to keep moving forward. "Come to me, all you who are weary and burdened, and I will give you rest. Take my yoke upon you and learn from me, for I am gentle and humble in heart, and you will find rest for your souls" (Matthew 11:28-29).

I have no idea if Jay is a Jesus follower or not, but I can tell you this: Through his example, I witnessed the love and goodness of Jesus through the way Jay cared for his dog.

We may never fully realize the impact of our actions until we get to heaven.

Jay had no idea we were watching him lovingly care for his dog. Gerry had no idea Janet would share my writings with Jay. And I had no idea Jay would read the post and be touched by it. We didn't know; but God did, and He used it for good.

I love this quote from Christian author, Oswald Chambers, *"You can never measure what God will do through you if you are rightly related to Jesus Christ. Keep your relationship right with Him, then whatever circumstances you are in, and whoever you meet day by day, He is pouring rivers of living water through you."*

I suppose the moral of the story is this… Someone's always watching. Let's make sure that what they see gives them a glimpse of the love and character of Jesus.

~Rae Lynn DeAngelis

Turn the Page

Typically, I'm a rule follower. Tell me what you expect from me, and I'll do it. Show me how you want it done, and I'll complete it ahead of schedule and beyond your expectations.

However, during a recent Bible study class, God taught me a valuable lesson while working through the questions from my homework assignment. When I got together with my group at the end of the week, I suddenly realized that I hadn't answered the last two questions for that week's lesson. It wasn't because I didn't know the answers to those questions. And it wasn't because I didn't have time to finish the assignment. I simply neglected to turn the page in the book. I thought I was at the end of the lesson, but in this case, there was more to be learned.

I love it when God provides profound lessons from the ordinary, mundane parts of life. He does it to teach us more about ourselves and the world around us.

Here's what God taught me this time. Sometimes, no matter how hard we try to be organized, ready, and prepared, questions go unanswered and things get left undone. It's true in Bible study, and it's true in life. Circumstances change, people move on, and life gets crazy. We need to ask ourselves if we are going to settle for the status quo (safe, stagnant, and comfortable) or are we willing to turn the page and see what God has next.

Friend, your story isn't over yet. As long as you have breath, there's more to be written. Take God's hand, turn the page, and begin the next chapter. Who knows? It just might be your most amazing adventure yet.

"Forget the former things; do not dwell on the past. See, I am doing a new thing! Now it springs up; do you not perceive it? I am making a way in the wilderness and streams in the wasteland" (Isaiah 43:18-19).

"Forgetting what is behind and straining toward what is ahead, I press on toward the goal to win the prize for which God has called me heavenward in Christ Jesus" (Philippians 3:13-14).

~Rae Lynn DeAngelis

Charging Boldly Ahead

I recently saw a great visual that helped me better appreciate a particular part of the Armor of God referenced in Ephesians 6:10-18. Before I share what the visual was, allow me to provide a bit of context.

Women who sign up to be part of the *Eyes Wide Open (EWO) Healing Program* receive a comprehensive packet of materials to support their journey. Week 4 of the 10-week program focuses on the importance of being covered with the Armor of God and taking your stand against the devil's schemes. The program packet includes a beautiful flowered postcard that has a prayer to help them do just that.

Lord,
Help me to remember as I face life's challenges that an
unseen battle is going on for my spiritual life. Send Your
Holy Spirit to give me the wisdom to recognize what is

*the truth and what is a lie. Remind me that the best ways
for me to win the battles of my mind is in prayer and by
reading Your Word.*

*To prepare myself for the battle ahead, by faith, I put on
Your Armor. I am thankful for the Armor You have
provided. I put on the Belt of Truth, the Breastplate of
Righteousness, the Boots of Peace, and the Helmet of
Salvation. I lift up the Shield of Faith against all the
fiery darts of the enemy; and I take in my hand the
Sword of the Spirit, the Word of God. I put on this Armor
and live and pray in complete dependence upon you.*

*Thank you for assuring me of victory today. I surrender
all to You today. I surrender all to You today and let You
fight for me. If you are with me, I know nothing can hurt
me, and I can be transformed. So by faith, I claim victory
over my life! In Jesus name I pray.*
Amen

I absolutely love this prayer and read it every morning during
my devotion time. I envision myself putting on each piece of the
armor; sometimes I even act it out. It's important that we are
protected with the *full* Armor of God so that we, too, can take our
stand against the enemy's schemes. Perhaps you have noticed,
Satan is becoming bolder with his attacks. That's because he
knows his time is short. "But woe to the earth and the sea, because
the devil has gone down to you! He is filled with fury, because he
knows that his time is short" (Revelation 12:12 NIV).

An important part of our armor is the Shield of Faith. In the
past, I envisioned myself holding up the shield of faith and almost
cowering behind it, hoping I wouldn't get hurt by the enemy's
fiery darts, coming my way. But then I saw something that forever
changed my perception of the Shield of Faith and how it is meant
to be used. This brings me to the visual I mentioned earlier.

I stumbled upon a video clip that showed a group of
courageous soldiers advancing towards their enemy in battle.
They were not cowering in fear behind their shields. Rather, they
had locked arms as a platoon with shields in place and charged

forward against their enemy, creating a greater impenetrable force.

When I saw this, God spoke to my heart and said, *Rae Lynn, the Shield of Faith is more effective when you link arms with other Believers. My children don't need to cower in fear behind their faith. They need to band together, charging boldly ahead. United you stand. Divided you fall.*

My fellow believers, in light of this revelation, I have a challenge for you as we come to the end of this devotional. Would you be willing to link arms with other believers and boldly take back the territory the enemy has stolen? Our rights, our freedoms, our voice, even our livelihoods in some cases have been stripped away. But no more. We don't need to cower in fear. We have God's Armor to protect and empower us. There is a way we can tangibly link arms. It is through prayer. And this ministry has a practical way that you can do just that.

The "Prayer of Protection" postcard is something that you can tuck into your Bible, prayer journal, or purse. You can place it on your night stand or even on your refrigerator.

If you would like one of these prayer cards, go to www.livingintruthministries.com/store and click on the Prayer of Protection "add to cart" button. Each prayer card is only $3 including postage. We will mail your prayer postcard directly to you. Buy several to put around your house and/or share with other believers. When you pass one along, be sure to share the visual I shared with you. The more soldiers we have praying and marching boldly behind the Shield of Faith, the better. Together, we are stronger.

"Finally, be strong in the Lord and in his mighty power. Put on the full armor of God... And pray in the Spirit on all occasions with all kinds of prayers and requests. With this in mind, be alert and always keep on praying for all the Lord's people" (Ephesians 6:10, 18 NIV).

NOTE: 100% of the proceeds from these prayer cards goes directly towards supporting the continuing mission of Living in Truth Ministries.

~Rae Lynn DeAngelis

Connect with Us and Free Resources

One of the best parts of being a writer is connecting with readers. Connect with Rae Lynn, the other contributors, and Living in Truth Ministries at our website, and get started with a free eBook, *Who Am I Really? A 12 Day Journey to Discover Your True Identity*, by signing up for our mailing list at:

livingintruthministries.com/subscribe

Enjoy this Book?

You Can Make a Big Difference!

I am so grateful for my committed and loyal readers! Your review is the best thank-you I can receive.

Reviews are the most powerful tool we have as authors when it comes to bringing books to the attention of other readers.

If you enjoyed this book, I would be very grateful if you could spend just five minutes leaving a review (it can be as short as you like) on the book's Amazon page.

Other Books and Resources by Living in Truth Ministries

Find a list of books written by Rae Lynn and other resources offered by Living in Truth Ministries to help you grow in your relationship with God at our website:

https://livingintruthministries.com/store

Here's a sampling of a few you'll enjoy:

REACHING NEW HEIGHTS: Whether you're a seasoned Christian, a new believer, or somewhere in-between, this program is for you.

Reaching New Heights is a 14-week, guided, one-on-one, discipleship experience that's designed to grow you spiritually. Registration includes mentor/disciple pairing and other tools and resources to guide your journey.

To learn more, go to livingintruthministries.com and click on the MENTORNING page.

EYES WIDE OPEN: This 10-week healing program emphasizes spiritual and emotional healing from struggles surrounding food, body-image, and self-esteem. Through community-based support and individual study, this program will help you discover truth, find hope, and embrace freedom with like-minded sisters-in-Christ. Group size is limited and advanced sign-up is mandatory. Some groups have a waiting list, so be sure to contact us right away to ensure placement.

To learn more, go to livingintruthministries.com and click to the HEALING page.

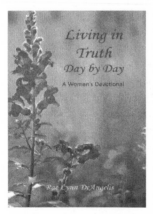

LIVING IN TRUTH DAY BY DAY: The Word of God is living and active, our handbook for everyday life. When day-to-day experiences are viewed against the backdrop of biblical truth, we become more aware of the deep spiritual lessons, life has to offer. With each revelation, God turns our ordinary into extraordinary! Each daily reading will inspire you to see God at work in your own life and encourage you to live in God's truth day by day.

To learn more, go to livingintruthministries.com, and click on the link to our STORE page.

About the Authors

Rae Lynn DeAngelis – I was lucky enough to marry the love of my life over 35 years ago and be blessed with two amazing children (now grown) with families of their own. No human grandchildren yet, but we absolutely love our grand pups—Westen and Finnley. Our family is small, but we have lots of friends who feel like family, so we are blessed indeed. I love to write, read, travel, ride bikes, go to restaurants, and watch movies. A day spent with family and friends is always a win. You can learn much more about me through this or other books I've written. My greatest passion is to encourage women through the promises of God—biblical truth. My favorite time of day is morning when I get to soak up God's Word, journal, and pray. I work full-time as the Founder/Executive Director of Living in Truth Ministries, but it doesn't really feel like work because ministry is my passion and life-calling. My heart's desire is to help women embrace their unique identity and see themselves through God's eyes. I've lived in the Cincinnati tri state area my entire life, but I spend as much time as possible in the beautiful state of Florida, enjoying the warm sunshine on my face and sand beneath my feet.

Melody Moore - I'm a Christian, teacher, wife, mother, daughter, and grandmother, among other roles. My favorite sound is the laughter of my grandchildren. I teach in juvenile detention and alternative education. In short, that means all of my students have problems that are, to them, bigger than education. I don't know anyone who loves his or her job more than I do. I count myself as incredibly blessed. I'm the editor and a guest blogger for Living in Truth Ministries. I cannot begin to quantify the blessing the women I've met through the ministry have been to my life. My

greatest desire is that someone could look at me and see anything that makes them think of Jesus. My most fervent prayer is that God will remove the scales from the eyes of those I love who don't believe and call them out. My greatest fear is not seeing them in Heaven. I enjoy hiking, kayaking, and scuba diving. My favorite places to go on vacation involve not having cell phone reception.

Tanya Jolliffe - I am a Registered Dietitian Nutritionist, Licensed Dietitian, and Certified Mental Health Integrative Medicine Provider. I have decades of experience providing nutrition education, medical nutrition therapy, discipleship, behavior modification, and health coaching. This experience helps me offer an integrative approach to health and wellness for healing and wholeness. I was an accomplished and acclaimed athlete in both high school and college and have received Hall of Fame recognition as well. I personally struggled with body image issues and disordered eating and was able to embrace mindful eating practices and movement to leave the disordered behaviors and chronic dieting behind. I wanted to help other people do the same, so I developed a mindfulness eating journaling program called, "The Mindful Me Journey: A 40-Day Journal Toward a Healthier Relationship with Food and Exercise" that people can use independently or as part of a one-on-one coaching program. I founded LIT Wellness Solutions in 2019 to provide integrative health and wellness solutions and values-based coaching services to help individuals and organizations create lasting health transformation.

Kimberly Davidson - I lived two decades of my life in complete turmoil, pain and addiction. Jesus heard the cry of my heart and interceded, freeing me. Today I refer to myself as a "wounded healer," using my voice, life wisdom, education, and pen to write curriculum and healing-based books for women. I am a board-certified pastoral counselor helping women mend their souls. I created Olive Branch Outreach, an interactive website dedicated to bring hope and restoration to women in pain. I live in Oregon on a small ranch with my husband and many critters.

Alison Feinauer - I love all things Jesus, fitness, coffee, computers, and people. Originally from Indiana, I transplanted to Northern Kentucky after getting my Information Technology Degree from Purdue University. I'm a mom and stepmom. I have been married 18 years. My husband and I volunteer in the marriage ministry at our church so that we can help other blended families as they grow. I love to help other stepmoms navigate their new role as they enter marriage, help other women believe their identities as beloved daughters of the King to help overcome addictions, teach women and men how to love their bodies by fueling it with proper nutrition, and teach bootcamps at a local gym. I've been on the Digital Products team at Crossroads Church for 13 years after leaving 8 years of work in the corporate workplace. My passion is changing from the inside out and growing through what you go through so that you can help point others to Jesus from your experiences.

Rhonda Stinson - I am a daughter of God with a heart full of joy (even on the horrible days). After 25 years of eating disorders, anorexia with a couple brief periods of bulimia, the Holy Spirit spoke to my heart and I knew my life would be forever changed. The eating disorders, along with Type 1 (juvenile) diabetes, was a lethal combination. It is only by the hand of God that I am still alive. It was a transformation created by Him. I cannot begin to tell of all that God has taught me within the past five years, but my life is living proof! I serve the Almighty through singing, teaching a women's Sunday school class, leading a puppet ministry, leading Bible studies, and doing programs for those with dementia and Alzheimer's disease. Oh, and how could I forget my most recent love, a Shiba Inu named Marley! "For I consider the sufferings of this present time are not worth comparing with the glory that is to be revealed to us" (Romans 8:18 ESV).

Sheree Craig - I am a wife, mother, and nurse. I battled an eating disorder for over a decade and continue to work through triggers that bring a desire to run back to disordered eating habits. Writing has been my greatest recovery tool. In writing, I reveal raw truth, the battles going on in my thoughts, and the process of working through triggers to choose the path of recovery. God did not intend

for us to keep things hidden in the dark for the enemy to gain leverage. Through writing, I bring thoughts to light in hopes to help others and remain honest with my struggles. Recovery is possible and a beautiful thing! Together, we can continue choosing recovery while building one another up through God's Truth.

Kelsey Klepper- I am from a small town in northwest Ohio where I currently reside with my husband and three young children. To me, nothing beats doing life with your parents, siblings, and nieces, and nephews on the daily. If I'm not wrangling my kiddos, you'll likely find me tending to my plethora of houseplants or working on a house project. I love a good conversation, Friday night pizza, coffee, my spin bike, and a little sarcasm. It took many years to find that there's so much more to enjoy in life than obsession over my body. I hope these devotions can help you navigate a life of freedom in Christ. I know writing for LITM did this for me, and I'm forever grateful.

Lindsey Jones - I am 31 years old and currently live in Okeana, Ohio. My biggest passion in life is to show others the grace and love of God. To see a life changed because they have let go of their own will and leaned into the Lord to find His will. There is no better feeling. I have been through many trials and struggles in life, yet God still continues to show me that He doesn't call the equipped. He truly does equip the called. For that, I will be forever grateful.

Acknowledgements

B ringing a project such as to life this takes a village. I would like to thank all those who have helped make this book possible.

First and foremost, thank you, Jesus, for making a way where there was no way. Thank you for providing biblical truth to direct our day-to-day lives, and thank you for setting me free!

I would like to thank you, the reader. With the literally millions of books, you could have chosen to read, I'm glad you chose this one. I pray this devotional encourages, inspires, and grows your relationship with Jesus.

Many thanks to my sisters-in-Christ who have co-authored this book and shared your gifts, talents, and wisdom to help women grow spiritually. Thank you: Melody Moore, Kimberly Davidson, Tanya Jolliffe, Alison Feinauer, Rhonda Stinson, Sheree Craig, Kelsey Klepper, and Lindsey Jones.

A special thank you to Melody Moore, our Editor-in-Chief, who has spent countless hours poring over this manuscript, making it ready for publication.

A big thank you to Heather, our interior format and cover design editor who has helped make this book a beautiful display of God's splendor.

And last, but certainly not least, I would like to thank my husband, Gerry, who not only provided me with ample writing material, but is the love of my life and biggest supporter. I love you with all my heart.